EUROPEAN DRAWINGS · 1
CATALOGUE OF THE COLLECTIONS

EUROPEAN DRAWINGS·1
CATALOGUE OF THE COLLECTIONS

George R. Goldner

with the assistance of
Lee Hendrix and Gloria Williams

THE J. PAUL GETTY MUSEUM
MALIBU · CALIFORNIA
1988

© 1988 The J. Paul Getty Museum
17985 Pacific Coast Highway
Malibu, California 90265

Mailing address:
P.O. Box 2112
Santa Monica, California 90406

Christopher Hudson, Head of Publications
Andrea P. A. Belloli, Editor-in-Chief
Patrick Dooley, Designer
Karen Schmidt, Production Manager
Thea Piegdon, Production Assistant
Elizabeth C. Burke, Photograph Coordinator
Charles Pasella and Stephenie Blakemore, Photographers

Typography by Wilsted & Taylor, Oakland, California
Printed by Mondadori, Verona

Printed in Italy

CONTENTS

FOREWORD

The Getty Museum's collection of drawings is seven years old, a small child among the mature museum collections of the world, but a child with promise.

In the spring of 1981, George R. Goldner, who was then head of the Museum's photographic archive, proposed to the Trustees that they bid at auction for the Rembrandt chalk study of a nude, the so-called *Cleopatra*. Dr. Goldner's timing was perfect. For while J. Paul Getty had never bought drawings, and although since his death in 1976 the Trustees had not strayed outside the three established areas of the collection—antiquities, French furniture and decorative arts, and European paintings—Getty had left a huge bequest, and it was clear that the Museum's collection could now be broadened as well as strengthened. Dr. Goldner, a specialist in Italian art, argued that the Museum could form a collection that eventually might become one of the finest in the world. He reasoned that there were enough private collections to provide a relatively generous supply of important examples for a long time to come, and that buying the Rembrandt seemed a brilliant way to start. The Trustees agreed, and their bid for the Rembrandt was successful.

By the time I arrived at the Museum in 1983, Dr. Goldner, who was in charge of drawings part-time, had secured some forty of them for the collection and had demonstrated that he was obviously the man to head a new department of drawings. Later that same year Nancy Yocco joined the department as conservation assistant. In 1984 a study room was created and a gallery fitted out for rotating exhibitions from the collection; in 1985 Lee Hendrix became assistant curator. Since then the department has been working intensively at collecting, exhibiting, publishing, lending, and facilitating scholarship.

There are now more than two hundred drawings in the Museum's collection. The reader will see from the proportion of examples of various schools and periods that we have been concentrating during this period on the rarest material, mainly from the Italian and German Renaissance; trying to find the best drawings of the seventeenth and eighteenth centuries; acquiring nineteenth-century drawings only when the greatest opportunities arose; and adding superb drawings by artists whose names will never be household words.

The rate at which the collection is growing ensures that this catalogue will immediately be outdated, so we intend to issue a sequel in five years or so. This volume, like the collection itself, owes everything to the energy of and skill of the curator.

John Walsh
Director

PREFACE AND ACKNOWLEDGMENTS

This volume represents the first in a series of catalogues of the Getty Museum's drawings collection. It contains entries on our acquisitions from 1981 through 1985 and takes into account bibliographical information through 1986. It is anticipated that future volumes will appear at more or less regular intervals marked by additions to the collection in sufficient numbers to warrant new publications. Later catalogues will also contain further material on the drawings included in this one. The format of this and future volumes will be standardized, with drawings organized by national school, alphabetically by artist's name, and then chronologically. The physical description of each sheet will mention any noteworthy irregularities.

The writing and production of this catalogue have involved the assistance of many individuals. I am grateful to Lee Hendrix, Assistant Curator, and Gloria Williams, Catalogue Assistant, for their work on all aspects of the project, ranging from the drafting of the introductory biographies to the contribution of many useful ideas about individual drawings. Their specific suggestions—like those of other scholars—are duly noted in the appropriate places in the text. Nancy Yocco, Conservation Assistant, carefully recorded relevant information about the condition of each drawing and the inscriptions and marks that each one bears. The entire text was reviewed and helpful criticisms offered by three readers: Diane DeGrazia, for the Italian drawings; Beverly Jacoby, for the French and Spanish drawings; and Anne-Marie S. Logan, for all of the Northern and British drawings. Giulio Bora was kind enough to read over those entries dealing with Lombard drawings and to make several helpful suggestions.

Andrea P. A. Belloli took over the editorship of the catalogue at an especially difficult moment and carried out her role with the optimum blend of editorial sternness and good cheer. Patrick Dooley produced the design of the volume. Lastly, many scholars have offered suggestions. In every case I have attempted to note their contributions in the entries on individual sheets, and thank them here collectively for their advice. Notwithstanding my respect for their opinions and for those of other scholars, full responsibility for the attributions and views expressed in the catalogue is my own. Where they depart from the opinions of others they do so respectfully, but unapologetically, since I believe that each connoisseur must attempt to make his or her own judgments instead of reporting the results of scholarly polls.

The publication of the first volume of our serial catalogue is an appropriate moment to thank the many people who have made possible the existence and development of the collection. Harold Williams and Otto Wittmann supported our initial purchase of the Rembrandt, and have—along with other members of the Board of Trustees—given great encouragement throughout the last six years. Since his appointment in 1983 as director, John Walsh has encouraged the evolution of a broader concept for the collection and has given me a degree of freedom and support unusual for any curator. Within the department, Lee Hendrix has been of enormous assistance with all curatorial matters, while Nancy Yocco has looked after the physical care of the drawings with exemplary dedication. Outside the Museum, Alexander Yow deserves special mention for the fine restoration work he has carried out on a number of our drawings and for his advice. In addition other scholars and dealers too numerous to list here have been of assistance in myriad ways. It is my hope that all those who have contributed to the beginnings of the collection and the writing of this catalogue will feel at least partially compensated for their generosity by seeing the result.

George R. Goldner
Curator, Department of Drawings

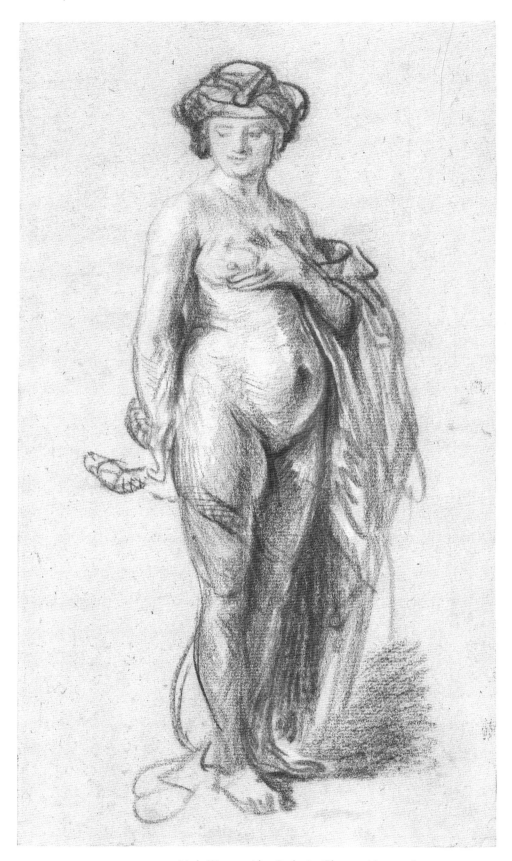

PLATE I. REMBRANDT VAN RIJN, *Nude Woman with a Snake (as Cleopatra)* (no. 114).

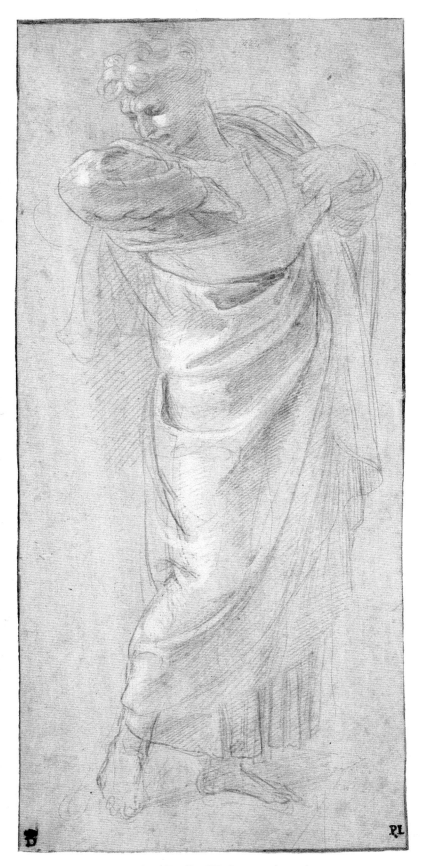

PLATE 2. RAPHAEL, *Saint Paul Rending His Garments* (no. 39).

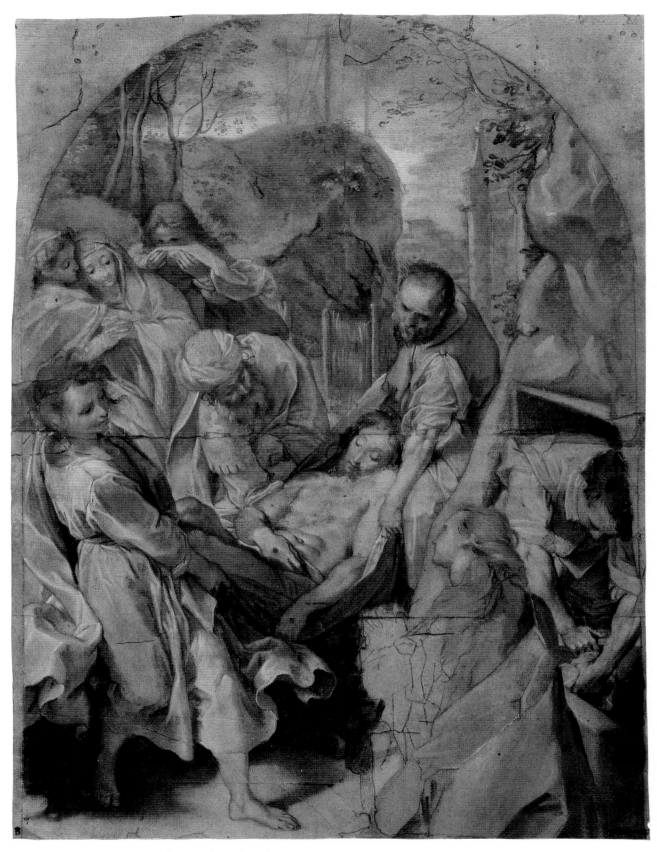

PLATE 3. FEDERICO BAROCCI, *The Entombment* (no. 3).

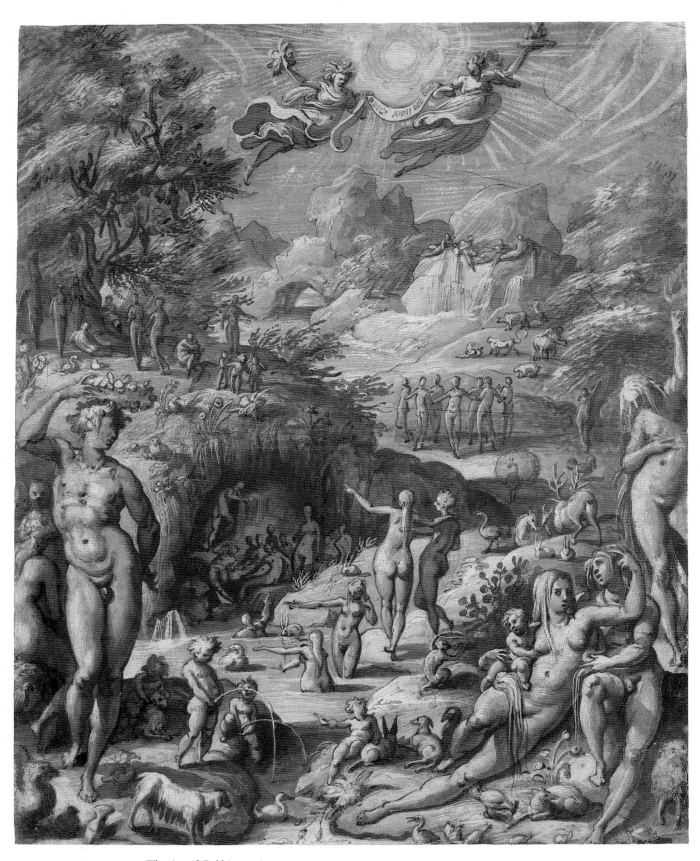

PLATE 4. JACOPO ZUCCHI, *The Age of Gold* (no. 57).

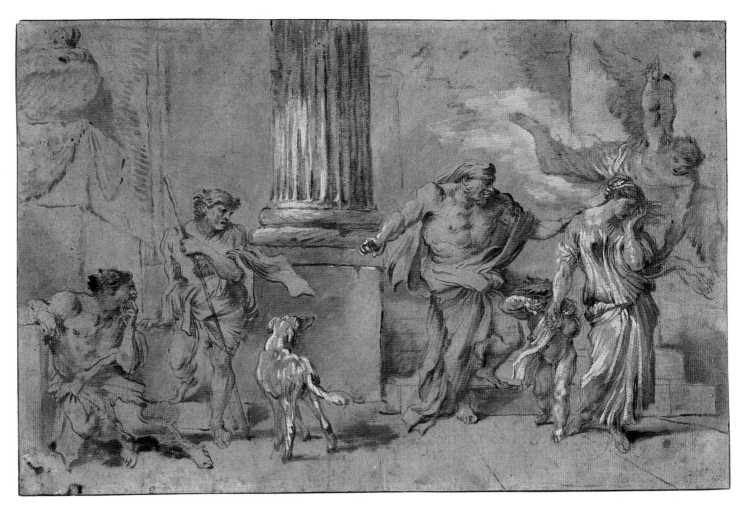

PLATE 5. GIOVANNI BENEDETTO CASTIGLIONE, *The Expulsion of Hagar* (no. 10).

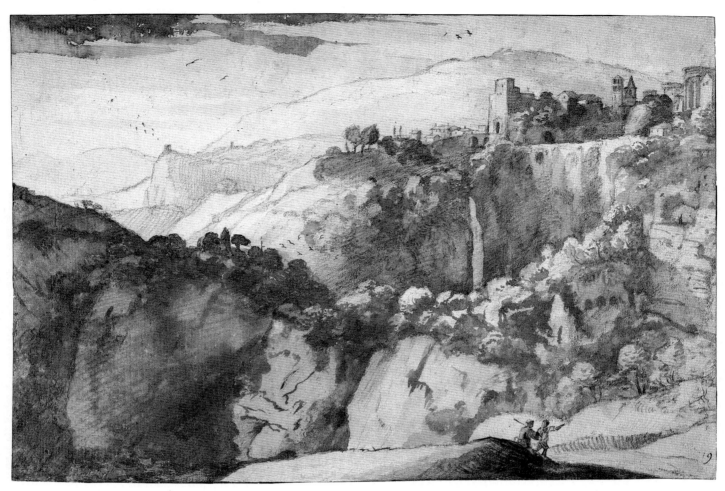

PLATE 6. CLAUDE LORRAIN, *View of Tivoli* (no. 78 recto).

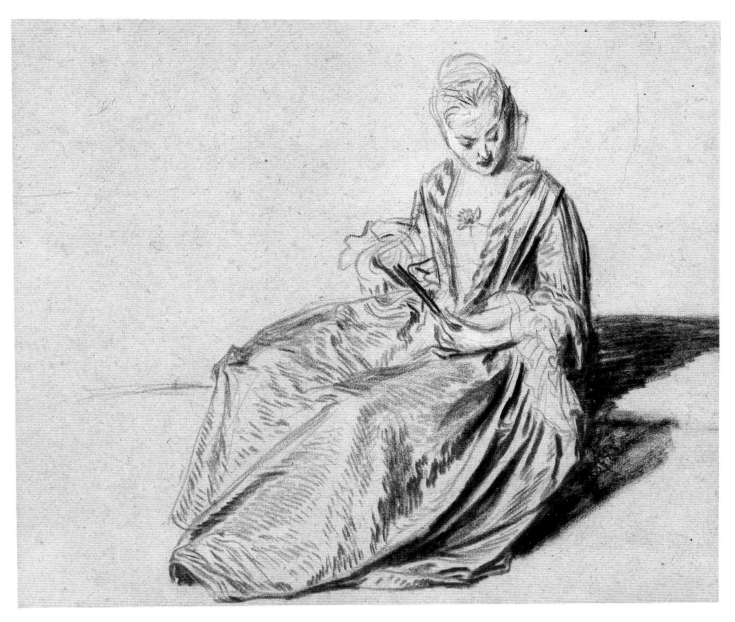

PLATE 7. JEAN-ANTOINE WATTEAU, *Seated Woman with a Fan* (no. 85).

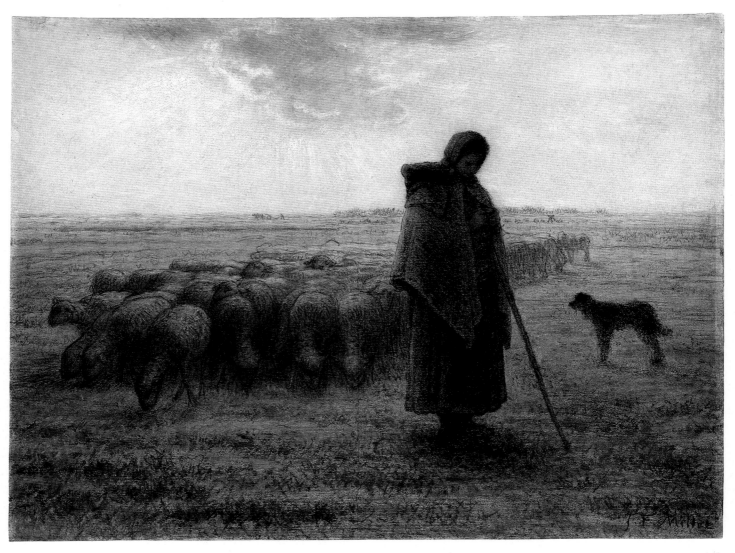

PLATE 8. JEAN-FRANÇOIS MILLET, *Shepherdess and Her Flock* (no. 80).

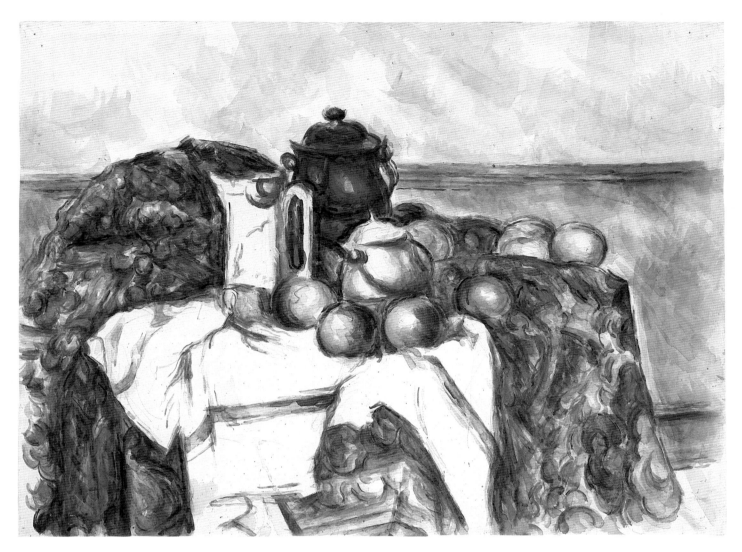

PLATE 9. PAUL CÉZANNE, *Still Life* (no. 65).

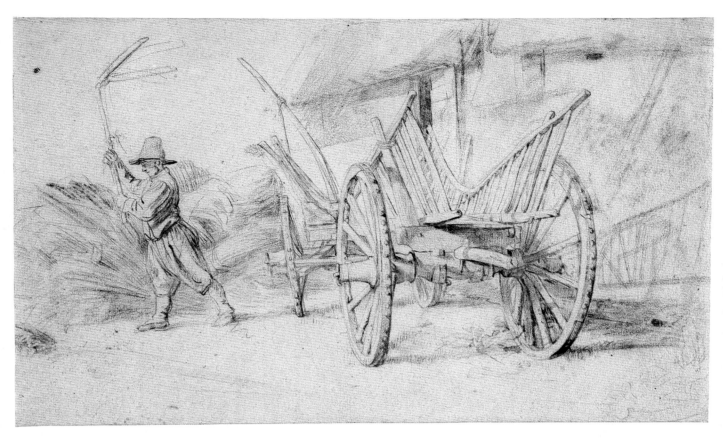

PLATE 10. PETER PAUL RUBENS, *A Man Threshing beside a Wagon, Farm Buildings Behind* (no. 92).

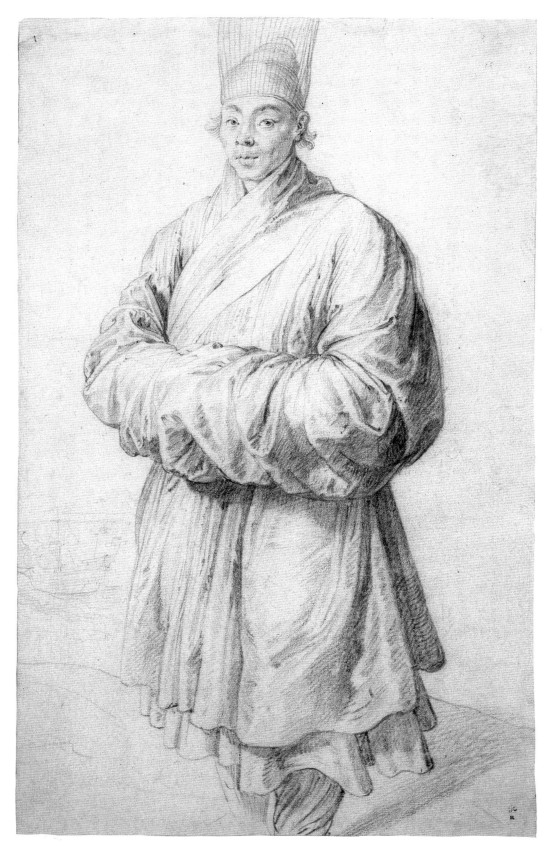

PLATE 11. PETER PAUL RUBENS, *Korean Man* (no. 93).

PLATE 12. ABRAHAM BLOEMAERT, *Three Studies of a Woman* (no. 102 recto).

PLATE 13. GERRIT VAN BATTEM, *Figures on a Frozen Canal* (no. 101).

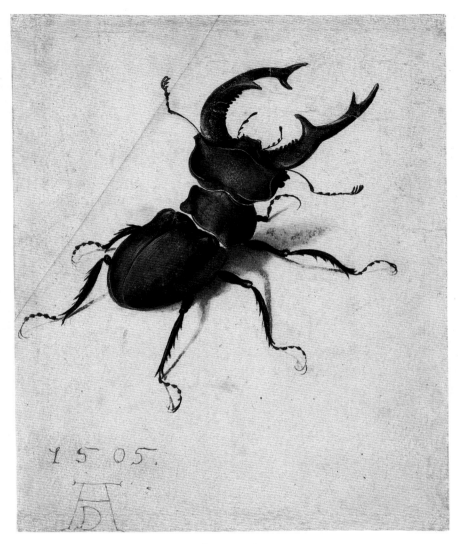

PLATE 14. ALBRECHT DÜRER, *Stag Beetle* (no. 129).

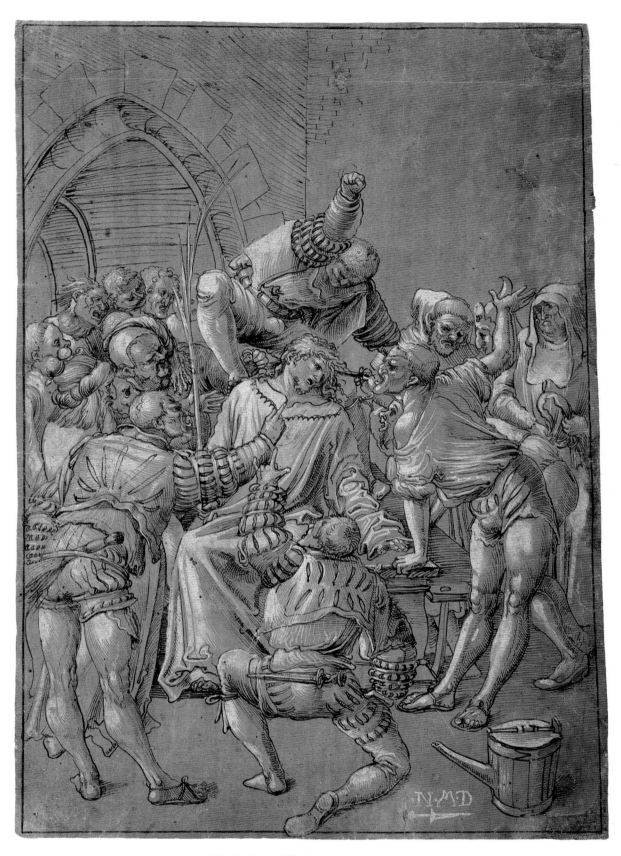

PLATE 15. NIKLAUS MANUEL DEUTSCH, *The Mocking of Christ* (no. 140).

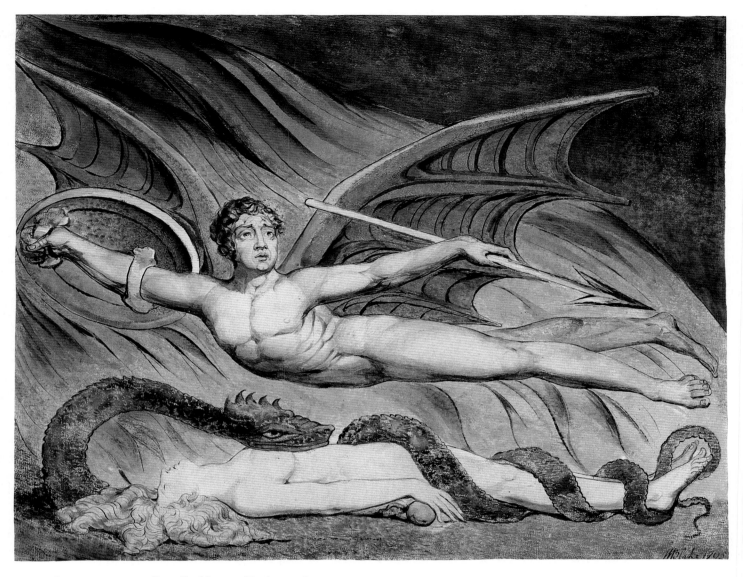

PLATE 16. WILLIAM BLAKE, *Satan Exulting over Eve* (no. 146).

ANDREA DEL SARTO

1 *Study of a Kneeling Figure with a Sketch of a Face*ʳ
*Figure Study and Face*ᵛ

Red chalk, black chalk sketch of face (recto); red chalk (verso); sheet torn horizontally and repaired; H: 27.2 cm (10 ¹¹⁄₁₆ in.); W: 19.8 cm (7 ¹³⁄₁₆ in.)
84.GB.7

MARKS AND INSCRIPTIONS: (Recto) at top, right of center, inscribed *39 =* in black chalk superimposed on *95* in red chalk.

PROVENANCE: Art market, Lausanne.

EXHIBITIONS: None.

BIBLIOGRAPHY: J. Shearman, "Andrea del Sarto's Two Paintings of the Assumption," *Burlington Magazine* 101, no. 673 (April 1959), p. 129; B. Berenson, *I disegni dei pittori fiorentini* (Milan, 1961), vol. 2, p. 34, no. 161 A-1; S. J. Freedberg, *Andrea del Sarto* (Cambridge, Mass., 1963), vol. 1, p. 118; R. Monti, *Andrea del Sarto* (Milan, 1965), p. 170; J. Shearman, *Andrea del Sarto* (Oxford, 1965), vol. 2, p. 386; A. Petrioli Tofani, in M. Chiarini et al., *Andrea del Sarto 1486–1530*, exh. cat., Palazzo Pitti, Florence, 1986, pp. 188; 267, under no. 56.

THE RECTO OF THIS SHEET WAS FIRST PUBLISHED IN 1959 by Shearman, who correctly identified the kneeling figure as a study for the apostle in the left foreground of the Panciatichi *Assumption* (Florence, Palazzo Pitti). The pose derives from Sarto's kneeling Saint Sebastian in the *Disputa* (circa 1518; Florence, Pitti) and the related drawing in the Uffizi (inv. 6918 F; Shearman 1965, vol. 1, pls. 66a, b). It was used again later in the Passerini *Assumption* in the Pitti. This appears to be an instance in which Sarto altered and developed an idea first conceived in relation to the earlier Panciatichi *Assumption*. The brief sketch of a face on the recto may have been made in relation to one of the apostles in that painting, but is not clearly the model for any of them.

The verso has never been published. The principal image of the standing nude figure with drapery is a study for the Saint Thomas in the Panciatichi *Assumption* and was employed later for the same saint in the Passerini *Assumption*. In fact the raised left arm is closer to the corresponding detail of the later painting. Contiguous to the figure is a form that appears to be bunched drapery. In addition there are two male heads, later crossed out by the artist. The one at the upper right bears some resemblance to the apostle for which the recto was drawn. Based on Shearman's accurate dating of the Panciatichi *Assumption*, the drawing should be placed in 1522–1523. It is stylistically in accord with other drawings of this period, including several for the same project, though it shows a somewhat greater than usual concern for the monumental rendering of muscular structure.[1]

1. For the other drawings related to the Panciatichi *Assumption*, see Freedberg 1963, vol. 1, pp. 115–118, no. 52; Shearman 1965, vol. 2, p. 253, no. 64.

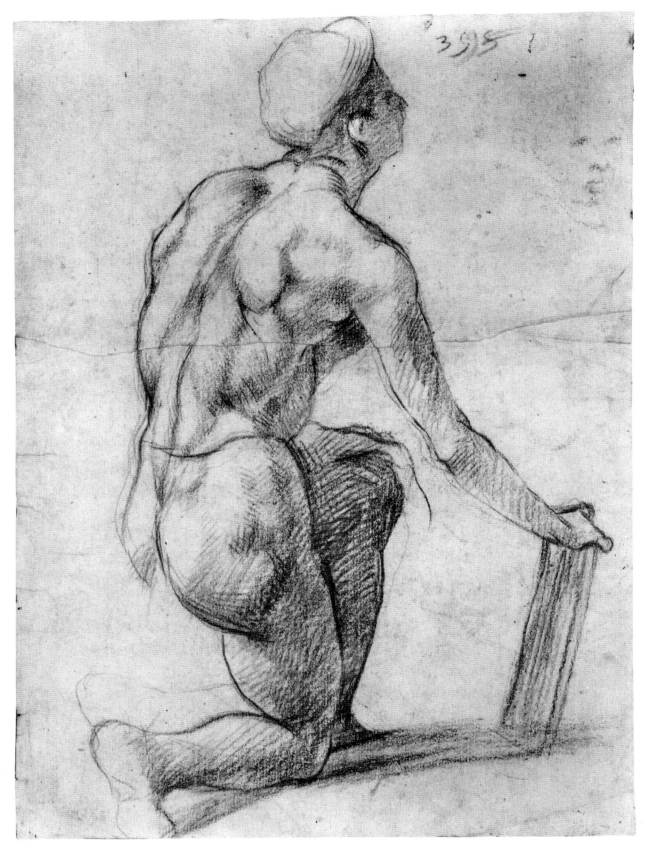

recto

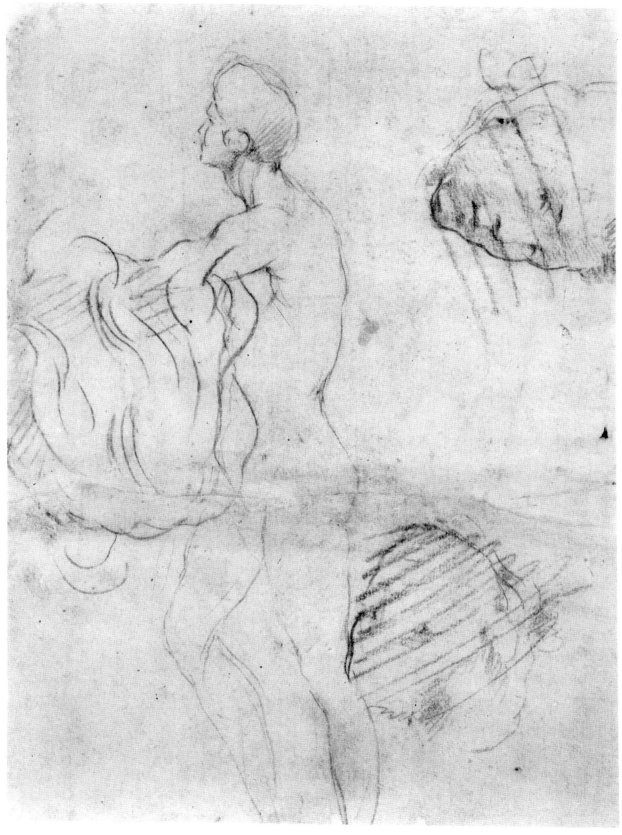

verso

2 Study of Two Men[r]
Study of the Head of a Bearded Man[v]

Pen and brown ink; H: 34 cm (13⅜ in.); W: 22.5 cm (8¹³⁄₁₆ in.)
85.GB.227

MARKS AND INSCRIPTIONS: (Verso) at top right corner, inscribed *Bacchio Bandinelli* in brown ink.

PROVENANCE: Anne-Louis Girodet de Roucy Trioson, Paris (sale, M. Perignon, Paris, April 11, 1825, lot 506[?], as "Trois dessins attribués à Michel-Ange et Baccio Bandinelli"); by descent, Girodet family, Paris; art market, Zurich.

EXHIBITIONS: None.

BIBLIOGRAPHY: None.

THE RECTO IS ONE OF A LARGE NUMBER OF NUDE STUDIES, several with two figures, by Bandinelli. The nude at left derives from the Apollo Belvedere, though the position of the right arm reflects Michelangelo's *David* just as the left hand of the other nude may suggest a knowledge of the corresponding detail of that statue. In terms of Bandinelli's drawings, the recto is closest to the study of two nudes in the Corcoran Gallery of Art, Washington, D.C. (inv. 26.183a). It is also relatable to studies of four nude men at Christ Church, Oxford (inv. 0082),[1] and to two sheets made in preparation for the *Hercules and Cacus* group, in the Uffizi (inv. 714E) and at Christ Church (inv. 0085).[2] The connection to studies for the *Hercules and Cacus* group would argue for a date of around 1525 for the Museum's drawing.[3]

This is confirmed by the drawing on the verso, which is a preparatory study for the head of Hercules. It is similar to the study at the left on the verso of the sheet at Christ Church which has a full-length drawing of Hercules on its recto (inv. 0085).[4] However, the Christ Church drawing for the head of Hercules is more precise in manner and more closely defined in detail. In the Museum's drawing and in the sculpture, Hercules is looking into the distance, whereas in the Christ Church sheet, his gaze is clearly directed downwards to Cacus. The style

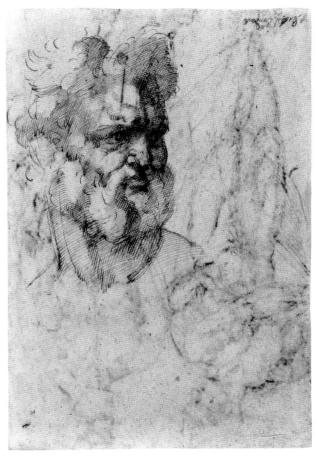

verso

of the Museum's verso is comparable to the drawing of two heads on the verso of the Christ Church sheet with four nude studies on its recto (inv. 0082).[5]

1. J. Byam Shaw, *Drawings by Old Masters at Christ Church Oxford* (Oxford, 1976), vol. 2, pl. 71.
2. P. Barocchi et al., *Mostra di disegni dei fondatori dell'Accademia delle Arti del Disegno*, exh. cat., Gabinetto Disegni e Stampe degli Uffizi, Florence, 1963, fig. 6; Byam Shaw (note 1), pl. 70.
3. C. Lloyd, "Four Drawings by Bandinelli at Christ Church," *Burlington Magazine* 3, no. 795 (June 1969), pp. 373–374. A copy of the recto was with Alistair Mathews in 1966 (Witt Library photo mount).
4. Byam Shaw (note 1), pl. 69.
5. Lloyd (note 3), fig. 53.

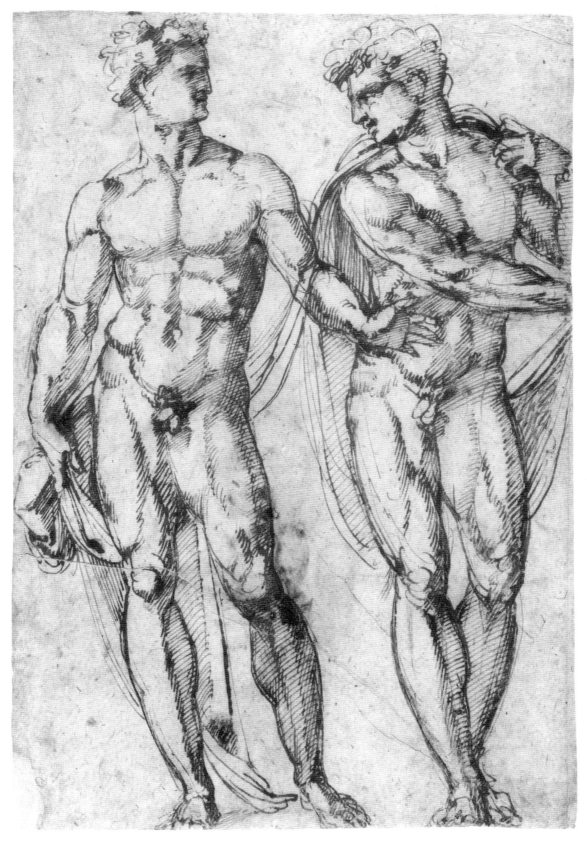

recto

3 The Entombment

Black chalk and oil paint on oiled paper; H: 47.7 cm
(18 13/16 in.); W: 35.6 cm (14 in.)
85.GG.26 (SEE PLATE 3)

MARKS AND INSCRIPTIONS: (Recto) at bottom left, collection mark of William, second duke of Devonshire (L. 718) (two impressions); (verso) inscribed *P.25* in brown ink.

PROVENANCE: William, second duke of Devonshire, Chatsworth; by descent to the current duke (sale, Christie's, London, July 3, 1984, lot 2); art market, Munich.

EXHIBITIONS: *Exhibition of Italian Art 1200–1900*, Royal Academy of Arts, London, 1930, no. 818. Bristol University, 1936, no. 892. *Mostra di Federico Barocci*, Museo Civico, Bologna, September–November 1975, no. 113 (catalogue by A. Emiliani). *The Graphic Art of Federico Barocci*, Cleveland Museum of Art and Yale University Art Gallery, New Haven, February–June 1978, no. 41 (catalogue by E. P. Pillsbury).

BIBLIOGRAPHY: E. Habich, "Handzeichnungen italienischer Meister," *Kunstchronik* (July 21, 1892), p. 545, no. 58; S. A. Strong, *Reproductions of Drawings by Old Masters in the Collection of the Duke of Devonshire at Chatsworth* (London, 1902), p. 15, no. 63; A. Schmarsow, "Federico Baroccis Zeichnungen: Eine kritische Studie," *Abhandlungen der philologisch-historischen Klasse*, vol. 30. Abhandlungen der Königlichen Sächsischen Gesellschaft der Wissenschaften, vol. 64 (Leipzig, 1914), pt. 3B, p. 41, no. 1; J. Q. van Regteren Altena and R. van Marle, *Italiaansche Kunst in Nederlandsch Bezit*, exh. cat., Stedelijk Museum, Amsterdam, 1934, p. 133, under no. 470; T. P. Baird, "Two Drawings Related to Barocci's *Entombment*," *Record of the Art Museum, Princeton University* 9, no. 1 (1950), p. 14; H. Olsen, *Federico Barocci: A Critical Study in Italian Cinquecento Painting* (Uppsala, 1955), p. 133; idem, *Federico Barocci* (Copenhagen, 1962), p. 171; G. G. Bertelà, *Disegni di Federico Barocci*, exh. cat., Gabinetto Disegni e Stampe degli Uffizi, Florence, 1975, p. 50, under no. 42; E. Pillsbury, "Barocci at Rome and Florence" (review), *Master Drawings* 14, no. 1 (Spring 1976), p. 62; A. Emiliani, *Federico Barocci (Urbino 1535–1612)* (Bologna, 1985), vols. 1, p. 159; 2, p. 444; D. DeGrazia, "Refinement and Progression of Barocci's *Entombment*: The Chicago Modello," *Museum Studies* 12, no. 1 (Fall 1985), pp. 35, 36, 38.

THE PREPARATORY PROCESS FOR BAROCCI'S *ENTOMB-ment* altarpiece has been convincingly established by Pillsbury (1978, pp. 63–66), who has suggested that the Museum's study was based upon a highly finished pen-and-ink drawing (Pillsbury 1978, no. 40) in the Art Institute of Chicago (inv. 1983.8). In the Museum's drawing Barocci has carefully evaluated the tonal values and painterly effect of the composition while leaving the development of its color for the oil *modello* in the Galleria Nazionale, Urbino. Although the Museum's drawing is very close to the final painting in most respects, it and the pen-and-ink drawing in Chicago differ from the painting, the *modello* in Urbino, and a chalk study in the Royal Collecton, The Hague, in the abbreviation of their foreground areas. In addition the figure of Saint Mary Magdalene was left unfinished in the Museum's drawing. Pillsbury (1978, p. 64) has suggested that this may have been due to the artist's intention to study this figure in an "auxiliary cartoon," now in a French private collection (DeGrazia 1985, p. 37, fig. 9). These differences from the final painting, as well as the exceptionally high quality of the Museum's drawing, render the doubts about its attribution expressed by Schmarsow (1914) and Olsen (1955, p. 133; 1962, p. 171) unsupportable.[1]

1. For additional drawings related to the same project, see Olsen 1962, pp. 171–172; Emiliani 1975, pp. 118–121; Pillsbury 1978, pp. 63–66.

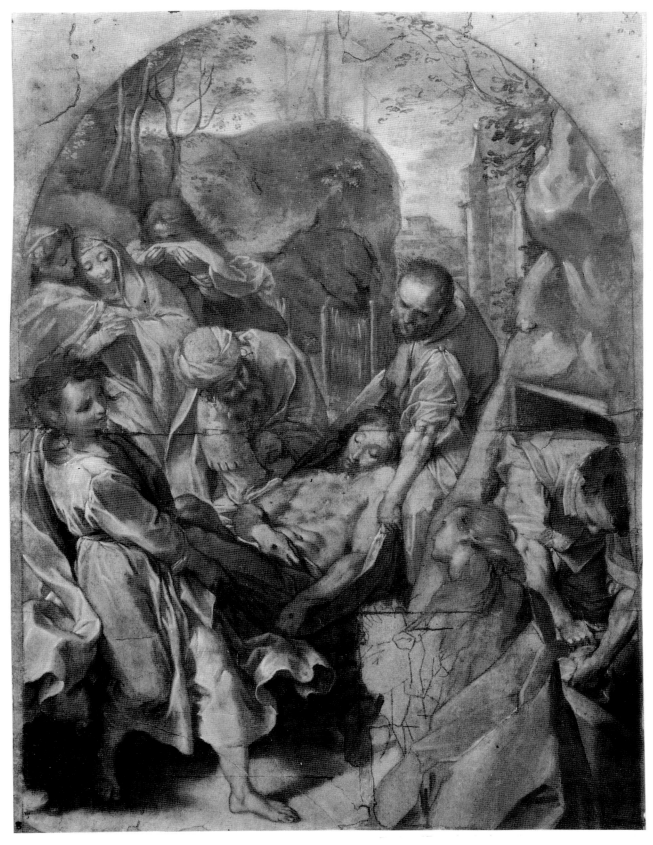

recto

4 Figure Studies [r, v]

Black and white chalk, beige chalk on right knee, stylus indentations on blue paper (recto); black and white chalk (verso); H: 30.1 cm (11 13/16 in.); W: 27.2 cm (10 11/16 in.) 83.GB.279

MARKS AND INSCRIPTIONS: None.

PROVENANCE: Theodore A. Heinrich (sale, Christie's, London, July 6, 1982, lot 134); art market, London.

EXHIBITIONS: *Old Master Drawings*, Colnaghi, London, June–July 1983, no. 6.

BIBLIOGRAPHY: A. Emiliani, *Federico Barocci (Urbino 1535–1612)* (Bologna, 1985), vol. 2, p. 381.

THE RECTO IS A STUDY FOR THE SERVANT AT THE LEFT front of the *Institution of the Eucharist* (Rome, Santa Maria sopra Minerva), which was painted by Barocci between 1603 and 1607. This figure does not appear in the first known version of the composition, a drawing in Chatsworth (inv. 361), but is included with very few changes in the definitive compositional drawing, now in an English private collection. The rich technique of free drawing employed for this study may be found in other preparatory studies for details of this altarpiece, including one for the legs of the same servant in the Kupferstichkabinett, Berlin (inv. 4283; Emiliani 1985, vol. 2, p. 385, fig. 847). The drawing on the verso—which was the only side known before the sheet's removal from its old mount following the 1982 auction—is certainly related to the same figure in the painting, though it shows the servant facing in the opposite direction. Perhaps it was made at a moment when Barocci was contemplating the placement of this figure at the right side of the composition.

verso

recto

FRA BARTOLOMMEO (Baccio della Porta)

5 *Madonna and Child with Saints*

Black chalk, traces of white chalk; H: 37.4 cm (14¾ in.);
W: 28.2 cm (11⅛ in.)
85.GB.288

MARKS AND INSCRIPTIONS: None.

PROVENANCE: Skene collection; John Postle Heseltine,
London; Henry Oppenheimer, London (sale, Christie's,
London, July 10, 1936, lot 26); private collection, Swit-
zerland; art market, London.

EXHIBITIONS: None.

BIBLIOGRAPHY: B. Berenson, *The Drawings of the Flor-
entine Painters* (London, 1903), vol. 2, p. 21, no. 434;
(1938), p. 38, no. 428A; (1961), p. 38, no. 428A; C.
Gamba, "Un disegno di Fra Bartolommeo nella raccolta
Heseltine," *Rivista d'arte* 8 (1912), pp. 15–18; *Original
Drawings by Old Masters of the Italian School, forming part
of the Collection of J. P. Heseltine* (London, 1913), no. 12;
H. von der Gabelentz, *Fra Bartolommeo und die florentiner
Renaissance* (Leipzig, 1922), vols. 1, pp. 159–161; 2, pp.
133–134, no. 310.

IN 1510 FRA BARTOLOMMEO WAS COMMISSIONED TO
paint an altarpiece with the Madonna and Child and
saints for the Sala del Gran Consiglio of the Palazzo Vec-
chio, Florence; the altarpiece was to be placed between
the frescoes showing the battle of Anghiari and the battle
of Cascina by Leonardo and Michelangelo. The altar-
piece was left unfinished, though Fra Bartolommeo was
still working on it in 1515. Later placed in the church of
San Lorenzo and then in the Uffizi, the uncolored paint-
ing is now in the Museo di San Marco, Florence.

The Museum's sheet is the most complete and elab-
orate study for the altarpiece, though it differs from it in
a number of minor details. For example, there are five
rather than four saints on either side of the throne in the
painting. The Museum's drawing was preceded by many
others, including an earlier and very different composi-
tional study in the Musée Wicar, Lille (inv. 397). There
is also a closely related drawing of the lower two-thirds
of the scene in the Uffizi (inv. 1204E), in which the figures
are studied as nudes.[1] The Museum's drawing elaborates
the composition developed in the Uffizi sheet and goes
on to carefully indicate areas of light and shadow. Its
emphasis on chiaroscuro reflects the generic influence of
Leonardo.

1. Other drawings for this project are listed in Gabelentz 1922,
vol. 1, pp. 160–161.

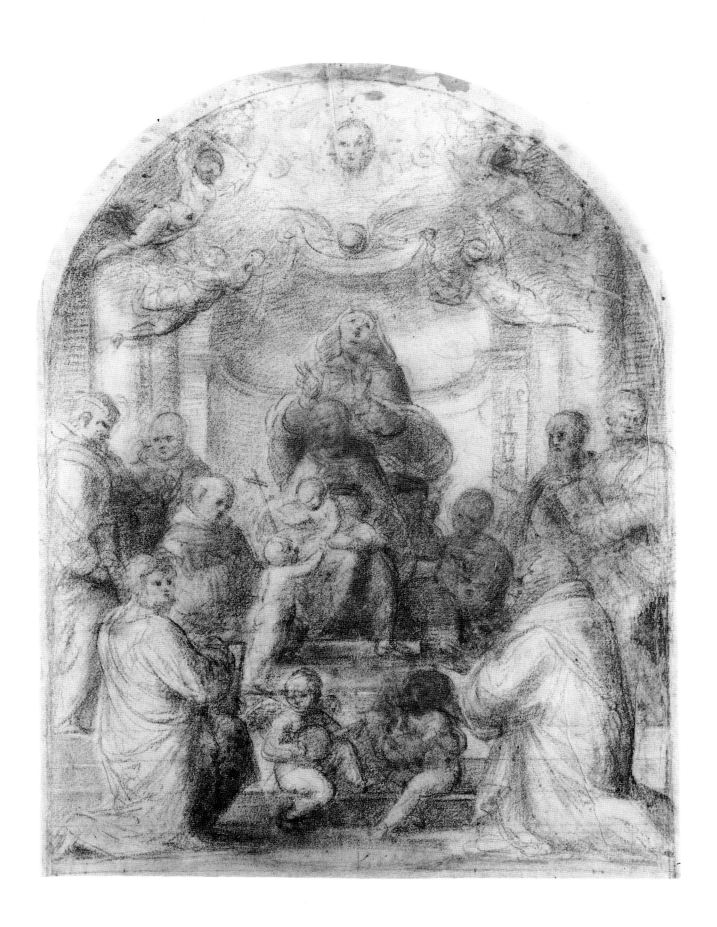

DOMENICO BECCAFUMI

6 Study for the Figure of Abraham

Pen and brown ink and brown wash; H: 15.3 cm (6 in.);
W: 9.3 cm (3¹¹⁄₁₆ in.)
83.GG.18

MARKS AND INSCRIPTIONS: (Recto) at bottom right corner, inscribed 77 in brown ink; on mount, at bottom right corner, collection mark of Richard Cosway (L. 628); (verso) on mount, inscribed *Eseguito nel pavimento de Duomo di Siena che . . .* in brown ink.

PROVENANCE: Richard Cosway, London (sale, Stanley's, London, February 19, 1822, lot 896); sale, Sotheby's, London, November 15, 1961, lot 249; private collection, Paris.

EXHIBITIONS: *Dessins français et italiens du XVIe et du XVIIe siècle dans les collections privées françaises*, Galerie Claude Aubry, Paris, December 1971, no. 8.

BIBLIOGRAPHY: D. Sanminiatelli, *Domenico Beccafumi* (Milan, 1967), p. 154, no. 75; G. Briganti and E. Baccheschi, *L'opera completa di Beccafumi* (Milan, 1977), p. 110, under no. 162.

THIS DRAWING IS A PREPARATORY STUDY FOR THE pavement showing the Sacrifice of Isaac which was designed by Beccafumi for the cathedral of Siena in 1547. Although a number of minor differences exist between the drawing and the pavement, the former established the basic pose and gesture of the figure of Abraham. The figure of Isaac in the drawing appears to reflect a knowledge of the Belvedere Torso, while in the pavement Isaac's pose seems closer to a Hellenistic type of the kneeling Venus that was admired in the sixteenth century.

The application of wash in broad areas of the drawing indicates its relationship to a final medium in which tonal areas had to be dealt with quite broadly. In the drawing Beccafumi used a wide patch of wash to dramatically hide Abraham's face, an approach he altered in the pavement, where the figure is brightly lit except at the left. The idiosyncratic draughtsmanship, a hallmark of the artist's manner, was given freest rein in the rendering of the hands and feet. Overall, the drawing is most akin to a study of an angel, perhaps used for this same pavement, and another of a man striding forward, both in the Uffizi (inv. 10762, 1260).

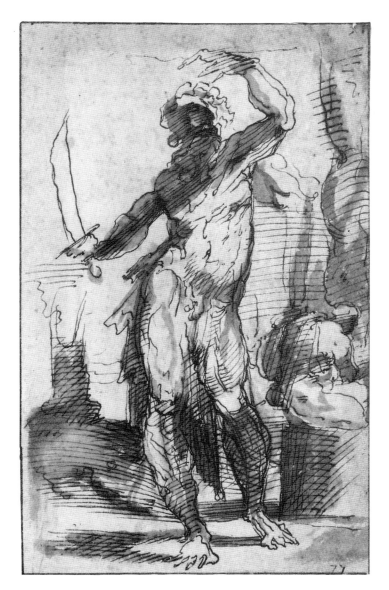

recto

7 Portrait of a Young Man

Red and white chalk; H: 33.2 cm (13 ¹⁄₁₆ in.); W: 21.8 cm (8 ⅝ in.)
82.GB.137

MARKS AND INSCRIPTIONS: (Recto) at top right corner, inscribed *LC* in red chalk; at bottom left corner, inscribed *L. Caracce* in black ink; at bottom right corner, inscribed *938* in black and brown ink; (verso) inscribed *Lud. Car.* in red chalk.

PROVENANCE: Private collection, Paris.

EXHIBITIONS: *Dessins français et italiens du XVIe et du XVIIe siècle dans les collections privées françaises*, Galerie Claude Aubry, Paris, December 1971, no. 13. *Baroque Portraiture in Italy: Works from North American Collections*, John and Mabel Ringling Museum of Art, Sarasota, December 1984–February 1985, no. 9 (catalogue by J. Spike).

BIBLIOGRAPHY: A. S. Harris, *Selected Drawings of Gian Lorenzo Bernini* (New York, 1977), p. 16.

THIS STUDY OF AN UNIDENTIFIED MAN IS UNUSUAL for Bernini in a number of respects, as has been noted by Harris (1977, p. xiv). The free, spontaneous characterization of the subject, with rather loose strokes in some areas, contrasts with the more polished manner employed in the majority of his portrait drawings. An old inscription on the recto suggests Ludovico Carracci as the draughtsman. In fact the drawing reflects a generic debt to his cousin, Annibale, in its direct, naturalistic vision. As Harris has pointed out (1977, p. xiv), the use of red chalk without black is rare for Bernini. Harris has dated the drawing to circa 1625–1630, thus making it contemporary with the portrait of a young man in the National Gallery, Washington, D.C. (inv. B-25,774; Harris 1977, no. 9, fig. 9), which was made in a more finished manner than the Museum's study.

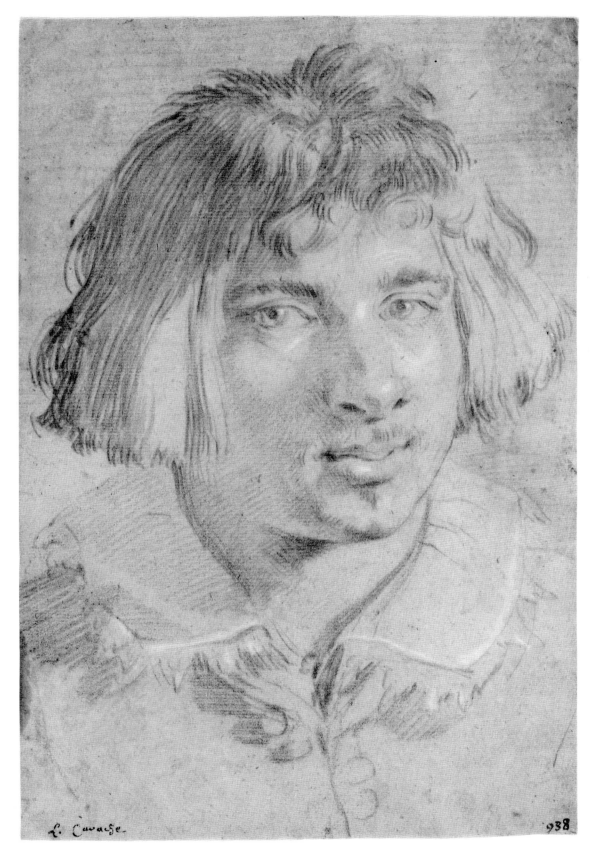

938

recto

8 Three Studies of Men and One of Saint John the Evangelist*^r* Three Studies of Men*^v*

Black chalk (recto); black and red chalk (verso); H: 27.7 cm (10⅞ in.); W: 20.7 cm (8⅛ in.)
85.GB.218

MARKS AND INSCRIPTIONS: At bottom left, blind stamp of Sir Thomas Lawrence (L. 2445); at bottom right, collection marks of Jonathan Richardson, Sr. (L. 2184), Lord Francis Egerton, first earl of Ellesmere (L. 2710b), Alain Delon.

PROVENANCE: Uvedale Price, Foxley; Thomas Dimsdale, London; Sir Thomas Lawrence, London; Lord Francis Egerton, first earl of Ellesmere, London; by descent to the sixth duke of Sutherland (sale, Sotheby's, London, July 11, 1972, lot 44); Alain Delon, Geneva.

EXHIBITIONS: *The Lawrence Gallery, Sixth Exhibition,* Woodburn's Gallery, London, 1836, no. 65. *17th Century Art in Europe,* Royal Academy of Arts, London, 1938, no. 375. *Drawings by Carracci and Other Masters,* P. and D. Colnaghi, London, 1955, no. 26. *Mostra dei Carracci, Disegni,* Palazzo dell'Archiginnasio, Bologna, September–October 1956, no. 221 (catalogue by D. Mahon). *The Carracci: Drawings and Paintings,* Newcastle-upon-Tyne, November–December 1961, no. 73 (catalogue by R. Holland).

BIBLIOGRAPHY: *Catalogue of the Ellesmere Collection of Drawings at Bridgewater House* (London, 1898), no. 71; P. A. Tomory, *The Ellesmere Collection of Old Master Drawings* (Leicester, 1954), p. 24, no. 56; D. Posner, *Annibale Carracci* (London, 1971), vol. 1, pp. 21, 64; 156, no. 54; 164, no. 84.

THE RECTO OF THIS DRAWING FIRST CONSISTED OF A tracing by Annibale of the figure of Saint John the Evangelist, copied from Correggio's fresco in the cathedral of Parma. Annibale then drew over this a series of several heads, repeating the man in profile. The boy with his head in his hands was engraved together with the upper profile by Arthur Pond in 1747 as one of his collected caricatures. The images of the man in profile and of the two boys are among the most striking of Annibale's early naturalistic portraits. They belong to a group that includes a number of paintings and several drawings—for example, the brilliant studies of a boy and a girl in the Metropolitan Museum of Art, New York (inv. 1972.133.3).[1] Like the studies in New York, the Getty Museum's sheet appears to date from the mid-1580s. Its relatedness to the drawing of the boy in New York is enhanced by one of the figures on the newly uncovered verso. The young boy resting on his arms appears to represent the same model as the drawing in New York. In addition to another study of a man with a hat, perhaps showing the same model as on the recto but full-face, there is also a remarkably abstract red chalk study of a man.[2]

1. J. Bean, *17th Century Italian Drawings in the Metropolitan Museum of Art* (New York, 1979), no. 97.
2. The verso was first revealed in New York late in 1985 when the sheet was lifted from its mount by Alexander Yow.

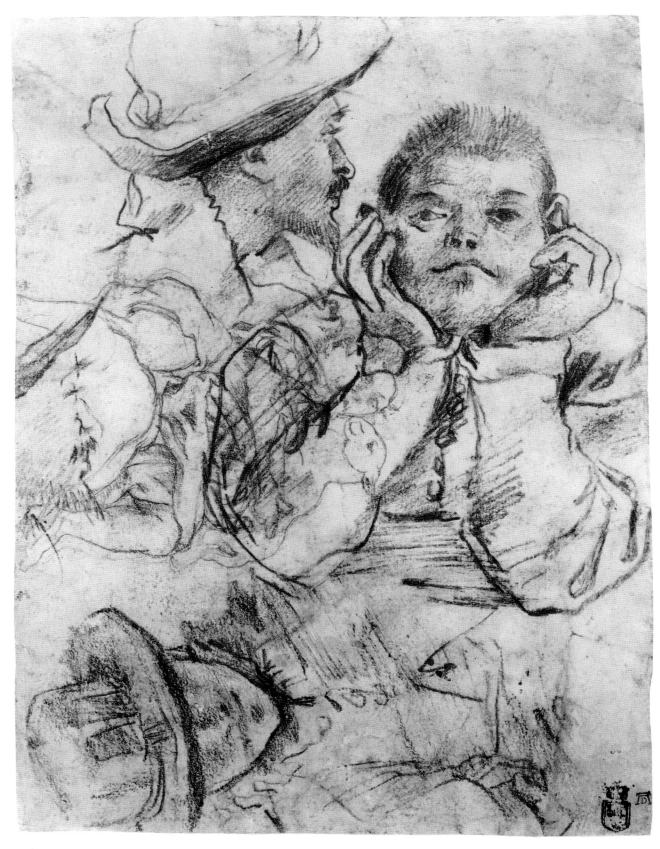

recto

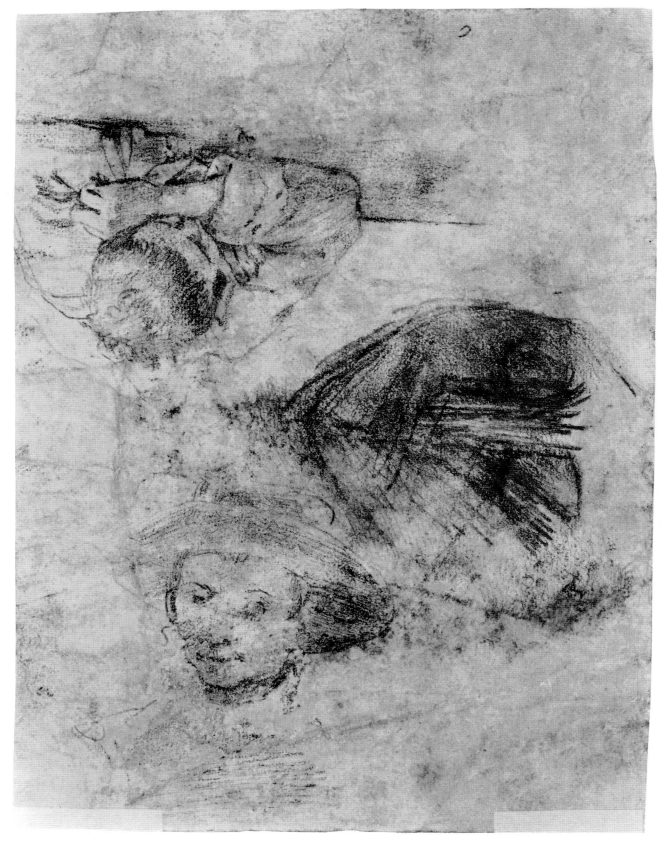

verso (no. 8)

9 Study for a Triton Blowing a Conch Shell[r] Detail of Arm[v]

Black and white chalk on blue paper (recto); black chalk (verso); H: 40.7 cm (16 in.); W: 24.1 cm (9½ in.)
84.GB.48

MARKS AND INSCRIPTIONS: (Recto) at bottom right corner, inscribed *25* in black ink; (verso) collection mark of Sir Bruce Ingram (L. 1405a); inscribed *32* followed by a third number in graphite.

PROVENANCE: Francesco Angeloni, Rome; Pierre Mignard, Rome and Paris; Pierre Crozat, Paris; Sir Bruce Ingram, Chesham, Buckinghamshire; Carl Winter, London; art market, London.

EXHIBITIONS: *Old Master Drawings from the Ingram Collection*, Colnaghi, London, 1952, no. 29. *Artists in 17th Century Rome*, Wildenstein Gallery, London, June–July 1955, no. 24. *Drawings from the Ingram Collection*, Fitzwilliam Museum, Cambridge, 1955–1956. *Mostra dei Carracci, Disegni*, Palazzo dell'Archiginnasio, Bologna, September–October 1956, no. 195 (catalogue by D. Mahon). *Exhibition of 17th Century Italian Drawings*, Fitzwilliam Museum, Cambridge, June–August 1959, no. 21. *Italian 16th Century Drawings from British Private Collections*, Scottish Arts Council, Edinburgh Festival Society, August–September 1969, no. 22 (catalogue by Y. Tan Bunzl et al.).

BIBLIOGRAPHY: D. Mahon, "Eclecticism and the Carracci: Further Reflections on the Validity of a Label," *Journal of the Warburg and Courtauld Institutes* 16 (1953), p. 337; idem, *Mostra dei Carracci, Disegni*, 2nd edn. (Bologna, 1963), pp. 135ff.; J. R. Martin, *The Farnese Gallery* (Princeton, 1965), pp. 214, 260; J. Bean, "A Rediscovered Annibale Carracci Drawing for the Farnese Gallery," *Master Drawings* 8, no. 4 (1970), pp. 390–391; M. Levey, *National Gallery Catalogues—The Seventeenth and Eighteenth Century Italian Schools* (London, 1971), p. 60; P.-J. Mariette, *Description de la collection Crozat*, 2nd edn. (Geneva, 1973), p. 50, no. 465 (description refers either to the Museum's drawing or to one in the Metropolitan Museum of Art, New York; see below); P. J. Cooney and G. Malafarina, *L'opera completa di Annibale Carracci* (Milan, 1976), no. 104RI (Museum's drawing is incorrectly cited as belonging to the Metropolitan Museum of Art); J. Bean, *17th Century Italian Drawings in the Metropolitan Museum of Art* (New York, 1979), p. 73; M. Cazort and C. Johnston, *Bolognese Drawings in North American Collections 1500–1800*, exh. cat., National Gallery of Canada, Ottawa, 1982, p. 72, no. 31.

ANNIBALE AND AGOSTINO CARRACCI BEGAN WORK on the fresco decoration of the Galleria Farnese in Rome in 1597. Agostino was responsible for designing and painting the so-called *Galatea*, now recognized as *Thetis Borne to the Wedding Chamber of Peleus*. His cartoon for it is in the National Gallery, London (inv. 148; Martin 1965, no. 82, fig. 194). As Mahon has shown (1953, p. 337), Annibale intervened between the creation of the cartoon and the execution of the fresco, composing a figure of truly Baroque character. This newly designed figure was incorporated into the final fresco by Agostino when he painted it before departing Rome in 1600.

The Getty Museum's drawing was once part of a much larger sheet that also contained the study of a triton now in the Metropolitan Museum of Art, New York (Bean 1970, pp. 390–391). The verso has a small fragment of the arm of the triton in New York. Considering the two drawings and the fresco in sequence, it appears that the triton in the New York drawing was made first, followed by the Getty Museum's study, as the latter is closer to the final solution. Both drawings owe a generic debt to the triton in Raphael's *Galatea* (Rome, Villa Farnesina).

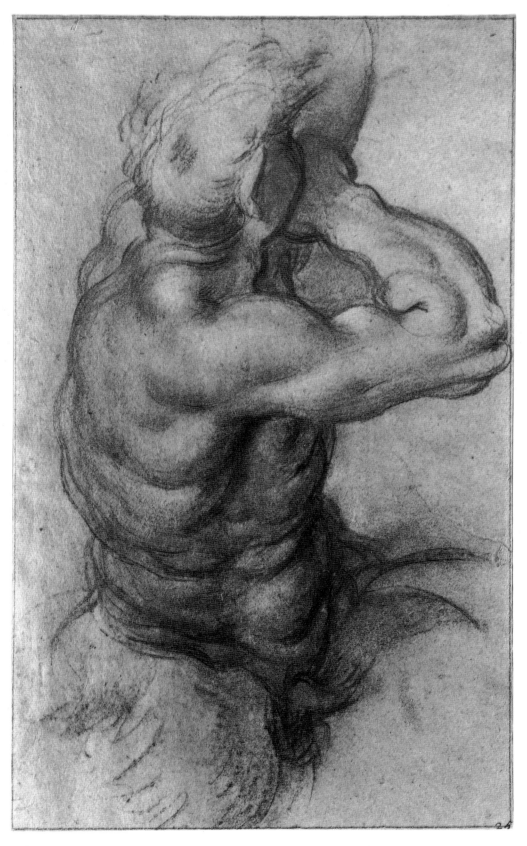

recto

ANNIBALE CARRACCI (Italian, 1560–1609). *A Triton Sounding a Conch Shell*. Black chalk on blue paper. H: 38.7 cm (15¼ in.); W: 24.1 cm (9½ in.). Metropolitan Museum of Art, Rogers Fund 1970.15. Photo courtesy Metropolitan Museum of Art.

verso

10 *The Expulsion of Hagar*

Red-brown, blue-green, and white oil paint and brush on tan paper; H: 28.9 cm (11⅜ in.); W: 41.6 cm (16⅜ in.) 83.GG.376 (SEE PLATE 5)

MARKS AND INSCRIPTIONS: (Recto) at bottom right corner, collection marks of marquis de Lagoy (L. 1710); at bottom, left of center, collection mark of V. C. collection (L. 2508); (verso) on mount, inscribed *97, 16.£ 24* in brown ink.

PROVENANCE: Marquis de Lagoy, Aix-en-Provence; V. C. collection; sale, Hôtel Drouot, Paris, 1982; art market, Paris.

EXHIBITIONS: None.

BIBLIOGRAPHY: None.

THIS HERETOFORE UNPUBLISHED DRAWING IS ONE OF four autograph depictions of this theme by Castiglione. The others are at Chatsworth (inv. 619)[1] and in the Albertina, Vienna (inv. 2842, 2843).[2] In its graphic manner, the Museum's version is closest to the one at Chatsworth, which is vertical in format, however. Based on Percy's dating of the Chatsworth drawing to the late 1640s,[3] the Museum's sheet appears also to have been made in Rome at that time. One of the drawings in Vienna (inv. 2842) is also a vertical composition, containing only three figures. The other is horizontal, but is quite different from the Museum's drawing in that the principal figures are centrally placed, and there are five rather than three onlookers at the left. The style of the second sheet in Vienna is looser and less monumental than that of the Museum's sheet. The Museum's version is highly Poussinesque in character, with the figures balanced carefully along the foreground plane in front of a rather dry architectural backdrop. The rich pictorial flavor of the drawing is enhanced by brilliant colorism and the judicious application of white highlights.[4]

1. A. Percy, *Giovanni Benedetto Castiglione—Master Draughtsman of the Italian Baroque*, exh. cat., Philadelphia Museum of Art, 1971, no. 17.

2. A. Stix and A. Spitzmüller, *Beschreibender Katalog der Handzeichnungen in der Staatlichen Graphischen Sammlung Albertina*, vol. 6 (Vienna, 1941), pp. 49, no. 528, pl. 115; 48, no. 513, pl. 110.

3. Percy (note 1), p. 69.

4. The Museum's drawing was copied in prints by Chasteau (Parma, Biblioteca Palatina, inv. 4095) and Coypel (M. Huber, *Catalogue raisonné du cabinet d'éstampes de feu Monsieur Winckler*, vol. 2 [Leipzig, 1803], p. 115, no. 505).

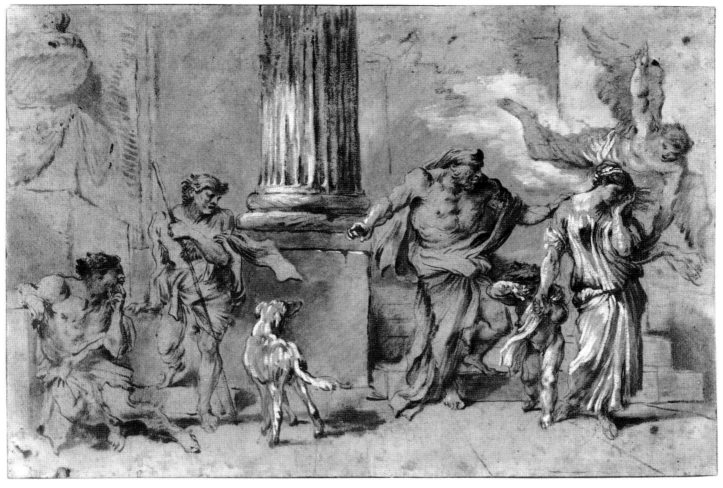

recto

11 *Unidentified Mythological(?) Subject*

Black chalk and pale brown ink wash; H: 21.8 cm (8⅝ in.); W: 17.7 cm (6¹⁵⁄₁₆ in.)
83.GB.344

MARKS AND INSCRIPTIONS: None.

PROVENANCE: Private collection, London.

EXHIBITIONS: *Italian 16th Century Drawings from British Private Collections*, Scottish Arts Council, Edinburgh Festival Society, August–September 1969, no. 31 (catalogue by Y. Tan Bunzl et al.). *Correggio and His Legacy: Sixteenth Century Emilian Drawings*, National Gallery of Art, Washington, D.C., and Galleria Nazionale, Parma, March–May and June–July 1984, no. 4 (catalogue by D. DeGrazia).

BIBLIOGRAPHY: None.

THIS IS ONE OF A SMALL HANDFUL OF DRAWINGS THAT date from Correggio's early years. Although exceptional in some respects, its various characteristics have been well elucidated by DeGrazia (1984, p. 74), who now believes more strongly in the attribution to Correggio than at the time of the exhibition "Correggio and His Legacy."[1] Perhaps most typical of the artist are the figures in the foreground, especially the man on the bull, with their rather soft contours and pronounced sfumato modeling. Ready comparisons are available in other drawings by the artist in the Musée du Louvre, Paris (inv. 10307), the British Museum, London (inv. 1957-12-14-1, 1859-9-15-740, 1922-2-9-93), and the Rijksprentenkabinet, Amsterdam (inv. 1955:01) (DeGrazia 1984, nos. 3, 6–9). Equally, the Leonardesque cast of the face of the bull-rider argues for Correggio's authorship.

DeGrazia has suggested that features such as the episodic division of the composition, the massing of figures in the background, and the sketchy quality of the foliage reflect the influence of Lotto. As she has noted, the *Martyrdom of Saint Alexander of Bergamo* (Washington, D.C., National Gallery of Art, inv. B-25,789)[2] contains several of these qualities. It may also be noted that the broad rendering of foliage occurs in Correggio's *Adam Picking the Forbidden Apple* (Amsterdam, Rijksmuseum, Rijksprentenkabinet, inv. 1955:01) and, in less elaborate form, in a still earlier drawing of a sacrificial scene in the Louvre (Cabinet des Dessins, inv. RF 529; DeGrazia 1984, nos. 9, 2). Lastly, the curiously indefinite rendering of the structure of the bull-rider's head is a mannerism that recurs throughout the artist's early drawings (DeGrazia 1984, nos. 3, 6, 9).

Given these points, it seems odd that doubts should have arisen concerning the attribution to Correggio, especially as no alternative authorship has been proposed and no drawing by any other artist—identifiable or not—has ever been associated with it. In large part such doubts are due to the lack of an adequate number of early sheets to provide a basis for comparison and—perhaps—to the paucity of drawings by Correggio done entirely in black chalk. With respect to the latter point, it is notable that one of his few drawings in this medium also dates from his early career, the *Head of a Woman* (New York, Pierpont Morgan Library, inv. IV30). The Museum's drawing has been dated to circa 1517–1519 by DeGrazia (1984, p. 74) on the basis of style. Her proposal is sustained by the fact, pointed out by R. Munman, that the man standing with legs crossed in the left foreground derives from the figure at the extreme left of Raphael's *Battle of Ostia* (Vatican, Stanza dell'Incendio).[3] Raphael's fresco dates from circa 1515–1517 and thus would have been seen by Correggio when he visited Rome around 1517/18. The iconography of this drawing has defied all efforts at interpretation, but may reflect ancient Roman images he saw during the same visit.

1. Conversation with the author, Malibu, early 1986.
2. D. DeGrazia et al., *Recent Acquisitions and Promised Gifts—Sculpture, Drawings, Prints*, exh. cat., National Gallery of Art, Washington, D.C., 1974, no. 25.
3. Conversation with the author, Malibu, 1985.

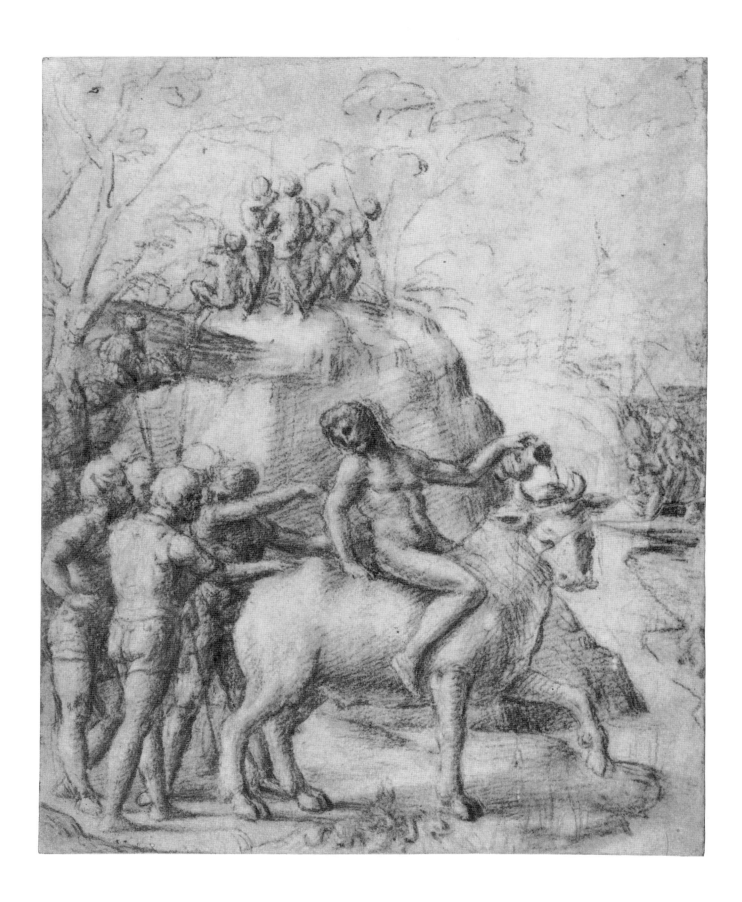

CARLO DOLCI

12 Portrait of a Girl

Black and red chalk on cream paper; H: 15.3 cm (6¹/₁₆ in.);
W: 12.5 cm (4⅞ in.)
83.GB.374

MARKS AND INSCRIPTIONS: At bottom right, collection mark of Count Gelosi (L. 545).

PROVENANCE: Count Gelosi, Turin; sale, Hôtel Drouot, Paris, December 6, 1982, lot 38; art market, Geneva.

EXHIBITIONS: None.

BIBLIOGRAPHY: None.

THIS SUBTLE IMAGE MAY BE COMPARED WITH SEVERAL of the artist's other portraits of women and children, including one, done in red chalk, of his wife, now in the Louvre (inv. 1140).[1] The directness of expression, emerging from large, carefully described eyes, is similar in the two drawings, as are the light and understated graphic style and the use of a series of zigzagging lines to model the front of the sitters' dresses. Such lines can be seen even more clearly in the *Head of a Young Boy*, also in the Louvre (inv. 1141).[2] Among the most distinctive elements of the Museum's drawing is the use of a sensitively integrated mixture of black and red chalk. Two chalks also were used in a self-portrait by Dolci in the British Museum, London (inv. 1899-9-15-577).[3] The oval shape of the Museum's rendering clearly indicates that it was made with a painting of the same configuration in mind.

1. F. Viatte et al., *Dessins baroques florentins du Musée du Louvre*, exh. cat., Cabinet des Dessins, Musée du Louvre, Paris, 1981, no. 114.
2. Ibid., no. 115.
3. N. Turner, *Italian Baroque Drawings* (London, 1980), no. 52.

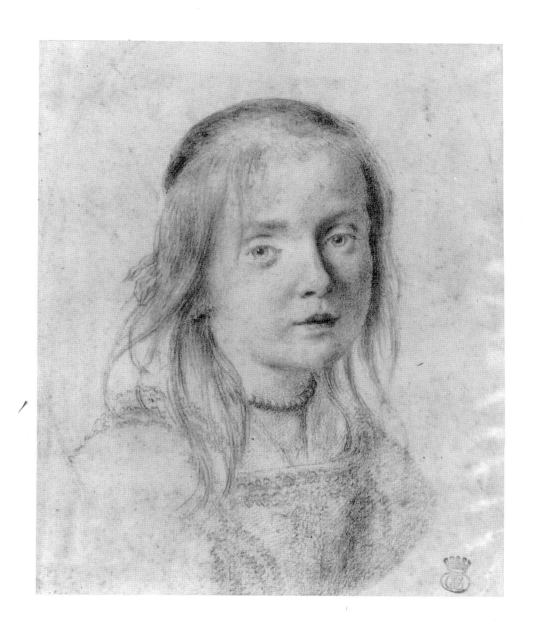

13 *Study for a Ceiling*

Pen and brown ink, brown and gray wash, white gouache heightening, and traces of black chalk; H: 30.7 cm (12 1/16 in.); W: 39.3 cm (15 7/16 in.)
85.GG.292

MARKS AND INSCRIPTIONS: (Recto) at top center, un-identified collection mark; at bottom center, inscribed *Lattanzio Gambara* in brown ink; (verso) on mount, col-lection mark of John Postle Heseltine (L. 1508) in red ink.

PROVENANCE: John Postle Heseltine, London (sale, Sotheby's, London, May 28, 1935, lot 112); sale, Chris-tie's, London, December 9, 1982, lot 13; art market, Zurich.

EXHIBITIONS: None.

BIBLIOGRAPHY: G. Bora, "Note sui disegni lombardi del Cinque e Seicento," *Paragone* 35, no. 413 (July 1984), pp. 18, 33, n. 64.

ACCORDING TO BORA (1984, P. 18), THIS COMPLEX drawing was made as a preparatory study for the ceiling of the monastic church of San Pietro al Po near Cre-mona. The commission was given to Gambara and the architectural painter Cristoforo Rosa in 1568, but it is likely that the actual project was never begun. The ceiling was destroyed in 1573. Bora has noted that the image of the Virgin ascending into the heavens is closely compa-rable to the representation of her in Gambara's *Assump-tion* in the Lechi collection, Montirone. It is also evident that the elaborate illusionism of the Museum's design re-calls the work of Giulio Romano at the Palazzo del Tè, Mantua. Such illusionism was one of the artist's contin-uing interests, as can be seen in works ranging from his early work at the Palazzetto a Le Caselle near Brescia to his late decoration of the Olivetan monastery at Rodegno.[1]

1. These and other decorative schemes by Gambara are illus-trated in P. V. Begni Redona and G. Vezzoli, *Lattanzio Gam-bara, Pittore* (Brescia, 1978), pp. 70, 99, 202–203.

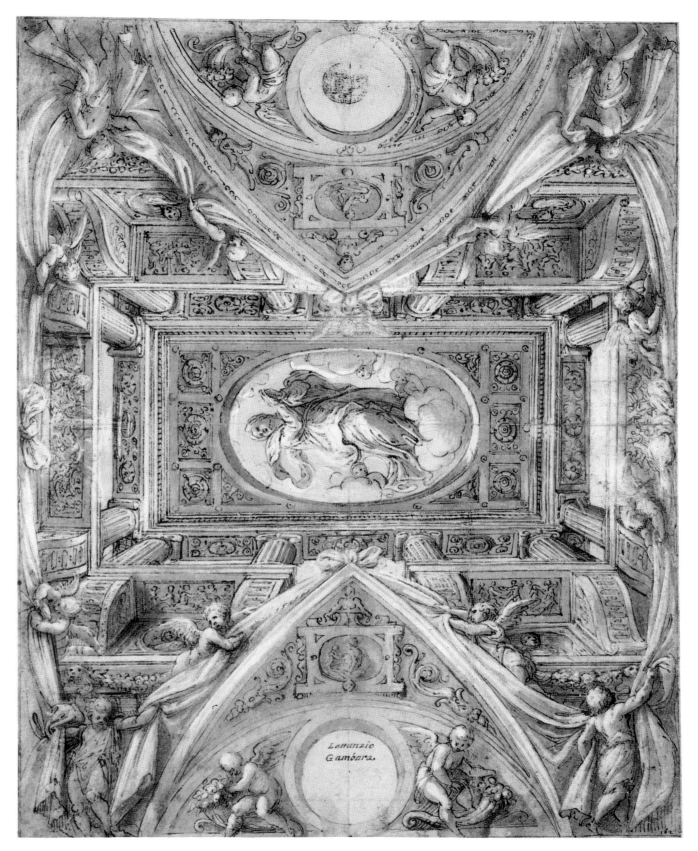

14 *Study of an Apostle*

Black and red chalk, brush and gray-black ink, gray wash, and white gouache heightening, squared in red chalk; H: 39.8 cm (15¹¹⁄₁₆ in.); W: 21.8 cm (8⁹⁄₁₆ in.) 84.GG.651

MARKS AND INSCRIPTIONS: At bottom right, collection marks of Sir Peter Lely (L. 2092), William, second duke of Devonshire (L. 718).

PROVENANCE: Sir Peter Lely, London; William, second duke of Devonshire, Chatsworth; by descent to the current duke (sale, Christie's, London, July 3, 1984, lot 15); art market, London.

EXHIBITIONS: None.

BIBLIOGRAPHY: K. T. Parker, *Catalogue of the Collection of Drawings in the Ashmolean Museum II, Italian Schools* (Oxford, 1956), p. 116, no. 243; J. A. Gere, "Drawings in the Ashmolean Museum" (review of Parker 1956), *Burlington Magazine* 99, no. 650 (May 1957), p. 161; *The Collection of Drawings belonging to the Duke of Devonshire, Chatsworth* (London, 1963), p. 25, nos. 303–305; M. L. Ferrari, *Il Tempio di San Sigismondo a Cremona* (Milan, 1974), p. 159, no. 216; M. di Giampaolo, "Aspetti della grafica cremonese per San Sigismondo," *Antichità viva* 13, no. 6 (1974), pp. 19–31; G. Godi, "Anselmi, Sojaro, Gambara, Bedoli: Nuovi disegni per una corretta attribuzione degli affreschi in Steccata," *Parma nell'arte* 8, no. 1 (June 1976), p. 66; M. di Giampaolo, "Disegni di Bernardino Gatti," *Antologia di belle arte* 1, no. 4 (December 1977), pp. 336, 338; H. Macandrew, *Catalogue of Drawings in the Ashmolean Museum* (Oxford, 1980), vol. 3, *Italian Schools: Supplement*, p. 262, no. 242-3; B. Meyer, in B. Adorni, *Santa Maria della Steccata a Parma* (Parma, 1982), p. 197, no. 41; D. DeGrazia, *Correggio and His Legacy: Sixteenth Century Emilian Drawings*, exh. cat., National Gallery of Art, Washington, D.C., 1984, pp. 276–299, under no. 92.

THIS IS ONE OF SEVERAL DRAWINGS BY GATTI THAT have alternatively been related to his *Ascension* of 1549 in San Sigismondo, Cremona, and his *Assumption* of circa 1560–1572 in Santa Maria della Steccata, Parma. The drawing of an apostle in the Ashmolean Museum, Oxford (Parker 1956, no. 243) appears to have preceded the Museum's sheet, which is squared for transfer. Both are clearly related to the apostle at the base of the drum in the Steccata *Assumption* (DeGrazia 1984, fig. 92b). On the other hand, there is no reason to feel certain that all similar studies must have been made for the same project. For example, two studies at Chatsworth of apostles (inv. 329, 331) are much closer to figures in the San Sigismondo *Ascension* than to the apostle in Parma.

Gatti's technique in making these drawings is notable. The richly modeled draperies were achieved with heavy applications of white and deep gray wash. It is reasonably suggested in the Christie's sale catalogue of drawings from Chatsworth (London, 1984, lot 15) that he used three-dimensional models in making these drawings.

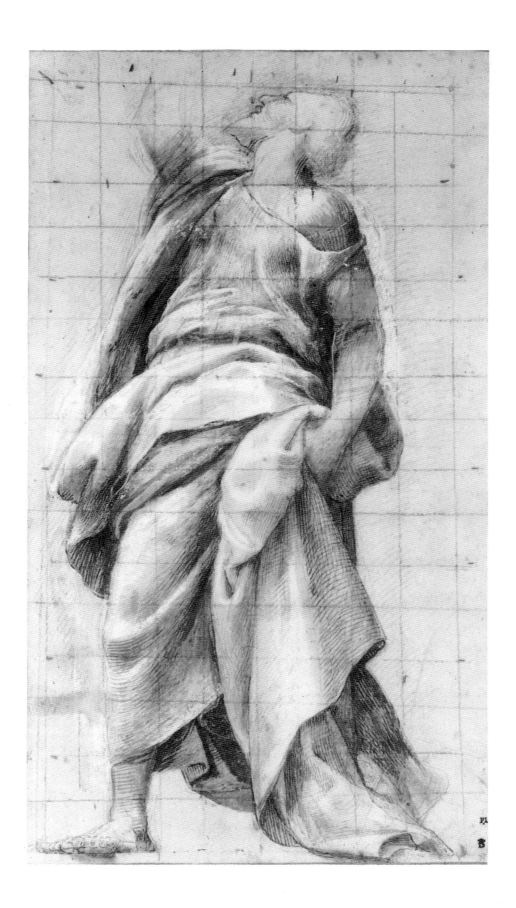

GIULIO ROMANO (Giulio Pippi)

15 An Allegory of the Virtues of Federico II Gonzaga

Pen and brown ink, black chalk, and white gouache used for heightening and corrections; H: 24.9 cm (9¹³⁄₁₆ in.); W: 31.8 cm (12½ in.)
84.GA.648

MARKS AND INSCRIPTIONS: At bottom left corner, collection mark of William, second duke of Devonshire (L. 718); at bottom right corner, collection mark of Sir Peter Lely (L. 2092).

PROVENANCE: Sir Peter Lely, London; William, second duke of Devonshire, Chatsworth; by descent to the current duke (sale, Christie's, London, July 3, 1984, no. 17); art market, Boston.

EXHIBITIONS: *Italian Art and Britain*, Royal Academy of Arts, London, 1960, no. 571 (catalogue by E. Waterhouse). *Old Master Drawings from Chatsworth*, Smithsonian Institution, Washington, D.C., and other institutions, 1962–1963, no. 25 (catalogue by A. E. Popham). *Old Master Drawings—A Loan from the Collection of the Duke of Devonshire*, Israel Museum, Jerusalem, April–July 1977, no. 22.

BIBLIOGRAPHY: E. Habich, "Handzeichnungen italienischer Meister," *Kunstchronik* (July 21, 1892), p. 545, no. 64; F. Hartt, *Giulio Romano* (New Haven, 1958), vol. 1, p. 147, no. 178; P. Pouncey and J. A. Gere, *Italian Drawings in the Department of Prints and Drawings in the British Museum: Raphael and his Circle* (London, 1962), p. 62, under no. 79; E. Verheyen, *The Palazzo del Tè in Mantua* (Baltimore and London, 1977), fig. 35; J. Martineau, *Splendors of the Gonzaga*, exh. cat., Victoria and Albert Museum, London, 1981, p. 189, under no. 166.

THIS IS A STUDY FOR THE CENTRAL CEILING FRESCO OF the Sala d'Attilio Regolo in the Casino della Grotta of the Palazzo del Tè, Mantua. This addition at the northeast corner of the garden was built around 1530, and the decoration was completed by 1534. The iconography consists of a central seated personification of the city of Mantua receiving various attributes, and was obviously intended to glorify the reign of Federico Gonzaga.

The Museum's drawing follows another study for this scene in the British Museum, London (inv. 1895-9-15-642; Pouncey and Gere 1962, pl. 72). The earlier drawing is predictably less developed in that the figure at the left is only indicated in black chalk, and Mercury (at the upper right) is not yet present. A notable *pentimento* occurs in the Museum's drawing in the right arm of the woman (placed to right of center) who holds a wreath: her right arm was originally extended, and she held a book. A further drawing related to this fresco is in the Louvre (inv. 3501), but its authorship is uncertain.

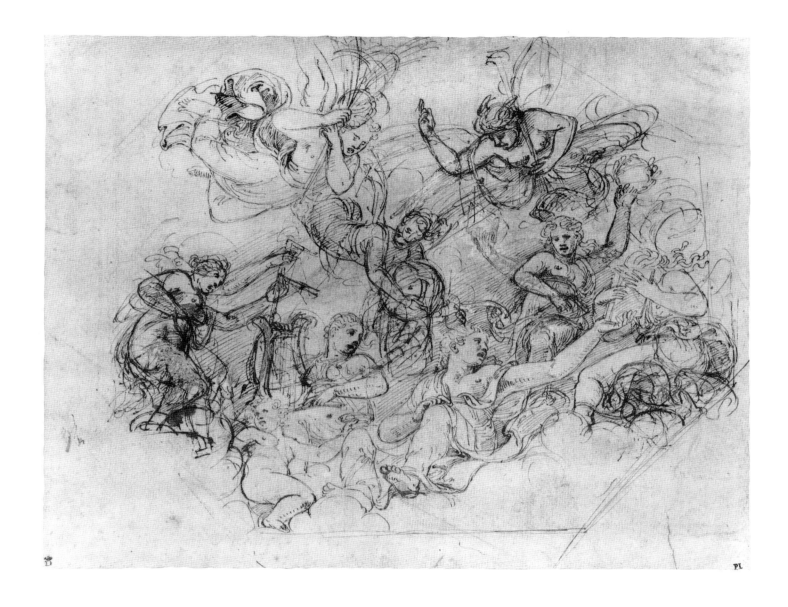

GUERCINO (Giovanni Francesco Barbieri)

16 Christ Preaching in the Temple

Pen and brown ink and brown wash; H: 26.9 cm (10%₁₆ in.); W: 42.7 cm (16¾₁₆ in.)
84.GG.23

MARKS AND INSCRIPTIONS: At bottom left corner, collection marks of Baron D. Vivant-Denon (L. 779), Jacques Petit-Horry, Marie Marignane (L. 1848); at bottom right corner, collection marks of baron de Malaussena (L. 1887), Marie Marignane; unidentified mark; inscribed *112* in black ink.

PROVENANCE: Baron D. Vivant-Denon, Paris (sale, A. N. Perignon, Paris, April 1–19, 1826, lot 443); baron de Malaussena, Indre; Marie Marignane, Paris; Hubert Marignane, Paris; private collection, Paris.

EXHIBITIONS: *Dessins français et italiens du XVIe et du XVIIe siècle dans les collections privées françaises*, Galerie Claude Aubry, Paris, December 1971, no. 55.

BIBLIOGRAPHY: *Monuments des arts du dessin* (Paris, 1829), vol. 3, no. 211 (engraving by D. Vivant-Denon); J. Bean, "Review of *Omaggio al Guercino . . . ,*" *Master Drawings* 5, no. 3 (1967), p. 304; E. Riccòmini, *Il Seicento ferrarese* (Milan, 1969), p. 38, no. 21A; J. Varriano, "Guercino, Bonfanti and 'Christ Among the Doctors,'" *Record of the Art Museum, Princeton University* 32, no. 1 (1973), pp. 11–15; F. Gibbons, *Catalogue of the Italian Drawings in the Art Museum, Princeton University* (Princeton, 1977), vol. 1, p. 111, under no. 334.

THIS DRAWING AND A TWO-SIDED SHEET ALSO BY Guercino in the Mount Holyoke Art Museum, South Hadley (inv. P.RIV.1.1954), were used by his follower Antonio Bonfanti for the latter's painting of the same subject in the church of San Francesco, Ferrara (Riccomini 1969, p. 38; Varriano 1973, pp. 11–15). The painting was commissioned by Cardinal Bonifacio Bevilacqua and dates from before 1627, when he died. Varriano has carefully and convincingly analyzed the chronological sequence of the three drawings, noting that the recto and verso of the Mount Holyoke sheet (in that order) preceded the Museum's drawing. His statement that "the only original features in the Paris [now the Getty Museum's] composition are found in the characterization of some of the doctors" (1973, p. 13) is, however, wide of the mark. Among other points, the principal gesture made by Christ's right arm appears only in the Museum's drawing and was adopted by Bonfanti. It is also noteworthy that Bonfanti's own preparatory study for this composition (Princeton University, Art Museum, inv. 48-730) contains several original elements he used in his painting in Ferrara (Gibbons 1977, vol. 1, no. 334).

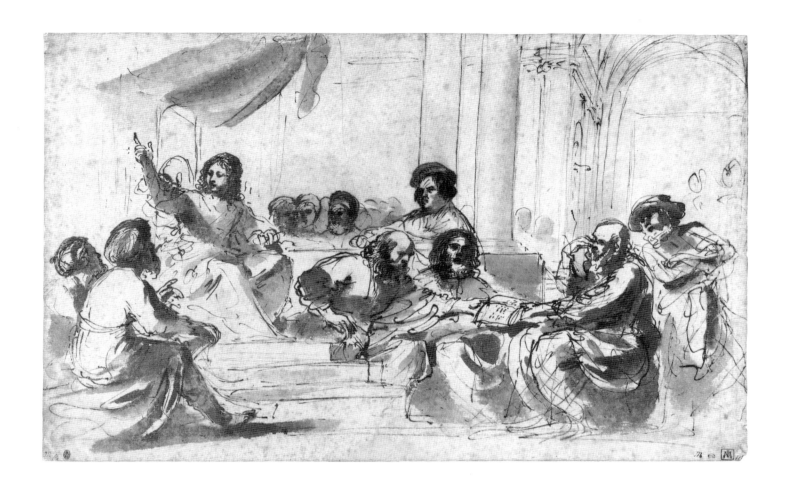

17 A Fortified Port

Pen and brown ink; H: 29 cm (11⁷⁄₁₆ in.); W: 43.2 cm (17 in.)
85.GA.408

MARKS AND INSCRIPTIONS: None.

PROVENANCE: Art market, Amsterdam; sale, Sotheby's, London, March 23, 1972, lot 121; art market, New York.

EXHIBITIONS: None.

BIBLIOGRAPHY: P. Bagni, *Il Guercino e il suo falsario— I disegni di paesaggio* (Bologna, 1985), p. 36, no. 18.

THIS IS ONE OF MANY LANDSCAPE DRAWINGS BY Guercino that seem to have been made for their own sake.[1] The location depicted here appears to be imaginary. The selection of a port is relatively uncommon in the artist's landscape drawings, though large circular towers occur elsewhere.[2] In its planar clarity and emphasis on architectonic form, this drawing may be compared with two others in the Pierpont Morgan Library, New York (inv. IV,168, I,100).[3] The Museum's sheet would seem to date from after 1630, as has been suggested by D. DeGrazia and N. Turner.[4]

1. For Guercino's landscapes, see D. Mahon, *Il Guercino, Disegni*, exh. cat., Palazzo dell'Archiginnasio, Bologna, 1968, pp. 178–200.
2. For example, in one of his drawings at Chatsworth (inv. 533; ibid., no. 208).
3. Mahon 1968 (note 1), nos. 212, 211.
4. Conversations with the author, 1985.

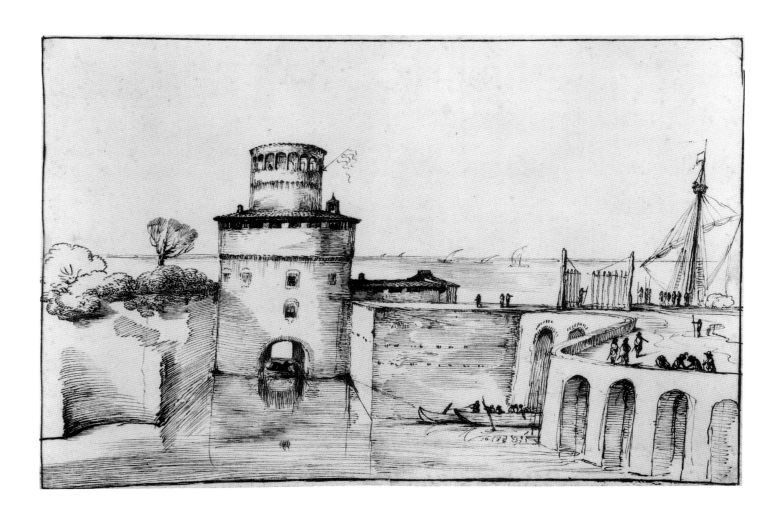

18 Studies of an Angel and of Drapery

Black chalk, brown wash, and white gouache heightening on brown tinted paper, corners removed; H: 25.7 cm (10⅛ in.); W: 19.5 cm (7¹¹⁄₁₆ in.)
85.GG.289

MARKS AND INSCRIPTIONS: At bottom right, collection mark of Richard Cosway (L. 628).

PROVENANCE: Jonathan Richardson, Sr., London; Richard Cosway, London; E. A. Wrangham collection, London (sale, Sotheby's, London, July 1, 1965, lot 9); art market, Zurich.

EXHIBITIONS: *Exhibition of Old Master and English Drawings*, P. D. Colnaghi and Co. Ltd., London, June 1970, no. 8.

BIBLIOGRAPHY: P. Pouncey, "Drawings by Innocenzo da Imola," *Master Drawings* 7, no. 3 (1969), p. 290, no. 5; M. Cazort and C. Johnston, *Bolognese Drawings in North American Collections 1500–1800*, exh. cat., National Gallery of Canada, Ottawa, 1982, p. 45, under no. 5.

AS WAS FIRST PROPOSED BY POUNCEY (1969, P. 290), this drawing is related to the angel in the upper section of Innocenzo's altarpiece of the Annunciation in the church of Santa Maria dei Servi, Bologna. The altarpiece, painted for Adalberto Bolognetti, reflects Innocenzo's rather vapid recollections of Raphael and Fra Bartolommeo. There are three studies by Innocenzo for this altarpiece. A study for the Virgin is in the Museo Horne, Florence (inv. 5913; Pouncey 1969, p. 289), and two for God the Father are in the Fogg Art Museum, Harvard University, Cambridge (inv. 1932.380, 1958.285; Cazort and Johnston 1982, nos. 4, 5). The Getty Museum's drawing indicates Innocenzo's careful analysis of drapery, especially the effects of light and shadow. In principle the sheet looks back to the famous chiaroscuro drapery studies of Leonardo and forward to those of Gatti. It appears quite clear that Innocenzo first made the full figure and then reconsidered the drapery at the lower right.[1]

1. The odd placement of the collection mark of Richard Cosway at the lower right indicates that the corners were cut off before his time.

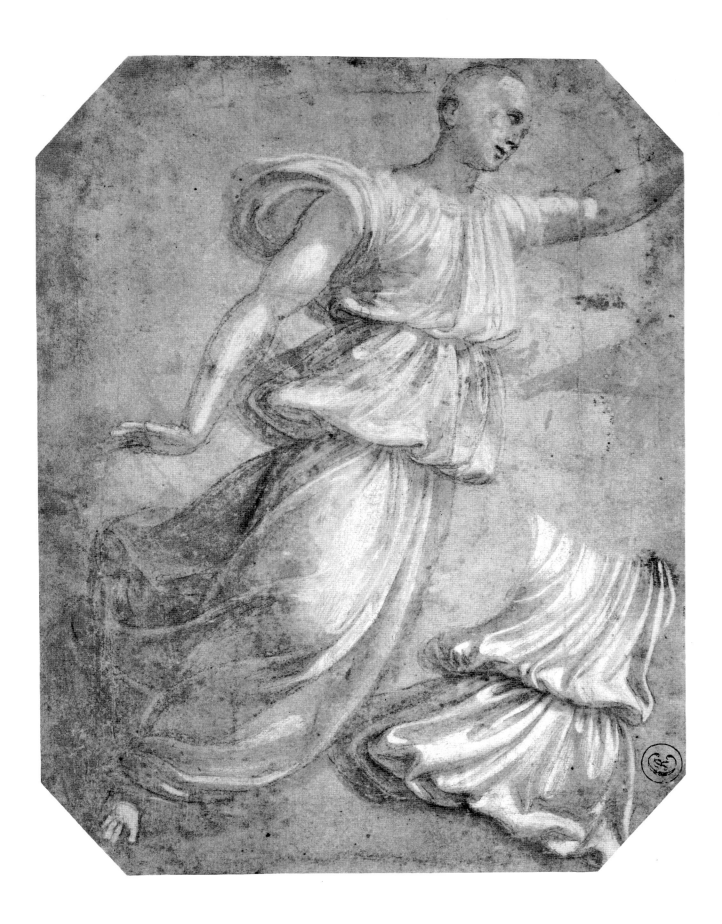

19 *Caricature of a Man with Bushy Hair*

Pen and brown ink; H: 6.6 cm (2⅝ in.); W: 5.4 cm (2⅛ in.)
84.GA.647

MARKS AND INSCRIPTIONS: At bottom left, partial collection mark of Nicholas A. Flinck (L. 959).

PROVENANCE: Thomas Howard, earl of Arundel; Nicholas A. Flinck, Rotterdam; William, second duke of Devonshire, Chatsworth; by descent to the current duke (sale, Christie's, London, July 3, 1984, lot 24); art market, Boston.

EXHIBITIONS: None.

BIBLIOGRAPHY: E. Habich, "Handzeichnungen italienischer Meister," *Kunstchronik* no. 31 (July 21, 1892), p. 544; A. Venturi, *I manoscritti e i disegni di Leonardo da Vinci*, Commissione Vinciana, vol. 5 (Rome, 1939), p. 19, no. 6; A. H. Scott-Elliot, "Caricature Heads after Leonardo da Vinci in the Spencer Collection," *Bulletin of the New York Public Library* 62, no. 6 (June 1958), p. 294, no. 31; K. Clark and C. Pedretti, *The Drawings of Leonardo da Vinci in the Collection of Her Majesty the Queen at Windsor Castle* (London, 1968), vol. 1, p. xliv; C. Pedretti, *Leonardo da Vinci: Studies for a Nativity and the 'Mona Lisa Cartoon' with Drawings after Leonardo from the Elmer Belt Library of Vinciana*, exh. cat., University of California, Los Angeles, 1973, p. 40, under no. 12; A. Marinoni and L. Cogliati Arano, *Leonardo all'Ambrosiana* (Milan, 1982), p. 120, under no. 21i.

THIS CARICATURE ONCE FORMED PART OF A LARGE series of such drawings at Chatsworth. Largely ignored in the vast Leonardo literature, the series was the object of an uncomplimentary comment by Clark (Clark and Pedretti 1968, p. xliv), who nevertheless accepted its attribution to Leonardo. These caricatures obviously were more highly considered in earlier times, if one may judge from the interest in copying them. A fine copy by Francesco Melzi, formerly at Wilton, is now in the Elmer Belt Library of Vinciana, University of California, Los Angeles (Pedretti 1973, p. 40). Others are in the Gallerie dell'Accademia, Venice (inv. 229) (also by Melzi), in the Spencer Collection, New York Public Library (Scott-Elliot 1958, no. 31), and in the Ambrosiana, Milan (Marinoni and Cogliati Arano 1982, no. 29i). Lastly, there is an etched copy of this caricature by Hollar showing the image in reverse.

This and other drawings of its type were, in all probability, originally rendered in pairs; they appear in this format in the copies from Wilton. It seems likely that the pairs were cut into individual drawings by the time Flinck owned the Museum's sheet as well as others; this can be surmised from the placement of his mark on the various caricatures (Christie's, London, 1984, lot 25, p. 54). The Museum's drawing was probably reduced a bit more for mounting, at least at the left, apparently when it came into the collection of the second duke of Devonshire, since Flinck's mark was cropped on that side.

Clark (Clark and Pedretti 1968, p. xliv) has dated this and other Chatsworth caricatures to Leonardo's period of work in Milan under the Sforza. Although he has suggested that the drawings were made "in response to some craze or fashion," separating them in a sense from the normal evolution of Leonardo's work, the Museum's drawing looks forward to the exaggeratedly expressive heads of the *Battle of Anghiari* (1503/04; destroyed) and the hair was executed with a characteristic sfumato.

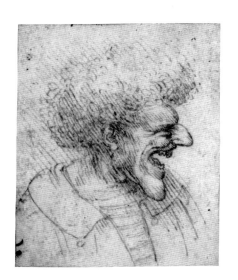

LORENZO LOTTO

20 Saint Martin Dividing His Cloak with a Beggar

Brush and gray-brown wash, white and cream gouache heightening, and black chalk on brown paper; H: 31.4 cm (12⅜ in.); W: 21.7 cm (8%₁₆ in.)
83.GG.262

MARKS AND INSCRIPTIONS: (Verso) signed . . . *entius Lotus* in brown ink.

PROVENANCE: S. Schwartz, New York; art market, Boston.

EXHIBITIONS: *Five Centuries of Drawings*, Montreal Museum of Fine Arts, October–November 1953, no. 53. *Old Master Drawings*, Newark Museum, March–May 1960, no. 23. *Drawings from New York Collections: The Italian Renaissance*, Metropolitan Museum of Art and Pierpont Morgan Library, New York, November 1965–January 1966, no. 45 (catalogue by J. Bean and F. Stampfle). *Early Venetian Drawings from Private Collections and the Fogg*, Fogg Art Museum, Harvard University, Cambridge, February–April 1983.

BIBLIOGRAPHY: E. Schilling, "A Signed Drawing by Lorenzo Lotto," *Gazette des Beaux-Arts* 6 pér., 4 (April 1953), pp. 277–279; B. Berenson, *Lorenzo Lotto* (New York, 1956), pp. 124–125; P. Pouncey, *Lotto disegnatore* (Vicenza, 1965), p. 13; R. Pallucchini and G. M. Canova, *L'opera completa del Lotto* (Milan, 1974), p. 122, no. 281.C.

THIS MAJOR SHEET BY LOTTO WAS FIRST PUBLISHED by Schilling (1953), who noted its broad, painterly effect and related it to the brush drawing in a painting by Lotto, the so-called *Lucretia* (circa 1529/30) in the National Gallery, London. Based on this analogy, he dated the Museum's drawing to circa 1530. The most penetrating analysis of the drawing is by Pouncey (1965), who has pointed to the complex architecture and rich chiaroscuro, which create a proto-Baroque atmosphere. Unlike Schilling, who believed the drawing to have been made in preparation for an individual painting or for a fresco, Pouncey has suggested that its asymmetry and very low viewpoint indicate that it was intended for one of a pair of organ shutters. Although no documentary evidence has been found on this issue, his solution is convincing.

In its stylistic character, the drawing owes much to the example of Pordenone (Pouncey 1965; Bean and Stampfle 1966, no. 45). The dramatic illusionism and powerful sense of movement can be seen as having resulted from Lotto's experience of Pordenone's work in the church of San Rocco, Venice. The latter's panels there date from 1528 and help to reinforce the dating of the Museum's drawing to around 1530. As has been noted by Schilling (1953, p. 279) and Pouncey (1965, p. 13), the drawing is signed on the verso.

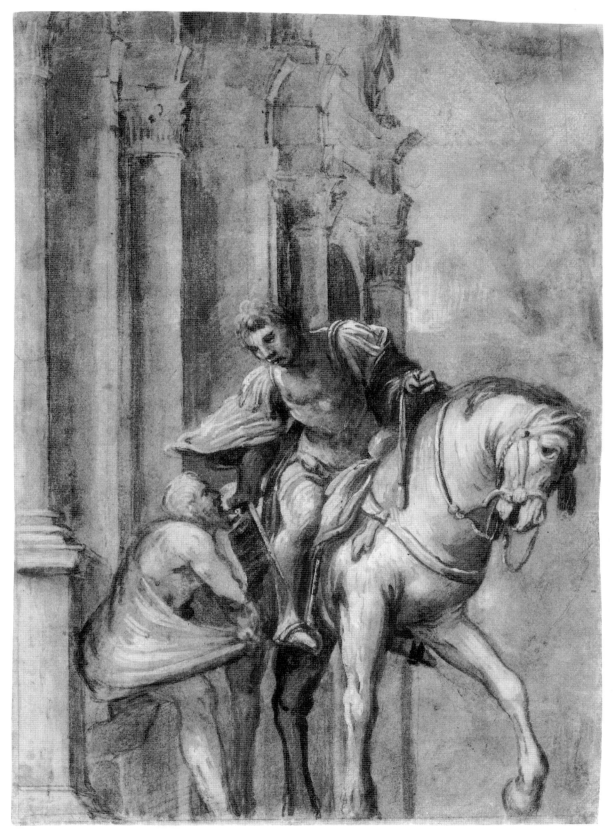

recto

21 Sheet of Studies of Various Figures

Pen and brown ink, brown wash, and white gouache heightening on paper washed blue; H: 26.7 cm (10½ in); W: 18 cm (7⁷⁄₁₆ in.)
85.GG.229

MARKS AND INSCRIPTIONS: (Recto) at top left corner, inscribed *132* in brown ink; at bottom right corner, inscribed *Luini* in brown ink; unknown round collection mark; (verso) inscribed *N177* in red chalk.

PROVENANCE: Charles Gasc, Paris; private collection, Paris; art market, Zurich.

EXHIBITIONS: None.

BIBLIOGRAPHY: M. di Giampaolo, "Review of G. Bora, *I Disegni Lombardi e Genovesi del Cinquecento*," *Prospettiva* no. 37 (April 1984), pp. 76, 78.

THIS EXCEPTIONALLY WELL-PRESERVED SHEET WAS first published by di Giampaolo (1984, p. 78), who related it to figures of apostles below the fresco of the Assumption in Santa Maria di Campagna, Pallanza.[1] It may well be true that the figure at the lower right of the Museum's drawing was preparatory for the apostle in the center left of the fresco,[2] but it is less clear that other studies from the sheet are connected to this section of the fresco cycle, as di Giampaolo has suggested. Bora does not accept the relationship between them, but dates the drawing to the 1570s in any case.[3]

The analysis of this drawing is further complicated by the presence of various other figures entirely unrelated to the Pallanza frescoes. They include the two versions of Saint Mary Magdalene near the bottom of the sheet, a figure of Charity(?) at the upper right, and unidentifiable studies of a seated figure and the back of a partially draped one.

The technique of the drawing is noteworthy. The complex distribution of forms across the sheet occurs in other drawings by Luini, but the rich use of white heightening and wash gives exceptional luminosity. It has been suggested by DeGrazia that the technique indicates the influence of Barocci on Luini.[4] As is suggested by the number inscribed at the upper left of the sheet, it may well have formed part of a sketchbook by the artist.

1. See also G. Bora, "Un ciclo di affreschi, due artisti e una bottega a S. Maria di Campagna a Pallanza," *Arte lombarda* 52, pt. 2 (1979), pp. 90–106.
2. Ibid., fig. 6.
3. Conversation with D. DeGrazia, 1986, related to the author.
4. Conversation with the author, 1986.

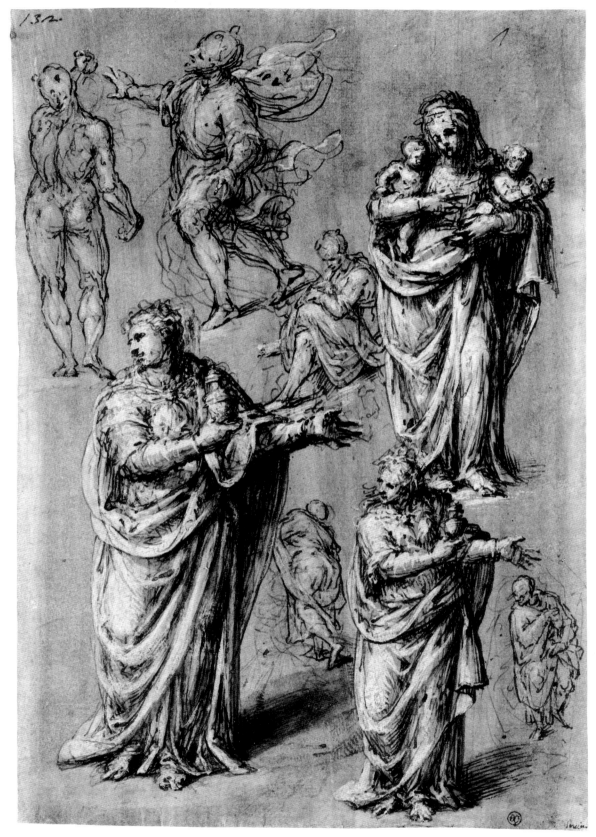

recto

22 Study of Four Saints: Peter, Paul, John the Evangelist, and Zeno

Pen and brown ink, traces of red chalk on book held by Saint Zeno; H: 19.5 cm (7¹¹⁄₁₆ in.); W: 13.1 cm (5³⁄₁₆ in.) 84.GG.91

MARKS AND INSCRIPTIONS: At bottom right, collection mark of William, second duke of Devonshire (L. 718).

PROVENANCE: William, second duke of Devonshire, Chatsworth; by descent to the current duke (sale, Christie's, London, July 3, 1984, lot 26).

EXHIBITIONS: *Drawings by Old Masters*, Royal Academy of Arts, London, 1953, no. 19 (catalogue by K. T. Parker and J. Byam Shaw). *Andrea Mantegna*, Palazzo Ducale, Mantua, 1961, no. 128 (catalogue by G. Paccagnini). *Old Master Drawings from Chatsworth*, National Gallery of Art, Washington, D.C., and other institutions, 1962–1963, no. 38 (catalogue by A. E. Popham). *Old Master Drawings from Chatsworth: A Loan Exhibition from the Devonshire Collection*, Royal Academy of Arts, London, July–August 1969, no. 38 (catalogue by A. E. Popham).

BIBLIOGRAPHY: G. Morelli, *Della pittura italiana: Studi storico-critici: Le Gallerie Borghese e Doria-Pamphili in Roma* (Milan, 1897), p. 275; 2nd edn. (1907), p. 271; J. P. Richter, *Lectures on the National Gallery* (London, 1898), p. 32; P. Kristeller, *Andrea Mantegna* (London, 1901), pp. 153; 154, n. 1; S. Strong, *Reproductions of Drawings by Old Masters in the Collection of the Duke of Devonshire at Chatsworth* (London, 1902), p. 9; A. Venturi, *Storia dell'arte italiana* (Milan, 1914), vol. 7, pt. 3, pp. 154–155; idem, "Scelta di rari disegni nei musei d'Europa," *L'arte* 29 (1926), p. 1; R. Longhi, "Un chiaroscuro e un disegno di Giovanni Bellini," *Vita artistica* (1927), p. 137; A. Venturi, *Studi dal vero* (Milan, 1927), p. 226; H. Tietze and E. Tietze-Conrat, *The Drawings of the Venetian Painters* (New York, 1944), no. A295; L. Dussler, *Giovanni Bellini* (Vienna, 1949), p. 80; G. Fiocco, "Disegni di Giambellino," *Arte veneta* 3, nos. 9–12 (1949), p. 40; A. Mezzetti, "Un Ercole e Anteo del Mantegna," *Bollettino d'arte* 43, no. 4 (July–September 1958), p. 240, n. 3; F. Heinemann, *Giovanni Bellini e i Belliniani* (Venice, 1959), vol. 1, p. 84, no. 339; G. Robertson, *Giovanni Bellini* (Oxford, 1968), pp. 22–23; J. Wilde, *Italian Paintings and Drawings at 56 Prince's Gate (Addendum)*, vol. 5 (London, 1969), p. 39; L. Puppi, *Il trittico per la Basilica di San Zeno Maggiore in Verona* (Verona, 1972), p. 63, no. 23; J. Byam Shaw, *Biblioteca di disegni: Maestri veneti del Quattrocento* (Florence, 1976), vol. 3, no. 34a; C. D. Denison et al., *Drawings from the Collection of Mr. and Mrs. Eugene Victor Thaw—Part II* (New York, 1985), p. 21.

THE CONFUSION CONCERNING THE ATTRIBUTION OF this (and other) drawings by Mantegna began with the first publication of it, by Morelli (1897), as by Giovanni Bellini. First to reassert the proper place of this sheet in the work of Mantegna was Popham (1962–1963, no. 38), who was followed by Robertson (1968, pp. 22–23). It was Wilde (1969), however, who offered the most convincing analysis of the drawing, fully explaining its role in Mantegna's creative development. It had been recognized since the time of Richter (1898) that the drawing is related to the left-hand panel of Mantegna's altarpiece for the church of San Zeno, Verona, which dates from 1456–1459. Wilde showed that the drawing is a *modello* for this section of the altarpiece and represents a relatively early stage in its evolution. This point is reinforced by his observation that the individual saints in the drawing are similar in proportion and pose to those of Mantegna's *Saint Luke* altarpiece (1453–1454; Milan, Brera). Wilde suggested that the *modello* was made for submission to the patron and was made after the altar frame had already been designed. Lastly, he pointed out that the compact grouping of the drawing, which leaves an open space to the right, perhaps for a landscape, was altered by the different and more isolated disposition of the figures across the painted panel.

The drawing is closest to the compositional study for *Saint James Led to Execution* in the church of the Eremitani, Padua, now in the British Museum, London (inv. 1976-6-16-1). Like the Museum's drawing, the sheet in London suffered a curious fate in the earlier literature and has been similarly restored by general consensus to its rightful position as one of a small handful of studies for known projects by Mantegna.

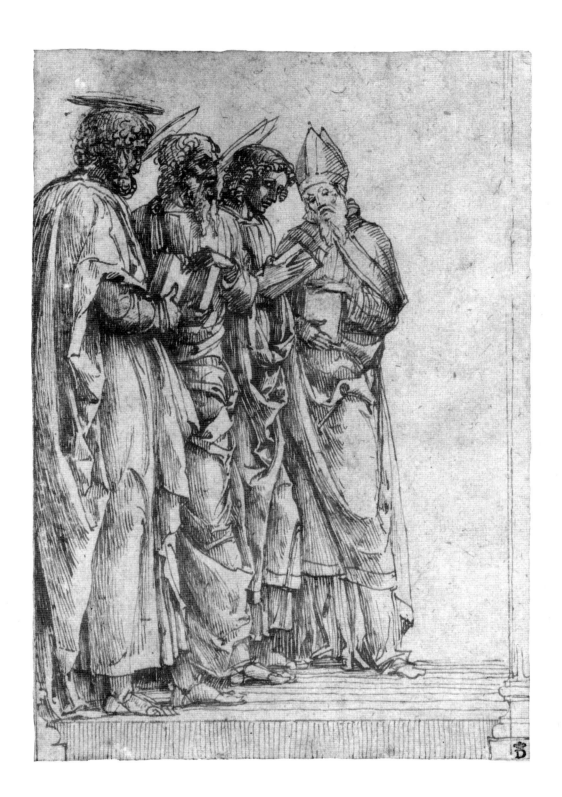

CARLO MARATTA

23 Faith and Justice Enthroned

Pen and brown ink, brown wash, white gouache heightening, and red chalk on brown paper, cut in an irregular shape; H: 48.4 cm (19 in.); W: 28.7 cm (11¼ in.)
85.GG.960

MARKS AND INSCRIPTIONS: (Recto) at bottom left corner, collection mark of William, second duke of Devonshire (L. 718); on mount, at bottom center, inscribed *Carlo Maratti* in brown ink by Jonathan Richardson, Sr.; (verso) on mount, inscribed *QQ1, Carlo Maratti* in brown ink by Jonathan Richardson, Sr.

PROVENANCE: Jonathan Richardson, Sr., London; William, second duke of Devonshire, Chatsworth; by descent to the current duke (sale, Christie's, London, July 3, 1984, lot 27); art market, London.

EXHIBITIONS: *Old Master Drawings from Chatsworth*, National Gallery of Art, Washington, D.C., and other institutions, 1969–1970, no. 42 (catalogue by J. Byam Shaw).

BIBLIOGRAPHY: J. Byam Shaw, "Drawings from Chatsworth," *Apollo* 119, no. 268 (June 1984), p. 458.

THIS LARGE DRAWING IS OF SPECIAL INTEREST ON account of its function, which was first discovered by J. Montagu and N. Turner when it was exhibited prior to the Christie's auction in 1984. It was made as a preparatory study, in reverse, for the upper left corner of a large map of Rome designed by Giovanni Battista Falda and published by Giovanni Giacomo de Rossi in 1676.[1] The map was published with a dedicatory scroll (to the newly elected pope, Innocent XI), borne by putti, below the paired figures of Justice and Faith. The rich use of white heightening enlivens the rather restrained monumentality of the figures. D. DeGrazia has noted the influence of Annibale Carracci in the sculptural use of white heightening and in the figural morphology.[2]

1. A. Frutaz, *Le piante di Roma* (Rome, 1962), vol. 1, pp. 221–222.
2. Conversation with the author, 1986.

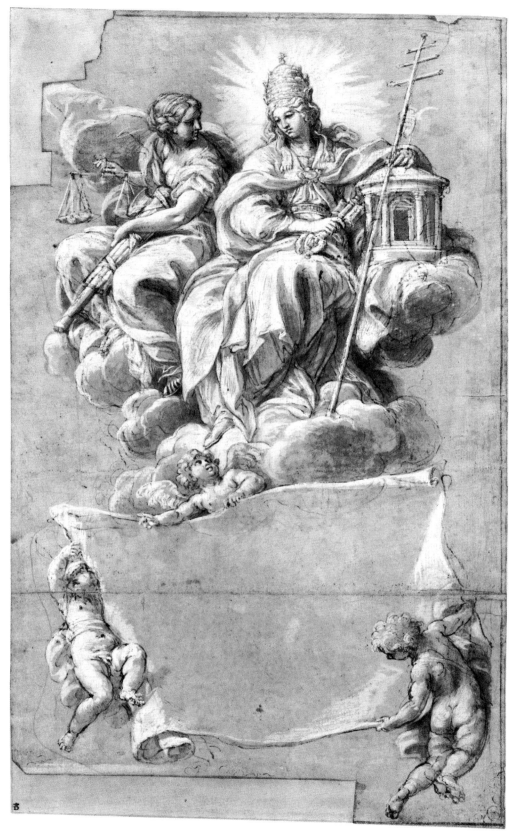

recto

24 Saint Catherine of Alexandria at the Wheel

Black chalk, brush and brown ink, and white gouache heightening on tan paper, irregularly shaped; H: 55.7 cm (21 15/16 in.); W: 42.1 cm (16 9/16 in.)
84.GG.650

MARKS AND INSCRIPTIONS: None.

PROVENANCE: William, second duke of Devonshire, Chatsworth; by descent to the current duke (sale, Christie's, London, July 3, 1984, lot 28); art market, London.

EXHIBITIONS: *Old Master Drawings from Chatsworth*, National Gallery of Art, Washington, D.C., and other institutions, 1962–1963, no. 2 (catalogue by A. E. Popham). *Mostra di Nicolò dell'Abate*, Palazzo dell'Archiginnasio, Bologna, September–October 1969, no. 37 (catalogue by S. Béguin). *Correggio and His Legacy: Sixteenth Century Emilian Drawings*, National Gallery of Art, Washington, D.C., and Galleria Nazionale, Parma, March–May and June–July 1984, no. 78 (catalogue by D. DeGrazia).

BIBLIOGRAPHY: J. Bean, "Chatsworth Drawings in America," *Master Drawings* 1, no. 1 (1963), p. 53; G. Godi, *Nicolò dell'Abate e la presunta attività del Parmigianino a Soragna* (Parma, 1976), pp. 78–79; J. Byam Shaw, "Drawings from Chatsworth," *Apollo* 119, no. 268 (June 1984), p. 458.

AMONG THE LARGEST AND MOST IMPORTANT OF Nicolò's drawings, this sheet was first attributed to him by Popham (1962–1963, no. 2), who noted that the figure of God the Father at the upper left also appears in a fresco of unknown date by Nicolò, the *Adoration of the Shepherds*, formerly in the portico of the Palazzo Leoni, Bologna (destroyed).[1] Béguin (1969, p. 95) has associated the drawing with a painting by Nicolò, the *Martyrdom of Saints Peter and Paul* (1547; Dresden, Gemäldegalerie), and with the battle fresco of uncertain date in the Palazzo Comunale, Modena. DeGrazia (1984, p. 242) has noted the similarity between the landscapes in the Dresden painting and the drawing. All of these relationships support Béguin's dating of the drawing to 1547–1550.

In addition to associations with certain of the artist's other works, the drawing reflects his interest in Pordenone, on whose ceiling fresco in the Cappella della Concezione, San Francesco, Cortemaggiore, the upper group of figures depends (DeGrazia 1984, p. 242). Nicolò's accomplishment here is notable in that he has integrated the two complex sets of figures against an elaborate landscape background. The representation of Saint Catherine exemplifies his graceful figure style.

1. The fresco is known through prints by Giuseppe Maria Mitelli and Gaetano Gandolfi (Béguin 1969, nos. 67, 68).

GIOVANNI PAOLO PANINI

25 *Three Figure Studies*

Gray wash and black chalk; H: 29.4 cm (11⁹⁄₁₆ in.); W: 38.4 cm (15⅛ in.)
84.GA.55

MARKS AND INSCRIPTIONS: At bottom right, inscribed *Hogarth* in black chalk.

PROVENANCE: Private collection, Geneva.

EXHIBITIONS: None.

BIBLIOGRAPHY: None.

THIS STUDY OF THREE MEN IN VARIED POSES APPEARS to have been made to provide figure types for the elaborately populated views of Rome for which Panini is best known. The figures were drawn in very quickly with thin black chalk lines, and then gray wash, in a range of strengths, was added. This technique, as well as the graphic style of the drawing, are analogous to those in a sheet showing a young gentleman holding a hat (New York, Metropolitan Museum of Art, inv. 1975.131.42).[1]

1. J. Bean and F. Stampfle, *Drawings from New York Collections: The Eighteenth Century in Italy*, exh. cat., Metropolitan Museum of Art and Pierpont Morgan Library, New York, 1971, no. 56.

PARMIGIANINO (Francesco Mazzola)

26 Figure Study

Pen and brown ink, brown wash, and white gouache heightening; H: 21.5 cm (8½ in.); W: 24.2 cm (9%6 in.)
84.GA.9

MARKS AND INSCRIPTIONS: At bottom left, collection mark of Sir Thomas Lawrence (L. 2445).

PROVENANCE: Sir Thomas Lawrence, London; private collection, France; art market, Paris.

EXHIBITIONS: None.

BIBLIOGRAPHY: None.

THIS DRAWING HAS BEEN KNOWN IN THE MODERN LITerature only through the etching and aquatint by Rosaspina.[1] As Popham has noted, the drawing was made in preparation for the figure of Saint Jerome in Parmigianino's altarpiece depicting his vision (London, National Gallery), which was almost finished by the time the artist left Rome in 1527.[2] The Museum's sheet is one of four drawings for the figure of Saint Jerome; the others are in the Louvre, Paris (inv. 6423, 6447) and in the Royal Library, Windsor (inv. 883).[3] The Museum's drawing is closest to one of the Louvre sheets[4] in terms of pose and anatomical rendering. In both drawings the figure is more muscular and younger than in the painting. The Museum's sheet would appear to have been cut at the top, especially as more of the head and arms are visible in Rosaspina's copy. Stylistically, the drawing reflects the artist's response to the monumental ancient sculpture he saw during his years in Rome.

1. A. E. Popham, *Catalogue of the Drawings of Parmigianino* (New Haven, 1971), no. O.R.83.
2. Ibid.
3. Ibid., nos. 402, 427, 672.
4. Ibid., no. 402.

27 David with the Head of Goliath

Pen and brown ink; H: 29.5 cm (11⅝ in.); W: 21.6 cm (8½ in.)
84.GA.61

MARKS AND INSCRIPTIONS: At bottom left corner, collection marks of Sir Thomas Lawrence (L. 2445), Nils Barck (L. 1959), J. F. Gigoux (L. 1164).

PROVENANCE: Sir Thomas Lawrence, London; Nils Barck, Paris and Madrid; J. F. Gigoux, Paris (sale, Hôtel Drouot, Paris, March 20–22, 1882, lot 125); private collection, Switzerland; art market, Switzerland.

EXHIBITIONS: *The Lawrence Gallery, Fourth Exhibition,* Woodburn's Gallery, London, 1836, no. 16.

BIBLIOGRAPHY: None.

ALTHOUGH THE DEPICTION OF A BEARDED DAVID with the head of Goliath is unusual, no alternative interpretation of the iconography of this drawing has been proposed. The drawing is closely related to Parmigianino's *Standard-Bearer* in the British Museum, London (inv. 1858-7-24-7).[1] The two sheets are comparable in size, medium, and style, both being highly finished presentation sheets. In addition they both once belonged to Lawrence and Barck and may have been considered a pair. It is even possible that Parmigianino made them as pendants, especially since their principal figures are shown in complementary poses. Such a pairing would have been fully in keeping with the Mannerist delight in complexly interrelated figures. Popham has placed the British Museum sheet in Parmigianino's second Parma period,[2] a dating that would also apply to the Museum's drawing.

1. A. E. Popham, *Catalogue of the Drawings of Parmigianino* (New Haven, 1971), no. 255.
2. Ibid.

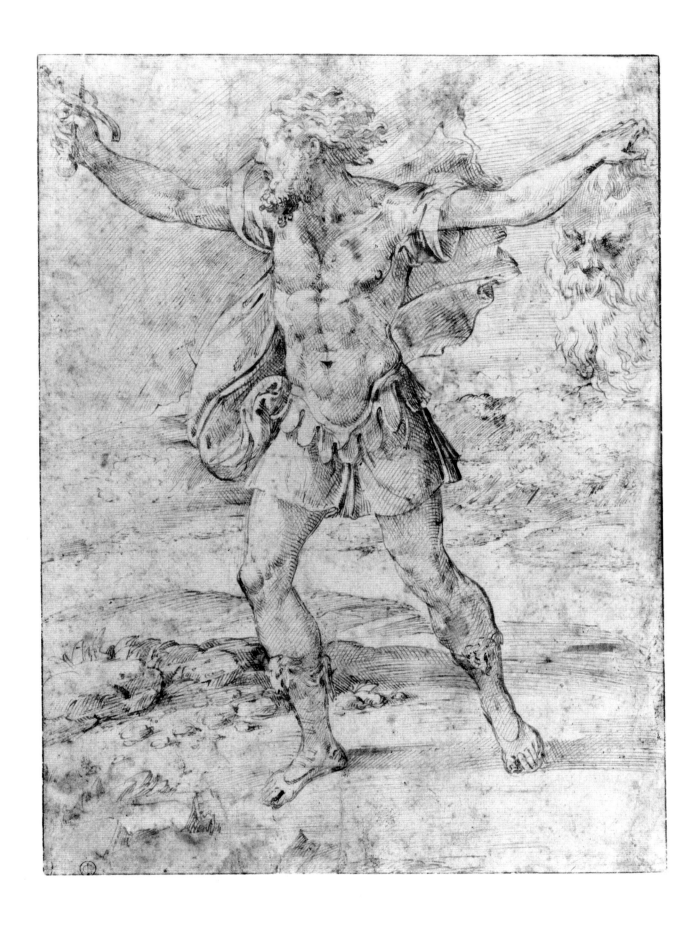

28 Study of the Madonna and Child[r]

Studies of the Madonna with an Architectural Detail[v]

Pen and brown ink; H: 10.2 cm (4 in.); W: 8.6 cm (3⅜ in.)
83.GA.265

MARKS AND INSCRIPTIONS: (Recto) at bottom right corner, collection mark of Earl Spencer (L. 1532).

PROVENANCE: Earl Spencer (eighteenth century [?]), Althorp; art market, Boston.

EXHIBITIONS: *Italy in the Time of Raphael*, Fogg Art Museum, Harvard University, Cambridge, February–April 1983.

BIBLIOGRAPHY: None.

THIS SHEET IS ONE OF MANY SURVIVING PREPARATORY drawings for Parmigianino's most famous painting, the *Madonna of the Long Neck* (Florence, Uffizi), which was commissioned late in 1534 but left unfinished at his death. On the recto of the Museum's drawing the artist was principally concerned with the relative placement of the Madonna and Child and with the latter's pose. The Virgin is studied separately in two drawings in the British Museum, London (inv. 1905-11-10-61/62);[1] they are similar to the Museum's study in scale and delicacy of handling. The pose of the Christ child here is most closely paralleled in a drawing in the Pierpont Morgan Library, New York (inv. IV42),[2] and in a lost study, known through a print.[3]

The verso of the Museum's sheet contains a study for the head of the Virgin at the upper left. She is shown with her head tilted downward, as in the painting, but wears a veil that was later discarded. Next to her in the drawing is a profile study of a woman, who does not appear in the painting. However, in several of the other preparatory studies for the composition, female figures, turned in profile, are seen in the background, and this quick sketch might be related to them. Lastly, there is a study of the entablature and columns of the temple at the lower right of the verso. Parmigianino considered depicting this detail in the background of the painting in a number of ways, but did not choose this solution.

1. A. E. Popham, *Catalogue of the Drawings of Parmigianino* (New Haven, 1971), nos. 243–244.
2. Ibid., no. 317 recto.
3. Ibid., no. O.R. 17.

recto

verso

LUCA PENNI

29 *The Entombment*

Black chalk, pen and brown ink, brown wash, and white gouache heightening; H: 43 cm (16¹⁵⁄₁₆ in.); W: 60 cm (23⅝ in.)
85.GG.235

MARKS AND INSCRIPTIONS: None.

PROVENANCE: V. Blacker, London; sale, Sotheby's, London, July 4, 1985, lot 52.

EXHIBITIONS: None.

BIBLIOGRAPHY: S. Béguin, *L'école de Fontainebleau*, exh. cat., Grand Palais, Paris, 1972, p. 65, under no. 64.

THE ATTRIBUTION OF THIS SHEET TO LUCA PENNI was proposed by P. Pouncey (Sotheby's, 1985, lot 52), who compared it to drawings in the Royal Library, Windsor (inv. 0407), the Louvre, Paris (inv. 1394), and the Stiftung Ratjen, Munich (Béguin 1972, nos. 136–138). This attribution is supported not only by the sheet's association with these drawings but also by its relationship to a print by Rota after Penni's design, also of the Entombment (B11.1[215] v.33,16). The Museum's drawing is compositionally related to one of the same subject in the National Gallery of Scotland, Edinburgh (inv. D3215; Béguin 1972, no. 64); formerly considered to be the work of Penni, it is now generally ascribed to Jean Cousin the Elder.

The Museum's drawing clearly reflects Penni's continuing interest in Raphael. This is hardly surprising in light of the fact that Penni's brother Giovanni Francesco was an important member of Raphael's shop and that Penni himself worked under Perino del Vaga at one point. The technique of the drawing is striking, with certain key elements drawn over for emphasis, especially various faces.[1] The sheet now has a somewhat chalky cast, perhaps due to the desiccation of the wash.[2] The study's purpose is not known, but—given the considerable size of the sheet—it may have been made with a painting in mind. Reference to a painting of this subject, now lost, has been made by Béguin (1972, under no. 136), who has noted the unusual detail of children present at the Entombment.[3]

1. The tendency to accentuate outlines, particularly of facial features, may also be seen in Penni's drawing *Venus and Nymphs Mourning the Dead Adonis* (Haarlem, Teylers Museum, inv. AX82); see B. W. Meijer and C. van Tuyll, *Disegni italiani del Teylers Museum provenienti dalle collezioni di Cristina di Svezia ed i principi Odescalchi*, exh. cat., Istituto Universitario Olandese di Storia dell'Arte, Florence, and Gabinetto Nazionale delle Stampe, Rome, 1983–1984, no. 26.
2. K. Keyes, conversation with the author, Malibu, early 1986.
3. It has been pointed out by C. B. Fuller that the composition of the Museum's drawing repeats in all essentials the relief by Donatello of the same subject on the pulpit in San Lorenzo, Florence (letter to the author, May 12, 1987).

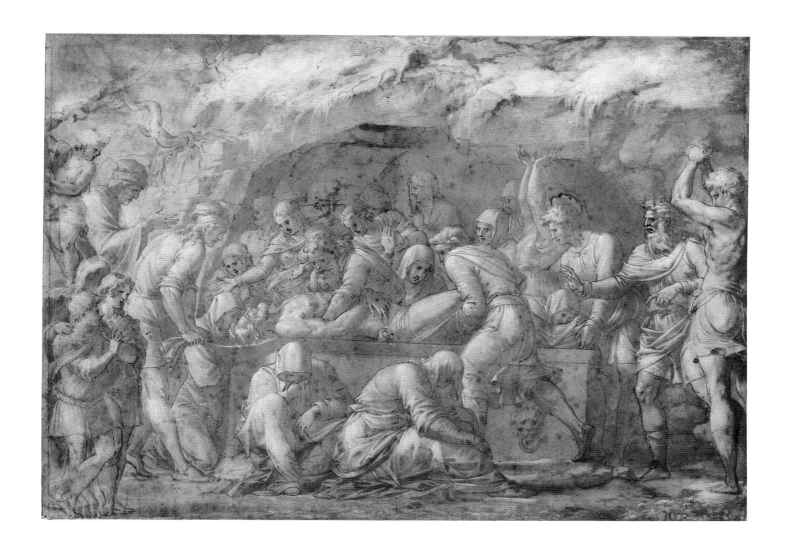

30 Odysseus and the Daughters of Lycomedes

Pen and brown ink, black chalk, and white gouache heightening, squared in black chalk; H: 17.6 cm (6¹⁵⁄₁₆ in.); W: 24.2 cm (9½ in.)
85.GG.39

MARKS AND INSCRIPTIONS: At bottom left, collection mark of William, second duke of Devonshire (L. 718); at bottom right, collection mark of Sir Peter Lely (L. 2092).

PROVENANCE: Sir Peter Lely, London; William, second duke of Devonshire, Chatsworth; by descent to the current duke (sale, Christie's, London, July 3, 1984, lot 35); art market, Boston.

EXHIBITIONS: *Italian Art and Britain*, Royal Academy of Arts, London, Winter 1960, no. 582 (catalogue by E. Waterhouse).

BIBLIOGRAPHY: C. L. Frommel, *Baldassare Peruzzi als Maler und Zeichner* (Vienna, 1967/68), vol. 2, pp. 101–104, no. 58C; R. Bacou, *Autour de Raphael*, exh. cat., Musée du Louvre, Paris, 1984, p. 22, under no. 17.

THIS DRAWING IS PREPARATORY TO ONE OF THE FOUR oval frescoes that Peruzzi painted in the vault of the northeast cupola of the loggia in the Villa Madama, Rome, in 1520–1523. The attribution of this and two related drawings—one, in the Louvre (inv. 10476), of Salmacis and Hermaphrodite and another, at Chatsworth (inv. 41), of Pan with a nymph and satyrs (Frommel 1967/68, pls. 48c, 48d), is due to P. Pouncey. A fourth oval contains a fresco showing the discovery of Achilles, but the final preparatory study for it does not survive.

It is suggested very plausibly in the Christie's sale catalogue (1984, lot 35) that the Museum's drawing shows Odysseus inviting the daughters of Lycomedes into the palace. It is proposed in the same place that the drawing may be a *modello* on account of its high degree of finish and the absence of *pentimenti*. This may well be true, but the very free black chalk underdrawing, indicating changes in some details, should be noted. Arguing in favor of the hypothesis are the facts that the pen work has a definitive character and the drawing is squared. It exemplifies Peruzzi's High Renaissance decorative manner in its spirited use of line and idealized forms.

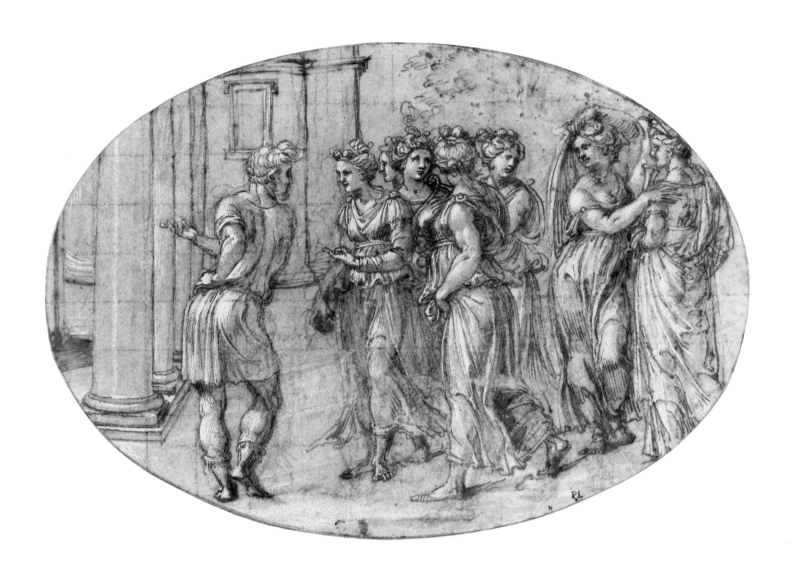

BERNARDINO POCCETTI (Bernardino Barbatelli)

31 A Seated Man

Red chalk; H: 39.4 cm (15½ in.); W: 24.7 cm (9¾ in.)
85.GB.291

MARKS AND INSCRIPTIONS: None.

PROVENANCE: Sale, Sotheby's, London, July 2, 1984, lot 74; art market, London.

EXHIBITIONS: None.

BIBLIOGRAPHY: None.

THIS IS ONE OF NUMEROUS INDIVIDUAL FIGURE DRAW-ings done by Poccetti in chalk as studies for painted compositions. In the Sotheby's sale catalogue (1984, lot 74), the male subject of the Museum's drawing is related to figures in frescoes of the Massacre of the Innocents in the Ospedale degli Innocenti, Florence, and of the martyrdom of saints Nereo and Achilleo in the Cappella del Giglio, Santa Maria Maddalena dei Pazzi, also in Florence. Other analogous seated men may be found at the upper right of Poccetti's altarpiece (1601) for the church of Santa Maria del Carmine, Florence, and at the left of his fresco of a scene from the life of Saint Antonino in the Museo di San Marco, Florence. These relationships to painted images, as well as the similarity to Poccetti's drawing of a seated woman[1] for the fresco in the chapel of the Madonna del Soccorso, SS. Annunziata, Florence, suggest a date for the Museum's drawing of roughly 1600–1610. Although the drawing has not as yet been connected to a known painted figure, it appears very likely that it was meant to be seen from below; this is suggested by the position of the legs and the angle of the man's face and right arm.

1. P. Hamilton, *Disegni di Bernardino Poccetti*, exh. cat., Gabinetto Disegni e Stampe degli Uffizi, Florence, 1980, no. 55.

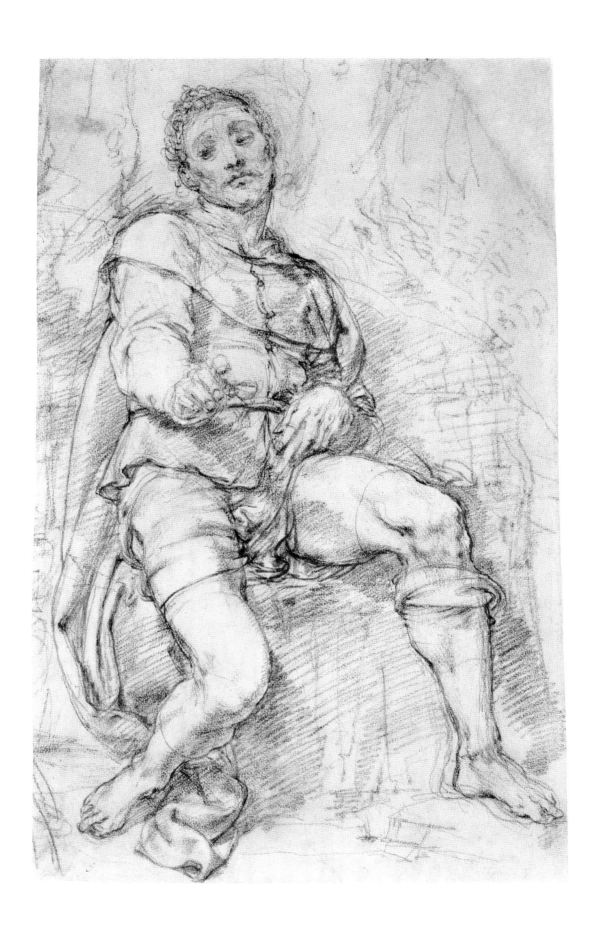

32 *The Deaths of the Blessed Ugoccione and Sostegno* [r]
A Study of the Farnese Hercules (by another hand [Giovanni Navarretti?]) [v]

Black chalk, brush and brown ink, brown wash, and white gouache heightening on blue-green paper, squared in red chalk (recto); pen and brown ink (verso); H: 27.6 cm (10⅞ in.); W: 41.7 cm (16⁷⁄₁₆ in.)
85.GG.223

MARKS AND INSCRIPTIONS: (Recto) at top left and bottom center, inscribed *Poccetti* in brown ink by a later hand; (verso) inscribed *Di Gio Navarretti* (the Tuscan sixteenth-century painter?) in brown ink; *Bernardino Pocce* in black ink.

PROVENANCE: Baron Horace de Landau, Paris and Florence; Mme Hugo Finaly, Florence; Tor Engestroem, Stockholm; sale, Christie's, London, July 5, 1983, lot 54; art market, London.

EXHIBITIONS: None.

BIBLIOGRAPHY: W. Vitzthum, *Die Handzeichnungen des Bernardino Poccetti* (Berlin, 1972), p. 75; P. Hamilton, *Disegni di Bernardino Poccetti*, exh. cat., Gabinetto Disegni e Stampe degli Uffizi, Florence, 1980, pp. 81, 83.

BETWEEN 1604 AND 1612 POCCETTI PAINTED A SERIES of fourteen frescoes with scenes from the lives of the founders of the monastery of Monte Senario, who belonged to the Servite order. The Museum's drawing, though quite elaborate and seemingly definitive (being squared), was superseded by a sheet in the Uffizi (inv. 851F; Hamilton 1980, no. 68), which differs from it in several details. The rather broad and deep spatial arrangement and the rhythmic character of the composition appear to owe a great deal to the example of High Renaissance painting, especially the work of Andrea del Sarto.[1]

1. Other drawings for the fresco are listed by Hamilton (1980, p. 81).

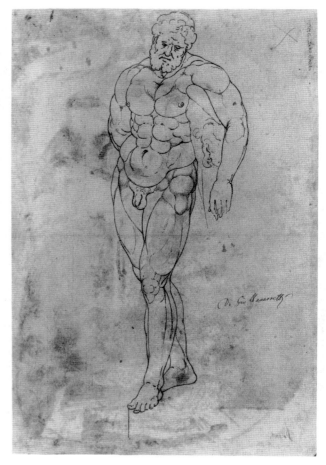

verso

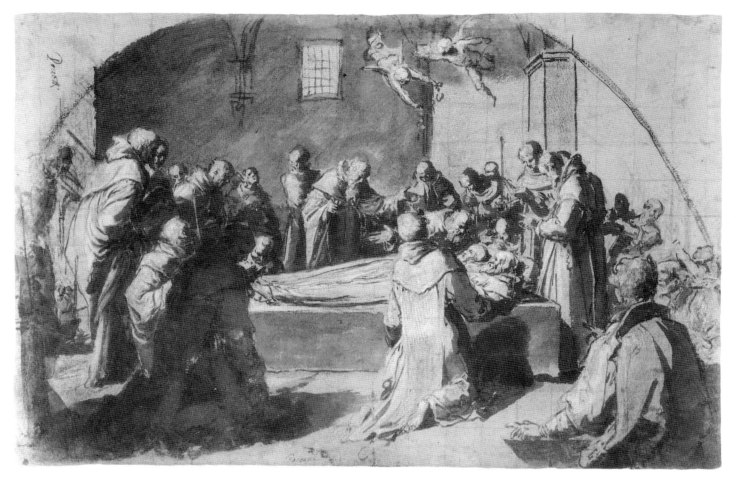

recto

33 Study of a Man with Various Sketches^r

Study of a Man's Draped Leg^v

Red chalk, recently reassembled after having been cut into an irregular shape; H: 20.6 cm (8⅛ in.); W: 18.5 cm (7¼ in.)
84.GB.31

MARKS AND INSCRIPTIONS: (Recto) at left, inscribed *Paulo* in brown ink by a later hand.

PROVENANCE: Private collection, France (sale, Hôtel Drouot, Paris, February 15, 1984, lot 35).

EXHIBITIONS: None.

BIBLIOGRAPHY: None.

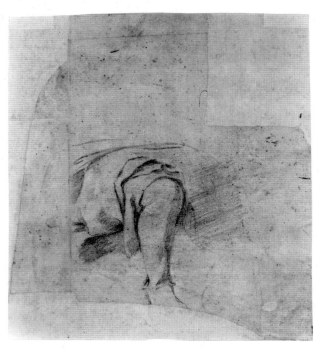

verso

THE CURRENT APPEARANCE OF THIS SHEET DIFFERS markedly from that at the time of its sale in Paris in 1984. As was discovered by A. Yow, who is responsible for its restoration, the arm now situated at the right margin of the recto formerly was attached incorrectly along the lower edge.

This sheet is clearly related to a pair of studies in the British Museum, London (inv. 1953-5-9-450, 1953-5-9-451).[1] Those drawings depict partial studies of a male figure with his left arm upraised; in neither case does the right side of the figure appear. The graphic character of the two studies in London is closely comparable to that of the Museum's sheet, with a similar care taken in the analysis of anatomy; they tend to be bolder in chiaroscuro effect, however. It is very likely that all three drawings were made during the artist's time in Messina and in connection with a scene of martyrdom, perhaps analogous to the one depicted on another sheet in the British Museum (inv. 1946-4-13-214).[2]

1. F. Clapp, *Les dessins de Pontormo* (Paris, 1914), p. 222.
2. Ibid., no. 199 verso.

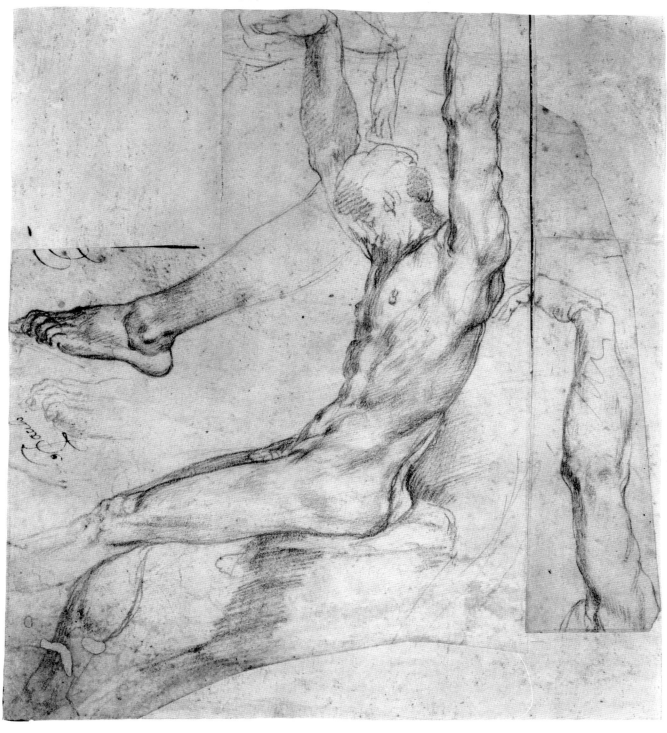

recto

PONTORMO (Jacopo Carucci)

34 Standing Male Nude *r, v*

Black, red, and white chalk, squared in black and red chalk (recto); red chalk (verso); H: 35.1 cm (13¹³⁄₁₆ in.); W: 19.7 cm (7¾ in.)
85.GB.440

MARKS AND INSCRIPTIONS: None.

PROVENANCE: Sale, Sotheby's, New York, January 16, 1985, lot 22; art market, London.

EXHIBITIONS: None.

BIBLIOGRAPHY: None.

THIS DRAWING WAS FIRST PUBLISHED IN THE 1985 Sotheby's sale catalogue (lot 22), where it is associated with Pontormo's studies for the Story of Joseph series and the San Michele Visdomini altarpiece and is dated to circa 1514–1519. The red chalk study on the verso, which is very faintly drawn and appears somewhat rubbed, renders the same figure with his hands placed in the higher of the two positions shown on the recto. The sheet may be from a still earlier phase of the artist's career. G. Smith has noted[1] that the striking pose of the figure on both recto and verso closely recalls the onlooker at the left in the window at the upper part of Sarto's *Last Supper* in San Salvi, Florence.[2] The unusual pose, with hands placed on a horizontal surface and head sharply turned to the right, recurs in the fresco, as does the profile of the head. Noteworthy too is the sketchy drawing of the legs, which the artist knew would never be employed in the fresco. The higher position of the arms and hands is repeated in Sarto's fresco.

Despite the connection with the latter, the Museum's drawing is clearly by Pontormo. The head on the recto can be compared with that of the study for Saint Zachary in the San Ruffillo altarpiece in Florence (Dresden, Kupferstichkabinett, inv. C80 recto),[3] while the spiky fingers can be seen again in a fragmentary study of the hands of Piero de' Medici (Rome, Gabinetto Nazionale delle Stampe, inv. F.C. 133 verso).[4] Equally, the anatomical character of the Museum's drawing and the manner in which the forms were rapidly redrawn throughout are typical of Pontormo's draughtsmanship during the early part of his career.

The explanation for this apparently anomalous situation can be found in the documents. Shearman has argued persuasively that Sarto was paid for work on a cartoon for the fresco between 1511, when the commission was given, and 1522.[5] It may well be that the Museum's drawing is a study for this cartoon made by Pontormo when he was with Sarto's workshop, where he appears to have been an assistant between 1512 and 1514. This dating is supported by the sheet's stylistic closeness to the study of Saint Zachary for the San Ruffillo altarpiece.

1. This and the following observations concerning the relationship of the drawing to Sarto's fresco were made in conversation with the author, Malibu, 1985.
2. S. J. Freedberg, *Andrea del Sarto* (Cambridge, Mass., 1963), vol. 2, fig. 174.
3. J. Cox-Rearick, *The Drawings of Pontormo*, 2nd edn. (New York, 1981), no. 3.
4. Ibid., no. 88.
5. J. Shearman, *Andrea del Sarto* (Oxford, 1965), vol. 2, pp. 254–257.

ANDREA DEL SARTO (Italian, 1486–1530). *The Last Supper* (detail). Fresco. Florence, San Salvi. Photo courtesy Alinari/Art Resource, New York.

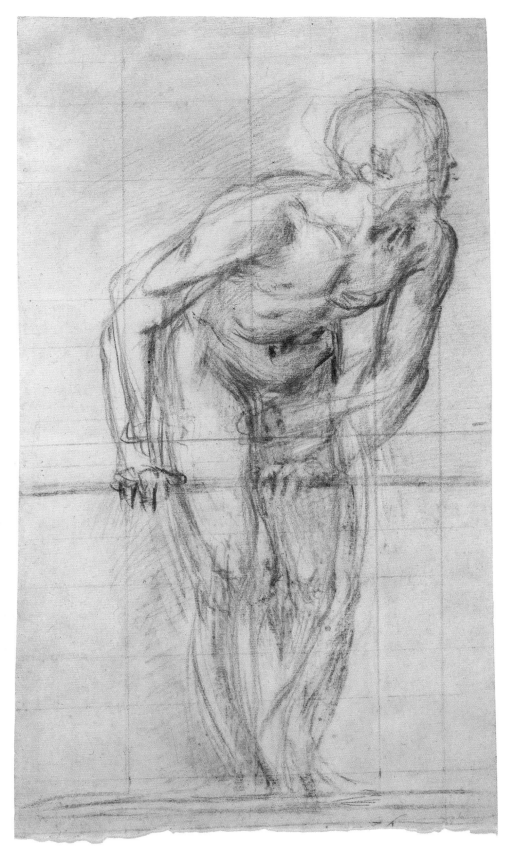

recto

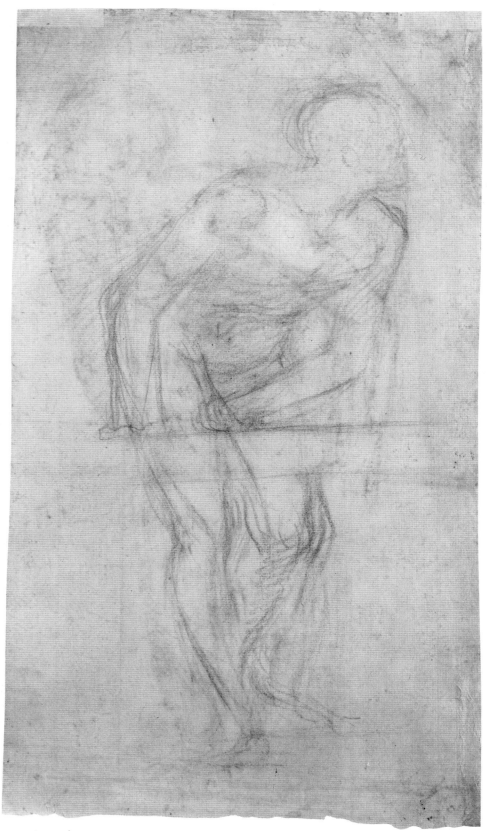

verso (no. 34)

35 *Study of Saint Francis*[r] *Dead Christ*[v]

Black chalk (recto); black and white chalk (verso); H: 40.5 cm (15¹⁵⁄₁₆ in.); W: 28.4 cm (11³⁄₁₆ in.) 83.GG.379

MARKS AND INSCRIPTIONS: (Recto) at bottom left corner, collection marks of Sir Joshua Reynolds (L. 2364), Thomas Hudson (L. 2432); at bottom right corner, collection mark of Jonathan Richardson, Sr. (L. 2183); (verso) unidentified stamp in purple ink.

PROVENANCE: Jonathan Richardson, Sr., London; Sir Joshua Reynolds, London; Thomas Hudson, London; Michel Gaud, Saint-Tropez.

EXHIBITIONS: *Il primato del disegno: Firenze e la Toscana dei Medici nell'Europa del Cinquecento*, Palazzo Strozzi, Florence, 1980, no. 404 (catalogue by L. Berti et al.).

BIBLIOGRAPHY: J. Cox-Rearick, *The Drawings of Pontormo*, 2nd edn. (New York, 1981), vol. 1, pp. 357-1, 357-2, nos. 48a, 67a; A. Forlani-Tempesti, "Un foglio del Pontormo," *Bollettino d'arte* 66 (January–March 1981), pp. 117–122.

THIS IMPORTANT SHEET MADE ITS FIRST APPEARANCE in the literature in 1980 and became the subject of a subsequent definitive study by Forlani-Tempesti (1981). The recto now consists of a study for the kneeling figure of Saint Francis at the right of the altarpiece in San Michèle Visdomini. Two other drawings for the same figure, one showing him studied as a nude, the other of his face, are in the Uffizi, Florence (inv. 6744F recto, 92201F verso; Cox-Rearick 1981, nos. 48, 49). The study of Saint Francis on the Museum's sheet was drawn over a partially obliterated standing man with a staff in his left hand, posed frontally with his head tilted to the left. In certain respects this figure recalls Pontormo's very early *Saint John the Baptist* (Florence, Palazzo Vecchio), but Forlani-Tempesti (1981, pp. 117, 119) is probably correct in preferring an association with the Saint James in the San Michele Visdomini altarpiece. In addition to its significance as a study for this painting, the Museum's recto illustrates the early evolution of Pontormo's mannerism, evident even in the development of the Saint Francis from the Uffizi's monumental and corporeal nude study to the Museum's more thinly proportioned and abstract drawing.

The verso of the Museum's drawing is no less complex. It now is dominated by the powerful image of the dead Christ, with his head thrown dramatically backward. As on the recto, this figure was drawn over another image, in this case a possibly female figure shown standing in profile. Forlani-Tempesti (1981, p. 121) has noted general similarities between this and other standing figures in the Story of Joseph series, but no single comparison appears definitive. The right margin of the verso also contains fragmentary sketches, perhaps of drapery, indicating that the sheet used to be larger and had further drawing on it. There are six chalk studies by Pontormo that are related to the dead Christ; these are in the Museum Boymans-van Beuningen, Rotterdam (inv. 1285 verso) and in the Uffizi (inv. 6670F recto and verso, 6689F recto, 6690F verso, 6691F recto; Cox-Rearick 1981, nos. 62–67). As Clapp has suggested, these series of drawings may well have been made for Pontormo's *Pietà* in the monastery of San Gallo (destroyed).[1] This one is among the most affecting of the series and seems to reflect the impact of Michelangelo on the young artist.

1. F. Clapp, *Les dessins de Pontormo* (Paris, 1914), p. 222.

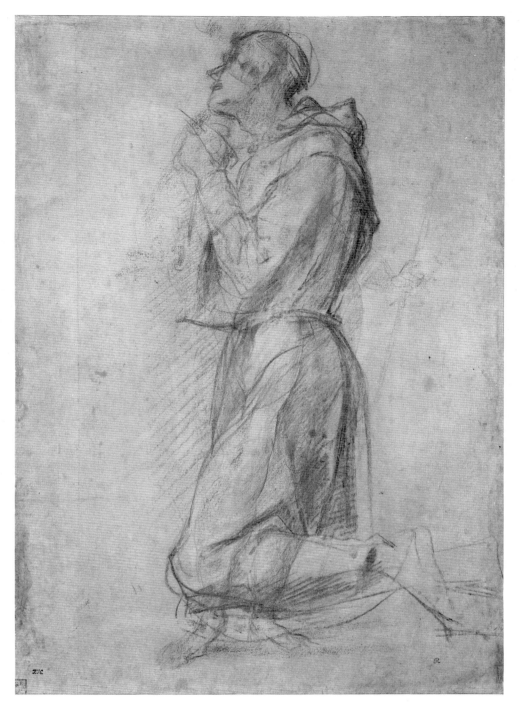

recto

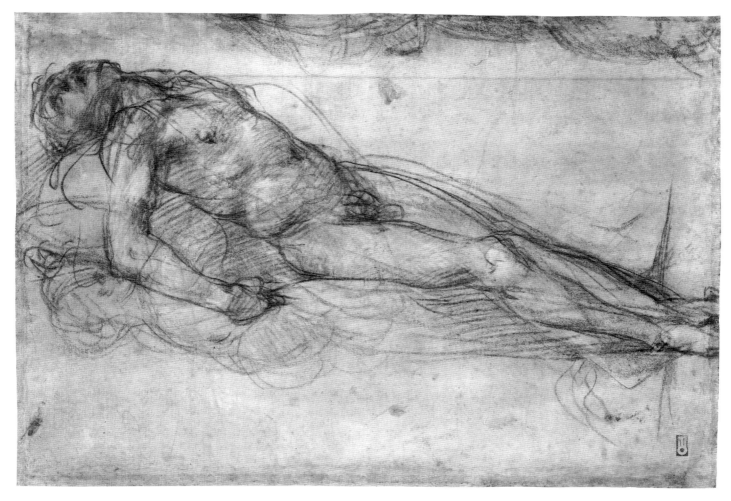

verso

FRANCESCO PRIMATICCIO

36 Vulcan at His Forge

Pen and brown ink, brown wash, and white gouache heightening, squared in black chalk; H: 25 cm (9⅞ in.); W: 14 cm (5½ in.)
84.GA.54

MARKS AND INSCRIPTIONS: (Recto) at bottom right corner, unidentified collection mark *D*; (verso) on mount, collection mark of Desneux de la Noue (L. 3014).

PROVENANCE: Desneux de la Noue, Paris; sale, Hôtel Drouot, Paris, March 2, 1984, lot 23.

EXHIBITIONS: None.

BIBLIOGRAPHY: S. Béguin, J. Guillaume, and A. Roy, *La Galerie d'Ulysse à Fontainebleau* (Paris, 1985), pp. 70, 135, 137.

THIS DRAWING WAS MADE AS A PREPARATORY STUDY for one of the ceiling paintings in the second bay of the Galerie d'Ulysse in the royal palace at Fontainebleau, as was first pointed out by Béguin.[1] The gallery was entirely destroyed in 1739, and our knowledge of it depends upon preparatory drawings, copies, and written descriptions. The painted decoration was designed by Primaticcio, but its execution was left to Nicolò dell'Abate and other younger artists. Although work on the gallery began in 1537, its decoration was not started until at least 1541. It is possible, though not demonstrable, that this and some of the other preparatory studies date from 1541–1543, a period between trips Primaticcio made to Italy.

The scene of Vulcan at his forge was situated at one of the four corners of the ceiling of the second bay, with depictions of Minerva, Mercury, and Eole at the other corners, all in rectangular formats. At the center of the ensemble was the octagonal painting of Neptune releasing the storm, with *Venus, Amor and Cupid* and *Vertumnus and Pomona* on either side in oval fields. Stylistically, the study of Vulcan is closest to drawings of Minerva and Mercury in the Louvre, Paris (inv. 8525, 8529; Béguin, Guillaume, and Roy 1985, p. 135, figs. 11, 13). The rather smooth texture and broken, twisting outline are common to all three drawings, as is the almost notational character of the interior modeling.

1. A full account of historical, documentary, and stylistic issues concerning the gallery is offered by Béguin, Guillaume, and Roy (1985).

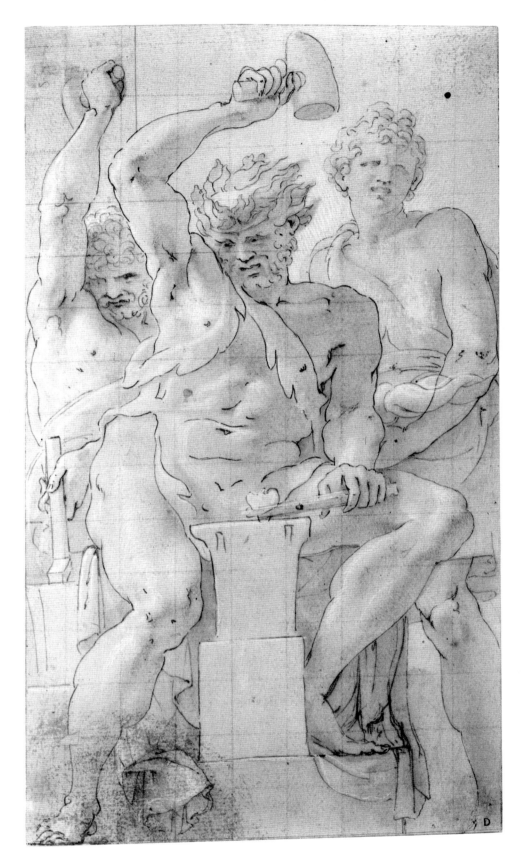

recto

37 Sheet of Studies

Red chalk; H: 24 cm (9⁷⁄₁₆ in.); W: 26.5 cm (10³⁄₈ in.)
84.GB.962

MARKS AND INSCRIPTIONS: At bottom right, inscribed *Ant.° Coregio, 3* (inverted) followed by two numbers in brown ink obliterated by an unknown collection mark.

PROVENANCE: Private collection, Paris; art market, Paris.

EXHIBITIONS: None.

BIBLIOGRAPHY: None.

THIS PREVIOUSLY UNPUBLISHED SHEET IS CHARACTER-istic of Procaccini's manner of drawing in chalk with Correggesque textures and richly modeled surfaces. It also exemplifies his way of covering a sheet with various differently scaled studies, which are nevertheless successfully, if somewhat accidentally, integrated. The three heads of young boys at the upper right appear to be related to the *Madonna and Child with Saints* (Saronno, Sanctuario dei Miracoli),[1] which was painted after 1610 but probably not much later, thereby providing an approximate date for the drawing. This connection is borne out by the somewhat more tenuous association of the small-scale study of a woman below the boys' heads and the figure at the left of *San Carlo Borromeo Healing the Blind Carlo Nava* (Milan, Duomo) of approximately the same date.

1. M. Valsecchi et al., *Il Seicento lombardo*, exh. cat. Palazzo Reale, Milan, 1973, vol. 2, no. 76, fig. 91.

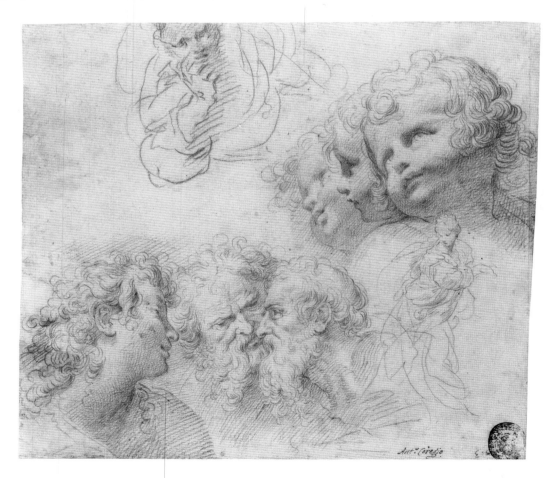

RAPHAEL (Raffaello Sanzio)

38 Studies for the Disputa [r, v]

Pen and brown ink; H: 31.2 cm (12¼ in.); W: 20.8 cm (8³⁄₁₆ in.)
84.GA.920

MARKS AND INSCRIPTIONS: (Recto) at bottom left corner, collection mark of Sir Joshua Reynolds (L. 2364); at bottom right corner, collection mark of Jonathan Richardson, Jr. (L. 2170).

PROVENANCE: Jonathan Richardson, Jr., London; Sir Joshua Reynolds, London; Lord Overstone, Lockinge; Lord and Lady Wantage and Harriet Loyd, Lockinge; A. T. Loyd, Lockinge; C. L. Loyd, Lockinge.

EXHIBITIONS: *Winter Exhibition*, Burlington Fine Arts Club, London, 1923–1924, no. 14. *Exhibition of Italian Art 1200–1900*, Royal Academy of Arts, London, 1930, no. 459. *Drawings by Raphael, from the Royal Library, the Ashmolean, the British Museum, Chatsworth and other English Collections*, British Museum, London, 1983–1984, no. 89 (catalogue by J. Gere and N. Turner).

BIBLIOGRAPHY: G. Redford, *Descriptive Catalogue of Works of Art at Overstone Park* (Lockinge House and Carlton Gardens, 1878), p. 26, no. 100; A. G. B. Russell, *The Vasari Society*, 2nd ser., pt. 5 (Oxford, 1924), p. 9, no. 6; O. Fischel, *Raphaels Zeichnungen* (Berlin, 1925), vol. 6, pp. 302–303, nos. 270, 271; idem, "An Unknown Drawing for Raphael's *Disputa*," *Burlington Magazine* 47, no. 271 (October 1925), pp. 174–179; *Guide to the Pictures at Lockinge House* (London[?], 1928), p. 29; *The Loyd Collection of Paintings and Drawings at Betterton House, Lockinge near Wantage, Berkshire* (London, 1967), p. 67, no. 116; P. Joannides, *The Drawings of Raphael* (Oxford, 1983), p. 183, nos. 203r, 203v; E. Knab, E. Mitsch, and K. Oberhuber, *Raffaello: I disegni* (Florence, 1983), p. 608, nos. 291, 292; idem, *Raphael: Die Zeichnungen* (Stuttgart, 1983), pp. 582–583, nos. 291, 292.

THIS DRAWING WAS DISCOVERED BY RUSSELL (1924, p. 9) and first associated with the *Disputa* in the Stanza della Segnatura by Fischel ("An Unknown Drawing . . . ," 1925, p. 175). The principal figure on the recto is an early study for the man with his back to the viewer standing on the steps to the left of the altar. The abstractly drawn hooded figure at the right of the drawing is probably a quick first thought for the seated Saint Gregory, also to the left of center in the fresco. Two men are shown in animated discussion behind and to the left of the drawing's principal figure, the one in monastic habit rendered with remarkable graphic economy. They reappear in the fresco at the left and well behind the main figure group to the left of the altar.

The verso was much more hastily composed. It consists of three studies of the primary image on the recto, along with a first idea for the young man turning outward to the viewer who stands in the left foreground of the fresco. These sketches illustrate again Raphael's capacity to suggest both the structure and movement of forms with a few lines.

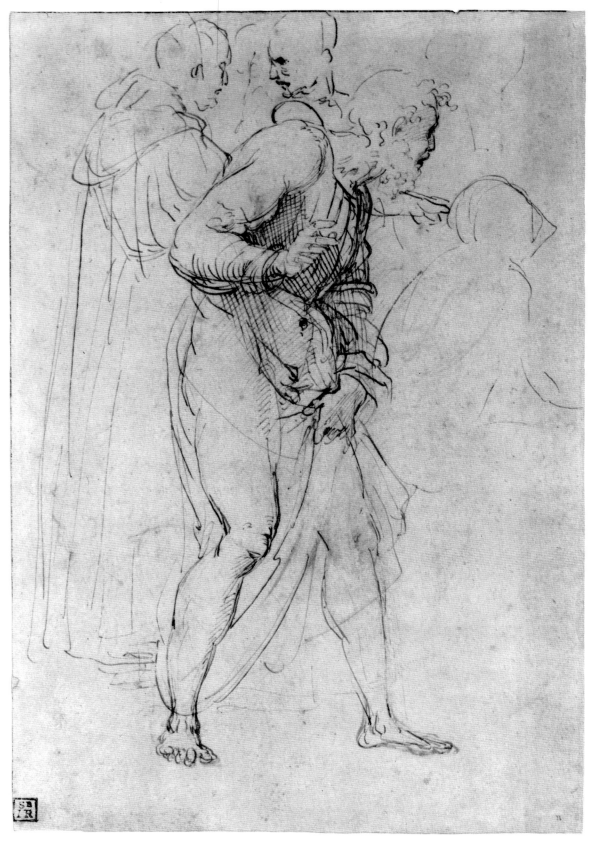

recto

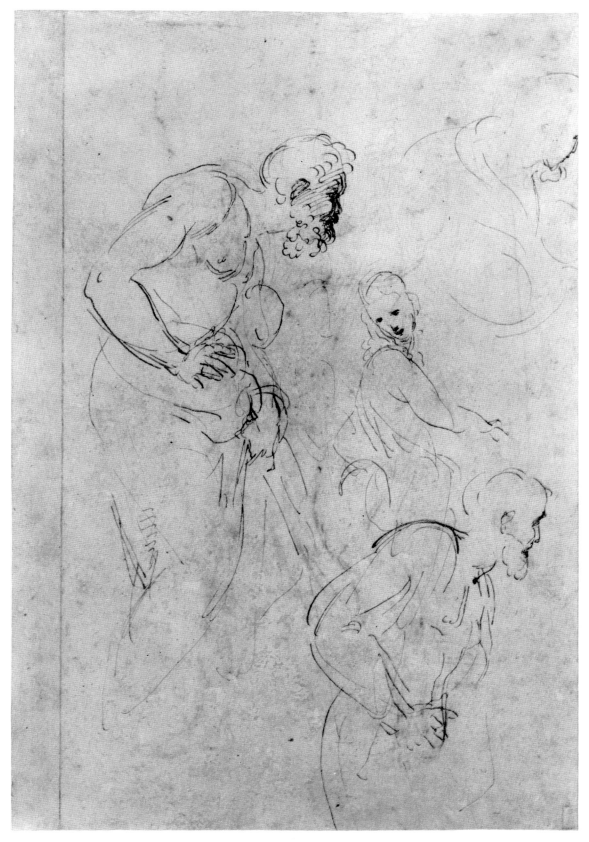

verso

39 Saint Paul Rending His Garments

Metalpoint and white gouache heightening on lilac-gray prepared paper; H: 23 cm (9¹⁄₁₆ in.); W: 10.3 cm (4¹⁄₁₆ in.) 84.GG.919 (SEE PLATE 2)

MARKS AND INSCRIPTIONS: At bottom left corner, collection mark of William, second duke of Devonshire (L. 718); at bottom right corner, collection mark of Sir Peter Lely (L. 2092).

PROVENANCE: Sir Peter Lely, London; William, second duke of Devonshire, Chatsworth; by descent to the current duke (sale, Christie's, London, July 3, 1984, lot 40).

EXHIBITIONS: *Drawings by Old Masters*, Royal Academy of Arts, London, 1953, no. 62 (catalogue by K. T. Parker and J. Byam Shaw). *Old Master Drawings from Chatsworth*, City Art Gallery, Manchester, July–September 1961, no. 52. *Old Master Drawings from Chatsworth*, National Gallery of Art, Washington, D.C., and other institutions, 1962–1963; no. 58 (catalogue by A. E. Popham). *Drawings by Raphael*, British Museum, London, 1983, no. 157 (catalogue by J. Gere and N. Turner).

BIBLIOGRAPHY: J. D. Passavant, *Tour of a German Artist in England* (London, 1836), vol. 2, p. 142; G. F. Waagen, *Treasures of Art in Great Britain* (London, 1854), vol. 3, p. 355; J. D. Passavant, *Raphael d'Urbin et son père Giovanni Santi* (Paris, 1860), p. 515, no. 563; C. Ruland, *The Works of Raphael Santi da Urbino* (London, 1876), p. 251, no. viii, 8; J. A. Crowe and C. B. Cavalcaselle, *Raphael: Sein Leben und seine Werke* (Leipzig, 1885), vol. 2, p. 246; S. A. Strong, *Reproductions of Drawings by Old Masters in the Collection of the Duke of Devonshire at Chatsworth* (London, 1902), p. 8, no. 7; A. P. Oppé, "Right and Left in Raphael's Cartoons," *Journal of the Warburg and Courtauld Institutes* 7–8 (1944), p. 90; J. Shearman, "Review of F. Hartt, *Giulio Romano*," *Burlington Magazine* 101, no. 681 (December 1959), p. 457, n. 4; S. J. Freedberg, *Painting of the High Renaissance in Rome and Florence* (Cambridge, Mass., 1961), vols. 1, pp. 273–274; 2, p. 256, no. 351; L. Dussler, *Raffael: Kritisches Verzeichnis der Gemälde, Wandbilder und Bildteppiche* (Munich, 1966), p. 114; R. Cocke, *The Drawings of Raphael* (London, 1969), pl. 119; A. Forlani-Tempesti, "The Drawings," in M. Salmi, ed., *The Complete Works of Raphael* (New York, 1969), p. 426, n. 166; J. Pope-Hennessy, *Raphael* (London, 1970), pp. 164–165; K. Oberhuber, *Raphaels Zeichnungen* (Berlin, 1972), vol. 9, p. 136, no. 449; J. Shearman, *Raphael's Cartoons in the Royal Collection* (London, 1972), pp. 103–105;

P. Joannides, *The Drawings of Raphael* (Oxford, 1983), p. 255, no. 364; E. Knab, E. Mitsch, and K. Oberhuber, *Raffaello: I Disegni* (Florence, 1983), p. 631, no. 520; idem, *Raphael: Die Zeichnungen* (Stuttgart, 1983), pp. 142, 607, no. 520; C. Monbeig Goguel, in A. Chastel et al., *Raphael dans les collections françaises*, exh. cat., Grand Palais, Paris, 1983, p. 285, under no. 101; J. Byam Shaw, "Drawings from Chatsworth," *Apollo* 119, no. 268 (June 1984), p. 457; R. Harprath, "Raffaels Zeichnung *Merkur und Psyche*," *Zeitschrift für Kunstgeschichte* 48, no. 1 (1985), pp. 408, n. 5; 423; F. Ames-Lewis, *The Draftsman Raphael* (New Haven and London, 1986), pp. 130–131, no. 139.

THIS PREPARATORY STUDY WAS MADE FOR THE FIGURE of Saint Paul at the left of Raphael's tapestry cartoon for the *Sacrifice at Lystra* (London, Victoria and Albert Museum; on deposit, Royal Collection). The dramatic gesture of Saint Paul arises out of his anger that the people of Lystra intended to offer a sacrifice to him and Saint Barnabas.

The use of metalpoint in this drawing is not unusual for Raphael, who continued to employ this technique throughout his career. Another metalpoint drawing consisting of a study for the center and right side of the cartoon was discovered recently in France and acquired by the Louvre (inv. R.F. 38813; Chastel et al. 1983, no. 101). It is similar to the Museum's drawing not only in medium and development of the figures but also in scale. This similarity has led C. Monbeig Goguel to suggest that the Museum's drawing may have been part of a larger sheet that also included the Louvre drawing.[1] No judgment can be made until the two are seen together. If true, the sheet would have been divided by the seventeenth century, given the placement of Peter Lely's mark at the lower right of the Museum's drawing.

1. Conversation with the author, Malibu, 1985.

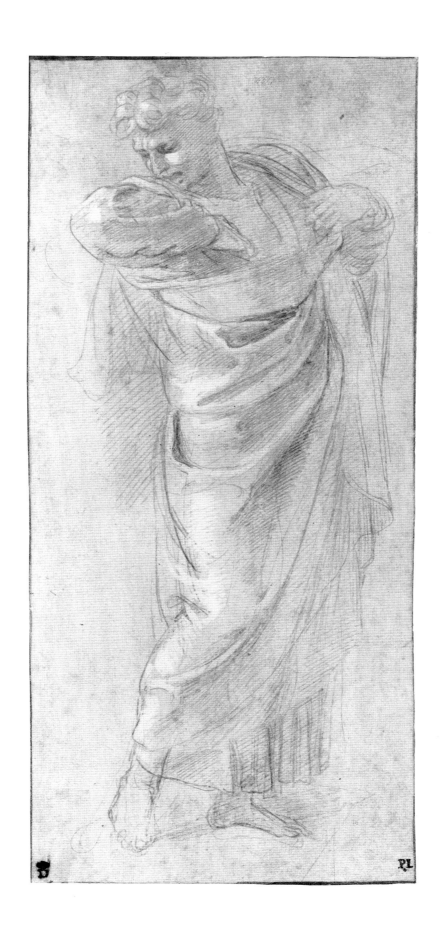

40 Christ in Glory

Black chalk, gray wash, and white chalk on pale gray prepared paper, cut down on sides, strips of paper added outside design; H: 22.5 cm (8⅞ in.); W: 17.9 cm (7¹/₁₆ in.)
82.GG.139

MARKS AND INSCRIPTIONS: At bottom left corner, collection mark of Sir Thomas Lawrence (L. 2445); at bottom right corner, inscribed *Raphaello da Urbino fe* in brown ink; at right, an indecipherable inscription in graphite.

PROVENANCE: C. Ploos van Amstel, Amsterdam; Dirk Versteegh, Amsterdam; Thomas Dimsdale, London; Sir Thomas Lawrence, London; King William II of Holland, Amsterdam (sale, Het Paleis, The Hague, August 12–20, 1850, lot 55); Grand Duke Charles Alexander of Saxe-Weimar-Eisenach, Thuringia; Schlossmuseum Weimar; Dr. Anton Schrafl, Zurich (sale, Christie's, London, December 9, 1982, lot 17).

EXHIBITIONS: *One Hundred Original Drawings by Raffaelle Collected by Sir Thomas Lawrence*, Woodburn-Lawrence Gallery, London, 1836, no. 18.

BIBLIOGRAPHY: J. D. Passavant, *Raphael d'Urbin et son père Giovanni Santi* (Paris, 1860), vol. 2, p. 536; C. Ruland, *The Works of Raphael Santi da Urbino* (London, 1876), p. 49, no. viii, 5; O. Fischel, *Raphaels Zeichnungen, Versuch einer Kritik der bisher veröffentlichten Blätter* (Strasbourg, 1898), p. 146, no. 362; K. Oberhuber, *Raphaels "Transfiguration," Stil und Bedeutung* (Stuttgart, 1982), pp. 43, 77, n. 17; P. Joannides, *The Drawings of Raphael* (Oxford, 1983), p. 247, no. 456; E. Knab, E. Mitsch, and K. Oberhuber, *Raffaello: I Disegni* (Florence, 1983), pp. 138, 642, no. 618; idem, *Raphael: Die Zeichnungen* (Stuttgart, 1983), pp. 142, 619, no. 618; C. Monbeig Goguel, in A. Chastel et al., *Raphael dans les collections françaises*, Grand Palais, Paris, 1983, pp. 240, 307, under no. 117; 358, under no. 43.

ALTHOUGH ALREADY RECOGNIZED AS THE WORK OF Raphael by Lawrence, in whose collection it resided for a time, this drawing received little attention until its appearance at Christie's (1982, lot 17). Since its publication by Passavant (1860, vol. 2, p. 536), scholars have noted its relationship to a late composition by the Raphael studio, showing the Deesis with saints Paul and Catherine of Alexandria below, which is preserved in a drawing by Giulio Romano in the Louvre, Paris (inv. 3867; Chastel et al. 1983, no. 117); an engraving by Marcantonio Raimondi (B.113 [100] v.26, 14); and a painting in the Galleria Nazionale, Parma, possibly by Penni.[1] It seems quite clear that the Museum's drawing of Christ was used by Giulio Romano as the basis for the same figure in the Louvre drawing, which in turn served as the final design for the engraving by Marcantonio Raimondi and the painting attributed to Penni.

The Museum's drawing was attributed by Fischel to Giulio Romano (1898, p. 146), but has been accepted as the work of Raphael by all other scholars. Joannides has correctly associated it with a drawing of the Virgin and Child at Chatsworth (inv. 902; Joannides 1983, no. 458). The broad, painterly use of black chalk and rich chiaroscuro tie them together. Joannides also has noted the relationship of the Museum's sheet to Raphael's earlier work, especially his Christ in the *Disputa*. The change between the draughtsmanship of his study for that figure in the Musée des Beaux-Arts, Lille (inv. PI.471; Joannides 1983, no. 212), and that of the Museum's drawing is analogous to the difference between the *Disputa* and the *Transfiguration*. The alternative possibility of Giulio's authorship of the Museum's drawing is disallowed by comparison of it with his study of the entire composition in the Louvre and with his early drawings in chalk (Joannides 1983, figs. 11–13), which are both harder in form and outline and less convincing in anatomical description. In none of them can one find modeling as subtle as that of Christ's torso in the Museum's sheet, nor are there passages of comparably brilliant free drawing, as in the quickly sketched legs below the drapery.

1. A. Rosenberg, *Raffael* (Stuttgart and Berlin, 1922), no. 216.

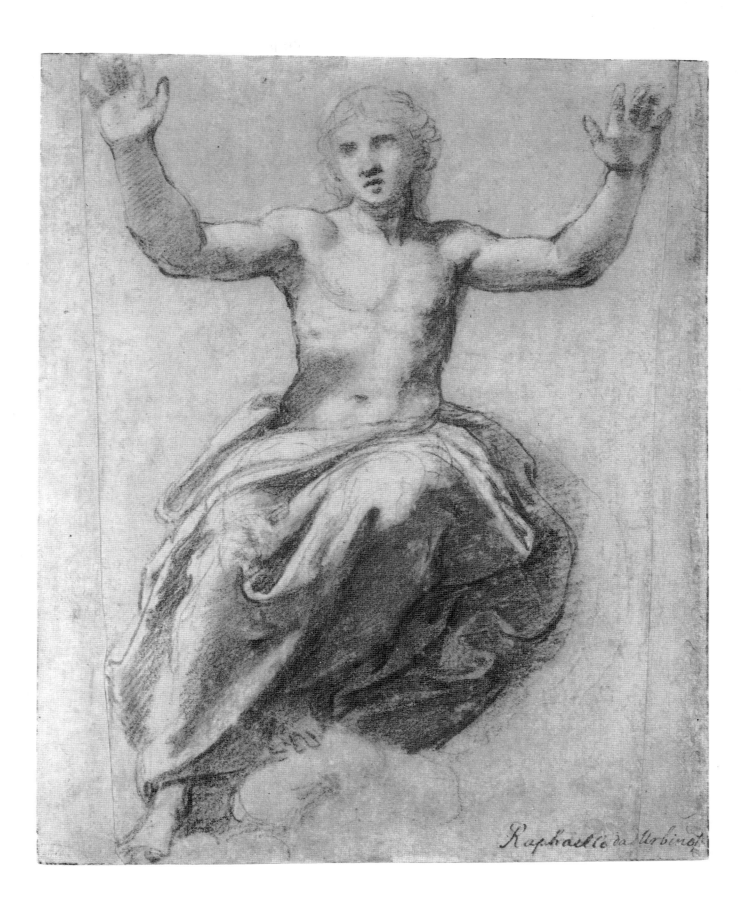

Raphaello da Urbino

41 Holy Family with an Angel

Pen and brown ink; H: 14.2 cm (5%16 in.); W: 20 cm (7⅞ in.)
83.GA.267

MARKS AND INSCRIPTIONS: None.

PROVENANCE: Art market, Boston.

EXHIBITIONS: None.

BIBLIOGRAPHY: None.

THIS INTIMATE COMPOSITION HAS BEEN RELATED BY S. Pepper[1] to another study of the Holy Family in pen and ink in the Weld collection, Dorset.[2] Pepper has pointed out that the two share a stylistic character that closely depends on Agostino Carracci and has placed the Reni compositions in the mid- to late 1590s. The manner of hatching and of rendering contours supports this analysis. The Museum's drawing may have been made with an etching in mind, though none relating to it survives. Reni presumably at least considered an oval format, as is indicated by the rounding off of all four corners of the design.

1. Conversation with the author, 1983.
2. C. Johnston, "Review of *Guido Reni Zeichnungen*," *Master Drawings* 20, no. 1 (1982), p. 41, fig. 1.

SALVATOR ROSA

42 The Dream of Aeneas

Black and white chalk; H: 32.6 cm (11 13/16 in.); W: 22.3 cm (8 13/16 in.)
83.GB.197

MARKS AND INSCRIPTIONS: (Recto) at bottom right corner, collection mark of H. C. Jennings (L. 2771); on mount, at bottom left, inscribed *Sal. Rosa* in brown ink; (verso) on mount, inscribed *AW* (L. 202[?]), *31/n* (?) in brown ink.

PROVENANCE: Sir Anthony Westcombe, Britain(?); H. C. Jennings, Shiplake and London; Sir William Forbes, Pitsligo; by descent (sale, Christie's, London, April 12, 1983, lot 19).

EXHIBITIONS: None.

BIBLIOGRAPHY: None.

M. JAFFÉ (CHRISTIE'S, 1983, LOT 19) WAS THE FIRST to note that this drawing is a finished study for Rosa's etching made circa 1663 (B.23 [277] v. 45,20). Aside from the placement of the scene a bit further away from the viewer, the etching repeats the drawing in all but the execution of minor details. It is interesting to note that although the drawing is highly developed, the sword of Aeneas was initially rendered facing in the opposite direction. This placement of the sword occurs in several other drawings by Rosa and also in his painting of the same subject in the Metropolitan Museum of Art, New York, which is generally taken to be later than the etching. This may indicate no more than that his ideas for print and painting overlapped to a degree. A number of further drawings relating to the etching and painting are known.[1] The Museum's sheet is an unusual example by Rosa of a large, complete compositional drawing in chalk.

1. M. Mahoney, *The Drawings of Salvator Rosa* (New York, 1977), nos. 74.1–7; Christie's, London, April 10, 1985, lot 60.

recto

ROSSO FIORENTINO (Giovanni Battista di Jacopo di Gasparre)

43 Study of a Male Figure (Empedocles)

Red and black chalk, stylus marks throughout; H: 25.1 cm (9⅞ in.); W: 14.8 cm (5¹³⁄₁₆ in.)
83.GB.261

MARKS AND INSCRIPTIONS: At bottom left, inscribed *Rosso* in red chalk (barely legible).

PROVENANCE: Private collection, Paris; art market, Paris.

EXHIBITIONS: *Il primato del disegno: Firenze e la Toscana dei Medici nell'Europa del Cinquecento*, Palazzo Strozzi, Florence, 1980, no. 461 (catalogue by L. Berti et al.).

BIBLIOGRAPHY: S. Béguin, "Empédocle, un dessin inédit de Rosso, *Paragone* 317–319 (1976), pp. 77–82; E. Carroll, "A Drawing by Rosso Fiorentino of Judith and Holofernes," *Los Angeles County Museum of Art Bulletin* 24 (1978), pp. 25, 36, 40, 42; 46, n. 8; 49.

THIS COMPLEX DRAWING WAS FIRST PUBLISHED BY Béguin, who pointed out that it was used by Boyvin for his engraving of Empedocles (1976, fig. 68). She also noted that Boyvin's engraving was, in turn, employed by Gaspare Oselli in 1563 for an engraving of Saint Roch, shown facing in the same direction as the figure in Rosso's drawing (1976, fig. 69). The crescent moon with rays of light and the hand of the philosopher pointing upward to the sun allude specifically to Empedocles, as do the grave expression and walking stance, which refer to his exile. Béguin also related the choice of this rare subject to Rosso's philosophical bent and his involvement with advanced intellectual currents in France. More complex is the question of how Oselli came to give this image an entirely different iconographical meaning. It has been suggested by Carroll (1978, p. 42) that the Museum's drawing depicts two personages simultaneously; he sees Saint Roch's pest mark not only on the print by Oselli but also on Rosso's drawing (1978, p. 49, n. 49). It is difficult to be confident that the small circle on the left thigh is such a mark. Moreover, as both Carroll and Béguin have stated, Oselli's image derives from Boyvin's print, not Rosso's drawing, thereby making this detail in the drawing irrelevant in the context of the Saint Roch print.

The Museum's drawing has been dated to circa 1538–1540 by Carroll in his thorough analysis of the artist's development. One factor perhaps worth adding to his views is the relationship between the drawing and Rosso's *Judith and Holofernes*, now known only through Boyvin's engraving (Carroll 1978, fig. 12), which Carroll dates to circa 1530–1531. The drapery styles of the two are remarkably close, as are other details such as the hair and hands. In both, the protagonists are shown in a meditative moment that interrupts their action. The figures are animated by similarly complex patterns of elaborate folds and by lively hand gestures. These associations would indicate that the Museum's drawing and the lost *Judith and Holofernes* were made around the same time, perhaps in the latter part of the 1530s, the dating Carroll has proposed for the former.

CARLO SARACENI

44 *Allegorical Figure*

Black chalk and white chalk heightening on blue-green paper; H: 32.9 cm (12¹⁵⁄₁₆ in.); W: 25 cm (9¹³⁄₁₆ in.) 83.GB.263

MARKS AND INSCRIPTIONS: (Recto) at bottom center, inscribed *A* (inverted) next to *8* in brown ink; (verso) inscribed *Cavalero Lanfranco di mano 12* in brown ink; *n 39* in black ink.

PROVENANCE: Art market, New York; art market, Boston.

EXHIBITIONS: None.

BIBLIOGRAPHY: K. Oberhuber, "A Saraceni Study," *Burlington Magazine* 127, no. 992 (November 1985), p. 785.

THIS DRAWING WAS FIRST RECOGNIZED AS A STUDY for an allegorical figure in the Sala Regia, Palazzo Quirinale, Rome, by Oberhuber (1985).[1] The seated allegory of papal authority was painted by Saraceni in 1616. In the fresco she is shown in a more elaborate costume than the one she wears in the drawing, suggesting that the latter was based on a studio model. The drapery study at the upper right was used for the fresco, superseding the corresponding detail in the drawing of the entire figure. As Oberhuber has noted, the drapery was used again for the pendant frescoed allegorical image in reverse, without reference to the corrective detailed study at the upper right of the sheet.

This appears to be the only drawing that can be attributed to Saraceni with certainty at this time and is a significant addition to our knowledge of drawing practice among the followers of Caravaggio.

1. He refers to the old mat, which apparently related the drawing to the Sala Regia. Unfortunately, the sheet was not attached to the mat when it was acquired by the Museum in 1983.

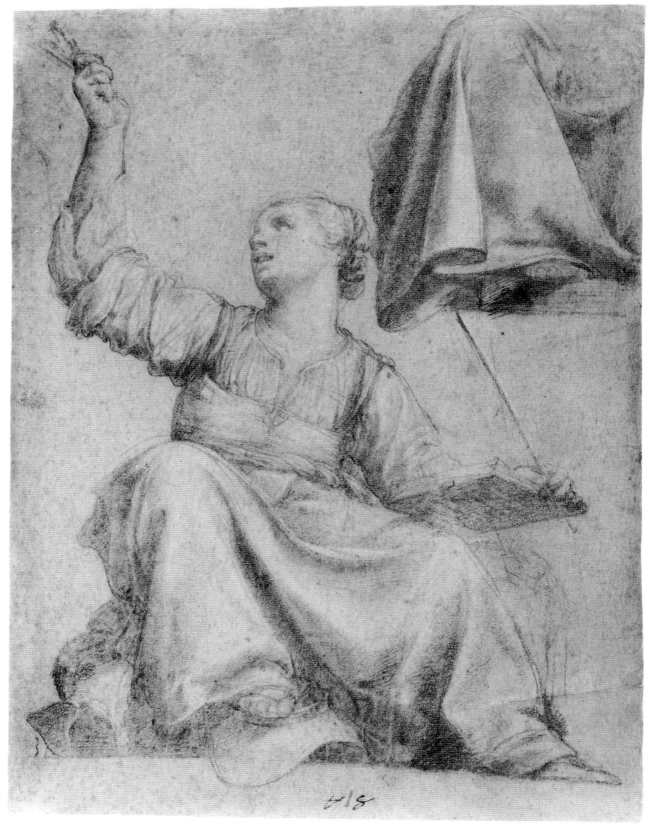

recto

45 *Study of the Head of a Bearded Man*

Black and white chalk on gray-green paper; H: 30.6 cm (12¹/₁₆ in.); W: 22.9 cm (9 in.)
83.GB.17

MARKS AND INSCRIPTIONS: (Recto) at bottom left corner, collection mark of Giuseppe Vallardi (L. 1223); (verso) inscribed *Rubens* in brown ink; undecipherable red chalk numbers superimposed on the inscription.

PROVENANCE: Giuseppe Vallardi, Milan; Countess Adelheid Lanckoronska, Vienna (sale, Christie's, London, March 30, 1971, lot 100); private collection, Paris; art market, Geneva.

EXHIBITIONS: *Dessins français et italiens .du XVIe et du XVIIe siècle dans les collections privées françaises*, Galerie Claude Aubry, Paris, December 1971, no. 99.

BIBLIOGRAPHY: None.

THE MAJORITY OF THE SMALL GROUP OF SURVIVING drawings by Savoldo are studies of heads comparable in scale and medium to this sheet. It is closest to the *Head of a Woman* in the Uffizi, Florence (inv. 12806) and to an untraceable study for the head of Saint Paul in the altarpiece in Santa Maria in Organo, Verona, of 1533 (formerly Florence, C. Loeser collection).[1] The Museum's sheet is comparable to the study of Saint Paul in the pose of the head, the morphology of the eyes and nose, and the broad, painterly draughtsmanship. It shares several of these same qualities with the Uffizi study of a woman, especially the way in which the eye sockets and lids are drawn. As is true of a large proportion of the head studies by Savoldo, the Museum's drawing shows considerable evidence of rubbing in some areas. Given the association with the drawing of Saint Paul, this sheet would appear to date from approximately the same point in the artist's career.

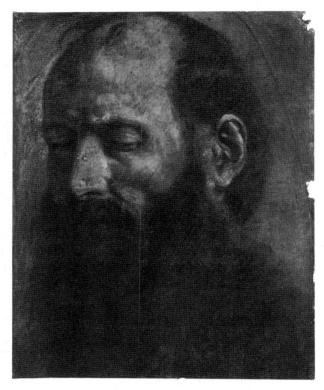

GIOVANNI GIROLAMO SAVOLDO (Italian, circa 1480–1548). *Study for the Head of Saint Paul*. Black chalk and white chalk heightening on greenish blue paper. H: 28 cm (11¼ in.); W: 22.4 cm (8⅞ in.). Location unknown.

1. J. Schönbrunner and J. Meder, *Handzeichnungen alter Meister aus der Albertina und anderen Sammlungen* (Vienna, 1904), vol. 9, no. 1007.

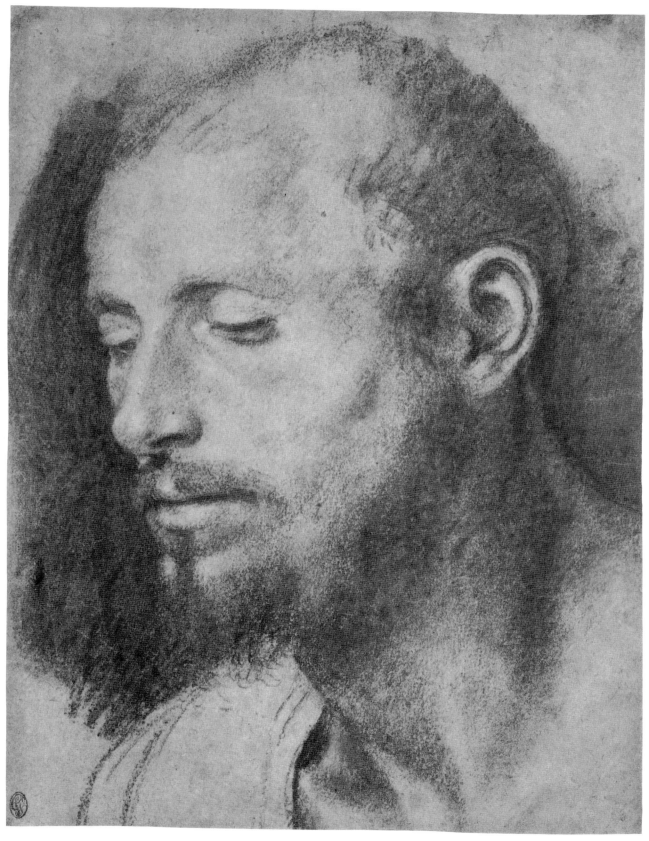

recto

46 Cartoon of the Head of Saint James

Black and white chalk, pricked for transfer on two joined sheets of tan paper, silhouetted; H (max.): 30.1 cm (11⅞ in.); W (max.): 30.6 cm (12 in.)
82.GB.107

MARKS AND INSCRIPTIONS: At right, inscribed *72* in brown ink.

PROVENANCE: Private collection, Paris.

EXHIBITIONS: None.

BIBLIOGRAPHY: M. Hirst, *Sebastiano del Piombo* (Oxford, 1981), p. 60; J. Martineau and C. Hope, eds., *Genius of Venice 1500–1600*, exh. cat., Royal Academy of Arts, London, 1983, p. 282, under no. D59.

THIS CARTOON WAS DRAWN BY SEBASTIANO FOR THE figure of Saint James in the *Transfiguration* fresco in the upper part of the chapel of Pierfrancesco Borgherini in San Pietro in Montorio, Rome. The project as a whole spanned the years 1516–1524. The cartoon was preceded by a squared study for the figure of Saint James at Chatsworth (inv. 47; Hirst 1981, pl. 86). In that drawing and in the fresco itself, the head of the saint is shown at a sharp angle, and the joins of the sheets making up the cartoon indicate that it too was composed in this way.[1] The cartoon has been silhouetted and somewhat damaged, but still retains the great sculptural impact Sebastiano intended. This sole surviving cartoon by Sebastiano was first identified by A. S. Harris while it was in a private collection in Paris.

1. The cartoon was laid down showing the head with no tilt at all until its acquisition by the Museum. It was then removed from its old mount by A. Yow and set at the correct angle.

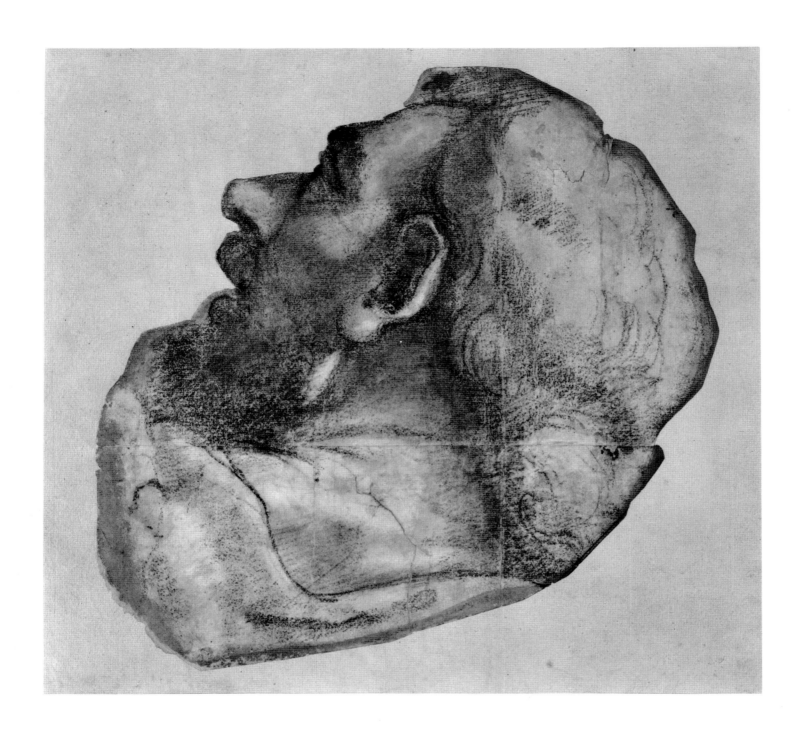

47 *Holy Family with Saint Anne*^r *Figure Sketches*^v

Pen and brown ink, brown wash, and black chalk (recto); faint black and red chalk (verso); H: 37.2 cm (14¹¹⁄₁₆ in.); W: 25.2 cm (9¹⁵⁄₁₆ in.)
84.GA.51

MARKS AND INSCRIPTIONS: (Recto) at bottom right corner, inscribed *di Piet Testa* in graphite.

PROVENANCE: E. Knight, London; art market, London.

EXHIBITIONS: None.

BIBLIOGRAPHY: None.

THIS DRAWING IS RELATED TO TWO FURTHER COMpositional studies in the Pierpont Morgan Library, New York (inv. IV.180.D) and in the Prado, Madrid (inv. F.D.982).[1] There are also smaller studies of the angels in the Louvre, Paris (inv. 1888), and for Saint Anne and the Christ child in the Nationalmuseum, Stockholm (inv. NM536). As has been noted by Perez Sanchez and A. S. Harris,[2] the format of the Prado drawing, with its round top, indicates that it was made in preparation for an altarpiece rather than for a print. It appears very likely that the Museum's drawing is the earliest of the three compositional studies since it is lacking in background detail and is the least finished. The details studied in the Paris and Stockholm sketches show that they were made in relation to the Museum's drawing and not to the Morgan Library or Prado sheets. The Morgan Library drawing would seem to have followed, since it is based upon the Museum's study in significant areas such as the placement and poses of the three principal figures. Lastly, the Prado drawing, which incorporates numerous changes from the other two and which alone is rounded at the top, represents the final stage in the evolution of the composition. Harris has dated the project to circa 1645–1650.

1. A. Perez Sanchez, *I grandi disegni italiani nelle collezione di Madrid* (Milan, 1978), fig. 25.
2. Ibid., p. 259; conversation with the previous owner.

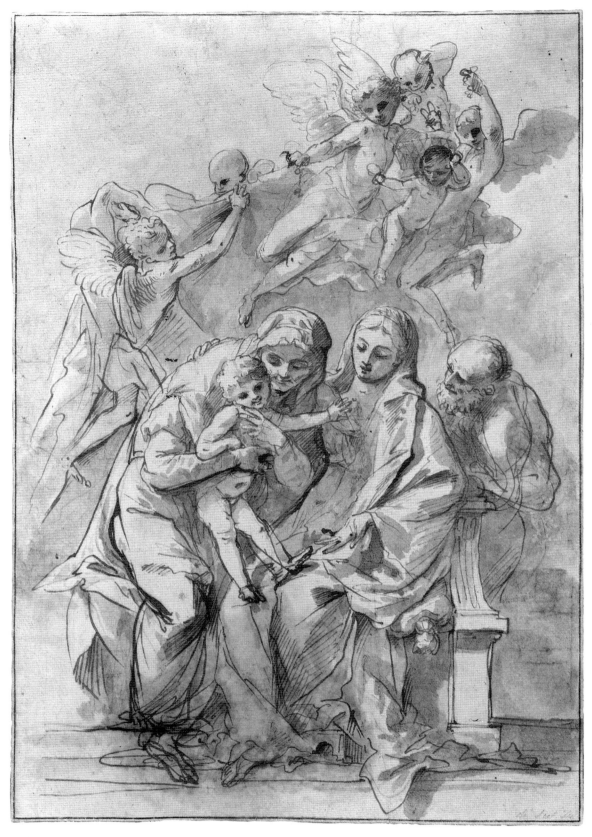

recto

48 *Flight into Egypt*^r

48 Flight into Egypt[r]

Various Studies[v]

Pen and brown ink, brown wash, and black chalk (recto); faint red chalk (verso); H: 30.4 cm (12 in.); W: 45.3 cm (17 13/16 in.)
85.GG.409

MARKS AND INSCRIPTIONS: None.

PROVENANCE: Prince Alexis Orloff, Paris (sale, Galerie Georges Petit, Paris, April 29–30, 1920, lot 88); sale, Sotheby's, London, July 13, 1972, lot 35; art market, New York.

EXHIBITIONS: None.

BIBLIOGRAPHY: G. Knox, "The Orloff Album of Tiepolo Drawings," *Burlington Magazine* 103, no. 699 (June 1961), pp. 269–275.

THIS SHEET ONCE FORMED PART OF THE FAMOUS ALbum of Tiepolo drawings in the Orloff collection, which were dispersed in 1920. Within the Orloff album the Museum's drawing was among three dozen religious compositions of comparable scale and medium which Knox has grouped together in the period 1725–1735 (1961, p. 273). He believes them to have been made as independent works of art, not preparatory to paintings or prints. Within this larger group there are six renderings of the theme of the Flight into Egypt (1961, nos. 24–29). This drawing was first sketched broadly in black chalk and then drawn in pen and wash. A considerable amount of the black chalk underdrawing survives, especially for the boatman and the background view.

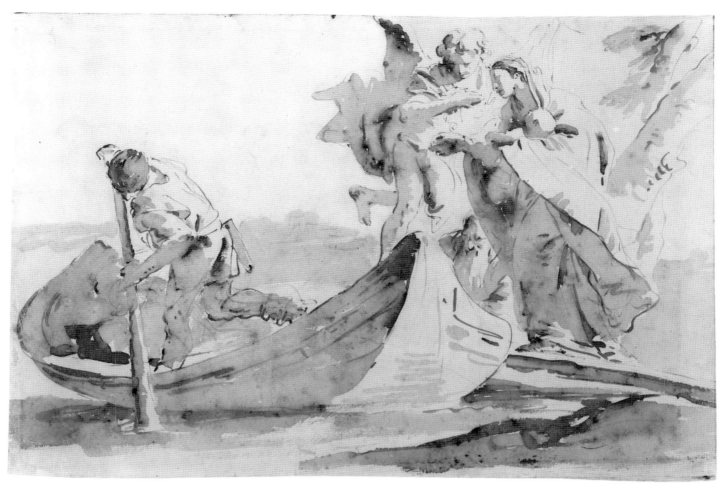

recto

49 *View of a Villa*

Pen and brown ink and brown wash; H: 15.3 cm (6 in.); W: 26.1 cm (10¼ in.)

85.GA.297

MARKS AND INSCRIPTIONS: None.

PROVENANCE: Richard Owen, Paris; Tomás Harris, London; private collection, United States; sale, Sotheby's, London, July 2, 1984, lot 108; art market, New York.

EXHIBITIONS: None.

BIBLIOGRAPHY: G. Knox, *Un quaderno di vedute di Giambattista Tiepolo* (Milan, 1974), p. 83, no. 70.

THIS IS ONE OF A NUMBER OF VIEWS OF ARCHITECTURE and landscape by Tiepolo which form a relatively small part of his drawings corpus. It has been dated by Knox to circa 1757–1759 (1974, p. 83) and is associated with other views made during the time of the artist's work at the Villa Valmarana, Vicenza (1757), and in Udine (1759). Although the villa shown in the drawing is typical of the Veneto, it has not been identified. As Knox has pointed out, the central section of the drawing showing the staircase and part of the facade was used by Tiepolo's son Giovanni Domenico in his *Lazarus at the Rich Man's Gate* (Musée de Besançon; Knox 1974, ill. p. 83). Domenico's drawing contains a slightly greater degree of architectural accuracy in detail, an issue of little interest to his father, who used the motif as a pretext for an analysis of tone and texture.

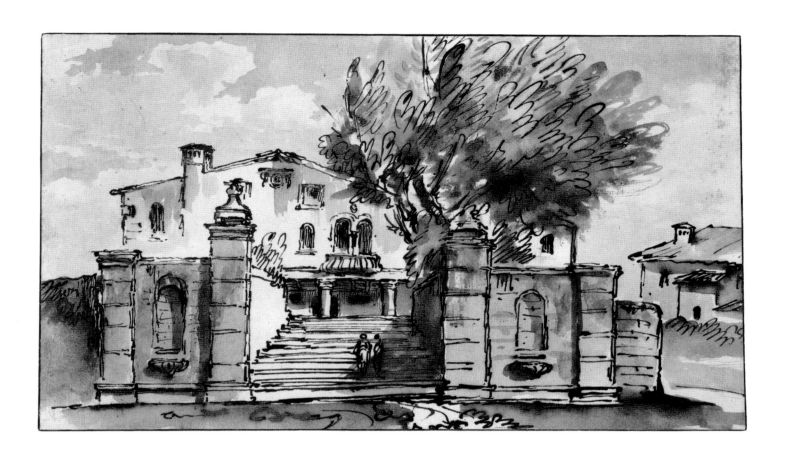

50 *Punchinello Is Helped to a Chair*

Pen and brown ink, brown wash, and black chalk; H: 35.3 cm (13¹⁵⁄₁₆ in.); W: 47 cm (18½ in.)
84.GG.10

MARKS AND INSCRIPTIONS: At top left corner, inscribed *96* in brown ink; at bottom right, signed *Dom o Tiepolo f* in brown ink.

PROVENANCE: Richard Owen, London; Paul Suzor, Paris; art market, Paris.

EXHIBITIONS: Musée des Arts Décoratifs, Paris, 1921.

BIBLIOGRAPHY: J. Byam Shaw, *The Drawings of Domenico Tiepolo* (Boston, 1962), p. 94; A. M. Gealt and M. E. Vetrocq, *Domenico Tiepolo's Punchinello Drawings* (Bloomington, 1979), p. 145; M. E. Vetrocq, "The Divertimento per li Ragazzi of Domenico Tiepolo," unpub. Ph.D. diss., Stanford University, 1979, p. 119, no. 28; A. Gealt, *Domenico Tiepolo: The Punchinello Drawings* (New York, 1986), p. 192.

THIS IS ONE IN THE FAMOUS SERIES OF 103 DRAWINGS by Domenico Tiepolo dealing with episodes in the life of Punchinello which bore the title Divertimento per li ragazzi (Diversion for Children). The scenes run the gamut from amusement to tragedy, illuminating the complex character of Punchinello, who was a favorite in the Commedia dell'arte and other popular entertainments.[1] He already had been represented by Domenico and his father in the frescoes of the Tiepolo villa at Zianigo.

This drawing shows Punchinello being helped to a chair, presumably after some tiring bout of bad behavior. As in other drawings of the series, there is considerable black chalk underdrawing still visible, suggesting numerous *pentimenti*, and the description of space is somewhat ambiguous, especially along the walls. The series has been dated by Byam Shaw to the years just before Domenico's death (1962, p. 57). It has been noted by Vetrocq (1979, p. 145) that the woman with a fan at the left was based upon a similarly posed figure in Domenico's drawing of a puppet show in a nunnery.[2] That drawing is dated 1791, lending further support to Byam Shaw's late dating for the entire series.

1. The figure of Punchinello is discussed in detail by Vetrocq (1979, pp. 19–33).
2. Sotheby's, London, July 6, 1967, lot 49.

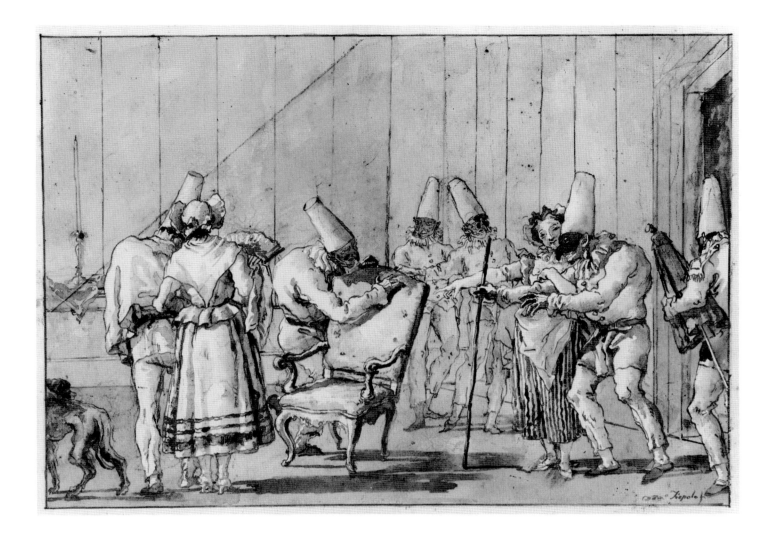

TITIAN (Tiziano Vecellio)

51 Pastoral Scene

Pen and brown ink, black chalk, and white gouache heightening; H: 19.6 cm (7 11/16 in.); W: 30.1 cm (11 7/8 in.)
85.GG.98

MARKS AND INSCRIPTIONS: At bottom, inscribed *Tiziano* in brown ink.

PROVENANCE: William, second duke of Devonshire, Chatsworth; by descent to the current duke (sale, Christie's, London, July 3, 1984, lot 44); art market, London.

EXHIBITIONS: *Drawings by Old Masters*, Royal Academy of Arts, London, 1953, no. 89 (catalogue by K. T. Parker and J. Byam Shaw). *Old Master Drawings from Chatsworth*, Manchester City Art Gallery, July–September 1961, no. 60. *Italian 16th Century Drawings from British Private Collections*, Scottish Arts Council, Edinburgh Festival, August–September 1969, no. 46 (catalogue by Y. Tan Bunzl et al.). *Old Master Drawings from Chatsworth*, National Gallery of Art, Washington, D.C., and other institutions, 1969–1970, no. 68 (catalogue by J. Byam Shaw). *Disegni di Tiziano e della sua cerchia*, Fondazione Giorgio Cini, Venice, 1976, no. 46 (catalogue by K. Oberhuber). *Old Master Drawings—A Loan from the Collection of the Duke of Devonshire*, Israel Museum, Jerusalem, April–July 1977, no. 8. *Treasures from Chatsworth: The Devonshire Inheritance*, Virginia Museum of Fine Arts, Richmond, and other institutions, 1979–1980, no. 64 (catalogue by A. Blunt et al.).

BIBLIOGRAPHY: S. A. Strong, *Reproductions of Drawings by Old Masters in the Collection of the Duke of Devonshire at Chatsworth* (London, 1902), p. 14, no. 59; T. Pignatti, "Disegni di Tiziano: Tre mostre a Firenze e a Venezia," *Arte veneta* 30 (1976), p. 269; W. R. Rearick, *Tiziano e il disegno veneziano del suo tempo*, exh. cat., Gabinetto Disegni e Stampe degli Uffizi, Florence, 1976, p. 45; T. Pignatti, "Fondazione Giorgio Cini, Esposizioni: Disegni di Tiziano e la sua cerchia; Tiziano e la silografia veneziano del Cinquecento," *Pantheon* 35 (April–June 1977), p. 169; M. Muraro, "Grafica Tizianesca," in R. Pallucchini, ed., *Tiziano e il manierismo europeo* (Florence, 1978), p. 140; T. Pignatti, *Tiziano: Disegni* (Florence, 1979), p. 11, no. 53; J. Byam Shaw, "Titian's Drawings: A Summing-Up," *Apollo* 112, no. 226 (December 1980), p. 387; T. Pignatti,

Master Drawings from Cave Art to Picasso (New York, 1982), p. 137; J. Byam Shaw, "Drawings from Chatsworth," *Apollo* 119, no. 268 (June 1984), pp. 456–457, 459.

THIS DRAWING WAS FIRST PUBLISHED BY STRONG AS by Campagnola (1902) and then went unnoticed until Byam Shaw attributed it to Titian (1969–1970, no. 68). Since then it has been accepted as such by all scholars except Muraro (1978, p. 140), who proposed the alternatives of Verdizotti or Cort, neither of whom can be shown ever to have made a drawing comparable to it in any sense. Strong's attribution to Campagnola may be dismissed with equal assurance. None of his many drawings possess the subtlety of pen stroke, control of spatial relationships, or atmospheric suggestiveness of this sheet.

The drawing fits very easily into Titian's corpus of drawings and alongside his paintings, as Oberhuber has demonstrated (1976, no. 46). He has associated it not only with the landscape drawing still at Chatsworth (inv. 751; 1976, no. 47) but also with the *Ruggiero and Angelica* in the Musée Bonnat, Bayonne (inv. 652; 1976, fig. 29) and the *Saint Theodore and the Dragon* in the Pierpont Morgan Library, New York (inv. 1977.46; 1976, no. 44). They form a group of late landscapes comparable in their spatial conception and mood. Oberhuber has related the woman in the Museum's drawing to nudes in late paintings, such as the *Venus and Cupid* (Cambridge, Fitzwilliam Museum), and the background to that of the *Saint Margaret* (Madrid, Prado). Although its Giorgionesque character seems to argue for a much earlier moment, Oberhuber's date of around 1565 is correct. It is buttressed by Titian's interest in Giorgione at that point, best seen in the *Nymph and Shepherd* (Vienna, Kunsthistorisches Museum). Also noteworthy is the daring application of white heightening on the most prominent of the trees, a technique in tune with the "impressionism" of Titian's late paintings.

Oberhuber has proposed that the underlying theme is Indolence leading to Lust. The drawing was copied in a number of prints, including one by Le Febre in which the woman was transformed into a male shepherd. A partial copy of the drawing, with the area including the woman and surrounding details left blank, is in the Uffizi (inv. 502P).

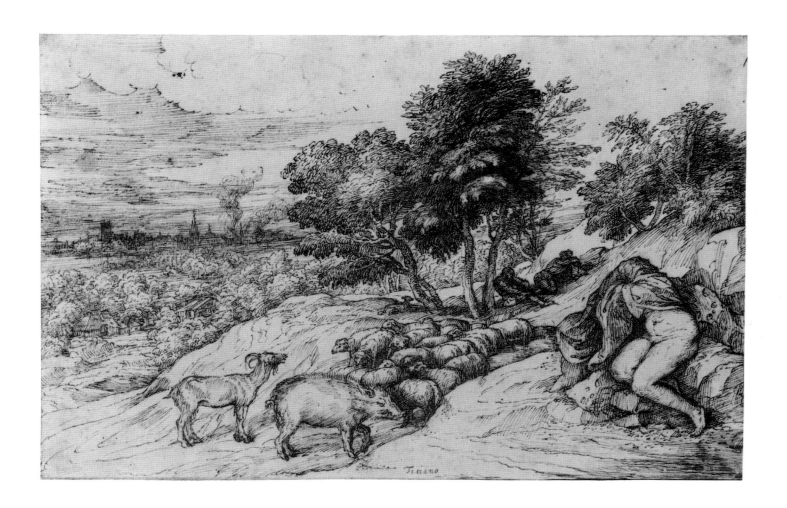

PAOLO VERONESE (Paolo Caliari)

52 Christ Preaching in the Temple

Pen and brown ink; H: 7.8 cm (3¹⁄₁₆ in.); W: 17.5 cm (6⅞ in.)
83.GA.266

MARKS AND INSCRIPTIONS: At bottom right corner, collection mark of Jonathan Richardson, Sr. (L. 2183).

PROVENANCE: Jonathan Richardson, Sr., London; S. Schwartz, New York; art market, Boston.

EXHIBITIONS: *Drawings from New York Collections: The Italian Renaissance*, Metropolitan Museum of Art and Pierpont Morgan Library, New York, 1965–1966, no. 125 (catalogue by J. Bean and F. Stampfle). *Early Venetian Drawings from Private Collections and the Fogg*, Fogg Art Museum, Harvard University, Cambridge, February–April 1983.

BIBLIOGRAPHY: H. Tietze, "Nuovi disegni veneti del Cinquecento in collezioni americani," *Arte veneta* 2, nos. 5–8 (1948), p. 60; R. Cocke, "An Early Drawing by Paolo Veronese," *Burlington Magazine* 113, no. 825 (December 1971), pp. 726, 729–730; D. Rosand, "Three Drawings by Paolo Veronese," *Pantheon* 29, no. 3 (1971), pp. 203–204; T. Pignatti, *Veronese* (Venice, 1976), vol. 1, p. 111; R. Cocke, *Veronese's Drawings—A Catalogue Raisonné* (London, 1984), pp. 18, 37, 39.

THIS DRAWING HAS ALWAYS BEEN RECOGNIZED AS A compositional study for Veronese's painting *Christ Preaching in the Temple* (Madrid, Prado), which is now dated by many scholars to 1548. Rosand (1971, pp. 203–204) has noted the artist's use of elaborate hatching and the absence of wash as well as a certain hesitancy in execution, which he has explained as indications of the sheet's early date. Cocke (1971, pp. 729–730; 1984, p. 18) has developed the analysis by pointing to the influence of Parmigianino's graphic style. Despite these analyses and the supposed date of 1548 for the painting in Madrid, it is difficult to understand this drawing as emerging from so early a point in Veronese's career. In fact it appears to have much in common with several drawings of around 1570 (Cocke 1984, nos. 57, 58). This being the case, the dating of both painting and drawing remains puzzling.[1] The drawing is perhaps a first thought concerning this complex composition and leaves out many elements that appeared later, including the entire background. There are also numerous individual changes that occurred as the composition developed. The sheet has obviously been cut, perhaps eliminating some further studies for the scene. A chalk drawing for the man seated at the front left of the composition has been published by Cocke (1984, no. 2).

1. I am grateful to R. Rearick for conveying his doubts about the early dating of the Madrid painting to me in a recent conversation.

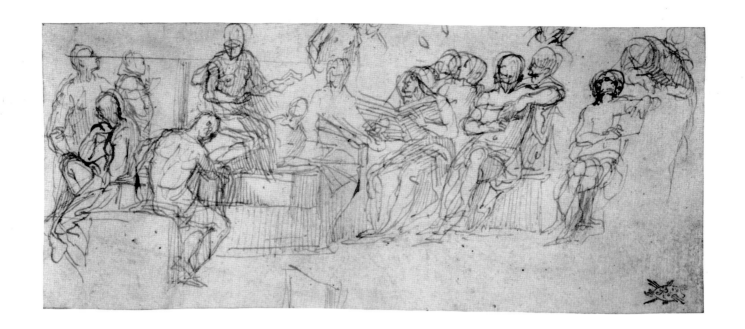

53 Sheet of Studies for the Martyrdom of Saint George[r] Studies of a House, Tree, Heads, Artist's Tools, Decorative Motifs, and Computations[v]

verso

Pen and brown ink and brown wash (recto); pen and brown ink (verso), upper corners have been replaced; H: 28.9 cm (11⅜ in.); W: 21.7 cm (8%₁₆ in.) 83.GA.258

MARKS AND INSCRIPTIONS: (Recto) at top left corner, inscribed . . . *in Vite et U*[tas] *in tri.te / trinitas in unitate* in brown ink by Veronese; at bottom left corner, collection mark of Emile Wauters (L. 911); at bottom, right of center, inscribed *moro* in brown ink by Veronese; at right, inscribed *27* in red chalk.

PROVENANCE: Baron Max zu Herrnsheim, Darmstadt; Emile Wauters, Paris (sale, Frederik Muller, Amsterdam, June 15–16, 1926, lot 33); Baron Robert von Hirsch, Basel (sale, Sotheby's, London, June 20, 1978, lot 26); Robert Smith, Washington; art market, New York.

EXHIBITIONS: None.

BIBLIOGRAPHY: F. Lee, *The Art of the Great Masters as Exemplified by Drawings in the Collection of Emile Wauters* (London, 1913), pp. 49–50; T. Borenius, "A Group of Drawings by Paul Veronese," *Burlington Magazine* 37–38, no. 225 (February 1921), p. 54; D. von Hadeln, *Venezianische Zeichnungen der Spätrenaissance* (Berlin, 1926), p. 32; P. H. Osmond, *Paolo Veronese: His Career and Work* (London, 1927), pp. 54–55, 100; G. Fiocco, *Paolo Veronese* (Bologna, 1928), p. 210; H. Tietze and E. Tietze-Conrat, *The Drawings of the Venetian Painters* (New York, 1944), pp. 337–339, no. 2029; R. Cocke, "Observations on some drawings by Paolo Veronese," *Master Drawings* 11, no. 2 (Summer 1973), pp. 138–139; T. Pignatti, *Veronese* (Venice, 1976), p. 131, under no. 161; R. Cocke, *Veronese's Drawings—A Catalogue Raisonné* (London, 1984), pp. 23, 132–133, no. 52.

THE RECTO OF THIS SHEET HAS ALWAYS BEEN RECOGnized as a study for Veronese's altarpiece in San Giorgio in Braida, Verona, of circa 1566. Although the drawing is very free and changes were made from it to the painting, it established the basic compositional format as well as the disposition and character of the individual figures. The saint is shown refusing to sacrifice while looking to the heavens, where Faith, Hope, and Charity intercede on his behalf with the Virgin and Child, who are accompanied by saints Peter and Paul and attended by music-making angels. Cocke (1984, p. 132) has suggested that Veronese made an alternate study for the saint toward the right of the present main group, but this figure is surely the soldier with the sword in the painting instead. The masterfully free and luminous integration of pen and wash is characteristic of Veronese's mature studies in this technique. A further drawing of various figures for the same painting, also in this technique, is in the Museum Boymans-van Beuningen, Rotterdam (inv. 139; Cocke 1984, no. 53).

The verso of this sheet was revealed when it was lifted from its former mount in 1983. Although somewhat damaged, the verso contains a few interesting details. At the lower right are two studies for architectural decoration, above which are columns of figures. To the left are a small, freely sketched bit of landscape with a house, two heads of bearded men, and a rather stark outline drawing of a woman in profile. The male head in profile may be a study for the Saint Peter in the upper right corner of the altarpiece in Verona. Lastly, below the heads is a round object upon which various implements, including a compass and a knife, have been placed.

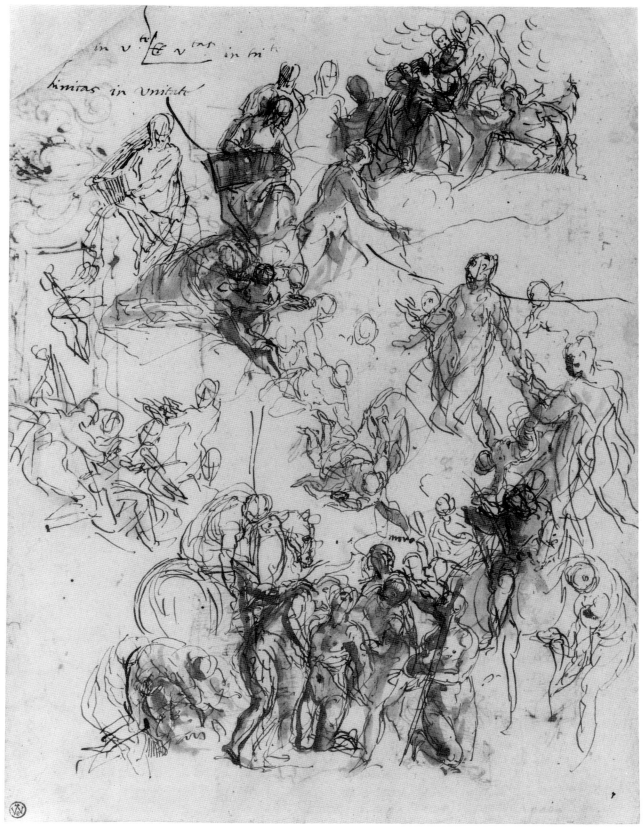

recto

54 Studies of Armor

Black chalk, brown wash, and white gouache heightening; H: 21.1 cm (8 5/16 in.); W: 20.5 cm (8 1/16 in.)
84.GB.33

MARKS AND INSCRIPTIONS: (Recto) at bottom left corner, inscribed *Paulo* in brown ink by a later hand; on mount, at top left, inscribed *SPN°|HS* in brown ink; (verso) inscribed *Paulo Veronese* in brown ink; on mount, inscribed *SPN|53* in brown ink.

PROVENANCE: Sagredo collection(?), Venice; private collection, France (sale, Hôtel Drouot, Paris, February 15, 1984, lot 140).

EXHIBITIONS: None.

BIBLIOGRAPHY: None.

THIS UNPUBLISHED SHEET COMES FROM THE SAME collection as ten Veronese drawings recently acquired by the Louvre.[1] Until Bacou's publication, only one armor study by Veronese had found general acceptance, the masterful wash drawing in the Kupferstichkabinett, Berlin (inv. KDZ 5120).[2] Like the drawing in Berlin, the Museum's study does not match any of the men in armor painted by Veronese either as portraits or as figures within larger compositions. However, it should be noted that the brilliant white highlights on the front of the armor in the Museum's sheet are closely analogous to corresponding passages in the Contarini portrait in the Johnson Collection, Philadelphia Museum of Art, and the Barbarigo portrait in the Cleveland Museum of Art.[3] In addition, as on the Berlin sheet, the armor was not conceived as a still-life form, but as if it contained an occupant gesturing with his right hand. The Museum's drawing differs from the Berlin and Louvre sheets (inv. RF 38934)[4] in that while the latter were undoubtedly drawn from specific suits of armor, the former was based on memory. This is why various details, such as the multiple scroll pattern on the left arm and shoulder, appear on only one side of the armor.[5]

The manner of rendering the shoulders and arms is comparable to that found in a study of a woman in the Louvre,[6] both in the rather broad, suggestive modeling and in the sharper, darker chalk lines used for emphasis.

Similarly, the more softly indicated center and lower sections of the armor occur again in the Louvre armor study.[7] Further support for the attribution to Veronese is given by the early attribution to him inscribed on the drawing by an early and usually reliable collector, probably a member of the Sagredo family. On the other hand, some degree of uncertainty is appropriate on account of the dearth of comparative material.

1. R. Bacou, "Ten Unpublished Drawings by Veronese Recently Acquired by the Cabinet des Dessins du Louvre," *Master Drawings* 21, no. 3 (1983), pp. 255–262.
2. Ibid.; R. Cocke, *Veronese's Drawings—A Catalogue Raisonné* (London, 1984), no. 51.
3. T. Pignatti, *Veronese* (Venice, 1976), nos. 108, 172.
4. Bacou (note 1), no. 5.
5. The armor is considered north Italian of circa 1560 by A. V. B. Norman (letter to R. Cocke, May 22, 1984), who has noted that the wash detail at the right is poorly understood. He also has objected to the inconsistencies between the left and right sides of the figure, which are explained here and have no relevance in terms of attribution.
6. Bacou (note 1), no. 6.
7. Ibid., no. 5.

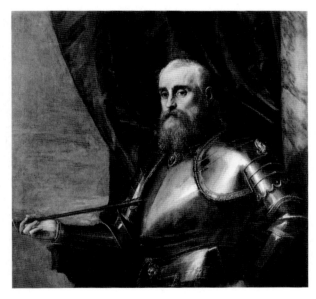

PAOLO VERONESE (Paolo Caliari) (Italian, 1528–1588). *Portrait of Agostino Barbarigo.* Oil on canvas. H: 113 cm (44½ in.); W: 116 cm (45¾ in.). Cleveland Museum of Art, Holden Collection 28.16. Photo courtesy Cleveland Museum of Art.

Paulo

recto

FEDERICO ZUCCARO

55 *The Submission of the Emperor Frederick Barbarossa to Pope Alexander III*

Pen and brown ink, brown wash, and black chalk on two attached sheets of paper; H: 55.4 cm (21¾ in.); W: 53.9 cm (21¼ in.)
83.GG.196

MARKS AND INSCRIPTIONS: At bottom, collection mark of Sir Peter Lely (L. 2092).

PROVENANCE: Sir Peter Lely, London; Sir William Forbes, Pitsligo; by descent (sale, Christie's, London, April 12, 1983, lot 10).

EXHIBITIONS: None.

BIBLIOGRAPHY: R. Ward, Review of *Master Drawings from the Woodner Collection, Burlington Magazine* 126, no. 973 (April 1984), p. 251.

IN 1582 FEDERICO ZUCCARO BEGAN WORK ON THE painting of this subject for the Sala del Gran Consiglio of the Palazzo Ducale, Venice, which was to replace Tintoretto's version destroyed in the fire of 1577. As was first noted by J. Gere,[1] the earliest surviving study for the painting, in the Pierpont Morgan Library, New York (inv. 1973.29),[2] shows the scene from the vantage point of the Piazzetta looking toward the Torre del'Orologio, though it does contain certain elements of the final composition. A second drawing, in a private collection, London,[3] established the composition in its final format, with a view to the Piazzetta, San Marco at the left, and many details, such as the baldachin, employed in the painting. This design was then elaborated in a large drawing in the Woodner collection, New York.[4] The Museum's drawing is comparable to the Woodner sheet in almost every respect excepting the notable *pentimento* in the situation of the Palazzo Ducale in the latter composition. It is impossible to compare them in terms of handling since that drawing is very damaged. A copy of it with its *pentimento* is at Christ Church, Oxford (inv. 1380).[5] The painting was only completed in 1603, with a number of details different from the various preparatory drawings. The present writer recently saw a further compositional drawing for this painting in a French private collection that would fit into the sequence of studies just before the Woodner sheet.

1. "The Lawrence-Phillips-Rosenbach 'Zuccaro Album,'" *Master Drawings* 8, no. 2 (1970), p. 132, no. 21.
2. C. Denison et al., *European Drawings: 1375–1825* (New York, 1981), no. 27.
3. Gere (note 1), fig. 1.
4. G. Goldner, *Master Drawings from the Woodner Collection*, exh. cat., J. Paul Getty Museum, Malibu, 1983, no. 25.
5. J. Byam Shaw, *Drawings by Old Masters at Christ Church Oxford* (Oxford, 1976), no. 553, pl. 301.

56 *View of Saint Peter's*^r
Study of a Young Man^v

Red chalk (recto); red and black chalk (verso); H: 27.4 cm
(10 ¹³⁄₁₆ in.); W: 41.3 cm (16¼ in.)
85.GB.228

MARKS AND INSCRIPTIONS: (Recto) on a strip of paper
attached to bottom of sheet, inscribed *D Vue de St pierre
de rome . . . Tire du Cabinet de Monsieur le Marquis de Gou-
vernet, 2*, several undecipherable letters in brown ink.

PROVENANCE: Marquis de Gouvernet, Paris; private
collection, Paris; art market, Zurich.

EXHIBITIONS: None.

BIBLIOGRAPHY: None.

verso

THIS IS ONE OF A RELATIVELY SMALL GROUP OF CITY
views by Federico. It shows the square in front of Saint
Peter's, Rome, as it appeared around 1590–1600. At the
extreme left there is a partial view of the Egyptian obelisk
that had been moved to the square by order of Pope Six-
tus in 1586. At the left of the row of buildings is the arch-
episcopal palace and to its right the old facade of Saint
Peter's. Further to the right is the three-story benediction
loggia, begun by Pope Pius II in 1462, and then the Palaz-
zo Vaticano. At the extreme right Federico has lightly
sketched in the edge of the loggia painted by Raphael. In
front of the entrance to the Vatican is the bastion for the
papal guard, and at the foot of the staircase are the
fifteenth-century statues of saints Peter and Paul. The
drawing can be dated to the period following Federico's
return from Spain in 1588, after the placement of the obe-
lisk in the square and following completion of the dome.
Stylistically, it is closest to his drawing of 1576 of the Pi-
azza della Signoria, Florence, in the Louvre, Paris (inv.
4624).[1] This is especially true of the freedom with which
architectural detail has been rendered.

The style of the verso bears out this late dating. It
shows a young boy drawn with great intimacy. The use
of black and red chalk together and the verso's delicacy
of touch are comparable to other late portrait studies by
Federico, such as the drawings of two children, in the
Louvre, Paris (inv. 4594), and of a family, in the Musée
de Lille (inv. 2568).

1. J. Gere, *Dessins de Taddeo et Federico Zuccaro*, exh. cat., Musée
du Louvre, Paris, 1969, pp. 61, 62, no. 76.

recto

JACOPO ZUCCHI

57 *The Age of Gold*

Pen and brown ink, brown and ocher wash, and white gouache heightening; H: 48 cm (18⅞ in.); W: 37.8 cm (14⅞ in.)
84.GG.22 (SEE PLATE 4)

MARKS AND INSCRIPTIONS: (Recto) at top, on bande-role, inscribed *O Belli Anni Del Oro* in brown ink by the artist; at bottom center, collection mark of Sir Thomas Lawrence (L. 2445); at bottom, illegible inscription in brown ink; (verso) inscribed *John Rottenhammer* in graphite.

PROVENANCE: Sir Thomas Lawrence, London; Adolphe-Narcisse Thibaudeau, Paris (sale, Ch. Le Blanc, Paris, April 20, 1857, lot 303); P. H. (Philipp Huart[?]), Paris; sale, Hôtel Drouot, Paris, October 10, 1983, lot 31; art market, Geneva.

EXHIBITIONS: None.

BIBLIOGRAPHY: None.

THIS DRAWING IS A HIGHLY FINISHED *MODELLO* FOR Zucchi's *Age of Gold*.[1] An iconographical program for a painting of the Golden Age had been sent by Vincenzo Borghini to Vasari in 1567 and became the inspiration for the latter's drawing in the Louvre, Paris (inv. 2170), and a painting by his assistant Francesco Morandini, Il Poppi, in the National Gallery of Scotland, Edinburgh. The iconography of Zucchi's painting reflects Borghini's ideas and Vasari's drawing, but contains many new elements not derived from them.[2] The painting also appears to have a political meaning, as T. Puttfarken has demonstrated.[3]

This drawing was preceded by a free compositional sketch in the Art Museum, Princeton University (inv. 47-151).[4] In certain respects it was inspired by Vasari's drawing,[5] especially in the dancing group in the background and in the inclusion of Apollo and other gods.[6] The Museum's *modello* incorporates many changes from the Princeton drawing, opening the center front of the composition, reducing the number of foreground figures, and clarifying the disposition of groups in the middle ground and background. Also added are a number of picturesque details of nature and a grotto much in tune with contemporary sculptural taste. The complex scene is richly orchestrated with the liberal application of colored wash and white heightening throughout. The combination of classicism and naturalism gives the drawing an almost Northern flavor, and, perhaps not accidentally, the standing nude at the extreme right margin finds close parallels in Northern drawings of the period.[7] The final painted version shows further changes, but follows the *modello* in essential matters.

1. E. Pillsbury, "Drawings by Jacopo Zucchi," *Master Drawings* 12, no. 1 (Spring 1974), fig. 5.
2. T. Puttfarken, "Golden Age and Justice in Sixteenth-Century Florentine Political Thought and Imagery: Observations on Three Pictures by Jacopo Zucchi," *Journal of the Warburg and Courtauld Institutes* 43 (1980), pp. 130–146.
3. Ibid.
4. Pillsbury (note 1), pl. 8.
5. P. Barocchi, *Vasari pittore* (Milan, 1964), fig. 92.
6. Pillsbury (note 1), n. 43.
7. For example, see the drawing by Spranger of Venus and Cupid in the Metropolitan Museum of Art, New York (inv. 1975.1.844; T. DaCosta Kaufmann, *Drawings from the Holy Roman Empire 1540–1680*, exh. cat., Art Museum, Princeton University, 1982, no. 50).

recto

FRANÇOIS BOUCHER

58 Landscape with Figures

Red chalk on vellum; H: 30.5 cm (12 in.); W: 49.3 cm
(19⅜ in.)
83.GB.200

MARKS AND INSCRIPTIONS: At bottom right corner,
collection mark of Earl Spencer (L. 1530).

PROVENANCE: Earl Spencer, Althorp; art market, New
York.

EXHIBITIONS: None.

BIBLIOGRAPHY: B. Schreiber Jacoby, *François Boucher's
Early Development as a Draughtsman* (New York, 1986),
p. 299, no. III.E.6.

IT HAS BEEN SUGGESTED BY JACOBY (1986) THAT THIS
drawing, which appears to be the only landscape draw-
ing by Boucher on vellum, may have been made as a
preparatory study for his tapestry *Les filles aux raisins et
les chasseurs*, part of the *Fêtes italiennes*, his first series pro-
duced at Beauvais. She has noted that the cottage with
the chimney at the distant left, the curved masonry ram-
part at the right, and the double arched bridge at the cen-
ter left all reappear in the tapestry in reverse. The exis-
tence of a counterproof taken from the drawing
(formerly Jean Bloch collection) also argues for this the-
sis, since the artist logically would have wished to see the
forms facing in the same direction as they eventually
would in the tapestry. Jacoby also has pointed out that
several motifs in the drawing occur in other works by
Boucher of circa 1730, such as the winding road with rich
foliage, which recurs in his painting *The Washerwomen*
(Clermont-Ferrand, Musée Bargoin, inv. 67.1.18).[1]
Equally, the two small figures in the lower right corner
occur with variations in a number of other composi-
tions. The date of the drawing would clearly seem to fall
around 1730–1735, which "accords with the genre of the
rustic-capriccio which Boucher introduced around 1730
wherein Northern and Italianate landscape and staffage
elements are fused in a delightful, new way" (Jacoby
1986, p. 299).

1. A. Ananoff, *François Boucher* (Paris, 1976), vol. 1, no. 56, fig.
280.

59 *Study of a Reclining Nude*

Red and white chalk on oatmeal paper, strips of paper added at top and bottom edges; H: 30.9 cm (12³⁄₁₆ in.); W: 24.6 cm (9¹¹⁄₁₆ in.)
84.GB.21

MARKS AND INSCRIPTIONS: At bottom right corner, signed *F. Boucher* in brown ink.

PROVENANCE: Margaret Singer, New York (sale, Doyle Galleries, New York, January 25, 1984, lot 82).

EXHIBITIONS: None.

BIBLIOGRAPHY: B. Schreiber Jacoby, *François Boucher's Early Development as a Draughtsman* (New York, 1986), p. 269, no. III.A.9.

THIS DRAWING IS A STUDY FOR THE FIGURE OF THE nymph at the left in Boucher's painting *Birth of Venus* (location unknown),[1] which appears to date from circa 1732–1735. A full compositional drawing is in the Crocker Art Museum, Sacramento (inv. 401). Other studies include the twisting female nude at the right and the figure of Venus herself (London, British Museum, inv. 5223; formerly Basel, von Hirsch collection [Sotheby's, London, June 20, 1978, lot 62], respectively). The Getty Museum's drawing is closely followed in the painting and in its use of red and white chalk recalls the precedent of Watteau.

1. A. Ananoff, *François Boucher* (Paris, 1976), vol. 1, no. 180, fig. 578.

60 Reclining Male Figure

Black, red, and white chalk on blue paper; H: 27.9 cm
(11 in.); W: 44.1 cm (17 3/8 in.)
83.GB.359

MARKS AND INSCRIPTIONS: On mount, at bottom left
corner, inscribed *Veateaut* in brown ink; *Bernard Vaillant*
in dark brown ink.

PROVENANCE: Art market, Geneva.

EXHIBITIONS: None.

BIBLIOGRAPHY: B. Schreiber Jacoby, *François Boucher's
Early Development as a Draughtsman* (New York, 1986),
p. 284, no. III.B.26.

THIS IS ONE OF VERY FEW SURVIVING DRAWINGS MADE
by Boucher for his first suite of tapestries, the *Fêtes ita-
liennes*. This young man reappears, in reverse, in the
lower right corner of the tapestry entitled *L'Opérateur* or
La Curiosité, which was woven in 1736 at Beauvais.[1] Ac-
cording to Jacoby (1986), this sheet is one of three such
studies known today. The *Two Young Girls Begging*
(Stockholm, National Museum, inv. 2941/1863)[2] was
executed with the same technique on blue paper. She also
has noted the continuing influence of Watteau on
Boucher, evidenced not only in the figure's pose but also
in his poetic characterization.

1. A. Ananoff, *François Boucher* (Paris, 1976), vol. 1, no. 128,
fig. 459.
2. Ibid., vol. 1, no. 128/2, fig. 458.

61 Venus and Cupid

Black, white, red, blue, and green chalk; H: 37.4 cm (14¾ in.); W: 21.2 cm (8⅜ in.)
84.GB.20

MARKS AND INSCRIPTIONS: (Verso) inscribed *Dessin donné a M. Denis par M. Boucher, peintre de l'academie Royal en avrille 1752* by Boucher on a separate piece of paper applied to the mount; printed *21* on a separate sheet of paper applied to the mount.

PROVENANCE: M. Denis; M. de Sireul, Paris (sale, Boileau, Paris, December 3, 1781, lot 51); Victorien Sardou, Paris (sale, Galerie Georges Petit, Paris, April 27, 1909, lot 55); Margaret Singer, New York (sale, Doyle Galleries, New York, January 25, 1984, lot 81).

EXHIBITIONS: None.

BIBLIOGRAPHY: A. Ananoff, *L'oeuvre dessiné de François Boucher* (Paris, 1966), p. 205, no. 785.

THIS SEEMS TO BE AN INDEPENDENT DRAWING MADE for its own sake. To judge from the inscription on the back of the mount, it was given to a M. Denis in 1752. There are a number of similar sheets by Boucher and his followers, including one that corresponds in reverse in almost all details (Kansas City, William Rockhill Nelson Gallery of Art, inv. 66-16). Aside from the reversal of the composition, the two differ only in minor sections of the drapery and foliage and in the richer application of white in the Museum's drawing, which would appear to date from around 1750–1752, in accord with its inscription.

recto

62 Architectural Project for the Church of the Madeleine

Pen and gray ink and black, pink, and gray wash; H: 54.3
cm (21⅜ in.); W: 71.4 cm (28⅛ in.)
84.GA.53

MARKS AND INSCRIPTIONS: None.

PROVENANCE: Private collection, United States; art
market, New York.

EXHIBITIONS: None.

BIBLIOGRAPHY: H. Rosenau, *Boullée and Visionary Architecture* (London, 1976), p. 15.

THIS SECTION DRAWING WAS MADE IN CONNECTION
with Boullée's unexecuted plans for the church of the
Madeleine, Paris. It was made after the death of the architect Contant d'Ivry in 1777 and before 1785 (Rosenau
1976, p. 15). Compared with another section drawing for
the same project in the Bibliothèque Nationale, Paris
(inv. HA.57, no. 3), this rendering contains a more centralized placement of the crossing, not an unexpected development for an architect with a keen interest in buildings "under the filiation of St Peter's" (Rosenau 1976, p.
16). The Museum's drawing is also a notable example of
Boullée's incorporation of painterly details of color and
light; these and the tiny figures around the altar remind
one of his early aspiration to be a painter.

63 *An Army Leaving a Castle*

Brush and brown wash and black chalk; H: 10.1 cm (4 in.); W: 21.8 cm (8⁹⁄₁₆ in.)
85.GG.294

MARKS AND INSCRIPTIONS: None.

PROVENANCE: Sale, Sotheby's, London, July 2, 1984, lot 94; art market, London.

EXHIBITIONS: None.

BIBLIOGRAPHY: None.

THE SUBJECT OF THIS SCENE HAS NOT BEEN IDENTI-fied. It shows a procession of figures, many carrying arms, leaving a castle or walled city. The setting appears to be Eastern, given the inclusion of a number of camels. In addition, the figures and animals are bearing various bundles and chests as well as flags and arms. It is conceivable that Callot simply meant to represent an army setting off for battle, but he may have intended a more specific theme. The characterization of the marching figures and animals is reminiscent of those shown in his print *Crossing of the Red Sea* (1630),[1] in which the presence of camels denotes the locale. Lastly, the rich use of wash and dramatic compositional rhythms recur in a number of the artist's drawings of this period, including several for The Miseries of War.[2]

1. J. Lieure, *Jacques Callot: Catalogue de son oeuvre gravé* (Paris, 1927), vol. 3, no. 665.
2. D. Ternois, *Jacques Callot: Catalogue complèt de son oeuvre dessiné* (Paris, 1962), nos. 915–920.

64 *A View of Mountains across a Lake*

Brush and brown wash and black chalk; H: 9.9 cm (3¹⁵⁄₁₆ in.); W: 22.1 cm (8¹¹⁄₁₆ in.)
85.GG.295

MARKS AND INSCRIPTIONS: None.

PROVENANCE: Sale, Sotheby's, London, July 2, 1984, lot 95; art market, London.

EXHIBITIONS: None.

BIBLIOGRAPHY: None.

COMPLEX AND HIGHLY EXPRESSIVE ROCK FORMATIONS such as these recur often in Callot's prints and drawings.[1] Here Callot has made such formations the subject of the drawing, rendered with sensitively observed effects of light and shade achieved through a carefully modulated use of wash. The sheet is closest in spirit and handling to several of his late landscapes, such as another with a rocky seashore and view of mountains in the British Museum, London (inv. Add. 34).[2]

1. See, for example, J. Lieure, *Jacques Callot: Catalogue de son oeuvre gravé* (Paris, 1927), vol. 1, nos. 276–277.
2. D. Ternois, *Jacques Callot: Catalogue complèt de son oeuvre dessiné* (Paris, 1962), no. 1322.

no. 63

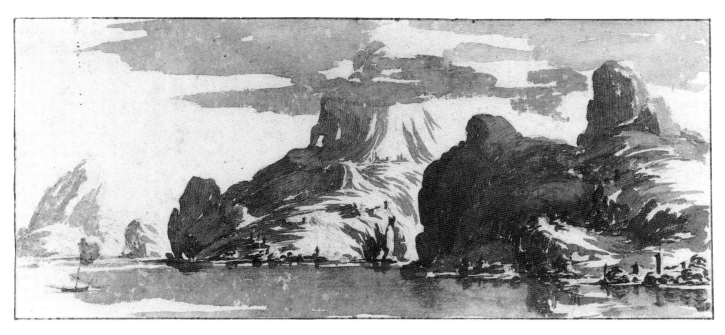

no. 64

65 Still Life

Watercolor and graphite; H: 48 cm (18¹⁵⁄₁₆ in.); W: 63.1 cm (24⅞ in.)
83.GC.221 (SEE PLATE 9)

MARKS AND INSCRIPTIONS: None.

PROVENANCE: Galerie Matthiesen, Berlin; Werner Feuz, Zurich; Gottfried Tanner, Zurich; Jacques Seligmann, Paris and New York; Lord Sieff of Brimpton; sale, Sotheby's, London, April 26, 1967, lot 18; Norton Simon, Los Angeles (sale, Parke-Bernet, New York, May 2, 1973, lot 9); Goury, Geneva(?); sale, Sotheby's, London, July 1, 1980, lot 5; Alain Delon, Geneva.

EXHIBITIONS: *Das Stilleben in der deutschen und französischen Malerei*, Galerie Matthiesen, Berlin, 1927. *Watercolors by Cézanne*, Jacques Seligmann Gallery, New York, 1933, no. 1. Haus der Kunst, Munich, 1956, no. 93. *Paul Cézanne 1839–1906*, Kunsthaus, Zurich, August–October 1956, no. 210. *A Great Period of French Painting*, Marlborough Galleries, London, June–July 1963, no. 6.

BIBLIOGRAPHY: G. Bierman, "Review of *Das Stilleben in der deutschen und französischen Malerei*," *Der Cicerone* 19 (1927), p. 151; L. Venturi, *Cézanne: Son art—son oeuvre* (Paris, 1936), pp. 51, 285, no. 1147; R. W. Murphy, *The World of Cézanne* (Leningrad, 1975), p. 181; J. Rewald, *Paul Cézanne: The Watercolors—A Catalogue Raisonné* (Boston, 1983), p. 233, no. 572.

THIS IS ONE OF A SMALL GROUP OF LARGE WATERcolors with still-life subjects from the latter part of Cézanne's career. In technique it is perhaps the most finished of these and possesses the monumentality of his paintings. Among the still-life watercolors it is closest to one in the Ford collection, Grosse Pointe Shores (Rewald 1983, no. 571). Basing his opinion on a supposed lack of a pencil underdrawing, Rewald has argued that the Museum's watercolor followed the latter and represents an attempt to improve upon its arrangement of forms (1983, nos. 571–572). In fact there is a considerable amount of free pencil drawing below the watercolor; indeed it is visible in every section except the background wall and wainscot. This does not entirely invalidate Rewald's theory, however, and it may well be that the Museum's watercolor represents a later stage in the evolution of Cézanne's thinking, especially as it appears more fully evolved and concentrated than the Ford sheet. The watercolor is noteworthy not only for its scale, degree of finish, and overall quality but also for its exceptional state of preservation. It was dated to 1895–1900 by Venturi (1936, no. 1147), who then revised the date to 1900–1905, and by Rewald to 1900–1906 (1983, p. 233).

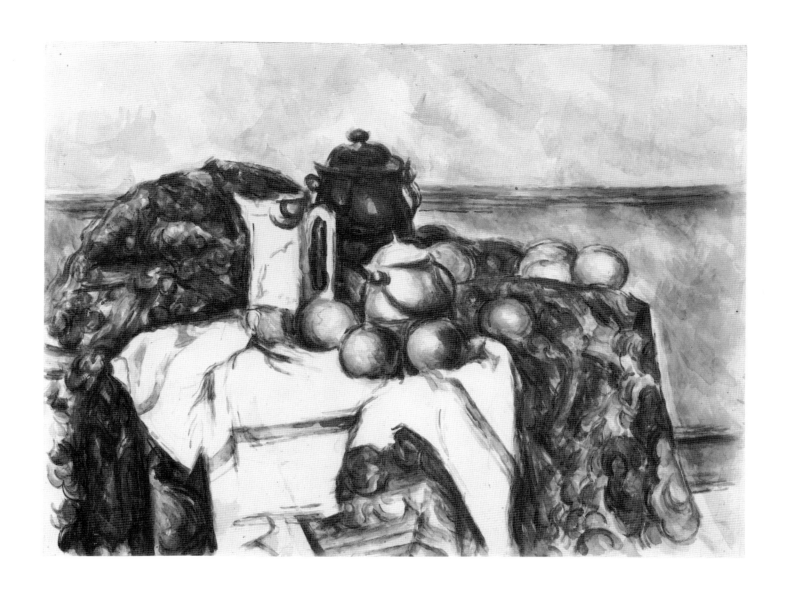

66 *Study for a Seated Man*[r]
Study of a Male Nude[v]

Charcoal and white chalk; H: 25.6 cm (10 1/16 in.); W: 16.7 cm (6 9/16 in.)

85.GB.224

MARKS AND INSCRIPTIONS: None.

PROVENANCE: Private collection, Paris; art market, Paris.

EXHIBITIONS: None.

BIBLIOGRAPHY: None.

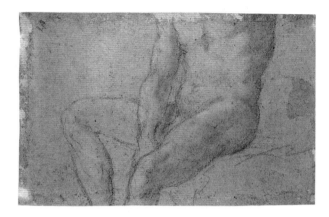

verso

THE ATTRIBUTION OF THIS RARE EXAMPLE OF THE draughtsmanship of Chardin is due to P. Rosenberg.[1] The figure on the recto is a study for the man seated at the extreme right in the artist's early painting *The Game of Billiards* (Paris, Musée Carnavalet).[2] In its use of charcoal and white chalk and its graphic style, the recto is closest to the drawing *La Vinaigrette* (Stockholm, Nationalmuseum, inv. 2960/1863).[3] In both, forms have been built up in a series of rapid and somewhat heavy black lines, heightened with additional thick white chalk strokes. The Museum's drawing is impressive in its directness of observation and characterization.

The verso consists of a fragmentary study of a male nude, a typical *académie* of the period. A very similar study, also greatly reduced, is on the verso of *La Vinaigrette*.[4] As Rosenberg has argued, the Stockholm nude study is compatible technically with its verso and reflects the artist's training under Pierre-Jacques Cazes.[5] The same may be said about the verso of the Museum's sheet, which is surely also by Chardin. It is interesting that both of these academic nude studies are fragments on the versos of presumably later drawings. The artist very likely kept a group of such studies from his younger days and reused the paper when the occasion demanded, cutting it down to the appropriate size. *The Game of Billiards* is dated to 1720–1725, to which period the recto of the Museum's drawing also belongs, whereas the verso is probably somewhat earlier. Another drawing for this painting is in the Nationalmuseum, Stockholm (inv. 2962/1863).[6]

1. His opinion was given to the former owner and will be published shortly. Rosenberg's views on Chardin's drawings are carefully elaborated in "The Issue of Chardin as a Draftsman," in *Chardin: New Thoughts*, The Franklin D. Murphy Lectures I, Helen Foresman Spencer Museum of Art (Lawrence, 1983), pp. 69–74.
2. P. Rosenberg, *Chardin, 1699–1779*, exh. cat., Grand Palais, Paris, 1979, no. 3.
3. Ibid., no. 1.
4. Ibid., no. 1 verso.
5. Ibid., p. 103, no. 1.
6. Ibid., no. 2.

JEAN-SIMÉON CHARDIN (French, 1699–1779). *The Game of Billiards* (detail). Oil on canvas. H: 55 cm (21 5/8 in.); W: 82.5 cm (32 1/2 in.). Paris, Musée Carnavalet. Photo courtesy Cliché Musées de la Ville de Paris—SPADEM, 1987.

recto

67 *Paris and Helen*

Pen and black ink and gray wash; H: 18.3 cm (7³⁄₁₆ in.);
W: 22.9 cm (9 in.)
83.GA.192

MARKS AND INSCRIPTIONS: At bottom right corner,
signed and dated *David 1786* in black ink.

PROVENANCE: Sale, Moitte, Paris, June 7, 1818, lot 20;
sale, Dumont, Paris, February 13, 1854, lot 118; sale,
Couton, Paris, April 18, 1860, lot 182; sale, Flury-
Herard, Paris, May 13, 1861, lot 465; sale, H. Dreux,
Paris, February 4, 1870, lot 28; sale, Hôtel Drouot, Paris,
March 22, 1983, lot 2.

EXHIBITIONS: *David*, Musée de l'Orangerie, Paris,
1948, p. 54, no. 26 e/f (catalogue by M. Florisoone).
David 1748–1828, Arts Council of Great Britain, Lon-
don, 1948, p. 16, no. 7 e/f.

BIBLIOGRAPHY: J. L. Jules David, *Le peintre Louis David*
(Paris, 1880), p. 656.

THIS IS ONE OF NUMEROUS STUDIES DAVID MADE IN
connection with his painting *Paris and Helen* (1788; Paris,
Louvre, inv. 3698).[1] The painting was commissioned by
the comte d'Artois, the future King Charles X. This
drawing, dated 1786, shows that David had already de-
veloped the composition at this early date even though
the final painting was not completed for two more years.
The two principal figures underwent only minor
changes in the painting, but Cupid was eliminated as was
the tall lamp at the right. Furthermore, the background
architecture was animated considerably with additional
details. The expressive character of the scene, however,
was not altered appreciably.

1. A number of further drawings are listed in Arts Council
(1948) under no. 7. A further compositional drawing in pen and
ink and wash is in the collection of Dr. Peter Nathan, Zurich.

68 The Lictors Carrying the Bodies of the Sons of Brutus

Pen and black ink and gray wash; H: 32.7 cm (12⅞ in.);
W: 42.1 cm (16 ⁹⁄₁₆ in.)
84.GA.8

MARKS AND INSCRIPTIONS: At bottom left on base of
Brutus' chair, signed and dated *L. David faciebat 1787* in
gray ink.

PROVENANCE: Sale, Paris, March 29, 1842, lot 67; Paul
Mathey, Paris; art market, Lausanne.

EXHIBITIONS: *David et ses élèves*, Palais des Beaux-Arts,
Paris, April–June 1913, no. 261 (catalogue by A.
Lapauze).

BIBLIOGRAPHY: None.

THIS SHEET IS THE MOST IMPORTANT AND COMPLETE
surviving drawing for David's painting of 1789 in the
Louvre, Paris, which was commissioned by King Louis
XVI. Dated 1787 by the artist at the base of Brutus' chair,
it provides an unexpectedly early *terminus ante quem* for
the choice of this subject to satisfy the royal commission.
Despite its relatively early position in the evolution of the
project, the drawing already contains most of the basic
ingredients found in the final version. The principal dif-
ferences are the continuation of the background colon-
nade in place of the wall coming forward toward Brutus,
the addition of the still-life motif of the basket on the ta-
ble, and the reduction and alteration of pose in the right-
hand figure group. A compositional sketch in the Musée
Toulouse-Lautrec et Galerie d'Art Moderne, Albi,[1] is
closer to the painting in the characterization of the female
figures at the right and may well represent the next stage
in the development of the composition.

1. A. Schnapper, *David* (New York, 1980), pl. 47.

69 *Oh! If Only He Were as Faithful to Me*

Black chalk and brush and brown wash; H: 24.8 cm (9¾ in.); W: 38.3 cm (15⅛ in.)
82.GB.165

MARKS AND INSCRIPTIONS: (Verso) on mount, inscribed *IIᵃ|2* in brown ink.

PROVENANCE: Comte Jacques de Bryas, Paris (sale, Galerie Georges Petit, Paris, April 4–6, 1898, lot 58); Pierre Decourcelle, Paris (sale, Galerie Georges Petit, Paris, May 29–30, 1911, lot 87); Baron Edmond James de Rothschild, Paris; Mme Goldschmidt de Rothschild, Paris; sale, Kunsthalle Basel, January 24, 1970, lot 28; private collection, France; art market, New York.

EXHIBITIONS: *Exposition Chardin et Fragonard*, Galerie Georges Petit, Paris, June–July 1907, no. 169. *Drawings by Fragonard in North American Collections*, National Gallery of Art, Washington, D.C., 1978, no. 27 (catalogue by E. Williams). *Fragonard*, National Museum of Western Art, Tokyo, and Kyoto Municipal Museum, March–May and May–June 1980, no. 122 (catalogue by D. Sutton).

BIBLIOGRAPHY: A. Dayot, "Fragonard," *L'art et les artistes* 5 (April–September 1907), p. 154; idem and L. Vaillat, *L'oeuvre de J.-B.-S. Chardin et de J.-H. Fragonard* (Paris, 1907), p. 19, no. 158; J. L. Vaudoyer, "La collection de M. Pierre Decourcelle," *Les arts* 10, no. 111 (March 1911), p. 14; L. Guimbaud, *St. Non et Fragonard d'après des documents inédits* (Paris, 1928), p. 201, no. 72; J. Cailleux, "A Note on the Pedigree of Some Paintings and Drawings," *Burlington Magazine*, suppl., 104, no. 12 (September 1962), p. iii; A. Ananoff, *L'oeuvre dessiné de Jean-Honoré Fragonard* (Paris, 1963), vols. 2, pp. 41–42, no. 636; 3, no. 636.

THE SUBJECT OF THIS SCENE SITS SADLY ON HER BED, bemoaning the unfaithfulness of her lover, while her dog resolutely offers the loyalty the latter evidently lacks. The composition is close in spirit to boudoir representations by Fragonard (Williams 1978, no. 28), but contains the added element of what is perhaps a degree of mock moralization. The media and technique of the drawing are fully in accord with its imagery. Richly underdrawn with rapid black chalk strokes, it is exemplary of Fragonard's command of varied tones of wash and his ability to suggest texture.

The drawing was published as a print by the Abbé de Saint-Non in 1776, which provides a *terminus ante quem* for it. A copy of the drawing is in the Fondation Ephrussi de Rothschild, Musée Ile de France, Saint-Jean-Cap-Ferrat (Williams 1978, fig. 3). The complex provenances of the two versions have been fully untangled and their respective positions clarified by Williams (1978, no. 27).

recto

CLAUDE GILLOT

70 Scene from the Italian Comedy^r
Figure Study^v

Pen and black ink and reddish wash (recto); pen and black ink (verso); H: 16 cm (6⁵⁄₁₆ in.); W: 21.6 cm (8½ in.) 84.GA.66

MARKS AND INSCRIPTIONS: (Recto) at bottom right corner, inscribed *24* in faint brown ink.

PROVENANCE: Private collection, France (sale, Hôtel Drouot, Paris, March 9, 1984, lot 14); art market, London.

EXHIBITIONS: None.

BIBLIOGRAPHY: None.

THIS IS ONE OF GILLOT'S MANY REPRESENTATIONS OF theatrical subjects, the facet of his work for which he is best known. The drawing was engraved by Gabriel Huquier[1] for his *Théâtre italien,* in which the scene is identified as "*Arlequin grapignant,*" that is, Harlequin as Procurer. It may reflect the comedy by Fatouville of the same name, which was first performed on May 12, 1682, and was published two years later, even though the precise actions taking place in the drawing do not occur in the 1684 publication, which omits the impromptu parts of the presentation.[2] The drawing shows Harlequin seated at a table acting as a notary or arbiter of some sort. At the left a young woman stands holding the doctor's hand while she looks across at a young man with a rather displeased expression. Pantaloon and Mezzetin look on with Harlequin. Whatever the precise moment depicted, the drawing is characteristic of commedia dell'arte representations in its lively wit and hidden meanings.

Stylistically, the animated pen strokes and liberal application of reddish wash are effective vehicles for conveying the gestures and mood of the scene. A comparable sheet by Gillot is in the Louvre, Paris (inv. 4195).[3]

verso

2. Ibid., pp. 292–293.
3. J. Guiffrey and P. Marcel, *Inventaire général des dessins du Musée du Louvre et du Musée de Versailles: Ecole française* (Paris, 1911), vol. 6, no. 4195.

1. E. Dacier, "Scènes et figures théâtrales de Claude Gillot," *Revue de l'art ancien et moderne* 49, no. 276 (May 1926), ill. p. 291.

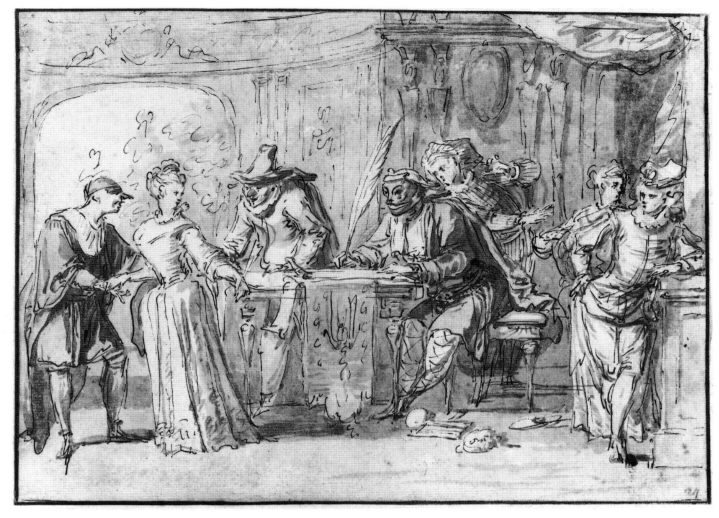

recto

ANNE-LOUIS GIRODET DE ROUCY TRIOSON

71 Phaedra Rejecting the Embraces of Theseus

Graphite, pen and brown ink, brown wash, and white gouache heightening; H: 33.5 cm (13¼ in.); W: 22.6 cm (8⅞ in.)
85.GG.209

MARKS AND INSCRIPTIONS: At bottom left, signed *GIRODET INV.* in graphite; below, inscribed *PHEDRE. / INDIGNE DE VOUS PLAIRE ET DE VOUS APPROCHER / JE NE DOIS DE-SORMAIS SONGER QU'A ME CACHER / THESEE. / QUEL EST L'ETRANGE ACCUEIL QU'ON FAIT A VOTRE PERE / MON FILS? / HIPPOLYTE. / PHEDRE PEUT SEULE EXPLI-QUER CE MYSTERE. / Phedre, Acte III, Scene IV et V* in brown ink.

PROVENANCE: Pierre Didot the Elder, Paris (sale, Paris, 1810, lot 679); private collection, United States; art market, New York.

EXHIBITIONS: Salon An XII, Paris, 1804, no. 212. *French Drawings: Neo-Classicism*, Heim Gallery, London, February–March 1975, no. 50. *French Drawings 1760–1880*, Colnaghi, New York, April–May 1985, no. 11.

BIBLIOGRAPHY: C.-P. Landon, *Annales du Musée et de l'Ecole Moderne des Beaux-Arts: Première collection, tome complémentaire* (Paris, 1809), p. 72.

THIS IS A HIGHLY FINISHED PREPARATORY STUDY FOR one of the illustrations in a deluxe edition of the work of Racine, published by Pierre Didot the Elder between 1801 and 1805 and dedicated to Napoleon Bonaparte, then first consul. Girodet was one of seven artists who collaborated on the project—a group that included Prud'hon and Gérard. He was responsible for the illustrations for *Andromaque* and *Phèdre*. This is one of ten drawings he made for the project, five for each drama.[1] It shows the moment when Theseus returns and is shocked by the cold reception he receives from his wife and Hippolytus; the latter then asks to depart (act 3, scenes 4, 5). The highly controlled compositional balance and clarity of both meaning and form are exemplary of Girodet's most refined Neoclassical manner.

1. The Didot edition of Racine is discussed by A. Sérullaz in the exhibition catalogue *Le Néo-Classicisme français: Dessins des musées de Province*, Grand Palais, Paris, 1974, pp. 63–65. For related drawings, see J. Lacambre and J. Vilain, "Dessins néo-classiques, bilan d'une exposition," *La revue du Louvre et des musées de France* 26, no. 2 (1976), p. 71. A similar drawing by Girodet for *Phèdre* was exhibited with the Museum's sheet in London (*French Drawings . . .* , 1975, no. 51).

GIRODET INV.

PHEDRE.

INDIGNE DE VOUS PLAIRE ET DE VOUS APPROCHER.
JE NE DOIS DESORMAIS SONGER QU'A ME CACHER.

THESEE.

QUEL EST L'ETRANGE ACCUEIL QU'ON FAIT A VOTRE PERE
MON FILS ?

HIPPOLYTE.

PHEDRE PEUT SEULE EXPLIQUER CE MYSTERE.

PHEDRE. ACTE III. SCENE IV ET V.

72 *Study of the Head of an Old Man*

Red chalk; H: 39.6 cm (15⅝ in.); W: 32 cm (12⅝ in.)
84.GB.72

MARKS AND INSCRIPTIONS: (Verso) Austrian customs stamp, *N.31*, in brown ink.

PROVENANCE: Von Amerling collection, Vienna (sale, Dorotheum, Vienna, May 3–6, 1916, lot 96); private collection, London; art market, London.

EXHIBITIONS: None.

BIBLIOGRAPHY: None.

THIS MOVING STUDY IS EXEMPLARY OF GREUZE'S analysis of facial expressions, for which he was much admired by his contemporaries. It does not correspond precisely to any painted image, but is closest to the old man seated at the right in his painting *L'Aveugle trompé* (Moscow, Pushkin Museum). The darkening of the closed eyes sustains this connection despite the many differences in detail between drawing and painted figure. The association of the two would indicate a date of circa 1755 for the study. The drawing also reflects the artist's profound involvement with the character of his subjects, a quality noted by his contemporary Diderot.[1]

1. *Salons*, ed. J. Seznec and J. Adhemar (Oxford, 1957), vol. 1, p. 135. A drawing showing the same figure in reverse and in an oval format is in the Musée du Berry, Bourges, and is known to the author only through a photograph (Bulloz 38411).

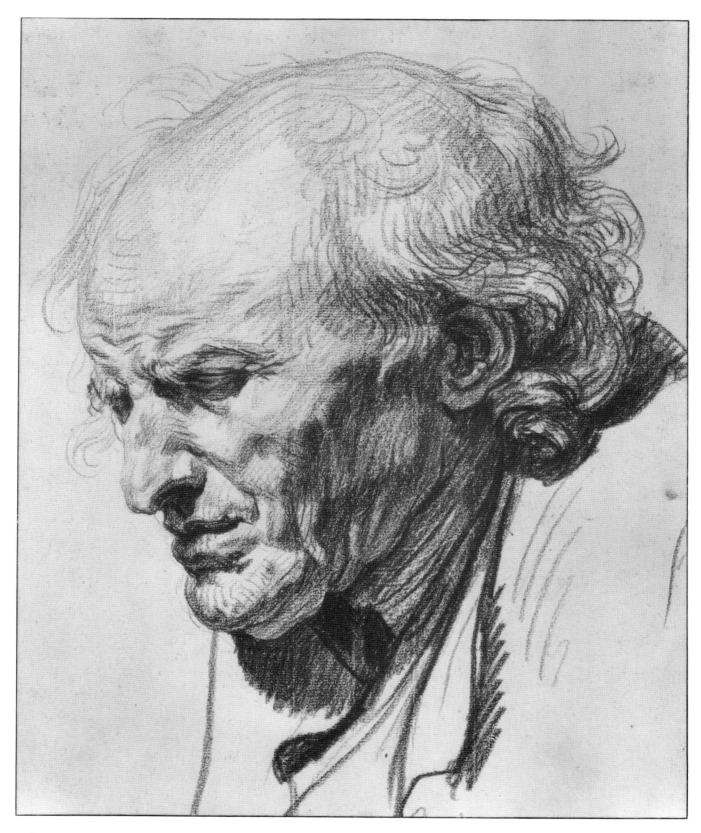

recto

73 Study of the Head of an Old Woman

Red chalk; H: 44.1 cm (17⅜ in.); W: 32.1 cm (12¹¹⁄₁₆ in.)
84.GB.73

MARKS AND INSCRIPTIONS: (Verso) on mount, inscribed *J. Bapt. Greuze* in brown ink.

PROVENANCE: Von Amerling collection, Vienna (sale, Dorotheum, Vienna, May 3–6, 1916, lot 96); private collection, London; art market, London.

EXHIBITIONS: None.

BIBLIOGRAPHY: None.

THIS IS A PREPARATORY STUDY FOR THE INVALID'S WIFE who kneels at his bedside in Greuze's painting *La Dame de Charité* (Lyons, Musée des Beaux-Arts). He was already at work on the painting by 1772 and completed it in 1775.[1] In the painting the wife is shown expressing her gratitude for the providential visit. Another study for the same figure is in the Musée des Beaux-Arts, Dijon.[2] It shows her facing in the opposite direction and considerably younger, and therefore represents an earlier stage in the artist's thinking than the Museum's drawing, which shows the figure much as she appears in the painting.

1. E. Munhall, *Jean-Baptiste Greuze*, exh. cat., Wadsworth Atheneum, Hartford, 1976, under no. 76.
2. Ibid., no. 76.

recto

74 The Father's Curse: The Ungrateful Son

Brush and gray wash, squared in pencil; H: 50.2 cm (19¾ in.); W: 63.9 cm (25³⁄₁₆ in.)
83.GG.231

MARKS AND INSCRIPTIONS: (Recto) at bottom right, signed *J. B. Greuze* in brown ink; (verso) inscribed *No. 2726* in black chalk.

PROVENANCE: Comte Adolphe-Narcisse Thibaudeau, Paris; Baron Solomon de Rothschild, Paris; René Fribourg, Paris; Harry Spiro, New York; Mr. and Mrs. Lester Avnet, New York; art market, Paris.

EXHIBITIONS: *Exhibition de l'art français au XVIIIème siècle*, Palais de Charlottenberg, Copenhagen, August–October 1935, no. 391. *Old Master Drawings from the Collection of Mr. and Mrs. Lester Avnet*, American Federation of Arts, New York, and Minneapolis Institute of Arts, 1969–1970, no. 25.

BIBLIOGRAPHY: J. Martin, *Catalogue raisonné de l'oeuvre peint et dessiné de Jean-Baptiste Greuze* (Paris, 1908), p. 13, no. 167; E. Munhall, *Jean-Baptiste Greuze*, exh. cat., Wadsworth Atheneum, Hartford, 1976, p. 172, under no. 84.

THIS LARGE AND HIGHLY FINISHED SHEET RELATES VERY closely to Greuze's famous painting of the same title in the Louvre, Paris, executed in 1777/78 (Munhall 1976, no. 84). Earlier, Greuze had made drawn versions of this and the companion subject (*The Father's Curse: The Son Punished*; Munhall 1976, no. 88). The study for the 1765 rendering of this scene (Lille, Musée des Beaux-Arts; Munhall 1976, no. 48) shows the composition in reverse and with many differences in detail. As Munhall has noted, the principal alterations concern the anger expressed by the father and the astonishment of the son in the later version; he has suggested that the Museum's drawing may be either a preparatory study or a record by Greuze of the Louvre painting (Munhall 1976, no. 84). The fact that the drawing is squared would seem to argue for the former solution, while the close correspondence in detail between the two might suggest the latter. It may be that the drawing was made after the painting for an engraving.[1] In its relief-like presentation of figures, emphasized by the white highlighting across the foreground group, the qualities of classical relief sculpture are emulated.

1. An engraving after Greuze's painting was executed by René Gaillard and published in *Mercure de France* (August 1781), p. 143 (E. Pognon and Y. Bruand, *Inventaire du fonds français: Graveurs du XVIIIe siècle* [Paris, 1962], vol. 9, p. 411, no. 186).

recto

ANTOINE-JEAN GROS

75 Napoleon at the Battlefield of Eylau

Pen and black and dark brown ink and graphite; H: 27 cm (10⅝ in.); W: 44.9 cm (17⅝ in.)
83.GG.361

MARKS AND INSCRIPTIONS: At top left, inscribed *champ de bataille d'Elau* in graphite by Gros; at bottom left corner, collection mark of Defer-Dumesnil (L. 739).

PROVENANCE: Jean-Baptiste Debret, Paris; Pierre Defer, Paris; Henri Dumesnil, Paris (sale, Hôtel Drouot, Paris, May 10–12, 1900, lot 154); art market, Lausanne.

EXHIBITIONS: Ecole des Beaux-Arts, Paris, 1884, no. 369.

BIBLIOGRAPHY: None.

THE BATTLE OF EYLAU TOOK PLACE ON FEBRUARY 8, 1807, and was among the bloodiest in Napoleon's campaigns. Five weeks later, on March 17, Dominique Vivant-Denon, director general of the Musée Napoleon, announced a competition for the commission to paint the emperor on the battlefield the day after the actual fighting. Vivant-Denon described the scene the artists were to depict, consisting of the emperor surveying the battlefield and directing his troops to assist the wounded. A specific anecdote was to be included, involving a wounded Lithuanian hussar who offered his allegiance to the emperor if he would heal him.[1]

This drawing is a study for the oil sketch that won the competition for Gros on the basis of the decision of a panel from the fine arts section of the Institut Français in June 1807. The oil sketch is in a Parisian private collection.[2] It differs only in minor details from the painting, now in the Louvre. By contrast, the oil sketch and the painting depart significantly from the Museum's drawing in that Napoleon is at the center of the latter composition and many more figures are included. Correspondingly, the significance of individual participants and their gestures is enhanced in the final version. The drawing was first freely sketched in graphite lines throughout, and then drawn over in thick black ink. The rather schematic handling of both nudes and landscape are characteristic of Gros.

The verso carries a slight graphite sketch of an unidentifiable subject.

1. P. Lelièvre, "Napoleon sur le champ de bataille d'Eylau par A. J. Gros," *Bulletin de la Société de l'Histoire de l'Art Français* (1955), pp. 53–55.
2. C. O. Zieseniss, "Napoleon à Eylau: Une esquisse de Charles Meynier," *La revue des arts* 10, nos. 4–5 (1960), ill. p. 217.

76 Portrait of Lord Grantham

Graphite; H: 40.5 cm (15¹⁵⁄₁₆ in.); W: 28.2 cm (11⅛ in.)
82.GD.106

MARKS AND INSCRIPTIONS: At bottom left, signed and dated *Ingres Del. Rome./1816* in graphite.

PROVENANCE: Thomas Phillip Robinson (Lord Grantham, later Earl de Grey), London and Yorkshire; Mrs. Henry Vyner, Yorkshire; Robert Charles de Grey Vyner, Yorkshire; Lady Alwynne Frederick Compton, Yorkshire; Major Edward Robert Francis Compton, Yorkshire; Robert Compton, Yorkshire; art market, London.

EXHIBITIONS: *British Portraits*, Royal Academy of Arts, London, 1956–1957, vol. 1, no. 693.

BIBLIOGRAPHY: B. Ford, "Ingres' Portrait Drawings of English People at Rome, 1806–1820," *Burlington Magazine* 75, no. 434 (July 1939), pp. 9, 11; H. Honour, "Newby Hall, Yorkshire," *Connoisseur* 134, no. 542 (January 1955), pp. 247–248, no. 4; "At the Royal Academy: Fine Portrait Drawings," *Illustrated London News* 229, no. 6130 (December 1956), fig. 950; H. Naef, *Rome vue par Ingres* (Lausanne, 1960), p. 27, n. 52; E. I. Musgrave, *Newby Hall, The Yorkshire House of the Compton Family* (Derby, 1974), p. 13; H. Naef, *Die Bildniszeichnungen von J. A. D. Ingres*, vols. 2 (Bern, 1978), pp. 79–84; 4 (Bern, 1977), pp. 326–327, no. 177.

AMONG THE MOST IMPRESSIVE OF THE PORTRAITS OF Ingres' Roman years, this drawing depicts Thomas Phillip Robinson, third Baron Grantham and later Earl de Grey. He was born in 1781 and was therefore thirty-five at the time of the portrait. Among his accomplishments were his appointments as first lord of the admiralty (1834–1835) and lord lieutenant of Ireland (1841–1844). In addition he was the first president of the Institute of British Architects (1834). The drawing shows Saint Peter's Basilica in the background, viewed from the Arco Oscuro, a vantage point Ingres also chose for his portrait of Charles Marcotte d'Argenteuil in the Chavane collection, Paris (1811; Naef 1977, no. 65), and a landscape study in the Musée Ingres, Montauban (inv. 867.4400).[1] It is less clear where Lord Grantham is standing, as the location is only suggested by a few horizontal and vertical lines.

This is a notable example of Ingres' finished portrait drawings that date from this phase of his career. It exemplifies an unusually diverse technique employing a variety of strokes and shows an exceptionally refined modeling of the face. There is a minor *pentimento* at the head, which was originally set a bit differently. The view of Saint Peter's in the background, drawn with great delicacy, plays a secondary role in the composition.

1. H. Naef, *Ingres in Rome*, exh. cat., National Gallery of Art, Washington, D.C., 1971, no. 110.

Jacques Delobeuve.
1816

CLAUDE LORRAIN (Claude Gellée)

77 *Figures in a Landscape before a Harbor*

Pen and brown ink, reddish brown wash, and white gouache heightening on blue paper; H: 23.7 cm (9⅜ in.); W: 33.9 cm (13⁵⁄₁₆ in.)
82.GA.80

MARKS AND INSCRIPTIONS: (Recto) at bottom right corner, collection mark of William Esdaile (L. 2617); (verso) inscribed *W Esdaile, Claude, 1834–35 xx* in brown ink; two collection marks of Baron Adalbert von Lanna (L. 1659, 2773).

PROVENANCE: William Esdaile, London (sale, February 6, 1840, lot 648); Baron Adalbert von Lanna, Prague (sale, Gutekunst, Stuttgart, May 6, 1910, lot 257); art market, Paris.

EXHIBITIONS: *Im Licht von Claude Lorrain*, Haus der Kunst, Munich, March–May 1983, no. 34 (catalogue by M. Roethlisberger).

BIBLIOGRAPHY: None.

DESPITE ITS DISTINGUISHED EARLIER PROVENANCE, this drawing was unknown in the Claude literature until the Munich exhibition of 1983 (as no. 34). In the accompanying catalogue, Roethlisberger notes the similarity between it and a painting in the Johnson collection, Princeton,[1] and states his belief that it is a copy by Claude after that picture. He dates the drawing to the same period, that is, the late 1630s.

The Museum's drawing is associated not only with the Johnson painting and the related drawing after it in the *Liber veritatis*[2] but also with a study in the Ecole des Beaux-Arts, Paris (inv. 939), and a sheet in the Städelsches Kunstinstitut und Städtische Galerie, Frankfurt (inv. 1266).[3] Both of these drawings have points in common with the Johnson painting, but the latter also shares certain details with the Museum's study that are not found in either of the other drawings. Among them are the group of fighting men at the left, the placement of the tower close to the composition's center, and the continuation of the water around the front and left of the tower, making this a harbor scene. The Museum's drawing also differs from the painting in several respects; it lacks foreground figures and animals as well as trees at the left. This analysis would appear to yield the conclusion that all three drawings preceded the painting, but that further studies were used that provided the basis for the changes between existing drawings and the picture.

The subject of both the painting and the Museum's drawing remains elusive and may not be more elaborate than a first reading would indicate. As Roethlisberger has pointed out (1983), the same tower appears in a pen drawing in the British Museum, London (inv.oo. 6-78),[4] with the inscription *fortezza di tivoli*. Equally, he has noted that the castle of Bracciano may have inspired the one in the upper left background of the Museum's sheet. The imaginative composite architectural setting and brilliant light effects make this a classic example of Claude's harbor scenes.

1. M. Roethlisberger, *Claude Lorrain: The Paintings* (New Haven, 1961), no. 26.
2. M. Roethlisberger, *Claude Lorrain: The Drawings* (Berkeley, 1968), no. 180.
3. Ibid., nos. 181–182.
4. Roethlisberger (note 2), no. 535r.

recto

78 *View of Tivoli*[r]
View of Tivoli[v]

Black chalk and brown and reddish brown wash (recto); pen and ink (verso); H: 21.3 cm (8⅜ in.); W: 31 cm (12³/₁₆ in.)
83.GB.357 (SEE PLATE 6)

MARKS AND INSCRIPTIONS: (Recto) at bottom left, inscribed *Bril* in brown ink by a later hand; at bottom right, inscribed *19* in brown ink; (verso) inscribed *Claud L* . . . in red chalk.

PROVENANCE: Sixth earl of Harewood (Viscount Lascelles), Harewood House (sale, Christie's, London, June 25, 1968, lot 73); private collection, New Jersey.

EXHIBITIONS: *Le paysage français de Poussin à Corot*, Petit Palais, Paris, May–June 1925, no. 460 (catalogue edited by L. Hourticq). *Fifth Loan Exhibition*, Magnasco Society, London, 1928, no. 37.

BIBLIOGRAPHY: T. Borenius, "Old Master Drawings in the Collection of Viscount Lascelles," *Apollo* 1 (1925), p. 193; T. Borenius, *Catalogue of the Harewood House* (London, 1936), pp. 51–52, no. 89; M. Roethlisberger, *Claude Lorrain: The Drawings* (Berkeley, 1968), pp. 63, 189, no. 431.

THESE ARE TWO OF MORE THAN THIRTY VIEWS OF Tivoli and the surrounding countryside by Claude and was very possibly once part of the "Tivoli Book" reconstructed by Roethlisberger (1968, pp. 62–63). As was characteristic of the artist, interest is focused on the rich landscape around Tivoli rather than on the town and its architecture, which are seen to the right on the recto. The latter is closest in medium and technique to the view of Tivoli in the British Museum, London (inv. 00.6-77; Roethlisberger 1968, no. 430), as was first noted by Borenius (1925, p. 193). The varied application of brown and reddish-brown wash provides a subtle range of tonal variations. The verso contains a pen-and-ink study of the same view, perhaps made first in order to provide a basic compositional outline for the principle drawing on the recto. The existence of the verso has not been noted previously.

recto

verso

JEAN-FRANÇOIS MILLET

79 *Man with a Hoe*

Black chalk and white chalk heightening on buff paper;
H: 28 cm (11 1/16 in.); W: 34.9 cm (13 3/4 in.)
85.GB.115

MARKS AND INSCRIPTIONS: At bottom right corner,
signed *J. F. Millet* in black chalk.

PROVENANCE: Feral collection, Paris (sale, Paris, March
12, 1874); Verdier collection, Paris; Mrs. Wertheimer,
Paris; Christian Humann, Switzerland; art market, Mu-
nich; Crocker family, San Francisco.

EXHIBITIONS: *J. F. Millet, dessinateur*, Galerie Hector
Brame, Paris, January–February 1938, no. 55. *Jean-
François Millet et ses amis—Peintures de Barbizon*, Kyoto
City Art Museum and other institutions, August–De-
cember 1970, no. 35. *A Collection of Nineteenth Century
French Drawings*, P. and D. Colnaghi, London, May–
June 1982, no. 18.

BIBLIOGRAPHY: A. Sensier and P. Mantz, *La vie et
l'oeuvre de J. F. Millet* (Paris, 1881), p. 237; L. Soullie, *Les
grands peintres aux ventes publiques II: Peintures, aquarelles,
pastels, dessins de Jean-François Millet* (Paris, 1900), p. 133;
R. Herbert, *Jean-François Millet*, exh. cat., Grand Palais,
Paris, 1975, p. 201; idem, *Jean-François Millet*, exh. cat.,
Hayward Gallery, London, 1976, p. 140.

MILLET'S PAINTING *MAN WITH A HOE* (MALIBU,
J. Paul Getty Museum, inv. 85.PA.114) of 1860–1862 is
among the most important and controversial pictures
created in mid-nineteenth-century France. Since that
time it has been associated with the imagery of social rad-
icalism, despite the artist's evident desire to represent a
less political and more philosophically timeless relation-
ship of the weary peasant to his land (Herbert 1975, p.
201). This drawing appears to be a preparatory study for
the painting, as has been indicated by Herbert (1975, p.
201). Arguing for this is the relatively free drawing of
certain passages, especially along the ground, and the
much more elaborate depiction of flora in the painting.
Equally, certain individual strokes—such as those estab-
lishing the hill in the left background or the mounds and
rocks in the immediate foreground—give the impres-
sion of an artist developing an idea rather than reiterating
it. Other preparatory studies are listed by Herbert (1975,
p. 201).

80 Shepherdess and Her Flock

Black chalk and pastel; H: 36.4 cm (14¹⁵/₁₆ in.); W: 47.4 cm (18¹¹/₁₆ in.)
83.GF.220 (SEE PLATE 8)

MARKS AND INSCRIPTIONS: At bottom right, signed *J. F. Millet* in black chalk.

PROVENANCE: E. Secrétan, Paris (sale, Galerie Charles Sedelmeyer, Paris, July 1, 1889, lot 101); private collection, Newport, Rhode Island; art market, New York.

EXHIBITIONS: *Millet Retrospective*, Ecole des Beaux-Arts, Paris, 1887, no. 117.

BIBLIOGRAPHY: R. Herbert, *Jean-François Millet*, exh. cat., Grand Palais, Paris, 1975, p. 204; idem, *Jean-François Millet*, exh. cat., Hayward Gallery, London, 1976, p. 143; A. R. Murphy, *Jean-François Millet*, exh. cat., Museum of Fine Arts, Boston, 1984, p. 157, under no. 108.

IN 1864 MILLET EXHIBITED HIS PAINTING *Shepherdess and Her Flock* (Paris, Louvre) at the Salon, where it achieved great success as one of his classic depictions of peasant life. This is one of at least four pastels that relate to the painting. Two others are in the Museum of Fine Arts, Boston (inv. 35.1162), and the Walters Art Gallery, Baltimore (inv. 37.906); another sold at Sotheby's, New York, on November 21, 1980, as lot 106. Herbert (1975, p. 204) has suggested that the Getty Museum's version was the earliest of the three then known to him (excluding the one at Sotheby's) and has hypothesized that it may have preceded the painting. In any event it is perhaps the most monumental of the pastel images of the theme, focusing around the sculptural form of the shepherdess. Among its notable features is the small dog in the right middle ground, which seems to anticipate the drawing style of Seurat a generation later. If this drawing was done in advance of the painting, it would be datable to 1862/63. Further studies related to it are listed by Herbert (1975, p. 204).

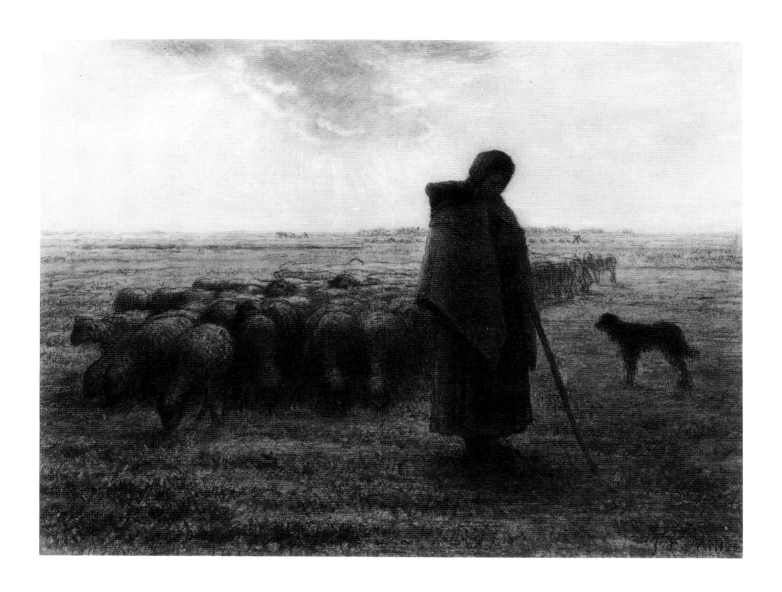

81 Have No Fear, My Good Friend!

Pen and brown ink and brown wash; H: 26.7 cm (10½ in.); W: 21.6 cm (8½ in.)
85.GG.416

MARKS AND INSCRIPTIONS: At bottom left corner, signed and dated *JM. moreau le jeune. 1775* in black ink; on mount, at bottom right corner, unidentified collection mark stamped twice.

PROVENANCE: King Ludwig II of Bavaria; (sale, Lepke's Kunst-Auction-Haus, Berlin, May, 1891); M. Morgand, Paris; Baron Edmond de Rothschild, Paris; Earl of Carnarvon, London; Irwin Laughlin; by descent to Mrs. Hubert Chanler, Washington, D.C.; sale, Sotheby's, London, June 10, 1959, lot 39; Mr. and Mrs. Deane Johnson, New York; sale, Christie's, London, April 10, 1985, lot 121; art market, London.

EXHIBITIONS: *Pictures, Drawings, Etc. of the French School of the Eighteenth Century*, Burlington Fine Arts Club, London, 1913, no. 53. *Exhibition of French Art 1200–1900*, Royal Academy of Arts, London, 1932, no. 835. *France in the Eighteenth Century*, Royal Academy of Arts, London, 1968, no. 478.

BIBLIOGRAPHY: R. Nevill, *French Prints of the Eighteenth Century* (London, 1908), p. 185; H. Cohen, *Guide de l'amateur de livres à gravures du XVIII siècle* (Paris, 1912), col. 358, no. 16; M. von Boehn, *Moreau und Freudenberg: Trois suites d'estampes* (Berlin, 1920), p. 17; J. Widener, *French Engravings of the Eighteenth Century in the Collection of Joseph Widener* (London, 1923), vol. 4, pp. 523–524; C. Dodgson, "Moreau le Jeune," *Old Master Drawings 2*, no. 6 (September 1927), p. 24.

THIS IS THE FINISHED PREPARATORY STUDY FOR THE fourth illustration in the second series of *Monument du costume*, engraved by I. S. Helman in 1776 in the same direction as the drawing (Widener 1923, vol. 4, no. 16). This series consists of three sets of twelve prints illustrating the childhood and early married years of a young man. Throughout, these vignettes reflect the social and moral behavior of the time, but they are also important for their representation of contemporary fashion and taste. In this scene a young woman named Céphise sits between two friends who are trying to assuage her fears as she is pregnant with her first child. The young *abbé* at the left turns to her and tells her to have no fear, the basis for the title of the print. The graphic style of the drawing, with its brilliantly observed textures and great delicacy of handling, is fully in accord with both theme and setting. It is exemplary of the artist's most refined and accomplished manner.[1]

1. Studies in *trois crayons* for the two lateral female figures were sold from the collection of Lucien Guiraud, Hôtel Drouot, Paris, June 14–15, 1956, lots 58, 59.

82 *Apollo and the Muses on Parnassus*

Pen and brown ink and brown wash, small irregular section at right margin made up; H: 17.6 cm (6¹⁵⁄₁₆ in.); W: 24.5 cm (9¹¹⁄₁₆ in.)

83.GG.345

MARKS AND INSCRIPTIONS: At bottom left corner, collection mark of Louis Deglatigny (L. 1768a); at bottom right corner, collection mark of Defer-Dumesnil (L. 739).

PROVENANCE: Pierre Defer, Paris; Henri Dumesnil, Paris (sale, Hôtel Drouot, Paris, May 10–12, 1900, lot 205); Louis Deglatigny, Rouen (sale, Galerie Jean Charpentier, Paris, May 28, 1937, lot 73); Georges Wildenstein, New York; Daniel Wildenstein, New York.

EXHIBITIONS: None.

BIBLIOGRAPHY: W. Friedländer and A. Blunt, *The Drawings of Nicolas Poussin* (London, 1953), vol. 3, pp. 20–21, no. 180; G. Wildenstein, *Les gravures de Poussin au XVIIe siècle* (Paris, 1957), p. 286, under no. 138 (originally printed in *Gazette des Beaux-Arts* 46, no. 6 [September–December 1955], p. 286); A. Blunt, "La première période romaine de Poussin," in *Nicolas Poussin: Actes du colloque Poussin* (Paris, 1960), vol. 1, p. 170; E. Panofsky, *A Mythological Painting by Poussin in the National Museum Stockholm* (Stockholm, 1960), pp. 50–51; 55, n. 126; 57, n. 131; D. Mahon, "Poussiniana: Afterthoughts Arising from the Exhibition," *Gazette des Beaux-Arts* 60, no. 6 (July–August 1962), pp. 86–92, nos. 266, 267; A. Blunt, *The Paintings of Nicolas Poussin: A Critical Catalogue* (London, 1966), p. 90, under no. 129; K. Badt, *Die Kunst des Nicolas Poussin* (Cologne, 1969), vol. 1, pp. 202–203, 213; J. Pope-Hennessy, *Raphael* (London, 1970), pp. 236; 292, n. 26; *Museo del Prado: Catalogo de las pinturas* (Madrid, 1972), p. 514, under no. 2312; A. Blunt, *The Drawings of Poussin* (New Haven and London, 1979), pp. 24, 27–28; D. Wild, *Nicolas Poussin* (Zurich, 1980), vol. 2, p. 29, under no. 26.

THE SUBJECT, COMPOSITION, AND SIGNIFICANT details of this drawing are derived from Raphael's *Parnassus* in the Stanza della Segnatura, Palazzo Vaticano, and from the engraving by Marcantonio Raimondi that reflects an earlier design for the fresco (B.247[200] v.26,14). The drawing resembles the fresco more closely in the presence of the Castilian Spring and in the *lira di braccio* played by Apollo, but the flying putti appear only in the engraving. As Panofsky noted (1960, pp. 51–52), Poussin altered Raphael's idea in a fundamental sense. In both fresco and engraved design, no action beyond spiritual discourse, music-making, and contemplation takes place, whereas in the drawing by Poussin the composition focuses on Calliope, who crowns Homer and Virgil with laurel wreaths while Melpomene introduces Tasso at the left. The more animated character of the drawing's composition is enhanced by features such as the displacement of Apollo off to the left center and of the putti to the right. In general the composition is also more cohesive.

Poussin's drawing is in turn a preparatory study for his painting of the same theme in the Prado, Madrid (Blunt 1966, no. 129). Here again Poussin introduced many modifications from his own drawing, changing the placement of Homer and Virgil (to the left) and of Apollo (right of center) and altering the latter's action completely. Other alterations, such as the addition of the nymph at the center, can be seen throughout, and the composition has been tightened and given a more precise structure.

The date of this and other related drawings by Poussin was the subject of a lively debate between Blunt and Mahon (Friedländer and Blunt 1953, vol. 3, no. 180; Blunt 1960, vol. 1, p. 170; Mahon 1962, pp. 86–92; Blunt 1979, pp. 27–28), the former placing it in the late 1620s and the latter in 1630–1631. The difference between the two dates is not great, but on balance Mahon's arguments seem more persuasive. Blunt noted Poussin's use here of a fine quill pen, which produced "a rather scratchy line" (Blunt 1979, pp. 27–28), thus giving a lively graphic quality to the drawing.

83 Presentation in the Temple

Pen and brown ink and brown wash; H: 14.9 cm (5⅞ in.);
W: 10.9 cm (4¼ in.)
84.GA.667

MARKS AND INSCRIPTIONS: At bottom left corner, inventory number *2536* and paraph of Pierre Crozat (?) (L. 2951) in brown ink; at bottom right corner, inscribed *Poussin* in brown ink by a later hand.

PROVENANCE: Pierre Crozat(?), Paris; Georges Wildenstein, New York; Daniel Wildenstein, New York.

EXHIBITIONS: None.

BIBLIOGRAPHY: P.-J. Mariette, *Description de la collection Crozat* (reprint of 1741, 1750, and 1751 edns.) (Geneva, 1973), p. 112, no. 966(?); W. Friedländer and A. Blunt, *The Drawings of Nicolas Poussin—Catalogue Raisonné*, vol. 5 (London, 1974), p. 76, no. 396.

THIS DRAWING CANNOT BE CONNECTED WITH ANY painting by Poussin, though it has the appearance of a preparatory study. There is a drawing of the same theme, perhaps by a follower, in the Fogg Art Museum, Cambridge (inv. 1941.13; Friedländer and Blunt 1974, no. B 53). Although similar in many respects, that composition contains alterations from the Museum's study that diminish the carefully orchestrated balance of form and tone, thereby reducing the effect of visual and intellectual concentration. The Museum's drawing is characteristic of Poussin's mature style, not only in these qualities but also in the featureless geometry of faces and the broad application of wash. A drawing of this subject by Poussin, which may well have been this one, was in Pierre Crozat's collection (Mariette 1973, p. 112).

2536

Paulin

84 *Landscape with Ruins*

Pen and brown ink, brown and blue wash, and black chalk; H: 57.2 cm (22½ in.); W: 78.3 cm (30¹³⁄₁₆ in.) 83.GG.37

MARKS AND INSCRIPTIONS: At bottom right corner, signed *H. Robert 1772* in ink; on mount, inscribed *Hubert Robert* in black ink.

PROVENANCE: Comte Jacques de Bryas, Paris (sale, Galerie Georges Petit, Paris, April 4–6, 1898, lot 149); De Jonge collection, Paris; Mitchell Samuels collection, New York; Spencer A. Samuels, New York.

EXHIBITIONS: *French and English Art Treasures Exhibition*, New York, December 1942. *The Intimate Notion*, Spencer A. Samuels and Company, Ltd., New York, October–November 1967, no. 36. *Fragonard and His Friends*, Museum of Fine Arts, St. Petersburg, Florida, November 1982–February 1983, no. 53 (catalogue by M. L. Grayson).

BIBLIOGRAPHY: None.

THIS UNUSUALLY LARGE WATERCOLOR REFLECTS THE artist's continuing interest in Roman themes after his return to Paris in 1765. Characteristic of his *capricci*, it shows peasants with their animals, happily at work and in repose or, in one instance, fishing beside the remains of a Roman temple. It has been suggested by Grayson (1982–1983, no. 53) that the ruin was based upon the temple of Antoninus and Faustina in the Campo Vaccino, Rome, which Robert knew through both personal experience and a popular Piranesi print. Grayson also has noted that the large, complex tree at the left reappears in a drawing of 1774 by Robert in the Musée des Beaux-Arts et d'Histoire Naturelle, Valence (inv. D.60).[1] This is perhaps the most accomplished detail of the watercolor, and has a curiously Oriental flavor. It serves as a compositional and poetic foil to the Roman temple on the other side of the river in this typical mixture of the classical and contemporary pastoral.

1. M. Beau, *La collection des dessins d'Hubert Robert au Musée de Valence* (Lyons, 1968), no. 7.

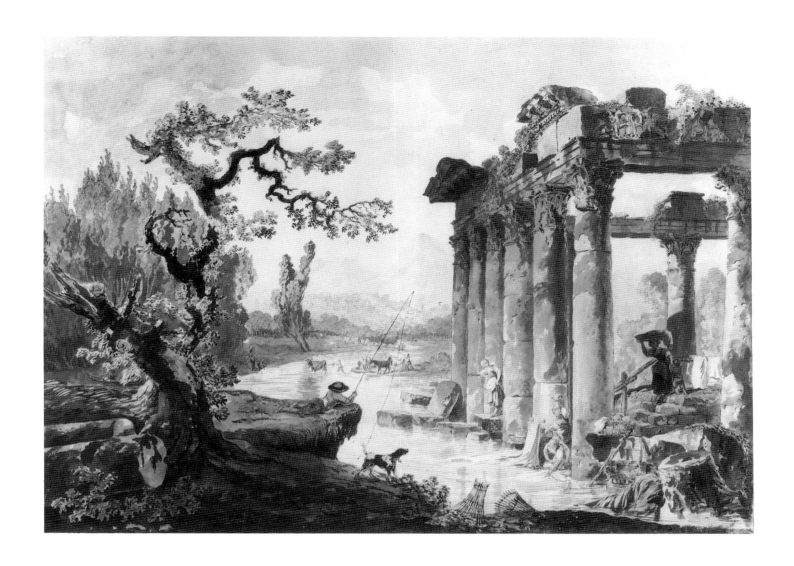

85 Seated Woman with a Fan

Red, black, and white chalk on light brown paper; H: 19.2 cm (7%₆ in.); W: 21.4 cm (8⁷⁄₁₆ in.)
82.GB.164 (SEE PLATE 7)

MARKS AND INSCRIPTIONS: (Verso) on mount, inscribed *Collection Lord Charles Townsend* in black chalk.

PROVENANCE: Camille Groult, Paris; Pierre Bordeaux-Groult, Paris; art market, New York.

EXHIBITIONS: None.

BIBLIOGRAPHY: J. Mathey, "Deux dessins de J.-B. Pater (Dessins de maîtres)," *Gazette des Beaux-Arts* 34, no. 6 (August 1948), p. 136, n. 5; K. T. Parker and J. Mathey, *Antoine Watteau: Catalogue complet de son oeuvre dessiné* (Paris, 1957), vol. 2, p. 309, no. 549; *Wallace Collection Catalogues: Pictures and Drawings*, 16th edn. (London, 1968), p. 361, under no. P389; P. Rosenberg and M. Grasselli, *Watteau 1684–1721*, exh. cat., Grand Palais, Paris, 1984, p. 351, under no. 44.

THIS EXCEPTIONALLY WELL-PRESERVED STUDY BY Watteau has been variously related to figures in *The Champs-Elysées* (London, Wallace Collection), the *Pleasures of Love* (Dresden, Gemäldegalerie), and the *Timid Lover* (Palacio Real de Madrid). Of the three it is clearly closest to the last, as has been noted by Rosenberg (Rosenberg and Grasselli 1984, no. 44). The seated young woman who appears in the other two paintings in a similar pose is instead based upon a study in Sèvres (formerly [?] Haumont collection; Parker and Mathey 1957, vol. 2, no. 585). The Museum's drawing anticipates not only the form of the woman in the Madrid picture but also the lighting and facial expression. In the painting she is shown looking down at a young man, who timidly holds a flower. The preparatory study for that male figure is in the Petit Palais, Paris (Parker and Mathey 1957, no. 666). The painting has been dated to circa 1716 by Rosenberg (Rosenberg and Grasselli 1984, no. 44) and others, providing an approximate date for the studies.

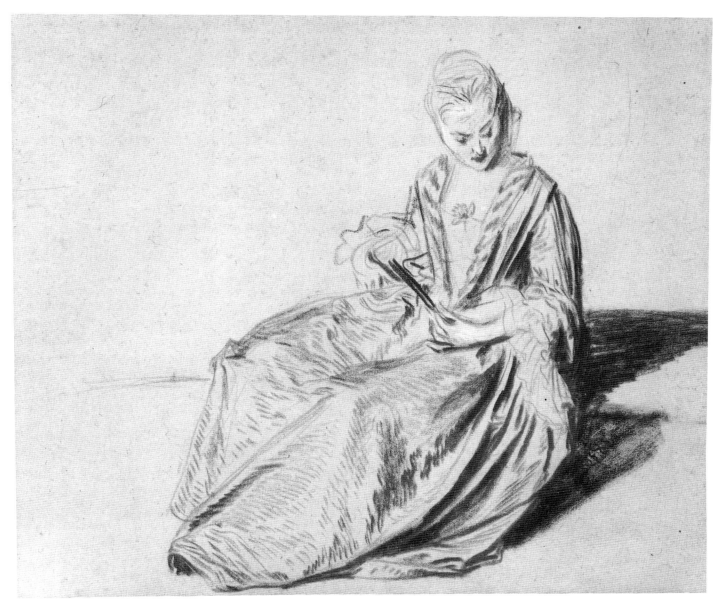

recto

86 *The Entombment* [r]
Partial Study of the Entombment [v]

Black chalk, pen and brown ink, brown and reddish wash, red and blue chalk, and white gouache heightening (recto); black chalk, pen and brown ink, and brown wash (verso), sheet folded twice vertically and six times horizontally; H: 25.4 cm (10 in.); W: 21.8 cm (8⅝ in.) 85.GG.97

MARKS AND INSCRIPTIONS: (Recto) at bottom right corner, collection mark of N. A. Flinck (L. 959); (verso) inscribed *N° 29* in brown ink.

PROVENANCE: N. A. Flinck, Rotterdam; William, second duke of Devonshire, Chatsworth; by descent to the current duke (sale, Christie's, London, July 3, 1984, lot 57); art market, New York.

EXHIBITIONS: *Seventeenth Century Art in Europe*, Royal Academy of Arts, London, 1938, no. 585 (catalogue of drawings by A. E. Popham et al.). *Tekeningen van Jan van Eyck tot Rubens*, Museum Boymans-van Beuningen, Rotterdam, December 1948–February 1949, no. 88, and Palais des Beaux-Arts, Brussels, March–April 1949, no. 110 (catalogue by J. C. Ebbinge Wubben). *Drawings by Old Masters*, Royal Academy of Arts, London, 1953, no. 290 (catalogue by K. T. Parker and J. Byam Shaw). *Flemish Art 1300–1700*, Royal Academy of Arts, London, December 1953–March 1954, no. 488 (catalogue of drawings by K. T. Parker and J. Byam Shaw). *Paintings and Drawings by Van Dyck*, Nottingham University Art Gallery, February–March 1960, no. 38 (catalogue by O. Millar). *Old Master Drawings from Chatsworth*, National Gallery of Art, Washington, D.C., and other institutions, 1962–1963, no. 78 (catalogue by A. E. Popham). *Old Master Drawings from Chatsworth: A Loan Exhibition from the Devonshire Collection*, Royal Academy of Arts, London, July–August 1969, no. 78 (catalogue by A. E. Popham). *Old Master Drawings from Chatsworth*, National Museum of Western Art, Tokyo, 1975, no. 74. *Old Master Drawings: A Loan from the Collection of the Duke of Devonshire*, Israel Museum, Jerusalem, April–July 1977, no. 30. *Van Dyck as a Religious Artist*, Art Museum, Princeton, April–May 1979, no. 6 (catalogue by J. R. Martin and G. Feigenbaum). *The Young van Dyck*, National Gallery of Canada, Ottawa, 1980, no. 19 (catalogue by A. McNairn).

BIBLIOGRAPHY: *The Vasari Society for the Reproduction of Drawings by Old Masters*, 1st ser. (London, 1910), vol. 6, no. 19; H. Leporini, *Die Künstlerzeichnung* (Berlin, 1928), p. 242; H. Vey, *Van-Dyck-Studien* (Cologne, 1955), pp. 36–38; J. G. van Gelder, "Van Dycks kruisdraging in de St.-Pauluskerk te Antwerpen," *Bulletin Musées Royaux des Beaux-Arts* 10 (1961), pp. 5, 7; I. Moskowitz, *Great Drawings of All Time* (New York, 1962), vol. 2, no. 543; H. Vey, *Die Zeichnungen Anton van Dycks* (Brussels, 1962), vol. 1, pp. 76, no. 4; 78, under no. 6; C. T. Eisler, *Flemish and Dutch Drawings From the 15th to the 18th Century* (New York, 1963), pl. 41; I. Q. van Regteren Altena and P. W. Ward-Jackson, *Drawings from the Teyler Museum, Haarlem*, exh. cat., Victoria and Albert Museum, London, 1970, p. 23, under no. 20.

THE RECTO AND VERSO[1] OF THIS SHEET BOTH CONTAIN studies of the *Entombment*; they are related to other drawings of this theme by van Dyck which appear to date from around 1617–1620. The others, also drawn on both recto and verso, are in the Ecole des Beaux-Arts, Paris (copy of a lost drawing), and the Teylers Stichting, Haarlem (inv. 1597, O★15; Vey 1962, nos. 5, 6). Vey (1962, p. 78) has argued that all of these drawings were not necessarily preparatory to a painting, but van Gelder (1961, p. 8) has expressed a contrary view and is likely to be correct. He has pointed out that the figure of the Virgin on the right of the recto appears again in one of van Dyck's drawings (Berlin, Kupferstichkabinett, inv. 6334; van Gelder 1961, p. 6, fig. 2) for the *Christ Carrying the Cross* (Antwerp, Sint-Pauluskerk), thereby indicating the intermingling of van Dyck's ideas for the various religious compositions he was developing at that moment. Furthermore, the monumental conception of the design on the Museum's recto speaks for it being a study for a painting. In the broad handling of wash, variety of technique, and relief-like composition of principal figures, it closely parallels the study for *Christ Carrying the Cross* (Provi-

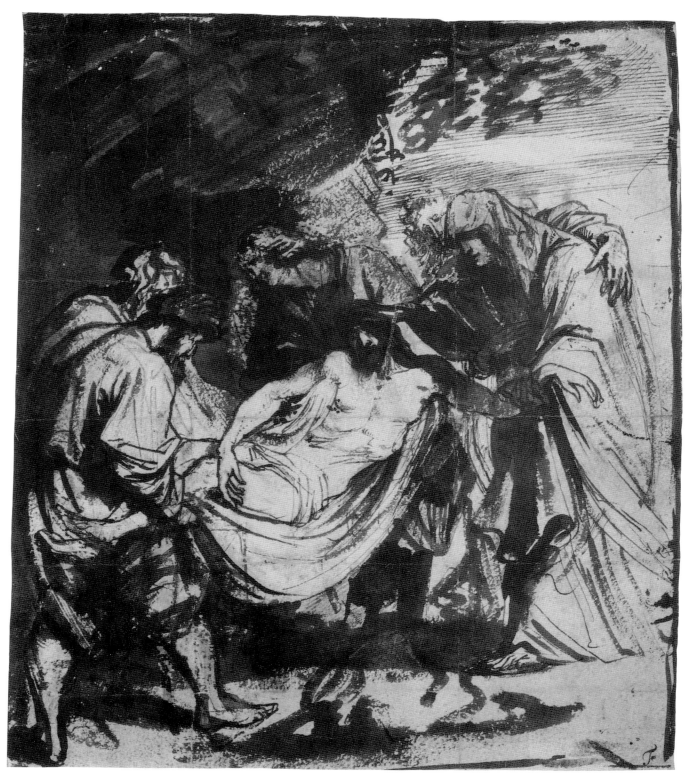

recto

dence, Rhode Island School of Design; Vey 1962, no.7). The addition of touches of color is found once more in the *Entombment* drawing in the Teylers Stichting, Haarlem.

The sequence of the various *Entombment* studies is difficult to ascertain. Very possibly, the drawing known through the Ecole des Beaux-Arts copy was done first, followed by the Teylers sheet. At this point van Dyck appears to have taken an interest in Titian's famous painting of the subject (Paris, Louvre), turning the body of Christ outward and adding the powerful figure of the man at his feet. In the Museum's recto the poignant gesture of Christ's limp right hand and the rendering of his head in shadow are features derived from Titian's painting. Lastly, the planar presentation of the figures reflects this distinguished precedent. As the most developed of the various drawings of this theme by van Dyck, the Museum's sheet would logically come near the end of the evolution of his ideas, a sequence that is made still more probable by van Gelder's observation concerning the figure of the Virgin. It is possible that van Dyck never executed a painting to follow these drawings, or that the composition was altered further and developed into the *Lamentation* (Munich, Alte Pinakothek),[2] which contains some of its elements.

1. The sheet was lifted from its mount in 1985 by Alexander Yow, revealing a further sketch of the same subject in black chalk at the left.
2. G. Glück, *Van Dyck, Des Meisters Gemälde*, Klassiker der Kunst (Stuttgart, 1931), no. 8.

verso

87 Portrait of Hendrick van Balen

Black chalk; H: 24.4 cm (9⅝ in.); W: 19.7 cm (7¾ in.)
84.GB.92

MARKS AND INSCRIPTIONS: At bottom right corner, collection mark of N. A. Flinck (L. 959).

PROVENANCE: N. A. Flinck, Rotterdam; William, second duke of Devonshire, Chatsworth; by descent to the current duke (sale, Christie's, London, July 3, 1984, lot 55).

EXHIBITIONS: *Old Master Drawings from Chatsworth*, Arts Council Gallery, London, 1949, no. 25 (catalogue by A. E. Popham). *Paintings and Drawings by Van Dyck*, Nottingham University Art Gallery, February–March 1960, no. 52 (catalogue by O. Millar). *Antoon van Dyck: Tekeningen en olieverfschetsen*, Rubenshuis, Antwerp, and Museum Boymans-van Beuningen, Rotterdam, July– August 1960 and September–November 1960, no. 78 (catalogue by R.-A. d'Hulst and H. Vey). *Van Dyck: Drawings and Etchings from Chatsworth House*, Eastbourne, 1978, no. 33.

BIBLIOGRAPHY: A. M. Hind, *The Vasari Society for the Reproduction of Drawings by Old Masters*, 1st ser. (Oxford, 1908), vol. 4, no. 23; M. Delacre, *Recherches sur le rôle du dessin dans l'Iconographie de Van Dyck*, Mémoires de l'Académie Royale de Belgique, 2nd ser. (1932), vol. 2, no. 4, pp. 81–82; idem, *Recherches sur le rôle du dessin dans l'Iconographie de Van Dyck. Notes complémentaires*, Mémoires de l'Académie Royale de Belgique, 2nd ser. (1934), vol. 3, no. 3, pp. 15–16; H. Vey, *Die Zeichnungen Anton Van Dycks* (Brussels, 1962), vol. 1, pp. 322–323, no. 257; C. T. Eisler, *Flemish and Dutch Drawings From the 15th to the 18th Century* (New York, 1963), p. 75; J. Kuznetsov, *I disegni dei maestri, Capolavori fiamminghi e olandesi* (Milan, 1970), p. 14, fig. 14; J. Byam Shaw, "Drawings from Chatsworth," *Apollo* 119, no. 268 (June 1984), pp. 458–459.

THIS PORTRAIT'S SUBJECT IS HENDRICK VAN BALEN (1575–1632), who lived in Antwerp and was a painter of religious and mythological themes. He was a friend of Jan Brueghel and Rubens and achieved considerable success. In 1609 van Dyck was his student.

The drawing is a study for a print of the same size and in reverse, executed by Paulus Pontius in the series of engravings and etchings of famous statesmen, scholars, and painters designed by van Dyck and known as his *Iconography*.[1] This ambitious project was conceived during his years in Antwerp between 1627 and 1635. The drawing must therefore date from the period between 1627 and van Balen's death five years later. It is among the most affecting and successful of the drawings for the *Iconography*, showing great sensitivity in the diversity of chalk strokes and a striking directness of vision in the characterization of van Balen. He is presented with his hand on the head of an antique statue, a motif that is more developed in the print. It has been noted by d'Hulst and Vey (1960, no. 78) that the fourth state of the print bears an inscription, *Pictor Antv:Humanarum Figurarum Vetustatis Cultor*, that attests to van Balen's respect for antiquity. The print also contains a classical column behind the sitter. Copies of the drawing are in the Louvre, Paris (inv. 19.932), and the Teylers Museum, Haarlem.[2] Grisaille oil sketches based on it are in the collection of the duke of Buccleuch, Drumlanrig Castle, and in an American private collection (formerly Schaeffer Gallery, New York).[3]

1. M. Mauquoy-Hendrickx, *L'Iconographie d'Antoine Van Dyck*, Académie Royale de Belgique, Mémoire 9 (Brussels, 1956), no. 42.
2. H. J. Scholten, *Musée Teyler à Haarlem: Catalogue raisonné des dessins des écoles française et hollandaise* (Haarlem, 1904), album O★, 19.
3. Other drawings by van Dyck for his *Iconography* have been catalogued by Vey (1962, nos. 242–281).

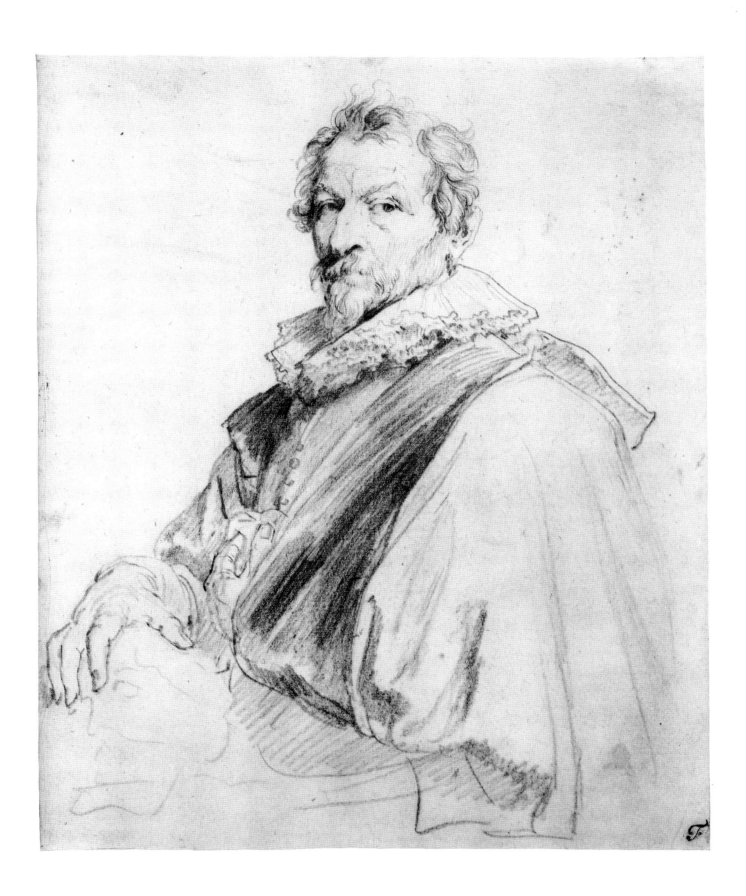

88 Landscape

Pen and brown ink and watercolor; H: 19 cm (7⁷⁄₁₆ in.);
W: 36.4 cm (14⁵⁄₁₆ in.)
85.GG.96

MARKS AND INSCRIPTIONS: At bottom left corner, collection mark of N. A. Flinck (L. 959).

PROVENANCE: N. A. Flinck, Rotterdam; William, second duke of Devonshire, Chatsworth; by descent to the current duke (sale, Christie's, London, July 3, 1984, lot 58); art market, New York.

EXHIBITIONS: *Old Master Drawings from Chatsworth*, Arts Council Gallery, London, 1949, no. 29 (catalogue by A. E. Popham). *Le cento opere di Van Dyck*, Palazzo dell'Accademia, Genoa, June–August 1955, no. 104. *Antoon van Dyck: Tekeningen en olieverfschetsen*, Rubenshuis, Antwerp, and Museum Boymans-van Beuningen, Rotterdam, July–August and September–November 1960, no. 121 (catalogue by R.-A. d'Hulst and H. Vey). *Old Master Drawings from Chatsworth*, National Gallery of Art, Washington, D.C., and other institutions, 1962–1963, no. 84 (catalogue by A. E. Popham). *Old Master Drawings: A Loan Exhibition from the Devonshire Collection*, Royal Academy of Arts, London, July–August 1969, no. 84 (catalogue by A. E. Popham). *The Age of Charles I: Painting in England 1620–1649*, Tate Gallery, London, 1972, no. 121 (catalogue by O. Millar). *Old Master Drawings from Chatsworth*, National Museum of Western Art, Tokyo, 1975, no. 80. *Old Master Drawings: A Loan from the Collection of the Duke of Devonshire*, Israel Museum, Jerusalem, April–July 1977, no. 29.

BIBLIOGRAPHY: H. Vey, *Die Zeichnungen Anton van Dycks* (Brussels, 1962), vol. 1, p. 362, no. 307; C. van Hasselt, *Dessins flamands du dix-septième siècle*, exh. cat., Collection Frits Lugt, Institut Néerlandais, Paris, 1972, p. 52, under no. 35.

THIS IS ONE OF A SMALL GROUP OF LANDSCAPE drawings with watercolor by van Dyck that have been dated by Vey to the artist's second English period (1962, nos. 303–307). Several of them have an unfinished appearance, which Vey has reasonably interpreted as indicating that they are studies of motifs rather than complete compositions (1962, no. 306). Nevertheless, they are fully coherent and unified, suggesting that Millar was correct in considering them as spontaneous impressions made during relaxed moments as well as material for backgrounds of paintings (1972, no. 120). The Museum's landscape is quite similar to that behind the sitter in the *Portrait of a Girl as Erminia, Attended by Cupid* in the collection of the duke of Marlborough,[1] which is considered by Millar as possibly from van Dyck's second Flemish period. Among the artist's landscape watercolors the Museum's sheet is closest in technique to one in the Devonshire collection, Chatsworth (inv. 1003; Vey 1962, no. 306). Its wide vista with a prominent tree near the center is comparable to the composition of a pen-and-ink drawing of the same period in the Frits Lugt Collection, Institut Néerlandais, Paris (inv. 5922; Vey 1962, no. 308). Vey has proposed that the Museum's sheet and related studies date from late in van Dyck's life. It is among the extraordinary moments in landscape drawing of the seventeenth century, with its rich and translucent colors, breadth of conception, and freshness of both watercolor and pen accents.

1. G. Glück, *Van Dyck, Des Meisters Gemälde*, Klassiker der Kunst, vol. 13 (Stuttgart, 1931), p. 408.

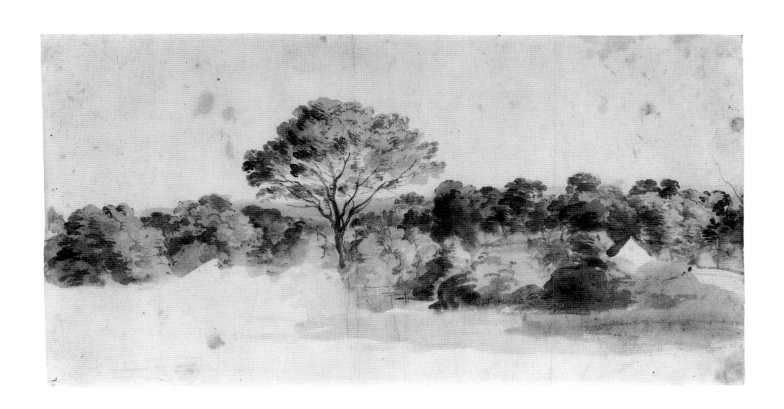

89 *Head of a Woman*

Black and red chalk, dark brown wash, and white gouache heightening; H: 25.2 cm (9¹⁵⁄₁₆ in.); W: 18.8 cm (7⅜ in.)
85.GG.298

MARKS AND INSCRIPTIONS: At bottom right corner, collection mark of A. G. B. Russell (L. Suppl. 2770a).

PROVENANCE: A. G. B. Russell, London (sale, Sotheby's, London, June 9, 1955, lot 5); César de Hauke, Paris; private collection, Switzerland (sale, Christie's, London, July 4, 1984, lot 128A); art market, New York.

EXHIBITIONS: *Exhibition on Behalf of the Artists' General Benevolent Institution*, Thomas Agnew and Sons, London, 1923, no. 32. *Exhibition of Flemish Art, 1300–1900*, Royal Academy of Arts, London, 1927, no. 621 (catalogue by C. Dodgson et al.).

BIBLIOGRAPHY: T. Borenius, "Drawings in the Collection of Mr. Archibald G. B. Russell," *Connoisseur* 66 (May 1923), pp. 2, 10; T. W. Muchall-Viebrook, *Flemish Drawings of the Seventeenth Century* (London, 1926), pp. 20; 36, no. 55; L. van Puyvelde, *Jordaens* (Paris, 1953), p. 211; R.-A. d'Hulst, *De Tekeningen van Jacob Jordaens* (Brussels, 1956), pp. 242, 244, 370–371, no. 119; idem, *Jordaens Drawings* (London, 1974), vols. 1, no. A124; 2, pl. 136; idem, *Jacob Jordaens* (London, 1982), pp. 164, 312.

THIS RICHLY DRAWN STUDY OF A WOMAN'S HEAD was thought by Borenius (1923, p. 10) to be a portrait of the artist's wife, Catharina van Noort. This hypothesis was ignored, and presumably rejected, by d'Hulst (1974, vol. 1, no. A124), who dated it to circa 1635. Despite its resemblance to known representations of her, d'Hulst appears to be correct. The sheet represents a study from life of a rather pedestrian figure, similar in feeling to others in the quite substantial group of drawings by Jordaens of about the same period (d'Hulst 1974, vol. 1, nos. A125–A135). It differs only in the use of wash shadows, a feature that recurs in a somewhat later drawing of a soldier in the A. Leysen collection, Antwerp (d'Hulst 1974, vol. 1, no. A142b).

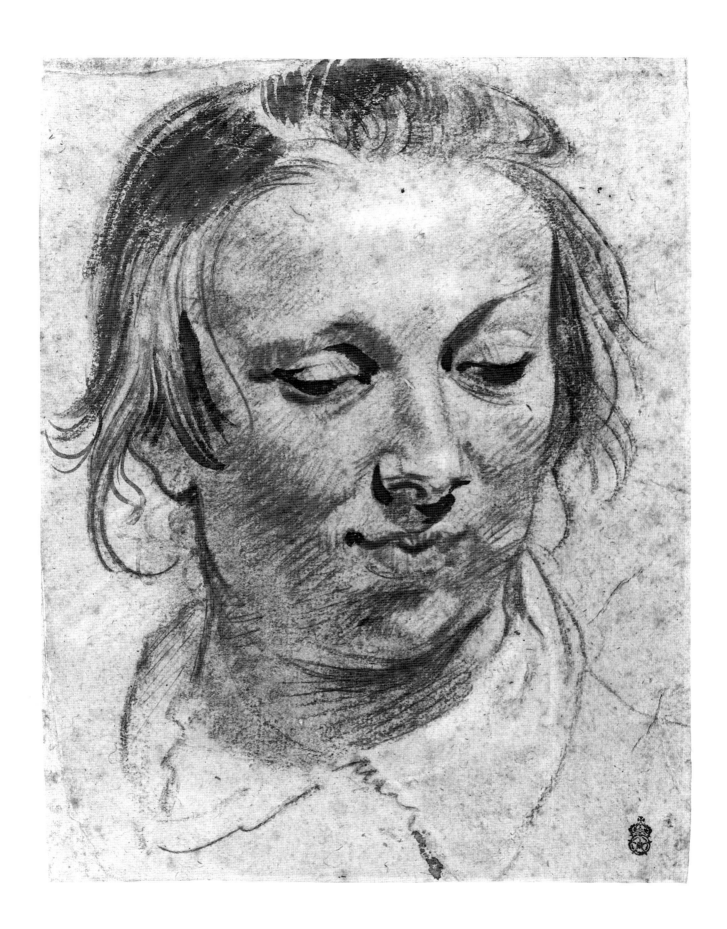

90 Three Groups of Apostles in a Last Supper[r]
Three Sketches for Medea and Her Children[v]

Pen and brown ink; H: 29.6 cm (11 11/16 in.); W: 43.9 cm (17 ¼ in.)
84.GA.959

MARKS AND INSCRIPTIONS: (Recto) at top right, inscribed *Gestus magis largi longiq[ue] / brachijs extensis, A* (twice), *lag* in brown ink by Rubens; (verso) inscribed *vel Medea respiciens Creusam ardentem et Jasonem velut Inseguens . . .* in brown ink by Rubens; faintly inscribed *Creusa ardens[s(?)]* in red chalk by Rubens.

PROVENANCE: William, second duke of Devonshire, Chatsworth; by descent to the current duke (sale, Christie's, London, July 3, 1984, lot 53).

EXHIBITIONS: *A Loan Exhibition of Works by Peter Paul Rubens*, Wildenstein and Company, London, October–November 1950, no. 39 (catalogue by L. Burchard). *Tekeningen van P. P. Rubens*, Rubenshuis, Antwerp, June–September 1956, no. 24; p. 52, under no. 40; *Addenda et Corrigenda*, nos. 24, 25 (catalogue by L. Burchard and R.-A. d'Hulst). *Rubens: Drawings and Sketches*, British Museum, London, 1977, no. 25 (catalogue by J. Rowlands). *Rubens in Italien: Gemälde, Ölskizzen, Zeichnungen*, Kunsthalle, Cologne, October–December 1977, no. 25; p. 238, under no. 48 (catalogue by J. Müller Hofstede).

BIBLIOGRAPHY: M. Rooses, "Dessins du duc de Devonshire," *Rubens-Bulletijn*, 3rd ser., vol. 5 (1900), pp. 202–203; idem, *Rubens* (London, 1904), vol. 1, p. 100; J. S. Held, "Rubens' Pen Drawings," *Magazine of Art* 44, no. 7 (November 1951), p. 288; M. Jaffé, "Rubens' Drawings at Antwerp," *Burlington Magazine* 98, no. 642 (September 1956), pp. 314, 318; J. S. Held, *Rubens: Selected Drawings* (London, 1959), pp. 45; 65; 95, under no. 6; 96, no. 7 recto; 99, under no. 12; 104, under no. 27; J. Müller Hofstede, "Review of Julius S. Held, *Rubens: Selected Drawings*," *Kunstchronik* 5 (May 1962), pp. 130, 132; idem, "Zur antwerpener Frühzeit von Peter Paul Rubens," *Münchner Jahrbuch der bildenden Kunst*, 3rd ser., vol. 13 (1962), p. 214, no. 84; L. Burchard and R.-A. d'Hulst, *Rubens Drawings* (Brussels, 1963), p. 31, under no. 14; no. 34; p. 63, under no. 35; A. Monballieu, "P. P. Rubens en het 'Nachtmael' voor St.-Winoksbergen (1611), een niet uitgevoerd schilderij van de meester," *Jaarboek, Koninklijk Museum voor Schone Kunsten, Antwerp* (1965), pp. 191, 193, 194; M. Jaffé, "Rubens as a Draughtsman," *Burlington Magazine* 107, no. 748 (July 1965), pp. 375, 380; idem, "Rubens as a Collector of Drawings," *Master Drawings* 4, no. 2 (1966), p. 129; idem, "Rubens," in *Encyclopedia of World Art* (New York, 1966), vol. 12, col. 600; J. Müller Hofstede, "Review of L. Burchard and R.-A. d'Hulst, *Rubens Drawings*," *Master Drawings* 4, no. 4 (1966), p. 442, nos. 34, 35; idem, "Aspekte der Entwurfszeichnung bei Rubens," in H. von Einem, ed., *Stil und Überlieferung in der Kunst des Abendlandes: Akten des 21. Internationalen Kongresses für Kunstgeschichte in Bonn, 1964* (Berlin, 1967), vol. 3, p. 123; M. Jaffé, "Rubens in Italy, Part II; Some Rediscovered Works of the First Phase," *Burlington Magazine* 110, no. 781 (April 1968), p. 179; idem, "Another Drawing from Rubens' Italian Period," *Master Drawings* 8, no. 3 (1970), p. 271; J. Müller Hofstede, "Rubens in Rom 1601–1602: Die Altargemälde für Sta. Croce in Gerusalemme," *Jahrbuch der Berliner Museen* 12, no. 1 (1970), pp. 63, 98; M. Jaffé, *Rubens and Italy* (Oxford, 1977), pp. 29, 30, 57, 62–64, 75; B. Magnusson, "Rubens som Tecknare," in G. Cavalli-Björkman, ed., *Rubens i Sverige* (Stockholm, 1977), pp. 93, 95; J. R. Judson and C. van de Velde, *Book Illustrations and Title-Pages*, Corpus Rubenianum Ludwig Burchard, vol. 21, pt. 2 (London and Philadelphia, 1978), pp. 140–141, under no. 26; H. Vlieghe, "Review of M. Jaffé, *Rubens and Italy*," *Burlington Magazine* 120, no. 904 (July 1978), p. 472; J. S. Held, *The Oil Sketches of Pieter Paul Rubens* (Princeton, 1980), vol. 1, p. 468, under no. 340; A. K. Wheelock et al., *Leonardo's "Last Supper": Precedents and Reflections*, exh. cat., National Gallery of Art, Washington, D.C., 1983, under no. 12; J. S. Held, *Rubens: Selected Drawings* (Mt. Kisco, 1986), pp. 39, 51; 72, under nos. 17, 18; 72–73, nos. 19–20; 170–171, pls. 19–20.

THE RECTO OF THIS SHEET CONSISTS OF THREE INDEpendent groups of apostles and two faint individual studies, all presumably related to a representation of the Last Supper. A second drawing of the same theme, closely

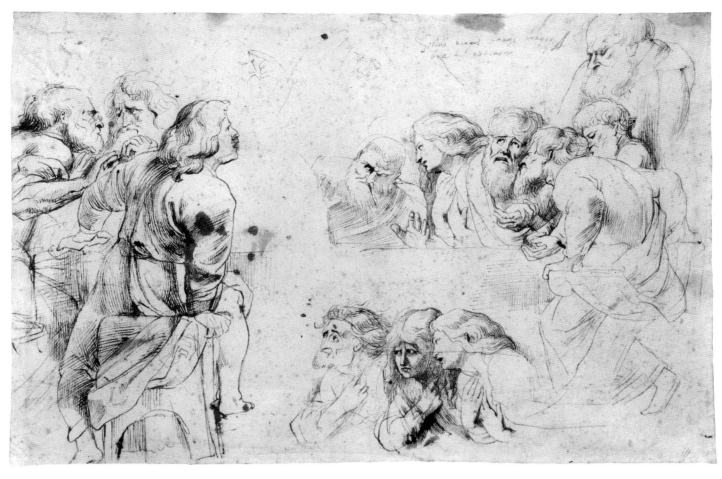

recto

related in execution as well as style and with several of the same individual figures, is still in the Devonshire collection, Chatsworth (inv. 1007; Jaffé 1977, pl. 194). It is extremely difficult to ascertain the relative chronology of the two, but as Held has suggested (1959, p. 96; 1986, p. 73), the Museum's drawing is the more developed in terms of specific figures, as can be seen in the young man with his back turned in the group at the left. It is also worth noting that this drawing begins to suggest a compositional arrangement, a feature almost entirely unexplored in the Chatsworth study.

The overall inspiration and individual apostles in the Museum's drawing have often been related to Italian models. Rooses was the first to suggest the generic influence of Leonardo's famous precedent (1900, p. 202). Held has noted the derivation of the young man with his back turned at the left from a figure in Caravaggio's *Calling of Saint Matthew* in San Luigi dei Francesi, Rome (1951, p. 288). Held also has proposed that the young apostle with his hands in front of his chest who appears twice in the drawing (in the upper and lower groups at the right side) is based on Marcantonio Raimondi's engraving of the same subject after Raphael's design, while the man at the upper right was derived from Michelangelo's Ezechias spandrel in the Sistine Chapel. Lastly, Held has pointed to the Caravaggesque inclusion of spectacles on the apostle at the far left (1959, p. 96; 1986, p. 73). In addition, Burchard and d'Hulst have suggested that the apostle seated on the folding chair at the right is based upon a figure in Raphael's fresco in the Vatican Loggie (1963, p. 62). Finally, the apostle at the center with his hands raised appears to be derived from Caravaggio's *Supper at Emmaus* (London, National Gallery).

With the exception of Burchard and d'Hulst (1963, p. 62), most scholars have dated the Museum's drawing to Rubens' early Italian years. For example, Held has placed it circa 1600–1604 (1959, p. 96; 1986, p. 73). However, Monballieu (1965, pp. 195–205) has published documents showing that Rubens was commissioned to paint an altarpiece of the Last Supper for the Benedictine abbey of Saint Winoksbergen in 1611, a project for which he seems to have made designs before he decided against completing it. Monballieu reasonably has proposed that this and the Chatsworth study were both made in connection with the Saint Winoksbergen painting, a view shared by A.-M. Logan.[1]

The verso of the Museum's sheet contains several studies of Medea with her slain children, a theme that seems to have interested Rubens alone among the artists of his time. Another drawing by him copied after an antique sarcophagus still in Mantua shows the more typical scene of Medea's flight, in which she mounts a chariot drawn by serpents (Rotterdam, Museum Boymans-van Beuningen, inv. Rubens 8; Burchard and d'Hulst 1963, pl. 14). Held has made the interesting suggestion that Rubens' involvement with this subject may have arisen out of his friendship with the humanist scholar Justus Lipsius (1959, p. 96; 1986, p. 73). Held also has noted the resemblance of Medea's movement to that of a classical maenad, as well as Rubens' derivation of the child hanging by one arm from a representation of one of the children of Niobe on an antique sarcophagus he could have seen in the Villa Borghese in Rome. Despite the use of these sources, Rubens' studies of Medea and her children are among the most original and freely conceived of his images, entirely appropriate for what may have been the first postclassical depiction of the theme.[2]

Stylistically, both recto and verso show a preference for drawing in rather long, thin lines, sometimes thickened for emphasis and shading. The figures range from the monumentally conceived apostles on the recto to the more finely drawn, animated renderings of Medea on the verso. Though both have points in common with drawings Rubens made in Italy, a date just after his return to Antwerp is supported not only by the documents discovered by Monballieu (1965, pp. 195–205) but also by the graphic character of the Museum's sheet. It is more developed and sensitive than his Italian studies and compares more closely with other drawings made in his first few years back in Antwerp (Held 1959, pls. 30–31, 33, 41–42; 1986, pls. 72, 77, 111, 124, 135).

1. Conversation with the author, Malibu, 1985.
2. Professor Held, in conversation with the author, Malibu, 1985, mentioned that L. Steinberg had indicated that this was the first postclassical depiction of this subject.

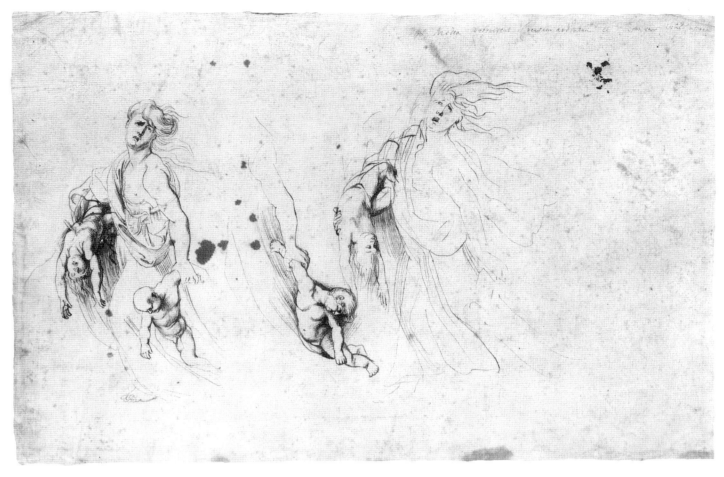

verso

91 *Assumption of the Virgin*

Pen and brown ink and brown wash over black chalk, indented for transfer; H: 30 cm (11¹³⁄₁₆ in.); W: 19 cm (7⁷⁄₁₆ in.)
83.GG.198

MARKS AND INSCRIPTIONS: (Recto) on mount, inscribed *Rubens, no. 14* in brown ink; (verso) on mount, inscribed *T. Philipe* in brown ink.

PROVENANCE: H. Tersmitten, Amsterdam (sale, de Bary and Yver, Amsterdam, September 23 et seq., 1754, lot 434); T. Philipe, London; Sir W. Forbes, Pitsligo; by descent (sale, Christie's, London, April 12, 1983, lot 155).

EXHIBITIONS: None.

BIBLIOGRAPHY: M. Rooses, *L'oeuvre de P. P. Rubens* (Antwerp, 1892), vol. 5, p. 61, under no. 1258; M. Jaffé, "Exhibitions for the Rubens Year I," *Burlington Magazine* 119, no. 894 (September 1977), pp. 620, 626; J. R. Judson and C. van de Velde, *Book Illustrations and Title-Pages*, Corpus Rubenianum Ludwig Burchard, vol. 21 (London and Philadelphia, 1978), pts. 1, p. 145, no. 27a; 2, pp. 447–448; D. Freedberg, *The Life of Christ After the Passion*, Corpus Rubenianum Ludwig Burchard, vol. 7 (New York, 1984), pp. 141, 143, n. 41; J. S. Held, *Rubens: Selected Drawings* (Mt. Kisco, 1986), pp. 103, no. 84; 202, pl. 79.

IN 1612 RUBENS WAS COMMISSIONED BY JAN AND Balthasar Moretus to design illustrations for a new *Breviarium Romanum*; the drawings were completed by March 1614.[1] The present drawing is the ninth original design by Rubens that is known to exist out of a total of thirteen (Held 1986, p. 103).[2] It was first published by Jaffé (1977, p. 626) as a study for the print. The plate for the engraving of the Assumption had been cut by Theodore Galle by April 12, 1614 (Judson and van de Velde 1978, pt. 1, p. 119). The engraving, in reverse of the drawing, follows it in all essentials (Judson and van de Velde 1978, pt. 2, fig. 92). A retouched impression of the engraving is in the Bibliothèque Nationale, Paris (inv. C. 10500; Judson and van de Velde 1978, pt. 2, fig. 93).

The drawing's composition is quite controlled and classical, echoing the great altarpiece in the Frari, Venice, by Titian and also reflecting a knowledge of Pordenone in the rendering of the angels (Judson and van de Velde 1978, pt. 1, p. 143). The Museum's study is quite free in its black chalk underdrawing and contains several *pentimenti*, most evident in the figure of the Virgin. This argues for it being the first complete study for the engraving. The use of pen and ink and brown wash, without white heightening, recurs in another study for the *Breviarium Romanum*, the *All Saints* (Vienna, Graphische Sammlung Albertina, inv. 8213; Judson and van de Velde 1978, pt. 2, pl. 28a). The drawing in Vienna exhibits a similar system of modeling in thin, parallel strokes and broad areas of wash, as can be seen in the rather sketchy rendering of the auxiliary figures in the heavens.

1. Jan Moretus to Jean Hasrey, Madrid, March 10, 1614, Archives du Musée Plantin-Moretus, register 13, p. 217, cited in Judson and van de Velde 1978, pt. 2, p. 399.
2. For the various prints and drawings associated with the *Breviarium*, see Judson and van de Velde 1978, pt. 1, pp. 118–151.

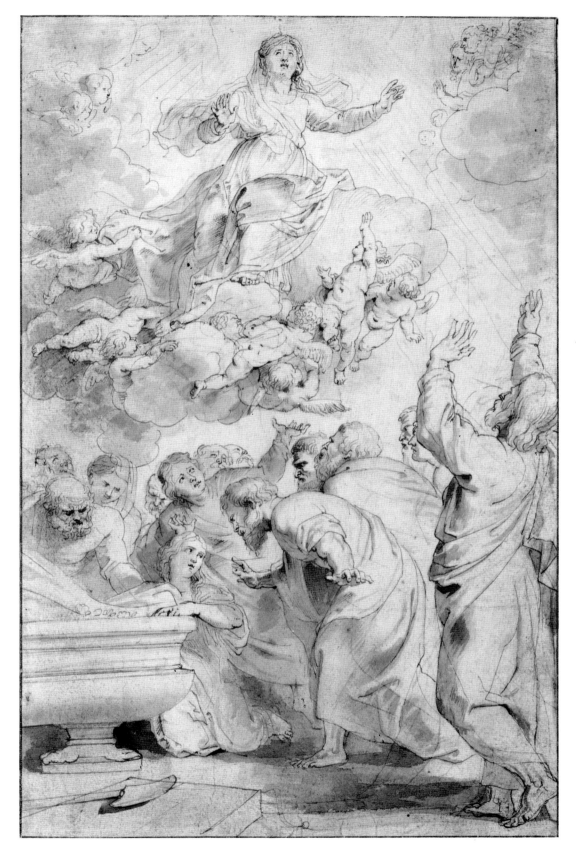

recto

92 A Man Threshing beside a Wagon, Farm Buildings Behind

Red, black, blue, green, and yellow chalk and touches of pen and brown ink on pale gray paper; H: 25.5 cm (10 in.); W: 41.5 cm (16�5⁄16 in.)
84.GG.693 (SEE PLATE 10)

MARKS AND INSCRIPTIONS: None.

PROVENANCE: William, second duke of Devonshire, Chatsworth; by descent to the current duke (sale, Christie's, London, July 3, 1984, lot 52).

EXHIBITIONS: *Seventeenth Century Art in Europe*, Royal Academy of Arts, London, 1938, p. 111, fig. 614 (catalogue of drawings by A. E. Popham et al.). *Dessins de Pierre-Paul Rubens*, Palais des Beaux-Arts, Brussels, December 1938–February 1939, no. 47 (catalogue by L. van Puyvelde). *Catalogus van Teekeningen van Petrus Paulus Rubens*, Museum Boymans-van Beuningen, Rotterdam, February–March 1939, no. 45. *Old Master Drawings from Chatsworth*, Arts Council Gallery, London, 1949, no. 45 (catalogue by A. E. Popham). *P. P. Rubens, esquisses, dessins, gravures*, Suomen Taideakatemia, Helsinki, and Musées Royaux des Beaux-Arts de Belgique, Brussels, 1952–1953, no. 45. *Tekeningen van P. P. Rubens*, Rubenshuis, Antwerp, June–September 1956, no. 77 (catalogue by L. Burchard and R.-A. d'Hulst). *Old Master Drawings from Chatsworth*, City Art Gallery, Manchester, July–September 1961, no. 96. *Old Master Drawings from Chatsworth*, National Gallery of Art, Washington, D.C., and other institutions, 1962–1963, no. 100 (catalogue by A. E. Popham). *Old Master Drawings from Chatsworth: A Loan Exhibition from the Devonshire Collection*, Royal Academy of Arts, London, July–August 1969, no. 100 (catalogue by A. E. Popham). *Rubens: Drawings and Sketches*, British Museum, London, 1977, no. 202 (catalogue by J. Rowlands).

BIBLIOGRAPHY: M. Rooses, *Rubens-Bulletijn*, 3rd ser., 5 (1900), p. 204; *The Vasari Society for the Reproduction of Drawings by Old Masters*, 1st ser. (Oxford, 1908), vol. 4, no. 21; L. Burchard, "Drei Zeichnungen in Dresdener Sammlungen," *Mitteilungen aus den Sächsischen Kunstsammlungen* 4 (1913), pp. 8, 9, 59–60; G. Glück and F. M. Haberditzl, *Die Handzeichnungen von Peter Paul Rubens* (Berlin, 1928), p. 40, no. 94; L. van Puyvelde, "Die Handzeichnungen des P. P. Rubens zu der Ausstellung in Brüssel," *Pantheon* 23, no. 3 (March 1939), p. 78; G.

Glück, *De landschappen van Peter Paul Rubens* (Antwerp and Amsterdam, 1940), pp. 17; 54, under no. 3; 72; idem, *Die Landschaften von Peter Paul Rubens* (Berlin, 1945), pp. 15, under no. 3; 72; A. J. J. Delen, *Flemish Master Drawings of the Seventeenth Century* (New York, 1950), pp. 19, no. 3; 37; M. Jaffé, "Rubens' Drawings at Antwerp," *Burlington Magazine* 98, no. 642 (September 1956), p. 321; J. S. Held, *Rubens: Selected Drawings* (London, 1959), no. 129; p. 146, under no. 133; H. Gerson and E. H. Ter Kuile, *Art and Architecture in Belgium, 1600–1800* (Harmondsworth, 1960), p. 189, n. 147; L. Burchard and R.-A. d'Hulst, *Rubens Drawings* (Brussels, 1963), vol. 1, no. 101; p. 167, under no. 102; J. Theuwissen, "De kar en de wagen in het werk van Rubens," *Jaarboek, Koninklijk Museum voor Schone Kunsten, Antwerp* (1966), pp. 199–210; idem, *Het landbouwvoertuig in de etnografie van de Kempen* (Antwerp and Utrecht, 1969), p. 44; idem, "Het werk van Bruegel en Rubens als beelddocument," *Volkskunde* (1971), pp. 351–352; I. Kuznetsov, *Risunki Rubensa* (Moscow, 1974), p. 16; J. Richardson and E. Zafran, *Master Paintings from the Hermitage and the State Russian Museum, Leningrad*, exh. cat., M. Knoedler and Co., New York, 1975, p. 62, under no. 16; K. A. Roy and S. D. Walther, "P. P. Rubens 1570–1640," in *Rubenism*, exh. cat., Bell Gallery, Brown University, Providence, 1975, p. 19; F. Baudoin, *P. P. Rubens* (New York, 1977), pp. 120, 124; M. Bernhard, *Rubens Handzeichnungen* (Munich, 1977), pl. 275; D. Bodart, *Rubens e l'incisione nelle collezioni del Gabinetto delle Stampe* (Rome, 1977), pp. 59–60, under no. 97; H. Mielke and M. Winner, *Peter Paul Rubens—Kritischer Katalog der Zeichnungen: Originale, Umkreis, Kopien, Staatliche Museen Preussischer Kulturbesitz, Kupferstichkabinett* (Berlin, 1977), p. 92, under no. 32; H. Vlieghe, *De schilder Rubens* (Utrecht, 1977), pp. 90–91; J. Theuwissen, "De Wereld Van De Boer Zoals Rubens die Zag," *Spiegel Historiael* 12, no. 6 (June 1977), pp. 358–360; W. Adler, *Landscapes*, Corpus Rubenianum Ludwig Burchard, vol. 18 (New York, 1982), pp. 57, under no. 12; 82, under no. 19; 100, under nos. 26, 26a; 154, under no. 48b; L. Vergara, *Rubens and the Poetics of the Landscape* (New Haven and London, 1982), pp. 75, 79; J. Byam Shaw, "Drawings from Chatsworth," *Apollo* 119, no. 268 (June 1984), p. 458, fig. 10; J. S. Held, *Rubens: Selected Drawings* (Mt. Kisco, 1986), pp. 113, no. 113; 115, under no. 119; 219, pl. 115.

THIS FAMOUS GENRE DRAWING HAS BEEN RELATED TO Rubens' painting of the Prodigal Son (Antwerp, Koninklijk Museum voor Schone Kunsten) and the *Landscape with a Country Wagon* (Leningrad, State Hermitage) since the time of Rooses (1900, p. 204). It is also associated

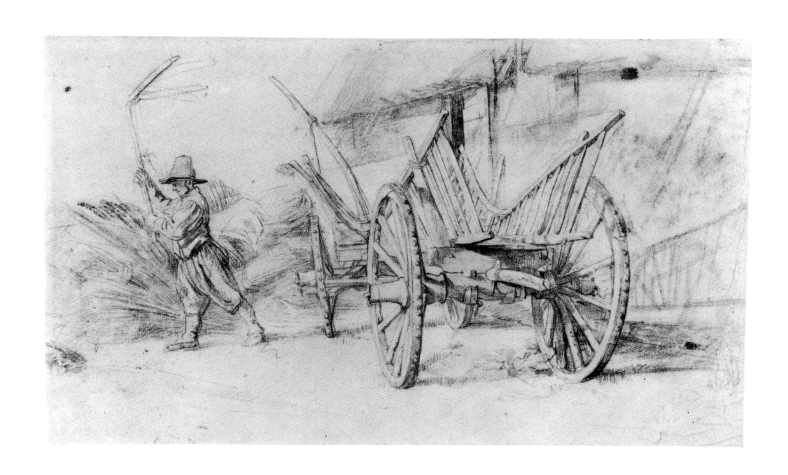

with the artist's *Winter* (Windsor Castle, Collection of Her Majesty the Queen), as was first noted by Burchard (1913, pp. 59–60). The drawing's relationship to the latter two paintings arises solely out of the presence of the same wagon, whereas in the Antwerp *Prodigal Son* the stable to its right is also included. Furthermore, the context in which the wagon is situated in the drawing is closer to that of the Antwerp painting than to those of the other two pictures. Despite its relationship to these paintings, the drawing appears to be an independent work, in this respect different from the *Two Studies of Wagons* (Berlin, Kupferstichkabinett, inv. 3237; Held 1959, pl. 142; 1986, pl. 118). The presence of the man threshing, who is unrelated to figures in any of Rubens' paintings, clearly supports this interpretation. By contrast the Berlin drawing represents two individual studies rather than a full composition and was in all likelihood made in preparation for a version of the Windsor *Winter* known through a print by P. Clouwet (Adler 1982, fig. 68), a point already noted by Burchard and d'Hulst (1963, vol. 1, p. 167). The Museum's drawing has been dated by Held and others to 1615–1617, which would accord with the usual dating of the *Prodigal Son*, *Landscape with a Country Wagon*, and *Winter* to around 1618–1620 (Held 1959, p. 144; 1986, p. 113).

This drawing of a man threshing is also of great interest in terms of its technique. The chalk strokes have been handled with considerable variation and range from the stronger and more precise forms of the wagon, accented in pen and ink, to the light, almost impressionistic and rapid strokes employed for the stable and the hay. It is also among the most coloristically subtle of Rubens' drawings.

93 Korean Man

Black chalk, touches of red chalk in face; H: 38.4 cm (15⅛ in.); W: 23.5 cm (9¼ in.)
83.GB.384 (SEE PLATE 11)

MARKS AND INSCRIPTIONS: (Recto) at bottom right, collection marks of Jonathan Richardson, Sr. (L. 2184), Jonathan Richardson, Jr. (L. 2170); (verso) collection mark of Baron Adalbert von Lanna (L. 2773).

PROVENANCE: Jonathan Richardson, Sr., London (sale, Cock, London, January 29, 1747, lot 41); Jonathan Richardson, Jr., London; R. Willett; Baron Adalbert von Lanna, Prague (sale, Gutekunst, Stuttgart, May 7, 1910,

lot 476); Christopher Head; inherited by Mrs. Head, later Lady Du Cane; by descent (sale, Christie's, London, November 29, 1983, lot 135).

EXHIBITIONS: *Drawings by Old Masters*, Royal Academy of Arts, London, 1953, no. 281 (catalogue by K. T. Parker and J. Byam Shaw). *Flemish Art 1300–1700*, Royal Academy of Arts, London, December 1953–March 1954, no. 522 (catalogue of drawings by K. T. Parker and J. Byam Shaw).

BIBLIOGRAPHY: W. Baillie, *Catalogue of Prints Engraved by Captain William Baillie after Pictures and Drawings in Various Collections* (London, 1792); C. G. Voorhelm Schneevoogt, *Catalogue des estampes gravées d'après P. P. Rubens* (Haarlem, 1873), no. 278; M. Rooses, *L'oeuvre de P. P. Rubens* (Antwerp, 1892), vol. 5, p. 277, no. 1531; C. S. Wortley, "Rubens' Drawings of Chinese Costume," *Old Master Drawings* 9 (June 1934–March 1935), pp. 40–47; L. Burchard and R.-A. d'Hulst, *Tekeningen van P. P. Rubens*, exh. cat., Rubenshuis, Antwerp, 1956, p. 67, under no. 66; J. S. Held, *Rubens: Selected Drawings* (London, 1959), vol. 1, pp. 137–138, under no. 105; L. Burchard and R.-A. d'Hulst, *Rubens Drawings* (Brus-

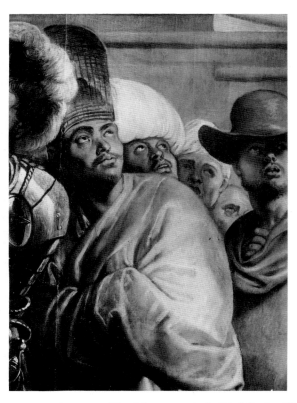

PETER PAUL RUBENS (Flemish, 1577–1640). *The Miracles of Saint Francis Xavier* (detail). Oil on canvas. H: 535 cm (17½ ft); W: 395 cm (13 ft). Vienna, Kunsthistorisches Museum 311. Photo courtesy Kunsthistorisches Museum.

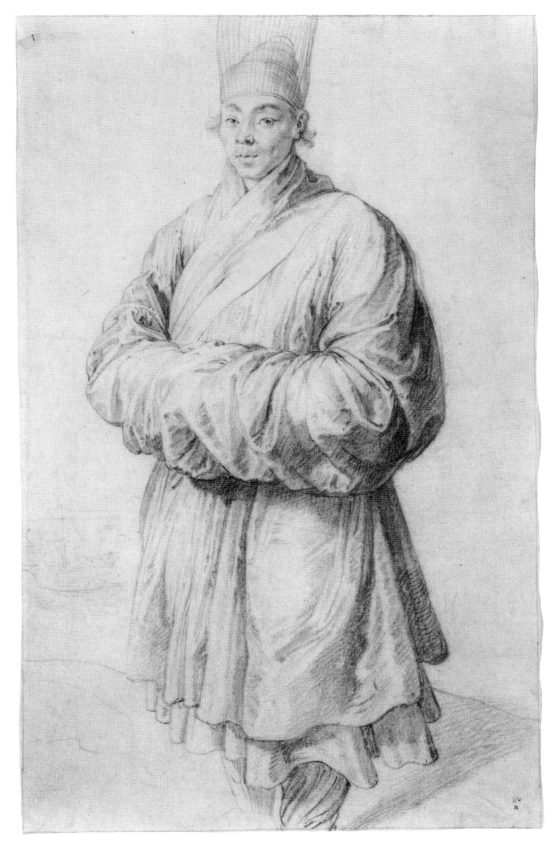

recto

sels, 1963), vol. 1, pp. 181, under no. 114; 183, under no. 115; 231–232, under no. 147; H. Vlieghe, *Saints*, pt. 2, Corpus Rubenianum Ludwig Burchard, vol. 8 (London, 1973), p. 31, under no. 104b; F. Stampfle, *Rubens and Rembrandt in Their Century*, exh. cat., Pierpont Morgan Library, New York, 1979, pp. 52–53, under no. 18; K. L. Belkin, *The Costume Book*, Corpus Rubenianum Ludwig Burchard, vol. 24 (Brussels, 1980), p. 51, n. 62; J. S. Held, *The Oil Sketches of Pieter Paul Rubens* (Princeton, 1980), vol. 1, p. 561, under no. 408; "Who was Korean Model for Rubens," *Korea News Review*, December 10, 1983, p. 25; J. S. Held, *Rubens: Selected Drawings* (Mt. Kisco, 1986), pp. 119, no. 130; 120, under no. 131; 231, pl. 133.

THIS IMPOSING PORTRAIT OF A MAN IN FORMAL Korean costume was used by Rubens as the basis for one of the central figures in his painting *The Miracles of Saint Francis Xavier* (Vienna, Kunsthistorisches Museum, inv. 311).[1] This was first proposed by Burchard and d'Hulst (1956, no. 66) and has since been accepted by the majority of specialists, including Held (1986, p. 120). In the preliminary oil sketch (Vienna, Kunsthistorisches Museum, inv. 528), the similarly placed figure is represented altogether differently, indicating that between the execution of the oil sketch (before April 13, 1617) and the final design for the painting (circa 1617–1618) Rubens encountered this individual, drew the portrait, and used it in his final version of the painted composition. There is no reason to believe that the sheet was made as a preparatory study; rather, it appears to be an independent drawing that inspired the somewhat differently posed man in the painting. It is noteworthy that while most scholars have seen the *Korean Man* as related to the painted figure in terms of costume, only Burchard and d'Hulst (1963, vol. 1, p. 183) have observed that the faces correspond as well, a point that is certainly correct and that underscores the direct relationship between the two.

It is difficult to ascertain how Rubens came into contact with a Korean man since contact between Europe and Korea was almost nonexistent in his time. However, at least one documented case of a Korean living in Italy is known, and it is possible that the man depicted in the drawing came with a Chinese mission.[2] The small boat sketched in the left background would appear to emphasize his having been a visitor from a distant place.

Since the time of Wortley's basic article (1934–1935), the *Korean Man* has been considered as part of a group of five drawings of comparable size and medium, the other four representing Caucasian men in Chinese costume. Wortley associated them all with a Jesuit festi-

val of 1622 and dismissed the connection between the *Korean Man* and the figure in *The Miracles of Saint Francis Xavier* (1934–1935, p. 44). The first to propose that the *Korean Man* may have been drawn earlier than the other four were Burchard and d'Hulst (1963, vol. 1, p. 232).

The subject is the only one of the five to be shown in a full spatial context with a background. The others (Wortley 1934–1935, pls. 42–45) are looser in style, with the exception of the drawing in the Robert Smith collection, Washington, D.C. (Wortley 1934–1935, pl. 44), which appears to be an autograph replica of the more rapid study in the Nationalmuseum, Stockholm (inv. c3441; Wortley 1934–1935, pl. 43).[3] The remaining two drawings, in the art market, New York, and the Pierpont Morgan Library (inv. III, 179; Wortley 1934–1935, pls. 42, 44) are quite linear in style, as is the Stockholm sheet. Given these differences, it is likely that Burchard and d'Hulst were correct in situating these four studies in the mid-1620s, well after the *Korean Man*.

The Museum's drawing is remarkably exact in the rendering of details of drapery and especially in the face, where rich highlights were added by Rubens in red. The sheet's graphic character underscores the likelihood that it is an independent portrait drawing.[4]

1. The precise nature of the costume is explained as "a kind of mourning dress worn by Korean gentlemen" in a letter to the author of December 1, 1983, from M. Jaffé, who refers to the opinion of the Korean ambassador to London as the source of this information. In an article in the *Korea News Review* (1983, p. 25), kindly sent to the author by Jaffé, the anonymous author states that unnamed historians consider the costume to be typical formal dress worn by Yi dynasty commoners at formal functions. First to note that the costume is Korean was B. Gray (Wortley 1934–1935, p. 42, n. 1).

2. "Who Was Korean Model . . ." (1983). The Korean taken to Italy arrived there in 1598 as a boy and took the name Antonio Corea.

3. Given the autograph notes on the sheet (as well as a thin, linear marginal sketch of the same subject at the top left margin which is fully characteristic of the artist), there is no substantial reason to believe that the Smith drawing is by anyone other than Rubens. Its more labored character results from the fact that it is a replica.

4. A copy of the head of the *Korean Man* appears in a drawing in red chalk in the Statens Museum for Kunst, Copenhagen (inv. v, 64). There is also an engraving after the drawing, dated June 17, 1774, and done by Captain William Baillie while the latter was in the collection of R. Willett. The print is inscribed *The Siamese Ambassador who attended the Court of K. Charles the 1st. Rubens made the above described drawing before he left England. Anno 1630.*

94 Studies of Women

Black, red, and white chalk, lower right corner replaced;
H: 44.9 cm (17 11/16 in.); W: 28.9 cm (11 3/8 in.)
82.GB.140

MARKS AND INSCRIPTIONS: At bottom, right of center, collection mark of Prosper Henry Lankrink (L. 2090).

PROVENANCE: Prosper Henry Lankrink, London; Dr. Nicholas Beets, Amsterdam; A. S. Drey, Munich; Dr. Gollnow, Stettin; Dr. Anton Schrafl, Zurich (sale, Christie's, London, December 9, 1982, lot 78).

EXHIBITIONS: None.

BIBLIOGRAPHY: T. W. Muchall-Viebrook, *Flemish Drawings of the Seventeenth Century* (London, 1926), pp. 27–28, no. 4; G. Glück and F. M. Haberditzl, *Die Handzeichnungen von Peter Paul Rubens* (Berlin, 1928), p. 28, no. 3; M. Jaffé, "Rubens' Drawings at Antwerp," *Burlington Magazine* 98, no. 642 (September 1956), p. 317; H. Voss, "Eine unbekannte Rubens-Zeichnung nach Tizian," in P. de Keyser, ed., *Miscellanea Prof. Dr. D. Roggen* (Antwerp, 1957), pp. 279–280; J. S. Held, *Rubens: Selected Drawings* (London, 1959), vol. 1, p. 123, under no. 64; L. Burchard and R.-A. d'Hulst, *Rubens Drawings* (Brussels, 1963), pp. 244–245, no. 158; M. Jaffé, "Rubens as a Draughtsman," *Burlington Magazine* 107, no. 748 (July 1965), p. 381, no. 159; D. Rosand, "Rubens Drawings," *Art Bulletin* 48, no. 2 (June 1966), p. 245; M. Jaffé, "Figure Drawings Attributed to Rubens, Jordaens, and Cossiers in the Hamburger Kunsthalle," *Jahrbuch der Hamburger Kunstsammlungen* 16 (1971), p. 43; idem, *Rubens and Italy* (Oxford, 1977), p. 33, pl. 16; H. Vlieghe, "Review of M. Jaffé, *Rubens and Italy*," *Burlington Magazine* 120, no. 904 (July 1978), p. 473; K. L. Belkin, *The Costume Book*, Corpus Rubenianum Ludwig Burchard, vol. 24 (Brussels, 1980), p. 51, n. 62; J. S. Held, *The Oil Sketches of Pieter Paul Rubens* (Princeton, 1980), vol. 1, p. 324; M. C. Volk, "Rubens in Madrid and the Decoration of the King's Summer Apartments," *Burlington Magazine* 123, no. 942 (September 1981), p. 520; J. S. Held, "Rubens and Titian," in D. Rosand, ed., *Titian: His World and his Legacy* (New York, 1982), p. 306; M. C. Volk, "On Rubens and Titian," *Ringling Museum of Art Journal* (1983), pp. 143, 152; J. S. Held, *Rubens: Selected Drawings* (Mt. Kisco, 1986), pp. 56; 137, no. 175; pl. 5.

THE VENETIAN INSPIRATION FOR THIS SHEET OF studies was already recognized by Muchall-Viebrook (1926), but the specific relationship to Titian was first mentioned by Glück and Haberditzl (1928, p. 28).[1] The latter pointed out that the head at the bottom center of the sheet was copied from Titian's *Venus and Adonis* (1554; Madrid, Prado); the head, arm, and half-length nude in the center from his *Diana and Actaeon* (1559); and the remaining heads from the *Diana and Callisto* (1559; both Collection of the Duke of Sutherland, on loan to the National Gallery of Scotland, Edinburgh). Glück and Haberditzl regarded the drawing as dating from Rubens' early visit to Spain (1603–1604), but all scholars since Jaffé (1956, p. 317) have situated it correctly during his visit to Madrid in 1628–1629. The two Sutherland paintings were hanging together in the first room of the royal palace when Cassiano del Pozzo visited that city in 1626, and the *Venus and Adonis* was two rooms away (Volk 1981, pp. 519–520). It is therefore entirely understandable that motifs taken from all three would be intermingled on one sheet. From the report of Pacheco, it appears that Rubens also made painted copies of all three paintings as well as the other Titians in the Spanish royal collection (Jaffé 1977, p. 33; Held, in Rosand 1982, p. 306). Apparently, only one of these painted copies has survived, the *Diana and Callisto* (Knowsley, Earl of Derby). It has been suggested by Jaffé (1971, p. 43) that Rubens already had these copies in mind when he made this drawing, whereas A.-M. Logan believes the drawing was made for its own sake, reflecting Rubens' interest in the paintings.[2] She is certainly correct in pointing out that the sheet is more than a direct copy; it contains none of the characteristics one would expect to find in a drawing made principally to record forms for later use. This does not invalidate the possibility that it was used later when Rubens painted his copies after Titian. Indeed it was noted by Burchard (Glück and Haberditzl 1928, p. 28) that the head at the bottom right of the sheet reappears in Rubens' painting *The Bath of Diana* (circa 1632–1635; Rotterdam, Museum Boymans-van Beuningen). Similarly, the attendant wiping Diana's feet in Rubens' *Diana and Callisto* now in the Prado appears to reflect the lower two heads on the sheet, as was already hinted by Held (1982, p. 324). Although no doubt made as a spontaneous reaction to Titian's pictures, the drawing clearly had considerable usefulness to Rubens in his own paintings.

In terms of style, the drawing is exemplary of the artist's graphic colorism. It was made in a *trois crayons*

technique anticipating Watteau, who must have been inspired by drawings of this kind when he studied Rubens' work in Parisian collections. At the same time, its naturalism and expansiveness of form separate it from the more classical figures of Titian on which it is based.

1. The drawing has been accepted by all scholars as by Rubens with the exception of Vlieghe (1978, p. 473), who offered no reasons for his doubts, which are certainly as unwarranted as they are unsupported. In addition to published views, the drawing is accepted by E. Haverkamp-Begemann, Logan, and C. White (conversations with the author, 1982–1986).
2. Conversation with the author, Malibu, 1985. Held (1986, p. 138) agrees.

95 *Seated Woman*

Pen and brown ink and graphite; H: 15 cm (5⅞ in.); W: 17.6 cm (6¹⁵⁄₁₆ in.)
83.GA.383

MARKS AND INSCRIPTIONS: Inscribed *gris mus, swartte purperren, swardtten mantel, swartte purpperen Rock, blauue Rock* in pen and brown ink and graphite by Savery.

PROVENANCE: Adolf Friedrich Albert Reinicke; by descent to Martin Reinicke, Darmstadt (sale, Sotheby's, Amsterdam, November 15, 1983, lot 145).

EXHIBITIONS: *Pieter Bruegel d. Ä. als Zeichner*, Kupferstichkabinett, Berlin, September–November 1975, no. 239 (catalogue by F. Anzelewsky et al.).

BIBLIOGRAPHY: J. Spicer-Durham, "The Drawings of Roelandt Savery," unpub. Ph.D. diss., Yale University, 1979, vol. 2, p. 617, no. C 186.

THIS DRAWING COMES FROM THE WELL-KNOWN SERIES of studies similar to one another in subject and style which was long considered to be the work of Pieter Bruegel the Elder. The studies were convincingly attributed to Savery by J. Spicer and F. van Leeuwen, whose views have received general support.[1] Many of the sheets are inscribed *naer het leven*, which Spicer has interpreted as indicating that they reflect reality rather than being copies from nature (Spicer-Durham 1979, vol. 1, pp. 211–212).

The *Seated Woman* and other drawings of the *naer het leven* group are inscribed by Savery with color notes, suggesting that their subjects were intended for use in paintings. They all have been dated by Spicer (1979, vol. 1, p. 217) to 1603–1608/09, when the artist was in Prague. She has situated the *Seated Woman* relatively early in the sequence, noting its similarity in style to a study in the Museum Boymans-van Beuningen, Rotterdam (1979, vol. 2, no. C 185 F 182).[2]

1. J. Spicer, "The 'Naer Het Leven' Drawings: By Pieter Bruegel or Roelandt Savery?" *Master Drawings* 8, no. 1 (1970), pp. 3–30; F. van Leeuwen, "Figuurstudies van 'P. Bruegel,'" *Simiolus* 5, nos. 3/4 (1971), pp. 139–149.
2. L. Münz, *Bruegel: The Drawings* (London, 1961), pl. 94.

96 Seated Man

Pen and brown ink and graphite; H: 15.4 cm (6 1/16 in.);
W: 17.5 cm (6 15/16 in.)
83.GA.382

MARKS AND INSCRIPTIONS: Inscribed *swardte mus*, *swartte rock*, *witte doeckker*, *nar hedt leuen* in pen and brown ink and graphite by Savery.

PROVENANCE: Adolf Friedrich Albert Reinicke; by descent to Martin Reinicke, Darmstadt (sale, Sotheby's, Amsterdam, November 15, 1983, lot 144).

EXHIBITIONS: *Pieter Bruegel d. Ä. als Zeichner*, Kupferstichkabinett, Berlin, September–November 1975, no. 238 (catalogue by F. Anzelewsky et al.); *The Age of Bruegel: Netherlandish Drawings in the Sixteenth Century*, National Gallery of Art, Washington, D.C., and Pierpont Morgan Library, New York, November 1986–January 1987 and January–April 1987, no. 102 (catalogue by J. O. Hand et al.).

BIBLIOGRAPHY: J. Spicer-Durham, "The Drawings of Roelandt Savery," unpub. Ph.D. diss., Yale University, 1979, vol. 2, p. 661, no. C 227.

THIS IS PART OF THE SAME SERIES OF DRAWINGS BY Savery as the *Seated Woman* (see previous entry). It has been dated later in the sequence by Spicer (1979, vol. 1, p. 221), who has noted that it and drawings related to it show an increased interest in volume and in the expressive potential of line. She has pointed out that the later *naer het leven* drawings are characterized by the use of a system of cross-hatching with short, hooked strokes of the pen. The relative chronology proposed by her appears convincing and would account for graphic differences between this drawing and the *Seated Woman*. Spicer has dated the *Seated Man* to the period between 1606 and 1608/09 and has related it to other drawings from the series in a private collection, Darmstadt (Anzelewsky et al. 1975, figs. 271, 274).

97 *Landscape with Waterfall*

Black chalk and red wash; H: 31.9 cm (12⁹⁄₁₆ in.); W: 41.1 cm (16³⁄₁₆ in.)
83.GB.381

MARKS AND INSCRIPTIONS: At bottom left foreground on rock, signed *SAVERY FE* in black chalk.

PROVENANCE: Private collection, Indonesia (sale, Christie's, Amsterdam, November 15, 1983, lot 12).

EXHIBITIONS: None.

BIBLIOGRAPHY: None.

THIS UNPUBLISHED DRAWING BY SAVERY FIRST AP-peared in a Christie's, Amsterdam, sale in 1983 (November 15, 1983, lot 12).[1] It is composed of several motifs that recur frequently in his work, such as the waterfall, the elaborate rock formation, and the remains of a round temple in the distance. Rather than being an accurate to-pographical rendering, this composition probably was drawn from the artist's imagination, though it was based on forms he had seen at various points in his travels. The drawing seems to date from relatively late in his career, perhaps the early 1620s, since it clearly relates to other works of that period.[2] The use of black chalk with col-ored wash continues the technique employed for his Al-pine drawings,[3] as do a number of the individual motifs.

1. The attribution was first affirmed by E. Haverkamp-Begemann at the time of the Christie's sale, a view he has since confirmed.
2. K. Müllenmeister et al., *Roelandt Savery in seiner Zeit (1576–1639)*, exh. cat., Wallraf-Richartz Museum, Cologne, 1985, nos. 49, 50, 54.
3. J. Spicer-Durham, "The Drawings of Roelandt Savery," unpub. Ph. D. diss., Yale University, 1979, vol. 1, pp. 68–69.

98 The Crypt of a Church with Two Men Sleeping

Pen and dark brown ink, brown wash, graphite, and white gouache heightening on tan paper; H: 12.3 cm (4¹³⁄₁₆ in.); W: 16.5 cm (6½ in.)
84.GG.42

MARKS AND INSCRIPTIONS: (Verso) on mount, signed(?) and dated *Henri van Steinwijck / 1625* in brown ink.

PROVENANCE: Private collection, The Netherlands (sale, Christie's, Amsterdam, November 26, 1984, lot 64).

EXHIBITIONS: None.

BIBLIOGRAPHY: None.

ALTHOUGH THE PAINTED WORK OF STEENWIJCK THE Younger is well known, his drawings have never been successfully identified, and the few attributions to him have been hypothetical at best. This previously unknown drawing appeared at Christie's, Amsterdam (1984), with a convincing attribution to him. The dimly lit, vaulted interior, with sleeping soldiers and a deep perspectival rendering of space, is completely characteristic of his paintings such as the *Liberation of Saint Peter* (Pasadena, Norton Simon Museum). Combined with the date and probable signature on the verso of the sheet, this similarity makes his authorship of the Museum's drawing a virtual certainty. It may have served as a preparatory *modello* for a painting, but it seems far more likely that the sheet was composed as an independent work, given its high degree of completeness. Furthermore, the seventeenth-century frame in which it has been preserved suggests that it was viewed as a finished composition from an early time.

recto

PIETER STEVENS

99 A Wooded Landscape with Travelers by a Stream, a Town Beyond

Pen and brown ink and red and blue wash; H: 21.4 cm (8⁷⁄₁₆ in.); W: 33.3 cm (13⅛ in.)
84.GG.807

MARKS AND INSCRIPTIONS: At bottom left corner, dated *97* in brown ink; on mount, inscribed *Savery* in brown ink by a later hand.

PROVENANCE: Christopher Head, London; by descent to the current owner (sale, Christie's, Amsterdam, November 26, 1984, lot 4).

EXHIBITIONS: None.

BIBLIOGRAPHY: None.

THIS DRAWING INITIALLY APPEARED AT CHRISTIE'S, Amsterdam (1984), with a correct attribution to Stevens. It has been pointed out by various scholars, including A. Zwollo, that the *97* inscribed in the bottom left corner refers to the date 1597.[1] In her fundamental study of the artist, Zwollo describes the painterly intensity and coloristic richness of Stevens' drawings at this moment in his career.[2] These effects are largely the result of the application of reddish wash highlights in the trees and blue wash in the sky. The rather flexible pen strokes and broad wash areas lend an atmospheric quality to the scene. From both a stylistic and a thematic point of view, this drawing is analogous to a landscape by Stevens in the Frits Lugt Collection, Institut Néerlandais, Paris (inv. 1693).[3] The town described at the right has not yet been identified, but similar structures appear often in Stevens' work.[4]

1. Conversation with the author, 1984.
2. A. Zwollo, "Pieter Stevens, Ein vergessener Maler des Rudolfinischen Kreises," *Jahrbuch der Kunsthistorischen Sammlungen in Wien* 64, new ser. 28 (1968), p. 159.
3. Ibid., fig. 200.
4. Ibid., figs. 205, 223, 231, 232, 234.

STRADANUS (Jan van der Straet)

100 The Arno with Fishermen

Pen and brown ink, brown and blue wash, and white gouache heightening on gray paper, irregular section cut out and replaced at bottom center by artist; H: 20.3 cm (8 in.); W: 30 cm (11 13/16 in.)
83.GG.380

MARKS AND INSCRIPTIONS: (Recto) at bottom left corner, inscribed *j. Stradanus* in brown ink; (verso) collection marks of John Clermont Witt (L. 656a), W. A. Baillie-Grohman (L. 370).

PROVENANCE: W. A. Baillie-Grohman, London and Château de Matzen, Tyrol; John Clermont Witt, London; private collection (sale, Christie's, Amsterdam, November 15, 1983, lot 3).

EXHIBITIONS: None.

BIBLIOGRAPHY: None.

COSIMO I COMMISSIONED FROM STRADANUS DESIGNS for tapestries showing hunting scenes to decorate the Medici villa at Poggio a Caiano. The first tapestry made after Stradanus' designs was executed in 1567, but the project was still incomplete ten years later.[1] Four of the designs resulting from this program were engraved in 1570 and another forty in 1578.[2] The engraving made from the Museum's drawing appears as plate 42 in the second of these series, which is dedicated to Cosimo I de' Medici. The planned tapestry series for Poggio a Caiano included fishing scenes,[3] and it is not unlikely that this drawing reflects one of those original designs. In addition the engraving was copied in a stucco relief in the courtyard of the Palazzo della Gherardesca, Florence.[4]

The scene represented shows fishermen on the Arno, with a personification of the river and the *marzocco* of Florence beneath him. The lower central section of the original sheet has been cut out, and the portion containing the river god is a replacement for a version discarded by Stradanus. It has been suggested by L. Hendrix that this may have been done in order to include the personification of the Arno. This drawing is complementary to another by Stradanus showing fishing on the Arno at flood season (as opposed to low water and from the opposite direction) (Witt collection, London, inv. 1634; formerly Baillie-Grohman collection, London).[5]

1. D. Heikamp, "Die Arazzeria Medicea im 16. Jahrhundert, Neue Studien," *Münchner Jahrbuch der bildenden Kunst* 20 (1969), pp. 47–57.
2. F. W. H. Hollstein, *Dutch and Flemish Etchings, Engravings and Woodcuts, ca. 1450–1700* (Amsterdam, 1949), vols. 4, nos. 512–515; 7, nos. 528–567.
3. Heikamp (note 1) pp. 49–50.
4. D. van Sasse van Ysselt, "Il Cardinale Alessandro de' Medici committente dello Strandano (1585–1587)," *Mitteilungen des Kunsthistorischen Institutes in Florenz* 24 (1980), pt. 2, p. 218.
5. As mentioned in Christie's, Amsterdam, sale catalogue (November 26, 1984); see W. A. Baillie-Grohman, *Sport in Art. An Iconography of Sport* (London, 1919), fig. 78.

recto

101 Figures on a Frozen Canal

Pen and dark brown ink, watercolor, and gouache; H: 27.6 cm (10¹³⁄₁₆ in.); W: 44.2 cm (17⁷⁄₁₆ in.)
85.GC.222 (SEE PLATE 13)

MARKS AND INSCRIPTIONS: At bottom left corner, signed *Battem* in dark brown ink.

PROVENANCE: H. Tersmitten, Amsterdam (sale, de Bary and Yver, Amsterdam, September 23 et seq., 1754, M514 or M515); Muilman (sale, Amsterdam, March 29, 1773, A4 or A5); Witsen, Amsterdam (sale, Amsterdam, August 16, 1790, A3); sale, Amsterdam, October 19, 1818, E13(?);[1] Witsen collection; F. Adama van Scheltema (sale, Muller, Amsterdam, June 11–14, 1912, lot 7); A. O. Meyer collection, Hamburg (sale, C. G. Boerner, Leipzig, March 19–20, 1914, lot 115); private collection; art market, London.

EXHIBITIONS: None.

BIBLIOGRAPHY: W. Schulz, *Die holländische Landschaftzeichnung 1600–1740*, exh. cat., Kupferstichkabinett, Berlin, 1974, p. 5, under no. 11.

THIS IS ONE OF A GROUP OF WINTER CITYSCAPES MADE by van Battem in richly colored gouache as independent works. They are all of comparable size and depict presumably imaginary scenes, with figures disporting in settings combining architecture—both monumental and rustic—and landscape. Closest to this drawing are examples in the Kupferstichkabinett, Berlin (inv. 1299),[2] and one sold by C. G. Boerner (Leipzig, November 7, 1929, lot 8). None of these gouaches are dated, but the rather tight and precise figure style and rendering of costume would suggest the decade of the 1670s. The combination of visual elements here is fanciful and thus is typical of van Battem, who "paraphrased topographical drawings" so that the original forms often became unrecognizable.[3] His work is perhaps closest to that of Abraham Beerstraaten in the overall blending of architecture and lively figures and the characterization of trees. However, the crisply drawn, elegant group at the left of this gouache may have more in common with Gerrit Berckheyde, just as the rowdier configuration at the right is more reminiscent of Adriaen van Ostade.

1. Detailed provenance information was kindly conveyed to the author by F. J. Duparc from the unpublished Ph.D. dissertation of Hans Verbeek (Rijksuniversiteit te Leiden, 1983).
2. W. Bernt, *Die niederländischen Zeichner des 17. Jahrhunderts* (Munich, 1957), vol. 1, no. 35.
3. D. Carasso et al., *Opkomst en bloei van het Noordnederlandse stadsgezicht in de 17de eeuw*, exh. cat., Amsterdams Historisch Museum, Amsterdam, 1977, p. 142.

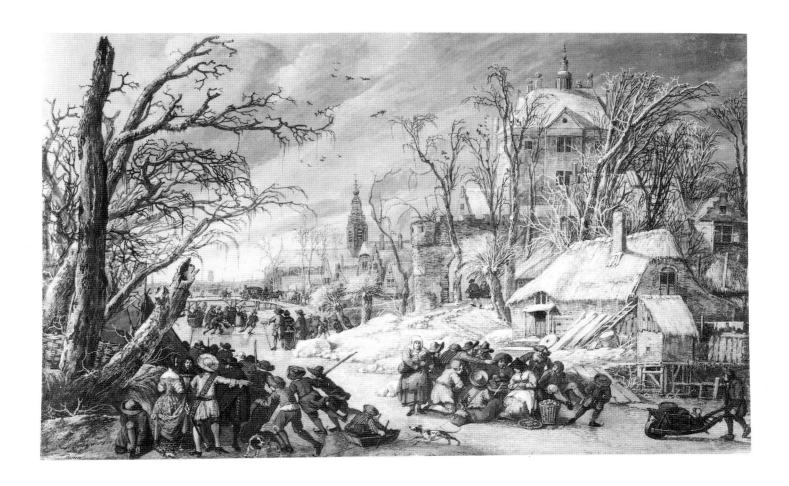

102 Three Studies of a Woman[r]
Four Studies of Hands and a Counterproof of a Kneeling Young Man[v]

Red chalk and white gouache heightening; H: 25.1 cm
(9⅞ in.); W: 17.2 cm (6¾ in.)
83.GB.375 (SEE PLATE 12)

MARKS AND INSCRIPTIONS: (Recto) at top right corner,
inscribed *76* in brown ink; (verso) inscribed *77* in brown
ink.

PROVENANCE: André Giroux, Paris (sale, Paris, April
18–19, 1904, part of lot 175); Loys Delteil, Paris; Mme
L. Delteil, Paris (sale, Paris, February 21, 1935); private
collection, Paris.

EXHIBITIONS: *Dessins des écoles du nord*, Galerie Claude
Aubry, Paris, 1974, no. 12.

BIBLIOGRAPHY: C. van Hasselt, *Rembrandt and His Cen-
tury: Dutch Drawings of the Seventeenth Century*, exh. cat.,
Pierpont Morgan Library, New York, and Institut Néer-
landais, Paris, 1978, p. 21, under no. 11; K. G. Boon, *At-
traverso il Cinquecento neerlandese: Disegni della Collezione
Frits Lugt Institut Néerlandais Parigi*, exh. cat., Istituto
Universitario Olandese di Storia dell'Arte, Florence, and
Institut Néerlandais, Paris, 1980, p. 41, under no. 27.

THIS IS ONE OF 136 BLOEMAERT DRAWINGS THAT
were in the Giroux collection, Paris, until 1904, and that
consist mainly of figure studies in red chalk. The recto
contains three renderings of the same model, who may
also be represented in a drawing in the Frits Lugt Collec-
tion, Institut Néerlandais, Paris (inv. 4881; van Hasselt
1978, no. 11), and in several others. There is no painting
or print by Bloemaert that relates directly to these stud-
ies, but the profile image looking upward recalls the Vir-
gin in the *Annunciation* by Jacob Matham after Bloemaert
(B.65[147] v.4,3). The counterproof of a kneeling man on
the verso bears a general resemblance to various depic-
tions of shepherds in Adoration scenes by Bloemaert,
and the different hands represented on the verso would
accord with gestures for such a depiction, but none are

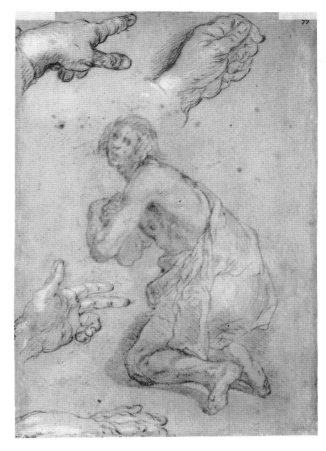

verso

close enough to be connected with specific composi-
tions. The hand studies are comparable to those on a sheet
in the Musée des Beaux-Arts, Rouen.[1] Van Hasselt (1978,
no. 11) and J. Bolten[2] have dated the Lugt sheet to the
1620s, a date that would appear correct for this drawing
as well. Since these and other drawings from the Giroux
series bear numbers at the upper right, it is likely that van
Hasselt was correct in proposing that they all came from
a single album.

1. O. Popovitch, *Choix de quelques peintures et dessins de la do-
nation H. et S. Baderou* (Rouen, 1977), n.p.
2. Bolten has proposed that this album was probably meant as
an exercise sketchbook to be copied by students in Bloemaert's
atelier, rather than as a collection of preparatory studies (in con-
versation with L. Hendrix, February 1987).

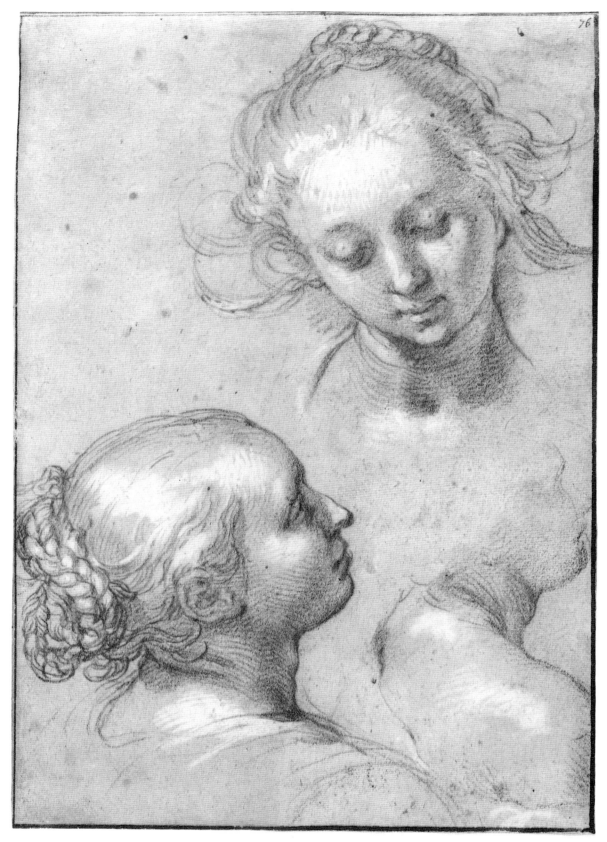

recto

103 Two Male Nudes

Grisaille in oil on paper; H: 27.2 cm (10¹¹⁄₁₆ in.); W: 19.2 cm (7⁹⁄₁₆ in.)
84.GG.32

MARKS AND INSCRIPTIONS: (Verso) inscribed *2* in brown ink.

PROVENANCE: Private collection, France (sale, Hôtel Drouot, Paris, February 15, 1984, lot 37).

EXHIBITIONS: None.

BIBLIOGRAPHY: J. O. Hand et al., *The Age of Bruegel: Netherlandish Drawings in the Sixteenth Century*, exh. cat., National Gallery of Art, Washington, D.C., and Pierpont Morgan Library, New York, November 1986–January 1987 and January–April 1987, p. 121, under no. 39, n. 2.

THIS OIL-ON-PAPER STUDY FIRST APPEARED AT AUCtion in Paris in 1984 with the correct attribution to Cornelis by C. van Hasselt.[1] Two other works in this medium are known by the artist,[2] who seems to have made them with some frequency, to judge from those mentioned in his inventory.[3] Van Thiel has suggested that Cornelis' oil study on paper in the Rijksmuseum, Amsterdam, *Studies of a Seated Naked Man and of Two Women* (inv. 65:167), was made in preparation for a painting,[4] and the same may well be true of the Museum's drawing. The latter, which may be a study for only a portion of a composition, has thus far defied iconographic interpretation. As L. Hendrix has pointed out, the visual contrast between muscular adult men and young boys occurs elsewhere in Cornelis' work, notably in the drawing *Olympic Games* (Warsaw, Gabinet Rycin Biblioteki Uniwersyteckiej, inv. 497),[5] his painting of the Massacre of the Innocents (Haarlem, Frans Halsmuseum), and the engraving by Muller after Cornelis of *Ulysses and Irus* (B.30[276] v.4,3). In addition, A.-M. Logan has noted a similar pair of figures at the right of Cornelis' painting *The First Family* (Quimper, Musée Municipal des Beaux-Arts) of 1589.[6] These examples all share a common late Mannerist muscularity characteristic of Cornelis' style at this juncture. In terms of execution, the Museum's study is nearest to the *Mercury* in the Kunstsammlungen der Universität, Göttingen,[7] with its rich tonal modulation and brilliant white accents. These relationships all argue for a date of around 1590 for the *Two Male Nudes*.

1. Van Hasselt's opinion was conveyed to the author by B. de Bayser in 1984.

2. P. J. J. van Thiel, "Cornelis Cornelisz. van Haarlem as a Draughtsman," *Master Drawings* 3, no. 2 (1965), n. 30.

3. A. Bredius, *Künstler-inventare*, vol. 7 (The Hague, 1921), p. 79.

4. P. J. J. van Thiel, "Keuze uit de aanwinsten," *Bulletin van het Rijksmuseum* 13, no. 2 (1965), p. 73.

5. Van Thiel (note 2), no. 20.

6. Letter to the author, June 11, 1986.

7. Van Thiel (note 2), no. 12.

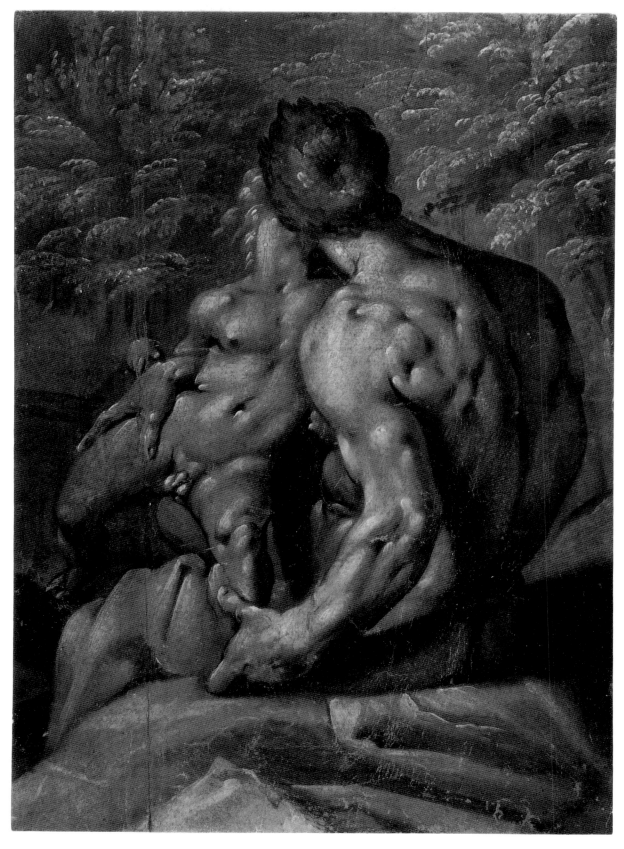

recto

104 *The Town and Castle of Saumur from across the Loire*

Pen and brown ink and brown, gray, red, and green wash on ledger paper; H: 24 cm (9⁷⁄₁₆ in.); W: 41.2 cm (16³⁄₁₆ in.)

84.GA.2

MARKS AND INSCRIPTIONS: (Recto) at bottom right margin, collection mark of William Esdaile (L. 2617); (verso) inscribed *De Stad Samur bij de kerk van St. Lambert / aldus te zien aan de revier d'Loire* in brown ink by Doomer; *abs / Barker 251 July 7, 1845* in graphite.

PROVENANCE: Jeronimus Tonneman, Amsterdam (sale, Hendrik de Leth, Amsterdam, October 21, 1754, probably Book S); William Esdaile, London (sale, Christie's, London, June 18, 1840, lot 1194); sale, Barker, London, July 7, 1845, lot 251; art market, London.

EXHIBITIONS: *Exhibition of Fifty Old Master Drawings,* Baskett and Day, London, 1983, no. 23.

BIBLIOGRAPHY: W. Schulz, "Lambert Doomer 1624–1700, Leben und Werke," unpub. Ph.D. diss., Freie Universität Berlin, 1972, vol. 2, p. 295.

THIS IS ONE OF MORE THAN NINETY DOOMER DRAW-ings on ledger paper formerly in the Tonneman collection, Amsterdam, that were auctioned there in 1754. It is also one of at least twenty depictions of Saumur by the artist (Schulz 1972, vol. 2, pp. 287–295). While Schulz mentions this sheet in his list of lost Doomer drawings (1972, vol. 2, p. 295), he does not make reference to it in his 1974 monograph[1] since the sheet had not yet reappeared. The drawing dates from around 1670 and is based upon another made by the artist in 1646, when he visited Saumur with his friend Schellinks between July 10 and 18 (Schultz 1972, vol. 2, p. 288). The earlier version is in the Musées Royaux des Beaux-Arts de Belgique, Brussels (inv. 1100).[2] It has been proposed by L. Hendrix that the stone structure to the left of the seated draughtsman is the church of Saint-Lambert, an identification supported by the inscription on the verso and by a reference in Schellinks' diary in which he notes his and Doomer's arrival at Saint-Lambert and the beauty of the view of Saumur from that vantage point.[3] Saumur is shown from the north, with the churches of Saint-Pierre at the foot of the château and Notre-Dame de Natilly and Notre-Dame des Ardilliers to the south (Schultz 1972, vol. 2, p. 288).

1. W. Schultz, *Lambert Doomer: Sämtliche Zeichnungen* (Berlin, 1974).
2. W. Sumowski, *Drawings of the Rembrandt School*, vol. 2 (New York, 1979), no. 391.
3. H. van den Berg, "Willem Schellinks en Lambert Doomer in Frankrijk," *Oudheidkundig Jaarboek*, ser. 4, 11 (1942), pp. 14–15.

recto

105 *Mountain Landscape, Peasants in a Clearing near a Waterfall*[r]
Landscape Sketch[v]

Brush and black ink, gray and brown wash, touches of blue and red wash in figures (recto); black chalk (verso); H: 36.9 cm (14½ in.); W: 52.3 cm (20⁹⁄₁₆ in.) 84.GG.50

MARKS AND INSCRIPTIONS: (Recto) at bottom left corner, collection mark of E. Calando (L. 837); at bottom right corner, signed *A.V.E.* on rock in black chalk; (verso) collection mark of Neville D. Goldsmid (L. 1962).

PROVENANCE: Neville D. Goldsmid, The Hague; E. Calando, Paris; private collection (sale, Palais Galliera, Paris, July 3, 1975, lot 7); Davenport collection, Kent; art market, London.

EXHIBITIONS: *Old Master Drawings*, Brian Koetser Galleries, London, 1976, no. 43.

BIBLIOGRAPHY: None.

THIS LARGE SHEET FIRST APPEARED AT A PARIS SALE (1975, lot 7) with an attribution to Savery that was fully understandable in light of its clear relationship to his work. The attribution to Everdingen was first proposed a year later (Koetser Galleries 1976, no. 43), and in spite of occasional suggestions of Waterloo as its author, this proposal is certainly correct, as has been confirmed by E. Haverkamp-Begemann.[1] The basic format recalls several of Everdingen's paintings made soon after his return from Scandinavia, with a richly foliated mountain setting animated by a waterfall.[2] The reduction of figures to a very small scale and the assertiveness of the landscape are characteristic of his work from the period around 1647.[3] The drawing compares closely in some details with another of a rocky landscape with trees (Cambridge, Fitzwilliam Museum, inv. PD. 697-1963),[4] formerly attributed to Savery but now given to Waterloo by J. Spicer,[5] who has associated the latter with drawings by Waterloo that depend on Savery. Rather than indicating Waterloo's authorship of the Museum's drawing, this hypothetical attribution of the Fitzwilliam sheet simply serves to confirm the close association of both drawings to the precedent of Savery's Alpine landscapes. It is interesting to note in this context the close graphic similarity between the left foreground of the Museum's landscape and the same sections of two Savery drawings in the Rijksmuseum, Amsterdam, and Kupferstichkabinett, Berlin (inv. 31:182, KdZ 4017),[6] which Spicer considers to have been reworked by Everdingen in those areas. A drawing similar in scale, medium, and style by Everdingen was sold at Sotheby's, Amsterdam, on November 26, 1984, as lot 65.

1. Conversation with the author, Malibu, 1986.
2. A. Davies, *Allart Van Everdingen* (New York, 1978), nos. 22–24, esp. no. 24.
3. Ibid., pp. 107–108.
4. M. Cormack and M. D. Robinson, *European Drawings from the Fitzwilliam Museum, University of Cambridge*, exh. cat., Pierpont Morgan Library, New York, and other institutions, New York, 1976, no. 90.
5. J. Spicer-Durham, "The Drawings of Roelandt Savery," unpub. Ph.D. diss., Yale University, 1979, vol. 1, p. 71.
6. Ibid., vol. 2, nos. C 19F20, C 20F21.

recto

106 Portrait of Joseph Roulin

Reed and quill pen and brown ink and black chalk; H: 32 cm (12⅝ in.); W: 24.4 cm (9⅝ in.)
85.GA.299 (SEE COVER)

MARKS AND INSCRIPTIONS: None.

PROVENANCE: John Peter Russell, Belle-Isle-en-Mer; sale, Hôtel Drouot, Paris, March 31, 1920, lot 70; A. Hahnloser, Winterthur; Mrs. H. Hahnloser-Bühler, Winterthur; private collection, Switzerland.

EXHIBITIONS: *Vincent van Gogh*, Frankfurter Kunstverein, Frankfurt, 1908, no. 97. *60 Zeichnungen und Aquarelle als Ergänzung der Ausstellung von Meisterwerken aus Privatsammlungen im Museum*, Graphisches Kabinett, Winterthur, August–October 1923, no. 124. *Vincent van Gogh*, Kunsthaus Zurich, July–August 1924, no. 79 (catalogue by W. Wartmann). *Vincent van Gogh*, Galerie Otto Wacker, Berlin, 1927–1928, no. 101 (catalogue by J.-B. de la Faille). *Moderne Aquarelle und Zeichnungen*, Graphisches Kabinett, Winterthur, 1929, no. 60. *Von Ingres bis Picasso*, Galerie Rosengart, Lucerne, July–August 1938. *Die Hauptwerke der Sammlung Hahnloser*, Kunstmuseum Luzern, 1940, no. 181. *Vincent van Gogh*, Kunsthalle Basel, October–November 1947, no. 155 (catalogue by A. M. Hammacher et al.). *Vincent van Gogh: Dipinti e disegni*, Palazzo Reale, Milan, February–April 1952, no. 99 (catalogue by A. M. Hammacher et al.). *Vincent van Gogh*, Kunsthaus Zurich, 1953. *Zeichnungen und Aquarelle von Vincent van Gogh aus dem Besitz des Rijksmuseum Kröller-Müller und von anderen Leihgebern*, Frankische Galerie, Nuremberg, 1956, no. 63. *Europäische Meisterwerke aus schweizer Sammlungen*, Staatliche Graphische Sammlung, Munich, 1969, no. 50 (catalogue by G. Hopp). *Vincent van Gogh: Zeichnungen und Aquarelle*, Frankfurter Kunstverein, Frankfurt, April–June 1970, no. 55 (catalogue by S. Rathke–Köhl). *Van Gogh in Arles*, Metropolitan Museum of Art, New York, 1984, no. 89 (catalogue by R. Pickvance).

BIBLIOGRAPHY: J. van Gogh-Bonger (ed.), *Vincent van Gogh: Brieven aan zijn broeder* (Amsterdam, 1914), vol. 3, p. 133; O. Hagen, "Vincent van Gogh, 16 Faksimiles nach Zeichnungen und Aquarellen," *15. Druck der Marées-Gesellschaft* (Munich, 1919), pl. 4; J.-B. de la Faille,

L'oeuvre de Vincent van Gogh: Catalogue raisonné (Paris and Brussels, 1928), vol. 3, no. 1458; W. Uhde, *Vincent van Gogh: Leben und Werk* (Vienna, 1936), pl. 25; H. Thannhauser, "Documents inédits, Vincent van Gogh et John Russell," *L'amour de l'art* 19, no. 7 (September 1938), p. 284; idem, "Vincent van Gogh and John Russell: Some Unknown Letters and Drawings," *Burlington Magazine* 73, no. 176 (September 1938), p. 104; G. F. Hartlaub, *Vincent van Gogh: Rohrfederzeichnungen* (Hamburg, 1948), vol. 9, pp. 9–10; O. Höver, *Vincent van Gogh als Zeichner* (Emmendingen, 1948), n.p.; A. M. Hammacher, *Van Gogh: Les grands maîtres du dessin* (Milan, 1953), pl. 25; H. R. Hahnloser, "Werke aus der Sammlung Hahnloser," *Du* 16, no. 11 (November 1956), pp. 8, 9; F. Elgar, *Van Gogh* (Paris, 1958), p. 119; R. Huyghe, *Vincent van Gogh* (New York, 1958), pl. 120; H. Jedding, *Van Gogh* (Munich, 1965), p. 12; G. Diehl, *Van Gogh* (Munich, 1966), p. 16; J. J. Kusnetzow and P. V. Meldovoy, eds., *Van Gogh: Pisma* (Leningrad and Moscow, 1966), p. 386; A. M. Hammacher, *Genius and Disaster: The Ten Creative Years of Vincent van Gogh* (New York, 1968), pp. 62, 184; J. Leymarie, *Qui était van Gogh?* (Geneva, 1968), p. 107; H. Keller, *Vincent van Gogh: Die Jahre der Vollendung* (Cologne, 1969), p. 37; J.-B. de la Faille, *The Works of Vincent van Gogh: His Paintings and Drawings* (Amsterdam, 1970) p. 510, no. 1458; M. W. Roskill, "Van Gogh's Exchanges of Work with Emile Bernard in 1888," *Oud Holland* 86, nos. 2–3 (1971), p. 171; J. Hulsker, ed., *Van Gogh door Van Gogh: De brieven als commentar op zijn werk* (Amsterdam, 1973), p. 145; J. Hulsker, "The Intriguing Drawings of Arles," *Vincent* 3, no. 4 (1974), p. 25, n. 2; C. W. Millard, "A Chronology of van Gogh's Drawings of 1888," *Master Drawings* 12, no. 2 (1974), p. 160; J. Hulsker, *The Complete van Gogh: Paintings, Drawings, Sketches* (New York, 1977), no. 1536; B. Bernard, ed., *Vincent by Himself* (London, 1985), p. 198.

AT THE VERY END OF JULY 1888, VAN GOGH WAS engaged in painting a portrait of his close friend the postal worker Joseph-Etienne Roulin seated next to a table.[1] The painting was completed by August 6 and is now in the Museum of Fine Arts, Boston (de la Faille 1970, no. F 432). In the course of making this picture, van Gogh decided also to paint a bust-length version, now in a private collection, Detroit (de la Faille 1970, no. F 433). Posed in the latter version with absolute frontality

against a light blue, rather undifferentiated backdrop, the sitter conveys much more of the Socratic impression made by Roulin on van Gogh than the larger version.[2] It is certain that the painting in Detroit had been completed by August 3 because on that day van Gogh sent this drawing based upon it to his friend the painter John Russell.[3] This sheet is one of a dozen drawings after his own paintings that van Gogh dispatched to Russell, himself an Impressionist painter and friend of several of the leading French artists of his time.

As has often been noted (Pickvance 1984, no. 89), the Museum's drawing differs in a number of respects from the painting in Detroit. In the former the face has been brought much nearer to the viewer, the number of buttons has been reduced to one, the lapels of the coat have been altered, and the background has been made into an elaborate web of horizontal and vertical lines. These changes create an effect that is more concentrated and intense, as well as more animated. Equally, Roulin's expressive character has been altered to appear more engaged and emotive. The emotional complexity results from the more elaborate visual presentation of the face, which has been rendered with richly diverse planes and facets.

The means by which all of this was achieved are no less complex than the result. Van Gogh began by making an under-drawing in black chalk (rarely noted in the literature), the remains of which are clearly visible in the area around the eyes and forehead. Over this he drew with both quill and reed pens, which enabled him to employ widely diverse lines ranging from the thin quill strokes of the background and detailing of the face to the broad reed lines of the hat, cloak, beard, and left side of the head. He also used pointillist dots on one cheek, adding to the variety of technique. The centralized focus of the image, so well achieved in the cloak, contrasts with the sharp differentiation established between the two sides of the face, adding a further dimension to the expressive complexity of this powerful image.

1. *The Complete Letters of Vincent van Gogh* (London and New York, 1958), vols. 2, pp. 623–625 (Letters 516, 517); 3, pp. 1–3 (Letter 518).
2. Ibid., vol. 2, pp. 623–625 (Letters 516, 517).
3. Ibid., p. 625 (Letter 517).

VINCENT VAN GOGH (Dutch, 1853–1890). *Portrait of Joseph Roulin*. Oil on canvas, H: 64 cm (24¼ in.); W: 48 cm (18⅞ in.).
Detroit, Private collection.

107 Venus and Mars Surprised by Vulcan

Pen and brown ink, brown wash, white gouache heightening, and black chalk, folded into squares, incised for transfer, lower right corner replaced; 41.6 cm (16⅜ in.); W: 31.3 cm (12⁵⁄₁₆ in.)

84.GG.810

MARKS AND INSCRIPTIONS: At bottom left corner, inscribed *Hk Goltzius* in graphite; on mount, at bottom right corner, collection mark of H. C. Valkema Blouw (L. 2505).

PROVENANCE: Lord Northwick, London (sale, Sotheby's, London, November 2, 1920, lot 157); private collection (sale, Beijers, Utrecht, June 5, 1946, lot 55); H. C. Valkema Blouw, Amsterdam (sale, Frederik Muller, Amsterdam, March 2–4, 1954, lot 179); private collection, Dordrecht (sale, Sotheby's, Amsterdam, November 26, 1984, lot 29).

EXHIBITIONS: None.

BIBLIOGRAPHY: F. W. H. Hollstein, *Dutch and Flemish Etchings, Engravings and Woodcuts ca. 1450–1700* (Amsterdam, 1957), vol. 8, p. 30, under H. 137; E. K. J. Reznicek, *Die Zeichnungen von Hendrick Goltzius* (Utrecht, 1961), vol. 1, pp. 68–69; 73, no. 105; 271–272; W. L. Strauss, *Hendrik Goltzius: The Complete Engravings and Woodcuts* (New York, 1977), vol. 1, p. 354, no. 216; H. Mielke, *Manierismus in Holland um 1600*, exh. cat., Kupferstichkabinett, Berlin, 1979, p. 24, under no. 2; K. Renger and C. Syre, *Graphik der Niederlande 1508–1617: Kupferstiche und Radierungen von Lucas van Leyden bis Hendrik Goltzius*, exh. cat., Staatliche Graphische Sammlung, Munich, 1979, p. 56; W. L. Strauss, *The Illustrated Bartsch: Netherlandish Artists, Hendrik Goltzius* (New York, 1982), vol. 3, 3, p. 122, under no. 139; E. K. J. Reznicek, "Two Drawings in the Uffizi: Goltzius and Wtewael," *Hoogsteder-Naumann Mercury* 2 (1985), pp. 3–8.

THIS DRAWING SERVED AS A STUDY IN REVERSE FOR AN engraving by Goltzius (B.139[43] v.3,3) dated 1585. As has been pointed out by Strauss (1977, vol. 1, p. 354), there are changes in the print. The arrow in Cupid's bow is now aimed at Mercury, while the cover held by Vulcan no longer has a checked pattern. In addition Goltzius both extended and altered the landscape in the distance. The inscription below the engraving, *HGoltzius invenit sculpsit et divulgavit*, certifies that he acted as engraver, designer, and publisher, which would have permitted him to make alterations of this kind at the last moment, a point noted by A.-M. Logan.[1]

The subject of the drawing and engraving has been shown by Mielke (1979, no. 2) to be derived from Homer's *Odyssey* (8, 266–366). In the drawing Apollo, with Hercules behind him, is at the left; next to them are Jupiter, Mercury, and Neptune. Below, in addition to Vulcan, Mars, Venus, and Cupid in the foreground, a second representation of Vulcan can be seen through an opening at the right. According to Mielke, there is additional byplay in the form of a discussion between Apollo and Mercury, the latter affirming his lustful interest in Venus. In this connection it is noteworthy that Goltzius has Cupid aiming at Mercury in the engraving.

As has been indicated by Reznicek (1961, vol. 1, pp. 68–69), this drawing is illustrative of a change in Goltzius' style toward the late Mannerism of Spranger. In 1588 he made an engraved copy (B.276[84] v.3,3) of a drawing of Mars and Venus by Spranger, which he seems already to have known three years earlier—that is, at the time he made *Venus and Mars Surprised by Vulcan* (Reznicek 1961, vol. 1, no. 105). Given the Sprangeresque subject and style of this engraving, it is possible that Goltzius added the previously mentioned inscription in order to underscore his authorship of both the engraving and the original drawing upon which it was based (Strauss 1977, vol. 1, p. 354). The Museum's drawing belongs to a group of late Mannerist images by Goltzius from the same period, including the newly identified composition *The Apotheosis of Aeneas* in the Uffizi, Florence (Reznicek 1985, fig. 1).

1. Conversation with the author, February 26, 1985.

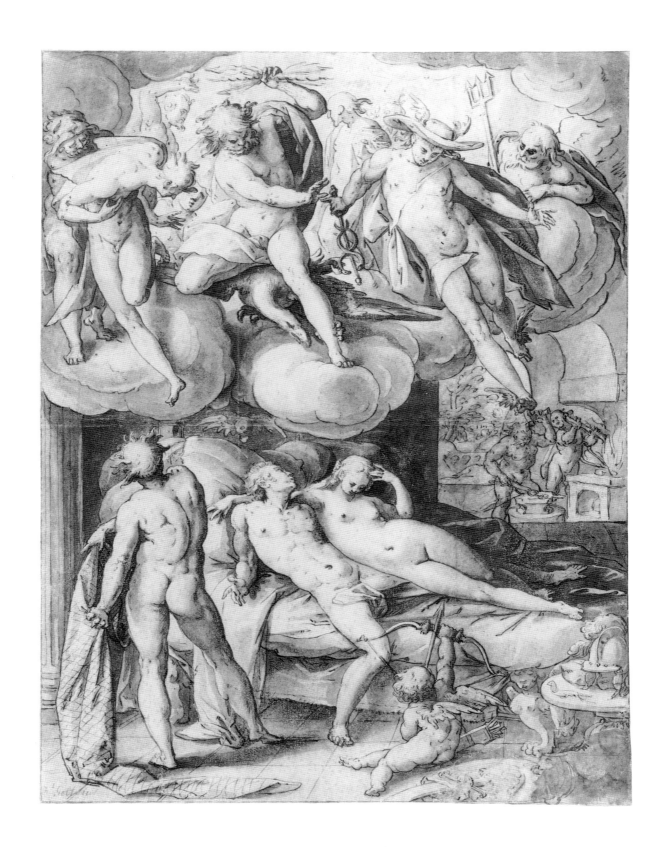

108 A Village Festival with Musicians Playing outside a Tent

Black chalk and gray wash; H: 17 cm (6¹¹⁄₁₆ in.); W: 27.7 cm (10⅞ in.)
85.GG.296

MARKS AND INSCRIPTIONS: At bottom left corner, signed and dated *VG 1653* in black chalk; collection mark of Defer-Dumesnil (L. 739); at bottom right corner, collection mark of Marius Paulme (L. 1910).

PROVENANCE: Pierre Defer, Paris; Henri Dumesnil, Paris (sale, Hôtel Drouot, Paris, May 10, 1900, lot 71); Léonce C. Coblentz (sale, Hôtel Drouot, Paris, December 15, 1904, lot 49); Marius Paulme, Paris (sale, Galerie Georges Petit, Paris, May 13, 1929, lot 94); sale, Sotheby's, Amsterdam, November 26, 1984, lot 107; art market, London.

EXHIBITIONS: None.

BIBLIOGRAPHY: H.-U. Beck, *Jan van Goyen: 1596–1656* (Amsterdam, 1972), vol. 1, no. 385.

THIS IS ONE OF MANY ELABORATE DRAWINGS VAN Goyen made as independent works in his studio; they are often signed and dated. There are well over two hundred such drawings dating from 1653 alone. Among them, this example falls within the group of village market scenes (Beck 1972, vol. 1, nos. 373–393a) in which the artist took full advantage of the proliferation of diverse action and form to create a lively and entertaining composition. In addition to portraying various individuals selling their wares, he included both elegant and ordinary shoppers as well as musicians at the left background who stand on a ladder, playing their instruments for a gathered audience. The energetic and varied use of black chalk accentuates the animated feeling of the drawing.

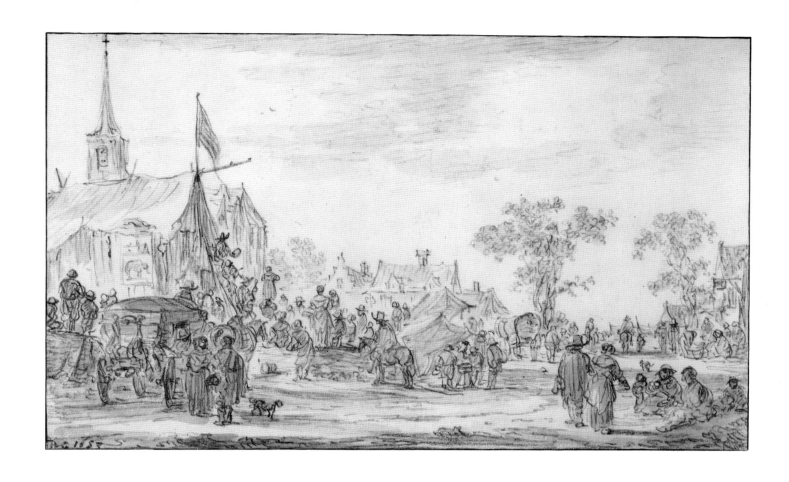

PIETER LASTMAN

109 Study of a Kneeling Man

Red chalk; H: 11.1 cm (4⅜ in.); W: 9.4 cm (3¹¹⁄₁₆ in.)
83.GB.268

MARKS AND INSCRIPTIONS: None.

PROVENANCE: Art market, Boston.

EXHIBITIONS: None.

BIBLIOGRAPHY: None.

THE KNEELING MAN REPRESENTED IN THIS DRAWING corresponds in a number of significant respects to figures in paintings by Lastman. The pose and drapery are comparable to those of the kneeling figure in the center of his *Coriolanus* of 1622 (Dublin, Trinity College).[1] Moreover, in both painting and drawing, the drapery consists of elaborate folds and deeply shadowed long grooves with a very similar motif in front of the knees. These same long drapery folds, richly textured and varied, occur again in Lastman's painting *Bileam and the Angel* of 1622 (Clapton Revel, E. C. Palmer collection).[2] Similarly, the unusual depiction of the eyes, with large whites and sharply defined pupils looking expressively upward, is found in his *Defeat of Maxentius* (Kunsthalle Bremen).[3] This same idiosyncracy and the rendering of the large, tremulous hands recur in the *Offering to Manoah* of 1627 (Saint Peter Port, D. Cevat collection).[4]

These quite clear relationships to his paintings would seem to argue conclusively for an attribution to Lastman. However, there is less available comparative material among his drawings. Only a small number of red chalk studies survive, and they are all looser and less detailed than the Museum's drawing. Nonetheless, among them certain analogies do exist. The large hands and characteristic eyes with stark pupils are found in a study, *Man Carrying a Crate*, in the van Regteren Altena collection, Amsterdam,[5] and another, of Saint Francis, in the Museum Boymans-van Beuningen, Rotterdam.[6] Both drawings exhibit less carefully worked drapery and are much more rapidly drawn in general than the Museum's sheet. However, it should not be assumed that Lastman used red chalk only for quick sketches, especially as this would be contrary to what we know of the drawings of Rembrandt and Lievens. Furthermore, the former owned a book of red chalk drawings by Lastman, suggesting that the medium was of greater importance to him than his small surviving corpus would indicate.[7] Therefore, given its association with his painted figures and certain aspects of his drawings—as well as the absence of any preferable attribution—the ascription to Lastman should be maintained.

1. W. Sumowski, "Rötelzeichnungen von Pieter Lastman," *Jahrbuch der Hamburger Kunstsammlungen* 14/15 (1970), fig. 1.
2. W. Sumowski, "Zeichnungen von Lastman und aus dem Lastman-Kreis," *Giessener Beiträge zur Kunstgeschichte* 3 (1975), fig. 21.
3. K. Bauch, *Der frühe Rembrandt und seine Zeit* (Berlin, 1960), fig. 38.
4. Sumowski (note 2), fig. 7.
5. W. Bernt, *Die niederländischen Zeichner des 17. Jahrhunderts* (Munich, 1958), vol. 2, no. 354.
6. Sumowski (note 1), fig. 4.
7. C. Hofstede de Groot, *Die Urkunden über Rembrandt* (The Hague, 1906), no. 264.

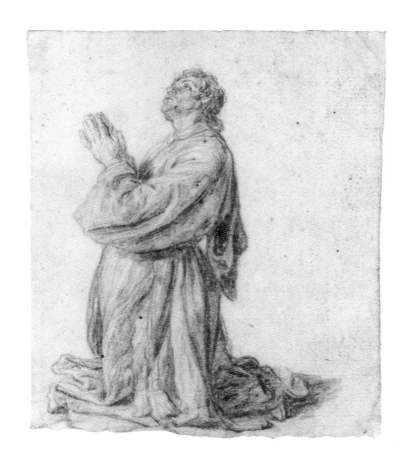

PIETER MOLIJN

110 A Scene on the Ice with Skaters and Wagons

Black chalk and gray wash; H: 14.9 cm (5⅞ in.); W: 19.4 cm (7⅝ in.)
84.GB.809

MARKS AND INSCRIPTIONS: At top right corner, signed and dated *P / · Molÿn / · 1655 ·* in black chalk.

PROVENANCE: Sir Anthony Westcombe, England; Bernard Granville, England; Benjamin Waddington of Llanover House, Monmouthshire; Lord Treowen, Llanover House (sale, Llanover House, Bruton and Knowles, June 26, 1934, lot 997); Alfred Jowett; M. de Beer; Baron Paul Hatvany (sale, Sotheby's, London, July 7, 1966, lot 56); private collection (sale, Christie's, Amsterdam, November 26, 1984, lot 70).

EXHIBITIONS: None.

BIBLIOGRAPHY: None.

THIS IS ONE OF NUMEROUS LANDSCAPE DRAWINGS of the mid-1650s which were made by Molijn as independent works. They frequently were drawn within his own framing lines and are often signed and dated. This example compares closely with a drawing of a winter landscape in the Kupferstichkabinett, Berlin (inv. 3121), which has been related by Schulz to van Goyen's work of around 1650.[1] The Museum's drawing is quite similar to the right side of the drawing in Berlin, as if the scene were shown in reverse and from a much nearer vantage point. The connection to the drawings of van Goyen is pertinent here as well, since several comparable scenes are depicted in his compositions of the late 1640s and early 1650s.[2] They are alike in their processions of figures moving with horses and carts diagonally into the distance on the ice, but van Goyen's scenes are much more anecdotal and include considerable auxiliary detail. Molijn preferred instead to focus on a principal group of figures, thereby creating a composition that is more concentrated and monumental in effect. It has been observed by F. Robinson that Molijn was less optimistic than van Goyen and his scenes more barren and less hospitable.[3] This difference is in part the result of a somewhat less animated chalk stroke, which tended to produce fuller modeling than van Goyen's. The resulting mood is more reflective, conveying as much as anything the isolation of the figures in nature.

1. W. Schultz, *Die holländische Landschaftszeichnung, 1600– 1740*, exh. cat., Staatliche Museen Preussischer Kulturbesitz, Berlin, 1974, no. 121.
2. H.-U. Beck, *Jan van Goyen: 1596–1656* (Amsterdam, 1972), vol. 2, nos. 170, 195, 197, 338, 353.
3. In *Seventeenth Century Dutch Drawings from American Collections*, exh. cat., National Gallery of Art, Washington, D.C., and other institutions, 1977, p. 24.

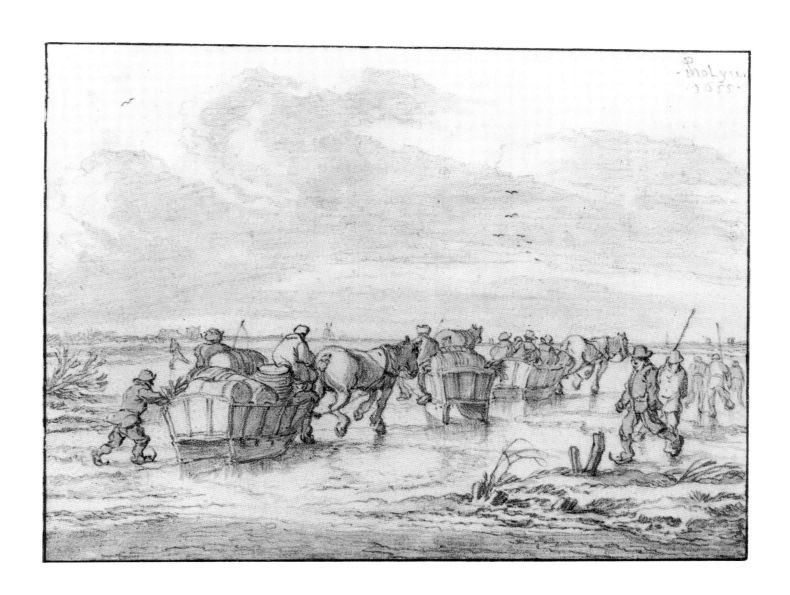

111 Peasant Festival on a Town Street

Pen and brown ink, watercolor, and gouache; H: 20.2 cm (8 in.); W: 31.5 cm (12⅜ in.)
85.GC.439

MARKS AND INSCRIPTIONS: At left on board, signed and dated *Av. ostade. 1674* in brown ink.

PROVENANCE: J. Witsen, Amsterdam (sale, Terwen and de Bosch, Amsterdam, August 16, 1790, Konstboek C, lot 1); Sir Francis Cook, Richmond; by descent; Mr. and Mrs. F. A. Drey, London; Mr. and Mrs. R. E. A. Drey, London; Robert Smith, Washington, D.C.; art market, New York.

EXHIBITIONS: None.

BIBLIOGRAPHY: J. O. Kronig, *Catalogue of the Paintings at Doughty House and Elsewhere in the Collection of Sir Frederick Cook* (London, 1914), vol. 2, no. 306; B. Schnackenburg, *Adriaen van Ostade, Isack van Ostade: Zeichnungen und Aquarelle* (Hamburg, 1981), vols. 1, p. 131, no. 252; 2, fig. 252.

THIS IS ONE OF A GROUP OF WATERCOLORS OF PEASANT scenes by van Ostade which date from the mid-1670s. A preparatory study in pen for the central and right middleground sections of the watercolor is in the Albertina, Vienna (inv. 23497; Schnackenburg 1981, vol. 1, no. 253). This and related watercolors were made as independent works, which must have been sold as if they were small paintings. They also have many figural and compositional details in common, so that the smoker seen from behind and the man with his leg extended in the foreground reappear in several other watercolors of this type, as do the principal figure groups and the diagonally disposed spatial organization. Though they contain coloristic and painterly characteristics, these watercolors derive their animated quality from their vivid pen strokes.

112 *View of Eindhoven from the Northeast*

Pen and brown ink, black and red chalk, and gray, blue, red, and green wash; H: 16.4 cm (6⁷⁄₁₆ in.); W: 22.6 cm (8⅞ in.)
84.GG.649

MARKS AND INSCRIPTIONS: At bottom right corner, inscribed *J. V. Ostade* in brown ink by another hand.

PROVENANCE: Adolf Friedrich Albert Reinicke; by descent to Martin Reinicke, Darmstadt; private collection (acquired in 1978) (sale, Galerie Kornfeld, Bern, June 22, 1984, lot 151); art market, Boston.

EXHIBITIONS: None.

BIBLIOGRAPHY: B. Schnackenburg, *Adriaen van Ostade, Isack van Ostade: Zeichnungen und Aquarelle* (Hamburg, 1981), vols. 1, pp. 54, 61, 190–191, no. 577; 2, fig. 244; P. Schatborn, "Tekeningen van Adriaen en Isack van Ostade," *Bulletin van het Rijksmuseum* 34, no. 2 (1986) pp. 90–91, 92, n. 26; K. Vermeeren, "Isaac van Ostade (1621–1649) tekende de middeleeuwse St.-Catherina-kerk van Eindhoven van twee kanten," *Brabants heem* 38, no. 4 (1986), pp. 228–236.

THIS IS ONE OF A NUMBER OF VIEWS OF TOWNS, farmers' houses, and farm tools which have been attributed to Isack van Ostade by Schnackenburg (1981, vol. 1, nos. 560–580). It is closest by far to another town view of comparable size and medium in the Rijksmuseum, Amsterdam (inv. 1978:65; Schnackenburg 1981, vol. 1, no. 578). Schatborn has identified the site depicted in the Museum's drawing as Eindhoven shown from the northeast (1986, p. 90) and has noted that a drawing by van Ostade of circa 1639/41 (Amsterdam, private collection; Schatborn 1986, no. 424 recto) similarly shows the church at Eindhoven, but from the west. A copy of the Museum's drawing is in the Frits Lugt Collection, Institut Néerlandais, Paris (inv. 110).[1] That watercolor was attributed by van Hasselt to Isack van Ostade,[2] but was already recognized by Schnackenburg as the work of Cornelis Dusart copying van Ostade before the Museum's drawing emerged. The latter shows van Ostade developing a genre of architectural subjects quite independent of the work of his brother. Schnackenburg has dated it and related sheets to the period 1646–1649.

1. C. van Hasselt, *Rembrandt and His Century: Dutch Drawings of the 17th Century*, exh. cat., Pierpont Morgan Library, New York, and Institut Néerlandais, Paris, 1978, no. 78.
2. Ibid.

J. V. ostade.

113 Two Studies of the Head of an Old Man

Pen and brown ink, sheet torn down the center and rejoined; H: 9 cm (3⁹⁄₁₆ in.); W: 15 cm (5⅞ in.)
83.GA.264

MARKS AND INSCRIPTIONS: None.

PROVENANCE: Private collection (sale, Christie's, Amsterdam, November 16, 1981, lot 32); art market, Boston.

EXHIBITIONS: None.

BIBLIOGRAPHY: None.

THIS SHEET MADE ITS FIRST APPEARANCE AT A Christie's, Amsterdam, sale (1981, lot 32) with an attribution to Rembrandt by W. Sumowski. An alternate attribution, to Jan Lievens, has been proposed by P. Schatborn.[1] The attribution to Rembrandt depends in large part on the clear relationship between the head at the right and that of the old man in his painting of 1626, *Christ Driving the Money Changers from the Temple* (Moscow, Pushkin Museum). Not only are the general pose and facial type similar, but the two renderings agree in several significant details. In both, the eyes have been left as undescribed dark caverns, and the ears were rendered as crude geometric forms. In both drawing and painting the furrowed forehead is indicated in a linear manner, and a strong area of shadow—suggested in the drawing and explicit in the painting—begins at the throat and continues behind the ear. Lastly, the two are alike in their pensive and withdrawn expressive characterization. To be sure, there are also differences, especially in the description of the hair at the back of the head, but such divergences are to be expected between a study freely drawn from life and a figure in a finished painting. The sketch of the model at the left on this sheet is more generally related to images by Rembrandt such as the *Portrait of an Old Man* (Staatliche Kunstsammlungen Kassel), but cannot be connected directly to any of them.

By contrast, the attribution to Lievens rests on grounds of graphic style and technique. Schatborn has related the drawing closely to one showing an old woman in the Abrams collection, Boston,[2] pointing to several characteristics that to him are closer to Lievens than to Rembrandt: the thin, smooth lines and thicker ones close to one another in certain areas; the use of broad contours and of dotting; and a tendency toward graphic elegance. Using the early prints of Rembrandt and Lievens as a standard of comparison, he has noted that Rembrandt "is bolder, nearly uglier, and his lines less graphic and regular. . . . He tends to painterly qualities." Schatborn also has pointed to "an ease and a self-evidence that is alien to Rembrandt's earliest drawings," and has stated his belief that the similarities between the painted money changer and the drawn figure "only illustrate [the two artists'] close collaboration."

Taking these arguments in favor of Lievens individually, it may be noted that Rembrandt employed a technique of dotting in his early self-portrait in the Rijksmuseum, Amsterdam (inv. 1961, 75),[3] and continued to use it later as well. The use of thin lines and then thicker ones near each other recurs in a drawing of not many years later showing an old man and another in a turban, formerly in the H. Oppenheimer collection, London.[4] A still closer similarity exists in both technique and date be-

REMBRANDT VAN RIJN (Dutch, 1606–1669). *Christ Driving the Money Changers from the Temple*, 1626 (detail). Oil on panel. H: 43 cm (16¹⁵⁄₁₆ in.); W: 33 cm (13 in.). Moscow, Puschkin Museum 1900. Photo courtesy Puschkin Museum.

tween the Museum's drawing and two of the early chalk drawings of men in the Rijksmuseum, Amsterdam (inv. A 2046, A 2045).[5] In both of these studies, direct parallels can be seen with the Museum's sheet in its broad, sometimes jagged lines, especially along the neck and shoulder of the man at the left and the neck of the one at the right. These are most evident in the left arm of the man facing forward and along the back, neck, and right sleeve of the man with a stick turned to the right in the Rijksmuseum drawings.[6]

A comparison with the Abrams drawing of an old woman does reveal a certain similarity. However, the works differ in important respects. The Abrams drawing is self-contained and timid, lacking the boldness of form and almost crude vigor of the Museum's study. The use of broad pen strokes illustrates the difference between them. In the Museum's drawing these are intrinsic to the design and have been used to develop broad areas such as the neck, shoulder (of the left figure), ear, and back of the head. In the Abrams drawing, broad strokes are employed without apparent consideration of their diverse effect; sometimes they simply continue or reiterate passages already drawn. The same is true of another Lievens drawing of a woman facing left (location unknown) which shows no greater understanding of the differentiation of pen work (the latter often becomes decorative).[7] Therefore it is precisely on the basis of the principal differences between early Rembrandt and Lievens ob-

served by Schatborn that the separation of hands can be established, with the Museum's drawing clearly the work of Rembrandt. It is both bolder and less elegant than Lievens' work, a rendering by a daring if not yet fully formed artistic personality.

It is to be fully expected that at this early point in his career Rembrandt would have been drawing with certain mannerisms of graphic technique analogous to those of Lievens, and it is predictable that the results would differ in just the ways described here. In addition the direct relationship between the drawing and the signed painting of 1626 fully conforms to the evidence of style, situating the former shortly before the two studies of men in the Rijksmuseum. Therefore this early drawing by Rembrandt, one of the few connected to a painting, should be accorded a place as an important datum for the study of his draughtsmanship.

1. Letter to W. Robinson, July 29, 1982.
2. W. Sumowski, *Drawings of the Rembrandt School* (New York, 1983), vol. 7, no. 1639x.
3. O. Benesch, *The Drawings of Rembrandt* (London, 1973), vol. 1, no. 54.
4. Ibid., no. 48.
5. Ibid., nos. 30 recto, 31.
6. Ibid., nos. 31 and 30 recto, respectively.
7. Sumowski (note 2), no. 1641x.

114 Nude Woman with a Snake (as Cleopatra)

Red chalk and white chalk heightening; H: 24.7 cm (9¹¹⁄₁₆ in.); W: 13.7 cm (5⁷⁄₁₆ in.)
81.GB.27 (SEE PLATE 1)

MARKS AND INSCRIPTIONS: None.

PROVENANCE: Fournet, Paris; Otto Gutekunst, London; Villiers David, London (sale, Christie's, London, July 7, 1981, lot 120).

EXHIBITIONS: *Catalogue descriptif des dessins de maîtres anciens*, Ecole des Beaux-Arts, Paris, May–June 1879, no. 371 (catalogue by C. Ephrussi and G. Dreyfus). Burlington Fine Arts Club, London, Winter 1927–1928. *Exhibition of Dutch Art 1450–1900*, Royal Academy of Arts, London, 1929, no. 580 (catalogue by D. Hannema et al.). *Rembrandt Tentoonstelling*, Rijksmuseum, Amsterdam, June–September 1932, no. 238 (catalogue by F. Schmidt-Degener). *Seventeenth Century Art in Europe*, Royal Academy of Arts, London, 1938, no. 539 (catalogue of drawings by A. E. Popham et al.). *Drawings by Old Masters*, Royal Academy of Arts, London, 1953, no. 304 (catalogue by K. T. Parker and J. Byam Shaw). *Rembrandt: Tentoonstelling ter herdenking van de geboorte van Rembrandt op 15 juli 1606. Tekeningen*, Museum Boymans-van Beuningen, Rotterdam, and Rijksmuseum, Amsterdam, May–August and August–October 1956, no. 68 (catalogue by E. Haverkamp-Begemann).

BIBLIOGRAPHY: J. Byam Shaw, *Old Master Drawings* 3, no. 10 (September 1928), pp. 31–32; C. Hofstede de Groot, "Einige Betrachtungen über die Ausstellung holländischer Kunst in London," *Repertorium für Kunstwissenschaft* 50 (1929), p. 141; A. M. Hind, *Commemorative Catalogue of the Exhibition of Dutch Art*, exh. cat., Royal Academy of Arts, London, 1930, p. 198; idem, *Rembrandt* (Cambridge, Mass., 1932), p. 33; O. Benesch, *Rembrandt: Selected Drawings* (London, 1947), p. 28, no. 85; idem, *The Drawings of Rembrandt* (London, 1954), vol. 1, no. 137, fig. 164; idem, *Rembrandt as a Draughtsman* (London, 1960), no. 30; L. Goldscheider, *Rembrandt: Paintings, Drawings and Etchings* (London, 1960), no. 16; C. White, *Rembrandt as an Etcher* (London, 1969), vol. 1, pp. 42, 177–178, fig. 266; O. Benesch, *The Drawings of Rembrandt* (London, 1973), vol. 1, no. 137, fig. 164; M. Bernhard, *Rembrandt: Handzeichnungen* (Munich, 1976), vol. 2, pl. 212; P. Schatborn, *Drawings by Rembrandt in the Rijksmuseum, His Anonymous Pupils and Followers*, Catalogue of the Dutch and Flemish Drawings in the Rijksprentenkabinet, Rijksmuseum, Amsterdam, vol. 4 (The Hague, 1985), pp. 114, n. 5; 257.

THIS DRAWING FIRST APPEARED IN 1879 IN AN exhibition in Paris (no. 371), with a correct attribution to Rembrandt. Its principal characteristics are described in the initial publication of J. Byam Shaw (1928), who identified the subject as Cleopatra and noted the similar use of chalk in the *Study of an Elephant* of 1637 in the Albertina, Vienna (inv. 17.558; Benesch 1973, vol. 2, no. 457). Rich line work rendering remarkably subtle surface textures and volumes is employed in both drawings. Byam Shaw's observation of the sensitive modeling and plasticity of form have been further developed in the penetrating analysis of the drawing by White (1969, vol. 1, p. 177). Taking up a hint by Byam Shaw (1928, p. 32, n. 1) concerning the relationship between the Museum's drawing and Rembrandt's etching *Adam and Eve* (B.28) of 1638, White has suggested that the figure in the former served as the model for Eve in the latter. The two are comparable in proportion and in the volumetric and rather classical presentation of form. Their differences are largely to be explained by thematic context and medium (White 1969, vol. 1, p. 178). The direct relationship between them is enhanced by the proposal—made by Byam Shaw (1928, p. 32)—that the drawing was a rendering of a studio model to which Rembrandt added the specific attributes of Cleopatra. The relationship of the *Cleopatra* to the model in Rembrandt's etching *An Artist Drawing from the Model* (B.192) of circa 1639 adds further weight to this idea. In fact the model is shown in this etching in a comparable pose, with a strongly classical flavor, and holding drapery bunched along her left side much as in the Museum's drawing. Based on these comparisons, the latter is generally dated to circa 1637. It is among the best preserved of the artist's chalk studies, with the luminous white highlights fully intact.

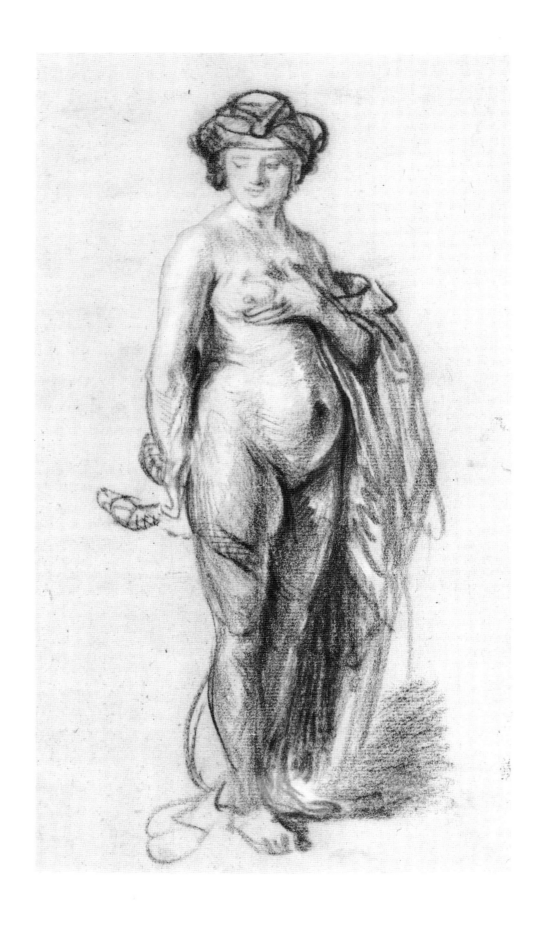

115 Two Thatched Cottages with Figures at a Window

Pen and brown ink, white gouache corrections; H: 13.2 cm (5¼ in.); W: 20.2 cm (7¹⁵⁄₁₆ in.)
85.GA.93

MARKS AND INSCRIPTIONS: None.

PROVENANCE: N. A. Flinck, Rotterdam(?); William, second duke of Devonshire, Chatsworth; by descent to the current duke (sale, Christie's, London, July 3, 1984, lot 61); art market, New York.

EXHIBITIONS: *Exhibition of Dutch Art 1450–1900*, Royal Academy of Arts, London, 1929, no. 603 (catalogue by D. Hannema et al.). *Drawings by Old Masters*, Royal Academy of Arts, London, 1953, no. 313 (catalogue by K. T. Parker and J. Byam Shaw). *Rembrandt: Tentoonstelling ter herdenking van de geboorte van Rembrandt op 15 juli 1606. Tekeningen*, Museum Boymans-van Beuningen, Rotterdam, and Rijksmuseum, Amsterdam, May–August and August–October 1956, no. 100 (catalogue by E. Haverkamp-Begemann). *Old Master Drawings from Chatsworth*, National Gallery of Art, Washington, D.C., and other institutions, 1969–1970, no. 96 (catalogue by J. Byam Shaw). *Treasures from Chatsworth: The Devonshire Inheritance*, Virginia Museum of Fine Arts, Richmond, and other institutions, 1979–1980, no. 96 (catalogue by A. Blunt et al.).

BIBLIOGRAPHY: F. Lippmann, *Original Drawings by Rembrandt*, 1st ser. (Berlin, 1888–1892), no. 65; C. Hofstede de Groot, *Die Handzeichnungen Rembrandts* (Haarlem, 1906), no. 852; A. M. Hind, *The Vasari Society for the Reproduction of Drawings by Old Masters*, 1st ser. (Oxford, 1907), vol. 3, no. 24; C. Neumann, *Rembrandt Handzeichnungen* (Munich, 1918), p. 6; J. Kruse and C. Neumann, *Die Zeichnungen Rembrandts und seiner Schule im Nationalmuseum zu Stockholm* (The Hague, 1920), p. 96; A. M. Hind, *Rembrandt* (Cambridge, Mass., 1932), pp. 104, 105; J. Rosenberg, *Rembrandt* (Cambridge, Mass., 1948), vols. 1, pp. 88–89; 2, fig. 127; H. E. van Gelder, *Rembrandt en het landschap* (Amsterdam, 1948), pp. 10, 20; O. Benesch, *The Drawings of Rembrandt* (London, 1955), vol. 4, no. 796, fig. 944; J. Rosenberg, *Rembrandt: Life and Work* (London, 1964), pp. 152; 353, n. 2a; S. Slive, *Drawings of Rembrandt* (New York, 1965), vol. 1, no. 65; O. Benesch, *The Drawings of Rembrandt* (London, 1973), vol. 4, no. 796, fig. 996.

THIS IS ONE OF FIVE DRAWINGS MADE BY REMBRANDT around 1640 that are similar to one another in setting and technique (Benesch 1973, vol. 4, nos. 794–797, 800). The *Three Cottages* in the Nationalmuseum, Stockholm (inv. 2087; Benesch 1973, vol. 4, no. 795), is closest to the Museum's drawing, as was observed by Hofstede de Groot (1906), and it has been proposed by Benesch (1955, vol. 4, p. 211) that they may represent the same locality. His suggestion gains weight from the fact that the Museum's drawing is unfinished and was originally planned to have three cottages, as can be seen by the existence of a roof for the third one, just as in the study in Stockholm. However, they would have to be free interpretations of their setting for this to be true, since they differ in many minor details. F. Saxl related the Stockholm drawing to an etching of 1641 (B.226; Kruse and Neumann 1920, p. 96), and another in the group, the drawing in the Louvre depicting cottages with a cart (inv. 29029; Benesch 1973, vol. 4, no. 797), was associated with it by Benesch. This provides a clear basis for dating the *Two Thatched Cottages*.

Stylistically, the drawing is filled with vigorous and animated pen work, creating large volumes as well as rich and varied effects of texture and surface. The moss growing on the nearest roof shows Rembrandt's delight in exploring the visual impact of varied, dense lines at this moment in his career. As in very few of his other landscapes, here he almost entirely avoided atmospheric considerations in favor of the building up of monumental architectural and textural forms. Appropriately, the boldness of the quill pen as used by Rembrandt in this study has suggested to many observers the work of van Gogh two and a half centuries later.

116 Christ and the Canaanite Woman

Pen and brown ink and brown wash, white gouache corrections; H: 19.9 cm (7⅞ in.); W: 27.9 cm (11 in.)
83.GG.199

MARKS AND INSCRIPTIONS: At bottom right corner, collection marks of Jonathan Richardson, Sr. (L. 2184), Sir Joshua Reynolds (L. 2364), Thomas Hudson (L. 2432).

PROVENANCE: Jonathan Richardson, Sr., London; Jonathan Richardson, Jr., London; Sir Joshua Reynolds, London; Thomas Hudson, London; H. E. Morritt, Rockby Park, Yorkshire (sale, Christie's, London, July 29, 1937, lot 15); J. B. S. Morritt; by descent to R. A. Morritt (sale, Sotheby's, London, December 4, 1969, lot 20); sale, Christie's, London, April 12, 1983, lot 157.

EXHIBITIONS: None.

BIBLIOGRAPHY: A. M. Hind, *The Vasari Society for the Reproduction of Drawings by Old Masters*, 2nd ser. (Oxford, 1920), vol. 10, no. 11; W. R. Valentiner, *Rembrandt: Des Meisters Handzeichnungen* (Stuttgart, 1934), vol. 2, p. 434, no. 823; O. Benesch, *Rembrandt: Werk und Forschung* (Vienna, 1935), p. 55; J. Rosenberg, *Rembrandt* (Cambridge, Mass., 1948), p. 213; O. Benesch, *The Drawings of Rembrandt* (London, 1957), vol. 5, no. 921, fig. 1132; J. Rosenberg, *Rembrandt: Life and Work* (London, 1964), p. 340; O. Benesch, *The Drawings of Rembrandt* (London, 1973), vol. 5, no. 921, fig. 1196.

THE SCENE DEPICTED HERE SHOWS THE CANAANITE woman who attempted to approach Christ and was turned away at first by the apostles (Matthew 15.22–28). Rembrandt has composed a tightly knit, classical group whose unity is accentuated by an emphatic isocephalism. The woman from Canaan shown at the left is set slightly apart, visually accenting the dramatic moment. The composition has two focal areas: the energetic interplay of the apostle at the left with the Canaanite woman, and the centrally placed figure of Christ who walks on impassively, at this juncture unaware of her presence. Two onlookers appear between the woman and the apostle, situated on a lower ground and animating the scene, as does the finely sketched landscape at the right, which is striking in its economy and spatial suggestiveness.

The drawing is a prime example of how Rembrandt corrected and altered a composition as he worked. The left hand and foot of Christ were covered over in white gouache, and the face of one of the onlookers at the left is partially blotted out in ink. Furthermore, Rembrandt seems to have begun with some detail of the ground at the left, as a spatial entry point to this side of the composition. An analogous grandeur of conception occurs in a drawing of the Crucifixion (Stockholm, Nationalmuseum, inv. 2006; Benesch 1973, vol. 5, no. 924). Additional comparable drawings include *Abraham Dismissing Hagar and Ishmael* and *Tobias and the Angel Taking Leave of Raguel* (Amsterdam, Rijksmuseum, inv. 1930:2, 1930:18; Benesch 1973, vol. 5, nos. 916, 817),[1] which exhibit similar figure types modeled by fine hatching as well as considerable variety in the width and character of lines. The drawing has been dated by Valentiner (1934, vol. 2, p. 434) to circa 1645 and by Benesch to about 1652–1653 (1973, vol. 5, no. 921). The classical cast of the scene argues for a date toward 1650, around the time of paintings such as the *Supper at Emmaus* of 1648 (Paris, Louvre).

1. P. Schatborn, *Drawings by Rembrandt, His Anonymous Pupils and Followers*, Catalogue of the Dutch and Flemish Drawings in the Rijksprentenkabinet, Rijksmuseum, Amsterdam, vol. 4 (The Hague, 1985), nos. 40, 41.

117 A Sailing Boat on a Wide Expanse (View of the Nieuwe Meer?)

Pen and brown ink and brown wash on light brown tinted paper; H: 8.9 cm (3½ in.); W: 18.2 cm (7³⁄₁₆ in.)
85.GA.94

MARKS AND INSCRIPTIONS: At bottom left corner, collection mark of N. A. Flinck (L. 959).

PROVENANCE: N. A. Flinck, Rotterdam; William, second duke of Devonshire, Chatsworth; by descent to the current duke (sale, Christie's, London, July 3, 1984, lot 60); art market, New York.

EXHIBITIONS: *Exhibition of Dutch Art 1450–1900*, Royal Academy of Arts, London, 1929, no. 606 (catalogue by D. Hannema et al.). *Rembrandt Tentoonstelling*, Rijksmuseum, Amsterdam, July–October 1935, no. 64. *Seventeenth-Century Art in Europe*, Royal Academy of Arts, London, 1938, no. 545 (catalogue of drawings by A. E. Popham et al.). *Old Master Drawings from Chatsworth*, Arts Council Gallery, London, 1949, no. 38 (catalogue by A. E. Popham). *Drawings by Old Masters*, Royal Academy of Arts, London, 1953, no. 300 (catalogue by K. T. Parker and J. Byam Shaw). *Rembrandt*, Nationalmuseum, Stockholm, January–April 1956, no. 130 (catalogue by B. Dahlbäck and P. Bjurström). *The Orange and the Rose: Holland and Britain in the Age of Observation, 1600–1750*, Victoria and Albert Museum, London, October–December 1964, no. 109. *Rembrandt 1669–1969*, Rijksmuseum, Amsterdam, 1969, no. 94 (catalogue of drawings by L. C. J. Frerichs and P. Schatborn). *"Shock of Recognition": The Landscape of English Romanticism and the Dutch Seventeenth-Century School*, Mauritshuis, The Hague, and Tate Gallery, London, November 1970–January 1971 and January–February 1971, no. 81 (catalogue by A. G. H. Bachrach). *Treasures from Chatsworth: The Devonshire Inheritance*, Virginia Museum of Fine Arts, Richmond, and other institutions, 1979–1980, no. 97 (catalogue by A. Blunt et al.).

BIBLIOGRAPHY: F. Lippmann, *Original Drawings by Rembrandt*, 1st ser. (Berlin, 1888–1892), no. 60; E. Michel, *Rembrandt, sa vie, son oeuvre, et son temps* (Paris, 1893), p. 121; C. Hofstede de Groot, *Die Handzeichnungen Rembrandts* (Haarlem, 1906), p. 194, no. 848; A. M. Hind, *The Vasari Society for the Reproduction of Drawings by Old Masters*, 1st ser. (Oxford, 1907), vol. 3, no. 25; M. Eisler, *Rembrandt als Landschafter*, Arbeiten des Kunsthis-torischen Instituts der K. K. Universität Wien (Munich, 1918), vol. 13, p. 65; C. Neumann, *Rembrandt Handzeichnungen* (Munich, 1918), p. 4, no. 27; F. Lugt, *Mit Rembrandt in Amsterdam* (Berlin, 1920), p. 155; A. M. Hind, *Commemorative Catalogue of the Exhibition of Dutch Art*, exh. cat., Royal Academy of Arts, London, 1930, p. 207; O. Benesch, *Rembrandt: Werk und Forschung* (Vienna, 1935), p. 42; idem, *The Drawings of Rembrandt* (London, 1955), vol. 4, no. 847, fig. 995; S. Slive, *Drawings of Rembrandt* (New York, 1965), vol. 1, pl. 60; B. Haak, *Rembrandt, His Life, His Work, His Time* (New York, 1969), p. 211; C. O. Baer, *Landscape Drawings* (New York, 1973), pp. 214, 216, no. 90; O. Benesch, *The Drawings of Rembrandt* (London, 1973), vol. 4, no. 847, fig. 1049; B. Haak, *Rembrandt Drawings* (London, 1976), no. 57. J. Byam Shaw, "Drawings from Chatsworth," *Apollo* 119, no. 268 (June 1984), p. 456.

IT WAS TENTATIVELY SUGGESTED BY LUGT (1920, p. 155) that the site depicted in this famous drawing is the Nieuwe Meer, a lake between the Schinckel River and the Haarlemmermeer, which has since been reclaimed. The drawing has been compared by Benesch (1973, vol. 4, no. 847) to the *Landscape with a Farmstead* in the Devonshire collection, Chatsworth (inv. 1048), which he has related in turn to the *Winter Landscape* in the Fogg Art Museum, Cambridge (inv. 1932.368). Benesch (1973, vol. 4, nos. 845–846) dated both drawings to around 1649–1650. They are certainly related through the suggestion of atmospheric distance, but the Museum's drawing is more complex and sophisticated than the *Winter Landscape* and more richly drawn than the *Landscape with a Farmstead*. In composition as well as execution it comes closest to the *View over Het Ij* (Chatsworth, Devonshire collection, inv. 1030; Benesch 1973, vol. 6, no. 1239). In both of the latter drawings Rembrandt has depicted a richly varied area of foliage at the left, containing considerable tonal range, and an open expanse of water which takes up most of the remainder of the composition. In each case a carefully disposed form at the right balances the composition, while distant, sensitively rendered architectural forms appear on the far horizon. The pen strokes are quite varied and change from thin, rapid touches to broader strokes that lend emphasis to details of the foliage and the sail. The drawing is datable to around 1650 and is exemplary of Rembrandt's mature command of the integration of light, form, and atmospheric suggestion, brought together within a rather simple and classical composition.

118 Landscape with the House with the Little Tower

Pen and brown ink and brown wash; H: 9.7 cm (3 3/16 in.);
W: 21.5 cm (8 7/16 in.)
83.GA.363

MARKS AND INSCRIPTIONS: None.

PROVENANCE: Paul Jodot, Paris; Otto Gutekunst, London; Baron Robert von Hirsch, Basel (sale, Sotheby's, London, June 21, 1978, lot 35); art market, New York.

EXHIBITIONS: *Exhibition of Dutch Art 1450–1900*, Royal Academy of Arts, London, 1929, no. 624 (catalogue by D. Hannema et al.). *Rembrandt Tentoonstelling*, Rijksmuseum, Amsterdam, 1932, no. 282 (catalogue by F. Schmidt-Degener). *Seventeenth Century Art in Europe*, Royal Academy of Arts, London, 1938, no. 564 (catalogue of drawings by A. E. Popham et al.). *Rembrandt-Ausstellung*, Katz-Galerie, Basel, 1948, no. 33 (catalogue by W. Martin et al.). *Le paysage hollandais au XVIIe siècle*, Orangerie des Tuileries, Paris, 1950–1951, no. 154 *bis* (catalogue by L. C. J. Frerichs et al.). *Rembrandt: Tentoonstelling ter herdenking van de geboorte van Rembrandt op 15 juli 1606. Tekeningen*, Museum Boymans-van Beuningen, Rotterdam, and Rijksmuseum, Amsterdam, May–August and August–October 1956, no. 162 (catalogue by E. Haverkamp-Begemann).

BIBLIOGRAPHY: *Vasari Society for the Reproduction of Drawings by Old Masters*, 2nd ser., pt. 5 (1924), no. 10; A. M. Hind, *Commemorative Catalogue of the Exhibition of Dutch Art*, exh. cat., Royal Academy of Arts, London, 1930, p. 210; idem, "A Landscape Drawing by Rembrandt," *British Museum Quarterly* 7, no. 3 (1932–1933), p. 63; M. Freeman, *Rembrandt van Rijn 1606–69*, Master Draughtsmen, no. 4 (London and New York, 1933), no. 6; O. Benesch, *Rembrandt: Werk und Forschung* (Vienna, 1935), p. 48; idem, *Rembrandt: Selected Drawings* (London, 1947), vol. 1, pp. 25–26, no. 177; 37; J. G. van Gelder, "Review of Otto Benesch, *Rembrandt, Selected Drawings*," *Burlington Magazine* 91, no. 556 (July 1949), p. 207; L. Münz, *A Critical Catalogue of Rembrandt's Etchings* (London, 1952), vol. 2, p. 85, under no. 168; J. Q. van Regteren Altena, "Retouches aan ons Rembrandt-beeld, Het landschap van den goudweger," *Oud Holland* 69, no. 1 (1954), pp. 1–17; O. Benesch, *The Drawings of Rembrandt* (London, 1957), vol. 6, no. 1267, fig. 1494; idem, *Rembrandt as a Draughtsman* (London, 1960), p. 155; C. White, *Rembrandt as an Etcher* (London, 1969), vol. 1, p. 212; idem and K. G. Boon, *Rembrandt's Etch-*

ings: *A New Critical Catalogue* (Amsterdam, 1969), p. 108, under no. B223; O. Benesch, *The Drawings of Rembrandt* (London, 1973), vol. 6, no. 1267, fig. 1564; M. Bernhard, *Rembrandt: Handzeichnungen* (Munich, 1976), vol. 2, pl. 439; B. Haak, *Rembrandt Drawings* (New York, 1976), no. 62.

THIS WELL-KNOWN DRAWING REPRESENTS THE HOUSE known as Het Toorentje, which belonged at the time to Jan Uytenbogaert, receiver general of the United Provinces (van Regteren Altena 1954, pp. 1–17). The site is located along the Schinckel River between Amsterdam and Amstelveen. As was first noted by Hind (1932–1933, p. 63), the same spot is depicted in an etching, *Landscape with Trees, Farm Buildings and a Tower* (B.223), which has been dated by White and Boon (1969, p. 107) to circa 1651. The print shows the house from a different vantage point, and Rembrandt appears to have taken greater liberties with topographical accuracy in it than in the drawing, removing the cupola of the tower in the third state. The drawing also has been related stylistically to the artist's famous print *The Goldweigher's Field* (B.234), dated 1651 (Benesch 1973, vol. 6, no. 1267), and there are many similarities in the characterization of the screen of trees and houses as well as in the overall composition and quality of light and atmosphere. The analogy between the drawing and this print provides a clear basis for dating the former to the beginning of the 1650s.

The technique of the drawing is astonishing, even by Rembrandt's standard. A row of trees and houses is set slightly above the middle of the sheet, providing for an open expanse of space in the foreground. The suggestion of river and land separating the viewer from the house and trees has been achieved with a few broad lines and numerous finer strokes depicting the rushes at left and their reflections in the river. The main lines of the foreground meet at a point directly below the tower. It and the surrounding houses and trees were first drawn in fine, short strokes, and then wash was added before the ink had dried, creating a blurred and luminous effect (White 1969, vol. 1, p. 212). Rembrandt further animated this part of the scene by using a fine dotting technique, adding to the sense of movement of form and diversity of texture. The endless subtlety of technique is nowhere better seen than in the passage of dots and wash at the left which leads into the far distance. Benesch (1973, vol. 6, no. 1267) has proposed that the technique employed here was inspired by Bruegel, while L. Hendrix has noted the similarity (in both technique and characterization of landscape) between it and several late landscape drawings made near Haarlem by Goltzius.[1]

In terms of Rembrandt's other drawings, the composition and style can be compared with the earlier and less advanced *Winter Landscape* (Cambridge, Mass., Fogg Art Museum, inv. 1932. 368; Benesch 1973, vol. 4, no. 845) and *Bend in the River Amstel* (Chatsworth, Devonshire collection, inv. 1025; Benesch 1973, vol. 6, no. 1268). The latter is quite similar in spatial organization and in the sensitive application of wash.

1. E. K. J. Reznicek, *Die Zeichnungen von Hendrick Goltzius* (Utrecht, 1961), vol. 1, nos. 400, 405.

119 A Wooded Road

Pen and brown ink and brown wash on gray-brown tinted paper, intentionally scratched by the artist; H: 15.9 cm (6¼ in.); W: 20.1 cm (7¹⁵⁄₁₆ in.)
85.GA.95

MARKS AND INSCRIPTIONS: At bottom left, collection mark of N. A. Flinck (L. 959).

PROVENANCE: N. A. Flinck, Rotterdam; William, second duke of Devonshire, Chatsworth; by descent to the current duke (sale, Christie's, London, July 3, 1984, lot 67); art market, New York.

EXHIBITIONS: *Exhibition of Dutch Art 1450–1900*, Royal Academy of Arts, London, 1929, no. 611 (catalogue by D. Hannema et al.). *Rembrandt Tentoonstelling*, Rijksmuseum, Amsterdam, July–October 1935, no. 73. *Old Master Drawings from Chatsworth*, National Gallery of Art, Washington, D.C., and other institutions, 1962–1963, no. 90 (catalogue by A. E. Popham). *Old Master Drawings from Chatsworth: A Loan Exhibition from the Devonshire Collection*, Royal Academy of Arts, London, July–August 1969, no. 90 (catalogue by A. E. Popham). *"Shock of Recognition": The Landscape of English Romanticism and the Dutch Seventeenth-Century School*, Mauritshuis, The Hague, and Tate Gallery, London, November 1970–January 1971 and January–February 1971, no. 80 (catalogue by A. G. H. Bachrach). *Old Master Drawings: A Loan from the Collection of the Duke of Devonshire*, Israel Museum, Jerusalem, April–July 1977, no. 38.

BIBLIOGRAPHY: F. Lippmann, *Original Drawings by Rembrandt*, 1st ser. (Berlin, 1888–1892), no. 55; E. Michel, *Rembrandt, sa vie, son oeuvre, et son temps* (Paris, 1893), p. 373; C. Hofstede de Groot, *Die Handzeichnungen Rembrandts* (Haarlem, 1906), p. 193, no. 843; M. Eisler, *Rembrandt als Landschafter* (Munich, 1918), fig. 36; A. M. Hind, *Commemorative Catalogue of the Exhibition of Dutch Art*, exh. cat., Royal Academy of Arts, London, 1930, p. 207; O. Benesch, *Rembrandt: Werk und Forschung* (Vienna, 1935), p. 49; idem, *Rembrandt: Selected Drawings* (Oxford, 1947), p. 26, no. 175; J. Rosenberg, *Rembrandt* (Cambridge, Mass., 1948), vols. 1, p. 90; 2, fig. 131; O. Benesch, *The Drawings of Rembrandt*, vol. 6 (London, 1957), no. 1253, fig. 1478; J. Rosenberg, *Rembrandt: Life and Work* (London, 1964), p. 155; S. Slive, *Drawings of Rembrandt* (New York, 1965), vol. 1, no. 55; O. Benesch, *The Drawings of Rembrandt* (London, 1973), vol. 6, no. 1253, fig. 1556.

AROUND 1650–1652 REMBRANDT MADE A NUMBER of generally related drawings of wooded scenes in pen and ink (Benesch 1973, vol. 6, nos. 1245–1254, 1284–1285, 1287). Here as in several others he drew the trees with quick, thin strokes of the quill pen, suggesting the forms impressionistically rather than describing them with specificity. The only passage upon which he dwelled is the isolated tree in the left foreground; he emphasized its bulk and scratched into the paper through the brown tint in order to produce white highlights. It is instructive to compare this drawing with a variant of the same view in the Hamburger Kunsthalle (inv. 22818; Benesch 1973, vol. 6, no. 1254), in which the artist rendered the forms with fewer, somewhat broader lines from a slightly nearer vantage point. The Hamburg drawing is somewhat problematical and contains at least one addition by another hand. The Museum's drawing is far closer in style to other landscapes of the period such as those in the Kupferstichkabinett, Berlin (inv. 5266, 5267) and in the Devonshire collection, Chatsworth (inv. 1044), in which paths through woods open up next to canals (Benesch 1973, vol. 6, nos. 1251–1252), achieving a similar overall effect. These drawings of wooded scenes can be dated to the early 1650s partly on account of analogies with etchings such as the *Landscape with a Road beside a Canal* (B.221) of circa 1652.

120 The Mocking of Christ

Pen and brown ink; H: 18.2 cm (7⅛ in.); W: 24.5 cm
(9¹¹⁄₁₆ in.)
83.GA.358

MARKS AND INSCRIPTIONS: At bottom left, collection
mark of Léon Bonnat (L. 1714).

PROVENANCE: Pierre Crozat, Paris; Edward Vernon Ut-
terson, London; Charles Gasc, Paris; Léon Bonnat, Paris;
Fernand Widal; Mme Josette Widal (sale, Sotheby's,
London, December 10, 1968, lot 58); private collection,
New Jersey.

EXHIBITIONS: *Exposition d'oeuvres de Rembrandt*, Biblio-
thèque Nationale, Paris, 1908, no. 355.

BIBLIOGRAPHY: F. Lippmann (continued by C. Hofste-
de de Groot), *Original Drawings by Rembrandt*, 3rd ser.
(The Hague, 1903–1911), no. 21; C. Hofstede de Groot,
Die Handzeichnungen Rembrandts (Haarlem, 1906), no.
697; E. W. Bredt, *Rembrandt-Bibel* (Munich, 1921), vol.
2, p. 83; O. Benesch, *Rembrandt: Werk und Forschung* (Vi-
enna, 1935), p. 62; idem, *Rembrandt: Selected Drawings*
(London, 1947), p. 28, no. 258 (wrongly described as in
the Bonnat collection, Bayonne); idem, *The Drawings of
Rembrandt* (London, 1957), vol. 5, no. 1024, fig. 1238; S.
Slive, *Drawings of Rembrandt* (New York, 1965), vol. 2,
no. 353; O. Benesch, *The Drawings of Rembrandt* (Lon-
don, 1973), vol. 5, no. 1024, fig. 1308; F. Stampfle, *Ru-
bens and Rembrandt in Their Century*, exh. cat, Pierpont
Morgan Library, New York, and other institutions,
1979, p. 105, under no. 73.

THIS IS ONE OF TWO DRAWINGS BY REMBRANDT OF
this subject, both of which appear to date from the early
to mid-1650s; the other is in the Pierpont Morgan Li-
brary, New York (inv. I, 189; Benesch 1973, vol. 5, no.
920). There has been some disagreement about their
chronological sequence. Benesch has placed the Morgan
Library drawing at about 1652–1653 and the Museum's
sheet around 1656–1657 (Benesch 1973, vol. 5, nos. 920,
1024), whereas Stampfle appears to have reversed their
order, suggesting that the Morgan Library sheet is the
more developed (1979, p. 105). The Morgan Library
drawing is more elaborate in the inclusion of detail and
more descriptive in terms of both setting and the phys-
ical substance of the figures. By contrast, the Museum's
drawing isolates the figures in a cavernous void in which
psychological meaning and the subtle dramatic interplay
of participants dominate. The composition is therefore
more reflective and profound in expression, intention-
ally less animated in gesture and anecdotal.

In the Museum's drawing Rembrandt first outlined
the composition in a pale ink and then went over it in a
darker ink to correct and emphasize parts of the left-hand
group. This process is comparable to his manner of ex-
ecuting *The Washing of the Feet* (Amsterdam, Rijksmu-
seum, inv. A 2053; Benesch 1973, vol. 5, no. 931). There
too Rembrandt left the setting almost entirely undes-
cribed, focusing attention on one significant figural and
gestural relationship. *The Mocking of Christ* evolved from
the style of the Amsterdam drawing and should proba-
bly be dated around 1652–1655.

The Mocking of Christ has few equals in its spatial and
expressive subtlety. The placement of a large, somewhat
undifferentiated group of figures at the left establishes a
visual foil for the spatially separate and emotionally dis-
parate presentation of the forlorn image of Christ and the
mocking soldier kneeling before him. The figure to his
right is only part of an "architectural" frame at the left,
hardly disturbing the principal dramatic contrast around
which the scene is built. There are few drawings in which
the areas left blank are used as purposefully and effec-
tively as here.

121 Shah Jahan and Dara Shikoh

Pen and brown ink, brown wash, and white gouache heightening on Japanese paper; H: 21.2 cm (8⅜ in.); W: 17.9 cm (7 in.)
85.GA.44

MARKS AND INSCRIPTIONS: At bottom left, collection mark of Thomas Hudson (L. 2432); at bottom right, collection mark of Jonathan Richardson, Sr. (L. 2184); on mount, at bottom, inscribed *Rembrandt* in brown ink.

PROVENANCE: Jonathan Richardson, Sr., London (sale, Cock, London, February 11, 1747, lot 70); Thomas Hudson, London; R. F. Symonds, London (sale, Sotheby's, London, May 10, 1961, lot 33); private collection, New Jersey; art market, New York.

EXHIBITIONS: None.

BIBLIOGRAPHY: O. Benesch, "Neuentdeckte Zeichnungen von Rembrandt," *Jahrbuch der Berliner Museen* 5 (1963), pp. 135–136, 138; idem, *Rembrandt*, Collected Writings, vol. 1 (London, 1970), pp. 262, 289, n. 25; idem, *The Drawings of Rembrandt* (London, 1973), vol. 5, no. 1194A, fig. 1498; P. Lunsingh Scheurleer, "Mogolminiaturen door Rembrandt nagetekend," *De kroniek van het Rembrandthuis* 32 (1980–1981), pp. 34–36; P. Schatborn, *Drawings by Rembrandt in the Rijksmuseum, His Anonymous Pupils and Followers*, Catalogue of the Dutch and Flemish Drawings in the Rijksprentenkabinet, Rijksmuseum, Amsterdam, vol. 4 (The Hague, 1985), p. 131, n. 11, under nos. 57–60.

THE 1747 AUCTION CATALOGUE OF THE COLLECTION of Jonathan Richardson, Sr., lists "A book of Indian drawings by Rembrandt, 25 in number." This is one of the series, of which twenty-one apparently are known, including those in Benesch (1973, vol. 5, nos. 1187–1197, 1199–1201, 1203–1206), one in the Aall collection, New York, and another in a private collection, Paris. They were all drawn on Japanese paper, but are of differing sizes and vary in the number of figures shown and manner of representation, with some shown only in bust length. Since F. Sarre,[1] it has been recognized that they all were based on Mogul miniatures of Rembrandt's time, and it has often been thought that the models were identical to the "album of curious miniature drawings" listed in the inventory of his possessions made in 1656.[2] These miniatures have been connected to a group of Mogul paintings in Schloss Schönbrunn, near Vienna.[3] However, considerable doubt has been cast on the iden-

tification of these pictures as Rembrandt's models, and P. Lunsingh Scheurleer (1980–1981, pp. 34–35, fig. 23) has pointed to a miniature in the Royal Library, Teheran, that is much closer to the Museum's drawing than the composite of two figures in Schönbrunn, first cited in the Sotheby's catalogue (1961, lot 33) and accepted by Benesch as the models (1963, p. 135).

The two figures depicted in the drawing are identified in the Sotheby's catalogue as Shah Jahan and his falconer, a view again adopted by Benesch. Lunsingh Scheurleer has improved upon this hypothesis by noting that the figure at the right is Dara Shikoh (1615–1659), the eldest and most beloved son of Shah Jahan. The same scholar has noted that from the time of the reign of Shah Jahangir (1605–1627), Shah Jahan's father, Mogul rulers were portrayed with aureoles, a derivation from Western usage (1980–1981, p. 13).

This and related drawings in the series are, as has often been noted, more than mere copies. Rembrandt has taken the imagery of Mogul miniatures and depicted it in his own style and technique, enlivening the figures and heightening the naturalism of their forms and expressions. Only in their extremely fine graphic manner do they suggest the influence of their source, though their imagery continued to have an impact on Rembrandt's rendering of other themes after this project was completed. He seems to have drawn the series for his own pleasure. Benesch's dating of these copies after Mogul miniatures to circa 1654–1656 (1973, vol. 5, no. 1187) appears to be correct.

1. "Rembrandts Zeichnungen nach indisch-islamischen Miniaturen," *Jahrbuch der preussischen Kunstsammlungen* 25 (1904), pp. 143–158.
2. W. L. Strauss et al., *The Rembrandt Documents* (New York, 1979), no. 1656/12, no. 203.
3. J. Strzygowski and H. Glück, *Asiatische Miniaturenmalerei* (Klagenfurt, 1933), pp. 18–21.

122 Dead Tree by a Stream at the Foot of a Hill

Black chalk, point of brush, and light and dark gray wash; H: 14.4 cm (5¹¹/₁₆ in.); W: 18.9 cm (7⁷/₁₆ in.) 85.GG.410

MARKS AND INSCRIPTIONS: (Recto) at bottom left, signed *JVR* (interlaced) in black ink; (verso) collection mark of Dr. H. E. ten Cate (L. Suppl. 533b).

PROVENANCE: Dr. H. E. ten Cate, Almelo; Adolph Schwarz, Amsterdam; art market, California.

EXHIBITIONS: *De verzameling van A. Schwarz*, Rijksprentenkabinet, Amsterdam, 1968, no. 90 (catalogue by J. W. Niemeijer).

BIBLIOGRAPHY: D. Hannema, *Catalogue of the H. E. ten Cate Collection* (Rotterdam, 1955), vol. I, p. 156, no. 283; J. Giltay, "De tekeningen van Jacob van Ruisdael," *Oud Holland* 94 (1980), pp. 155, no. 13; 190, 205.

THIS DRAWING HAS BEEN INCLUDED BY GILTAY IN A group of eight landscapes with numerous trees, all of which he has dated to 1650–1660 (1980, p. 155). This dating would conform with the setting, tentatively identified by him as Bentheim (Giltay 1980, p. 190), a suggestion supported by S. Slive.[1] The latter has noted that half-timbered buildings are not found in Holland and that van Ruisdael only began incorporating them into his paintings and drawings after his trip to Bentheim around 1650.[2] A similar structure recurs in van Ruisdael's painting of 1653, *The Castle of Bentheim* (Blessington, Beit collection).[3]

The composition of this drawing was anticipated in the painting *Landscape with Cottages, Dunes and Willows* of 1646 (Southhill, Biggleswade, S. Whitbread collection).[4] In both, a relatively large mass of trees and foliage appears in the right foreground, while the left side opens to a deep diagonal vista interrupted by only a few minor motifs. Equally, the composition of the Museum's drawing is paralleled in an etching by van Ruisdael, *The Little Bridge*, dated by Slive to around 1650–1655, just after the artist's return from Bentheim.[5] The two not only agree in overall composition but also contain the same detail of a man walking across a small footbridge.

Van Ruisdael first sketched the Museum's composition in black chalk and then went over it with a brush in gray wash of various tonalities, creating a rich diversity of textural and light effects, especially at the right. On the basis of similar handling, Giltay (1980, pp. 150–151, 155) has related this sheet to a group of eight drawings of the ruins of the castle at Egmond aan den Hoef, dating them all to the mid-1650s.

1. During a visit to Malibu in 1985 Slive also noted his acceptance of the authenticity of the monogram.
2. S. Slive, *Jacob van Ruisdael*, exh. cat., Fogg Art Museum, Harvard University, Cambridge, 1982, p. 253.
3. Ibid., no. 14.
4. Ibid., fig. 6.
5. Ibid., no. 105-A.

recto

123 A Lion Snarling

Black and red chalk and black and brown wash; H: 39.6 cm (15⁹⁄₁₆ in.); W: 32.9 cm (12¹⁵⁄₁₆ in.)
84.GG.808

MARKS AND INSCRIPTIONS: At bottom left, inscribed *CSL* in brush and brown ink by a later hand.

PROVENANCE: Private collection, Nancy; J. D. Augarde, Paris (sale, Hôtel Drouot, Paris, December 20, 1982, lot 23); sale, Christie's, Amsterdam, November 26, 1984, lot 37.

EXHIBITIONS: None.

BIBLIOGRAPHY: None.

THIS IS ONE OF A LARGE GROUP OF STUDIES OF animals by Cornelis Saftleven, executed in a variety of media including chalk, wash, and watercolor. Although animals frequently appear in his paintings, there is no reason to believe that this is a preparatory study. It is among the largest and most elaborate of the artist's animal drawings and is closest in scale and technique to another rendering of a lion in the Stichting Hannema-de-Stuers, Heino.[1] In each case the lion is shown up close and cut off at the chest. The two drawings also share a softness of modeling in the fur and an overelaborate use of watercolor in the face. It is not unlikely that they date from the same moment and were meant to be seen together. Schulz has dated the lion in Heino to circa 1625–1633, which would also provide the date of its companion.[2]

1. W. Schulz, *Cornelis Saftleven, 1607–1681* (Berlin, 1978), no. 303.
2. Ibid., p. 56. In the Christie's, Amsterdam, sale catalogue (1984, lot 37), Schulz's acceptance of the attribution of this drawing to Saftleven is noted.

124 Mountain Landscape with Figures

Black chalk and brown wash; H: 23.6 cm (9⅕⁄₁₆ in.); W: 27.9 cm (11 in.)
84.GG.961

MARKS AND INSCRIPTIONS: At bottom center, signed and dated *HSL 1652* in black chalk.

PROVENANCE: J. Goll van Franckenstein, Amsterdam; P. Langerhuizen, Crailoo near Bussum (sale, Frederik Muller, Amsterdam, April 29, 1919, lot 682); Anton Mensing, Amsterdam (sale, Frederik Muller, Amsterdam, April 27, 1937, lot 650); private collection, Sweden; art market, California.

EXHIBITIONS: *Dutch and Flemish Drawings in the Nationalmuseum and Other Swedish Collections*, Nationalmuseum, Stockholm, 1953, no. 176 (catalogue by N. Lindhagen). *Oude tekeningen uit de Nederlanden: Verzameling Prof. E. Perman, Stockholm*, Singer Museum, Laren, 1962, no. 96 (catalogue by E. Perman et al.).

BIBLIOGRAPHY: W. Bernt, *Die niederländischen Zeichner des 17. Jahrhunderts* (Munich, 1958), vol. 2, no. 521; idem, *Die niederländischen Maler und Zeichner des 17. Jahrhunderts* (Munich, 1980), vol. 5, no. 520; W. Schulz, *Herman Saftleven 1609–1685* (Berlin and New York, 1982), p. 343, no. 824.

THIS IS ONE OF A LARGE NUMBER OF LANDSCAPE drawings by Herman Saftleven grouped by Schulz in the period 1648–1652 (1982, nos. 735–824). Closest to this composition in type are two drawings in the Musées Royaux des Beaux-Arts de Belgique, Brussels (inv. De Grez 3178, 3184; Schulz 1982, nos. 743–744), executed in a similar technique and also showing large and prominently situated rocks with distant views dominating small figures. In a number of the drawings from this series, Saftleven has used interchangeable motifs. The drawings do not appear to be preparatory for paintings or prints and are not topographical. They reflect, in a general sense, the precedent of Roelandt Savery's mountain landscapes.

125 Young Woman Assisted by a Gentleman

Pen and black ink, gray wash, and white gouache heightening; H: 19.2 cm (7⅝ in.); W: 25 cm (9¹³⁄₁₆ in.)
85.GA.230

MARKS AND INSCRIPTIONS: At bottom left corner, signed *Jo Wte / Wael / 9* in gray ink.

PROVENANCE: Private collection, Stockholm; art market, California.

EXHIBITIONS: None.

BIBLIOGRAPHY: W. Bernt, *Die niederländischen Zeichner des 17. Jahrhunderts* (Munich, 1958), vol. 2, no. 699; E. McGrath, "A Netherlandish History by Joachim Wtewael," *Journal of the Warburg and Courtauld Institutes* 39 (1975), pp. 182, 184, 200–202; F. W. Robinson, *Seventeenth Century Dutch Drawings from American Collections*, exh. cat., National Gallery of Art, Washington, D.C., and other institutions, 1977, p. 12, under no. 9; K. G. Boon, *Netherlandish Drawings of the Fifteenth and Sixteenth Centuries in the Rijksmuseum Amsterdam* (Amsterdam, 1978), vol. 1, p. 186.

THIS IS ONE OF AT LEAST THIRTEEN DRAWINGS MADE by Wtewael for a series in which incidents from the Eighty Years War of Dutch independence are represented through allegorical means (McGrath 1975). In this scene Prince Maurice of Orange is shown lifting up Belgica, who turns to him hopefully. The prince also directs her attention to the barge in the background, the then well-known "turf ship of Breda" on which his troops were brought secretly into that town in 1590 to capture it from the Spaniards (McGrath 1975, pp. 200–201).

Several of the allegories in this series are known in more than one version, and the principal ones are signed and numbered. Others are of lesser quality and may well be studio repetitions, though there seem to be autograph replicas as well. The purpose for which they were made is elusive, even though most scholars have seen them as designs for an unexecuted print series. A. Lowenthal believes that they were more probably made as independent finished drawings, however, especially as the direction of gesture and action in drawings such as this one would be rendered less satisfactory if reversed in the process of making prints.[1] The allegories all have been dated by McGrath (1975) to the years just after the signing of a truce with Spain in 1609 and by Lowenthal to the early 1620s.[2]

A copy of this drawing was sold at Christie's, London, on July 8, 1975, as lot 200 and was in the possession of Jean Willems in Brussels in 1983. It appears clearly to be a workshop repetition.[3]

1. Conversation with the author, Malibu, 1985.
2. A. W. Lowenthal, *Joachim Wtewael and Dutch Mannerism* (Doornspijk, 1986), p. 34, n. 64.
3. J. Willems, *Master Drawings from the 16th to the early 20th century* (Brussels, 1983), no. 8.

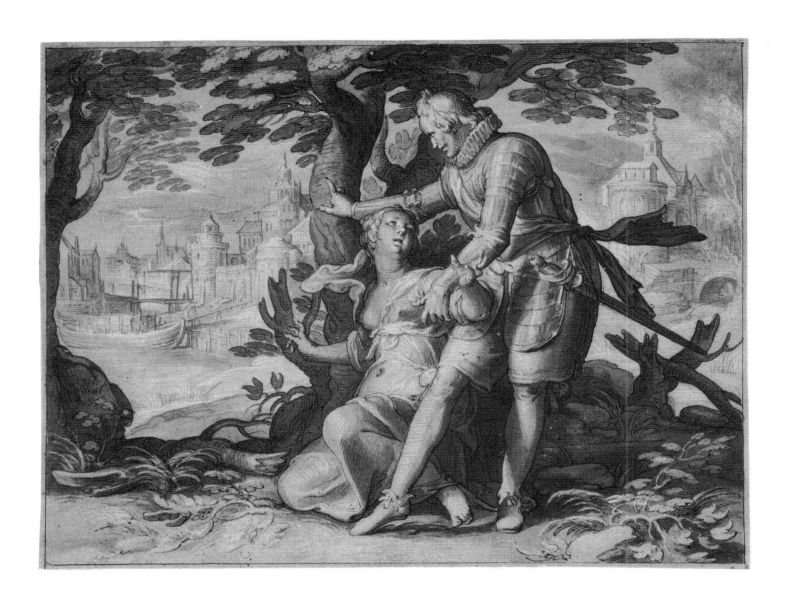

126 A Monk Preaching

Pen and brown ink and black chalk; H: 30.8 cm (12 ⅛ in.); W: 22.3 cm (8 ¹³⁄₁₆ in.)
83.GA.194

MARKS AND INSCRIPTIONS: (Verso) unidentified collection mark of B. S. (L. Suppl. 414b).

PROVENANCE: B. S. collection; G. Schwarting, Delmenhorst; art market, London.

EXHIBITIONS: *Hans Baldung Grien*, Staatliche Kunsthalle, Karlsruhe, July–September 1959, no. 108 (catalogue by C. Koch et al.). *Zeichnungen alter Meister aus deutschem Privatbesitz*, Kunsthalle Bremen, February–April 1966, no. 64 (catalogue by W. Stubbe).

BIBLIOGRAPHY: B. Hausmann, *Albrecht Dürers Kupferstiche, Radirungen, Holzschnitte und Zeichnungen* (Hannover, 1861), p. 94; F. Winkler, *Die Zeichnungen Albrecht Dürers* (Berlin, 1936), vol. 1, pp. 143, under no. 202; 144, under no. 207; H. Möhle, "Zur Karlsruher Baldung Ausstellung," *Zeitschrift für Kunstgeschichte* 22 (Summer 1959), p. 129; P. Halm, "Die Hans Baldung Grien Ausstellung in Karlsruhe 1959," *Kunstchronik* 13 (May 1960), p. 127; K.-A. Knappe, "Baldung als Entwerfer der Glasgemälde in Grossgründlach," *Zeitschrift für Kunstwissenschaft* 24 (1961), pp. 60, 76; F. Winkler, "Ein Titelblatt und seine Wandlungen," *Zeitschrift für Kunstwissenschaft* 24 (1961), pp. 155–156, fig. 7; K. Oettinger and K.-A. Knappe, *Hans Baldung Grien und Albrecht Dürer in Nürnberg* (Nuremberg, 1963), p. 125, no. 25; W. L. Strauss, *The Complete Drawings of Albrecht Dürer* (New York, 1974), vol. 6, pp. 2946, under no. XW.198; 2952, under no. XW. 202; 2968, under no. XW. 210.

THIS DRAWING WAS FIRST PUBLISHED IN THE CATALOGUE of the Baldung exhibition of 1959 (no. 108), in which it is associated with his early woodcuts of the *Deposition* and the *Last Judgment* (Koch et al. 1959, II H, nos. 10, 17), and his securely dated drawings of 1504–1505. Here Winkler and Schilling are cited as proposing that the sheet is among the earliest existing drawings from Baldung's Nuremberg period. It is also noted that the Museum's drawing is related thematically and compositionally to the drawing *Saint Benedict Preaching* (Germanisches Nationalmuseum, Nuremberg, inv. H25480; Winkler 1936, vol. 1, no. 201), one of the designs for cycles of stained-glass windows showing the life of Saint Benedict produced by Dürer and his shop. The attribution to Baldung and the date of circa 1504/05 have been universally accepted since 1959.

Taken individually, the various details in the drawing find many parallels in Baldung's other works. The listening female is quite similar in physiognomy and expressive character to the Virgin in the woodcut of the Last Judgment, while the drapery worn by the Virgin in the *Deposition* woodcut and in a slightly later woodcut, *Holy Family with Rabbits* (Koch et al. 1959, II H, no. 23), are nearly identical. Knappe (1961, p. 76) has noted that the rather porcine man just behind the seated female is comparable to the figure at the left of Christ in a stained-glass window illustrating the Supper at Emmaus that was designed by Baldung for the parish church of Grossgründlach, and that the fingers of the disciple facing Christ in the window are very similar to those of the preacher in the Museum's drawing. L. Hendrix has added that the robust man at the left side of another window, *Christ Preaching in the Temple*, from the same cycle is still closer to the porcine man with the hat in the drawing (Knappe 1961, fig. 2). The right hand of Saint John the Baptist in the *Last Judgment* woodcut, with the fifth finger in front of the fourth and the thumb extended, almost precisely repeats the left hand of the preacher here. Similarly, the rather stubby fingers of the preacher's right hand, with their curiously described nails, are analogous to the left hand of Saint Bartholomew in a pen-and-ink drawing by Baldung of 1504 in the Kunstmuseum Basel (Kupferstichkabinett, Amerbach-Kabinett, inv. U. III. 74).[1] The execution of the two drawings is also very similar, with a combination of long, thin strokes to describe outlines and smaller, sometimes looped strokes for modeling and shading. The manner of depicting eyes is also quite comparable. All of these visual and stylistic relationships support the placement of the Museum's drawing within Baldung's work of around 1505.

Knappe (1961) and Winkler (1961) both have proposed that the Museum's drawing was made as a study for a stained-glass window, a hypothesis that has received general agreement. The character of the composition, with the figures crowded closely in the foreground; the design of the upper framing consisting of

recto

intertwined branches; and the black chalk indications for the sake of the glass painter all point in this direction. Some scholars, beginning with Knappe (1961, p. 60), have identified the monk preaching as Saint Vincent Ferrer on account of the prominent placement of Christ as judge above his left hand. As J. Marrow has noted, this detail indicates the subject of the sermon.[2] The identification of the preacher is somewhat vitiated by the absence of a halo, but no preferable suggestion has yet been offered.

1. C. Koch, *Die Zeichnungen Hans Baldung Griens* (Berlin, 1941), no. 3.
2. Conversation with the author, Malibu, 1984.

127 *Studies of Heads*[r]
Studies of a Male Figure[v]

Pen and black ink; H: 12.3 cm (4⅞ in.); W: 17.2 cm (6¾ in.)
84.GA.81

MARKS AND INSCRIPTIONS: At bottom right corner, signed with monogram *HBG* in black ink.

PROVENANCE: Private collection, France (sale, Hôtel Drouot, December 1983); art market, Paris.

EXHIBITIONS: None.

BIBLIOGRAPHY: None.

THIS NEWLY DISCOVERED SHEET IS ONE OF FOUR BY Baldung showing various studies of heads. Two others are in the Louvre, Paris (inv. 37, 38), and a third was formerly in the collection of Robert von Hirsch, Basel.[1] As in the other drawings, here Baldung has drawn a wide variety of types within one spatial unit, and all are woven together by the abstract hatching applied throughout, in particular between the rows of heads. The drawing also includes both a piece of drapery at the right and a young man looking upward at a sharp angle, as in the larger Louvre drawing.[2] This young man, as well as the frontal crowned woman and the bearded man at the top left of the sheet, are all facial types the artist was studying for possible later use in paintings and prints. By contrast, the six faces clustered in groups of two and four near the upper center of the sheet have the appearance of physiog-

nomic characterizations or types. This is especially true of the three profile heads at the center right, which have much in common with physiognomic studies by Dürer in Kansas City (William Rockhill Nelson Gallery of Art and Mary Atkins Museum of Fine Arts, inv. 58–62) and Berlin (Kupferstichkabinett, inv. KDZ 42),[3] with the latter containing a drapery study as well. Stylistically, the Museum's drawing is closest by far to the one formerly in the von Hirsch collection, with which it shares a diversity of pen work; in both, lighter strokes are employed in most areas and broader, darker accents in others, above all in the eyes, noses, and mouths. However, the Museum's recto seems less a composed sheet, and its pen strokes are a bit freer in execution, suggesting a date of around 1512/13 or somewhat later than the ex-von Hirsch drawing. The slight sketches of a nude figure on the verso do not provide enough visual information for evaluation.

1. C. Koch, *Die Zeichnungen Hans Baldung Griens* (Berlin, 1941), nos. 17, 18, 33.
2. Ibid., no. 18.
3. W. L. Strauss, *The Complete Drawings of Albrecht Dürer* (New York, 1974), vol. 3, nos. 1513/4, 1513/6.

recto

verso

128 Study of a Stag^r
Three Goats^v

Brush and brown and red-brown wash and white gouache heightening (recto); brush and black, gray, and green wash, and black chalk (verso); H: 13.5 cm (5⁵⁄₁₆ in.); W: 16.6 cm (6⁹⁄₁₆ in.)
84.GC.36

MARKS AND INSCRIPTIONS: None.

PROVENANCE: S. Rosenthal, Bern; L. V. Randall, Montreal (sale, Sotheby's, London, July 6, 1967, lot 2); private collection, New Jersey.

EXHIBITIONS: *Five Centuries of Drawings*, Montreal Museum of Fine Arts, October–November 1953, no. 101.

BIBLIOGRAPHY: T. L. Girshausen, *Die Handzeichnungen Lucas Cranachs des Älteren* (Frankfurt am Main, 1936), p. 76, no. 68a; J. Rosenberg, *Die Zeichnungen Lucas Cranach des Älteren* (Berlin, 1960), pp. 26–27, no. 63.

SINCE HIS EARLY MATURITY, CRANACH HAS BEEN widely admired for his portrayal of animals.[1] This holds true not only for the hunting pictures he made for the Saxon court but also for religious and mythological depictions. Perhaps most frequently included are stags, both as victims of the hunt and as onlookers to scenes such as Cranach's different versions of *Adam and Eve*. Stags also serve as the principal motifs decorating the lower borders of his drawings for the Prayer Book of Emperor Maximilian (1515; Munich, Bayerische Staatsbibliothek) and the title page of Luther's treatise *Das diese Wort Christi (Das ist mein Leib etce) noch fest stehen wider die Schwermgeister*, published in Wittemberg in 1527.

This is one of Cranach's few surviving studies of a stag. It was first published by Girshausen (1936, p. 76, no. 68a), who referred to the attribution by Schilling to Cranach, though neither he nor Rosenberg (1960, p. 76) offered much interpretive comment. The stag on the Museum's recto is perhaps closest to one at the right of Cranach's drawing *Adam and Eve* (formerly Staatliche Kunstsammlungen Dresden, Kupferstich-Kabinett; Rosenberg 1960, no. 39) in terms of the detailing of the eyes and muzzle and shading of the face. Notable too is the

expressiveness of the eyes, a feature that recurs frequently in Cranach's depictions of stags, as for example in his *Adam and Eve* (Detroit Institute of Arts).[2]

The Museum's drawing of a stag appears to have been made rapidly with a brush. To judge by the verso, Cranach began with a sketch in black chalk, which he then went over with a brush in broad strokes, applying varied washes freely. The rhythmic character of the strokes indicating the fur and the painterly method apparent throughout are characteristic of the artist's few comparable animal studies (Rosenberg 1960, nos. 61, 64–70).

The verso, which was hidden by an old mount but already noticed in the literature (Girshausen 1936, p. 76, no. 68a), shows a goat grazing, with the head of another at the right margin and a black chalk sketch of a third peering outward above the neck of the fully represented animal.[3] If anything, the verso was drawn with a still more painterly technique than the recto. The relative placement of the fully rendered goat and her companion looking out from above her neck recurs in Cranach's work in a painting, *Adam and Eve*, of 1526 (London, Courtauld Institute Galleries),[4] and in his woodcut *Deer in the Forest*, of 1541,[5] the latter noted by C. Andersson.[6] The lively manner of rendering the grass also recurs in the woodcut. Lastly, there—as in the Museum's recto—Cranach displays his tendency to show animals looking expressively at the viewer. Given the fact that his datable animal studies are from around 1530 and that comparative material in other media by him falls into the period from the mid-1520s to around 1540, a date in the early 1530s would appear most likely for the Museum's sheet.

1. C. Andersson and C. Talbot, *From a Mighty Fortress: Prints, Drawings, and Books in the Age of Luther 1483–1546*, exh. cat., Detroit Institute of Arts, 1983, p. 222.
2. M. J. Friedländer and J. Rosenberg, *The Paintings of Lucas Cranach* (Ithaca, 1978), no. 192.
3. The drawing was removed from its mount by Alexander Yow following its purchase in 1984.
4. Friedländer and Rosenberg (note 2), no. 191.
5. K. G. Boon and R. W. Scheller, *F. W. H. Hollstein, German Engravings, Etchings, and Woodcuts ca. 1400–1700* (Amsterdam, 1959), vol. 6, no. 121.
6. Conversation with the author, Malibu, 1984.

recto

verso (no. 128)

129 Stag Beetle

Watercolor and gouache, top left corner added with tip of left antenna painted in by a later hand; H: 14.2 cm (5⁹⁄₁₆ in.); W: 11.4 cm (4½ in.)
84.GC.214 (SEE PLATE 14)

MARKS AND INSCRIPTIONS: At bottom left corner, signed and dated *1505/AD* in brown ink; on mount, at bottom left, collection mark of John Postle Heseltine; on mount, at bottom right, collection mark of Alain Delon.

PROVENANCE: Horace Walpole, earl of Oxford (sale, G. Robins, London, June 23, 1842, lot 1266); Charles Sackville Bale, London (sale, Christie's, June 9, 1881, lot 2277); John Postle Heseltine, London; Henry Oppenheimer, London; G. Tyser, London (sale, London, Sotheby's, June 26, 1969, lot 53); Alain Delon, Paris.

EXHIBITIONS: *Drawings by Old Masters*, Royal Academy of Arts, London, 1953, no. 232 (catalogue by K. T. Parker and J. Byam Shaw). *Albrecht Dürer 1471–1528: Gravures, Dessins*, Centre Culturel du Marais, Paris, April–July 1978, no. 145 (catalogue by H. Mielke). *Albrecht Dürer und die Tier- und Pflanzenstudien der Renaissance*, Graphische Sammlung Albertina, Vienna, April–June 1985, no. 36 (catalogue by F. Koreny).

BIBLIOGRAPHY: C. Ephrussi, *Albert Dürer et ses dessins* (Paris, 1882), pp. 78–80; M. Thausing, *A. Dürer—Geschichte seines Lebens und seiner Kunst* (Leipzig, 1884), vol. 1, p. 21, no. 303; S. Killermann, *A. Dürers Pflanzen- und Tierzeichnungen und ihre Bedeutung für die Naturgeschichte*, Studien zur deutschen Kunstgeschichte, 119 (Strasbourg, 1910), vol. 119, p. 49; M. Deri, *Naturalismus, Idealismus, Expressionismus* (Leipzig, 1922), p. 25; H. Wölfflin, *Die Kunst Albrecht Dürers* (Munich, 1926), pp. 166, n. 1; 128, no. A140; F. Lippmann, *Zeichnungen von Albrecht Dürer in Nachbildungen* (Berlin, 1927), vol. 2, no. 169; C. Dodgson, "Two Dürer Catalogue Raisonnés," *Burlington Magazine* 53, no. 307 (October 1928), p. 201; G. Pauli, "Der süddeutsche Dürer und die Methode der Kunstgeschichte," in G. Bierman, ed., *Albrecht Dürer: Festschrift der internationalen Dürer-Forschung* (Leipzig, 1928), p. 71; H. Tietze and E. Tietze-Conrat, *Kritisches Verzeichnis der Werke Albrecht Dürers*, vol. 1 (Basel and Leipzig, 1928), p. 128, no. A140; F. Winkler, "Dürerstu-

dien, I. Dürers Zeichnungen von seiner ersten italienischen Reise (1494–95)," *Jahrbuch der Preussischen Kunstsammlungen* 50 (1929), pp. 137, 138; E. Flechsig, *Albrecht Dürer—Sein Leben und seine künstlerische Entwicklung*, vol. 2 (Berlin, 1931), pp. 9, 310; H. Tietze, "Dürerliteratur und Dürerprobleme im Jubiläumsjahr," *Wiener Jahrbuch für Kunstgeschichte* 7 (1932), pp. 246, 247; F. Winkler, *Die Zeichnungen Albrecht Dürers*, vol. 2 (Berlin, 1937), pp. 74–75; 81–82, no. 370; E. Panofsky, *Albrecht Dürer* (Princeton, 1943), vol. 2, p. 131, no. 1359; H. Tietze, *Dürer als Zeichner und Aquarellist* (Vienna, 1951), pp. 35, 36; H. T. Musper, *Albrecht Dürer—Der gegenwärtige Stand der Forschung* (Stuttgart, 1952), pp. 126, 149; S. Killermann, *A. Dürers Werk—Eine natur- und kulturgeschichtliche Untersuchung* (Regensburg, 1953), p. 24; F. Winkler, *Albrecht Dürer—Leben und Werk* (Berlin, 1957), pp. 181–182; G. Zampa and A. Ottino della Chiesa, *L'opera completa di Dürer* (Milan, 1968), p. 115, no. 195; W. J. Hofmann, *Über Dürers Farbe* (Nuremberg, 1971), p. 39; W. L. Strauss, *The Complete Drawings of Albrecht Dürer* (New York, 1974), vol. 2, no. 1505/15; L. J. Bol, *Goede Onbekenden* (Utrecht, 1982), pp. 36, 37; F. Piel, *Albrecht Dürer, Aquarelle und Zeichnungen* (Cologne, 1983), pp. 142–143, no. 58; M. L. Hendrix, "Joris Hoefnagel and the 'Four Elements': A Study in Sixteenth Century Nature Painting," unpub. Ph.D. diss., Princeton University, 1984, p. 121; E. Schlumberger, "La nature d'après Dürer," *Connaissance des arts* 399 (May 1985), p. 84.

THE *STAG BEETLE* IS AMONG THE MOST FAMOUS animal studies of the early German Renaissance. It was accepted as the work of Dürer by all scholars of the subject with the exception of the Tietzes (1928) and Panofsky (1943) until the exhibition at the Albertina (1985), in the catalogue for which Koreny expressed new doubts. For the Tietzes, the division of the beetle into three parts seemed inorganic and therefore characteristic of late sixteenth-century form, while Panofsky offered no explanation for his difficulties with the attribution to Dürer. By contrast Koreny has raised a number of new questions bearing on the attribution, pointing out that the anatomical rendering of certain details is inaccurate and that it is also later in date than the drawing of 1503, *Madonna with a Multitude of Animals*, in the Albertina, Vienna (inv. 3066 D 50; Koreny 1985, no. 35), in which a similar stag beetle is included. According to his argument, the Mu-

seum's *Stag Beetle* contradicts Dürer's normal practices by following rather than preceding the finished work. Moreover, Koreny has observed that the stag beetles represented in the Albertina drawing and in Dürer's painting of the Adoration of the Kings (1504; Florence, Uffizi) are more clearly defined and forceful in movement, and differ from the Museum's *Stag Beetle* in certain anatomical details. Lastly, he has pointed out that Winkler's expressed faith in the authenticity of the monogram and date (1937, vol. 2, no. 370) was unwarranted, since it was based on a comparison with a drawing no longer accepted as by Dürer (Munich, Staatliche Graphische Sammlung, inv. Mu.24; Strauss 1974, vol. 2, no. 1505/33). Koreny has also compared the date on the *Stag Beetle* with the inscribed dates of 1505 on a group of disputed drawings (Strauss 1974, vol. 2, nos. 1505/9, 1505/11–13, 1505/23), several of which are now widely accepted as the work of Baldung. These arguments need to be considered individually since they carry the appearance of great weight.

The issue of anatomical accuracy is of some interest, but irrelevant to the matter of attribution. There is nothing to indicate a consistent scientific accuracy in Dürer's animal and plant studies, as is evident from Koreny's own observation that the *Wing of a Roller* in the Albertina, Vienna (inv. 4840 D 104; Koreny 1985, no. 22) is much too bright coloristically and contrary in this respect to the way the bird appears in nature. Similarly, M. A. Fischer has pointed out botanical inaccuracies in the *Great Piece of Turf* and the *Irises* in the Albertina and the Kunsthalle Bremen (inv. 3075 D 54, 35; Koreny 1985, nos. 61, 66).[1] In addition it has been correctly observed by K. Oberhuber[2] that the *Stag Beetle* and other Dürer animal and plant drawings in watercolor and gouache were not made *en plein air*, but in the studio, based on quick sketches and memory. It is therefore neither surprising nor significant with respect to the attribution that some of them lack precision of scientific rendering.

It is, of course, true that the *Stag Beetle* postdates the *Madonna with a Multitude of Animals* by two years, but there is no reason to suppose that it must either be a study for the latter or not by Dürer. In his discussion of the *Wing of a Roller*, Koreny (1985, p. 70, no. 22) separates that rendering from the finished wing in Dürer's *Nemesis* engraving, with which it has been associated in past literature. There is no reason not to do the same with respect to the *Stag Beetle*, which—like the *Wing of a Roller*—was done independently, not as a preparatory study.

The difference in animation and anatomy between this stag beetle and those in the Uffizi painting and the *Madonna with a Multitude of Animals* is again predictable,

not revealing or surprising. In each of those instances the insect is shown in action, moving across a step or being confronted by a dog (Koreny 1985, ills. pp. 112, 114), whereas in the Museum's drawing the animal is studied in a naturalistic space but in a contextual void. A comparison of the *Studies of Hares* in the British Museum, London (inv. Sloane 5218/157; Koreny 1985, no. 42), with the famous *Hare* in the Albertina (inv. 3073 D 49; Koreny 1985, no. 43) yields an analogous difference, one based on context and medium, not on the issue of authorship. Indeed the two drawings of hares fully elucidate Oberhuber's excellent point, already mentioned, that the finished watercolors and gouaches are works made in the studio, presumably based on sketches and memory. As for the fact that the stag beetles in the Uffizi painting and Albertina drawing differ from the *Stag Beetle* in anatomical terms, one should note that they also differ from each other in the same respect and that, as Koreny has noted, the beetle in the Albertina drawing is also "incorrectly" divided into segments! Lastly, the effort to make precise comparison between images of varying scale, purpose, and medium is at best tendentious and at worst forced and bound to be inconclusive.

The last question raised by Koreny is over the handwriting of the date; he does not discuss the monogram. He has related the date to the *1505* inscriptions on five other drawings, at least three of which he believes may be by Baldung (Strauss 1974, vol. 2, nos. 1505/9, 1505/11–13, 1505/23). He is certainly correct in noting that the first four of these (nos. 1505/9, 1505/11–13) were inscribed by the same hand, and it indeed seems highly probable that the draughtsman in these cases was Baldung. However, the fifth drawing, the *Head of a Man* in the British Museum, London (inv. Sloane 5218/31; Strauss 1974, no. 1505/23), was quite obviously dated by another hand, just as the drawing itself is by a different artist. The dates on the first four differ entirely from that on the *Stag Beetle* as well. The *1* in the dates on the first four drawings is written much like a capital *i*, whereas in the *Stag Beetle* it has an obvious loop at the top and only a horizontal line forward at the bottom. The *o* in the first four drawings appears to have been made with one continuous motion, whereas in the *Stag Beetle* it is clearly composed of two separate halves, which barely meet at top and bottom. Lastly, the *5*'s are drawn in the first four instances with less pronounced curvature in the lower half and no comma-like motif at the bottom, as in the second 5 inscribed on the *Stag Beetle*. By contrast the date on the *Stag Beetle* is similar to that on the *Head of a Man* in the British Museum, not only in the presence of virtually every one of the characteristic mannerisms just

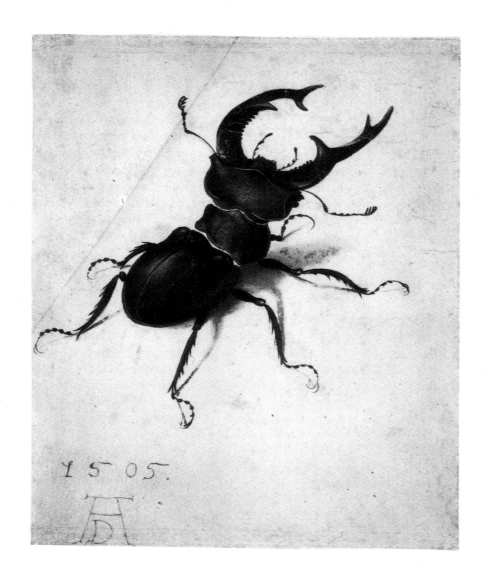

ALBRECHT DÜRER (German, 1471–1528). *Stag Beetle*, 1505 (monogram and date). Watercolor and gouache (pen and brown ink). H: 14.2 cm (5⁹⁄₁₆ in.); W: 11.4 cm (4½ in.). Malibu, J. Paul Getty Museum 84.GC.214.

ALBRECHT DÜRER. *Head of a Man*, 1505 (date). Pen and brown ink. H: 20.8 cm (8⁵⁄₁₆ in.); W: 14.8 cm (5⅞ in.). London, British Museum Sloane 5218/31. Photo courtesy Trustees of the British Museum.

ALBRECHT DÜRER. *Head of an Angel*, 1506 (monogram). Brush and gray ink and white gouache heightening on blue paper (brush and black ink). H: 27 cm (10⅝ in.); W: 20.8 cm (8³⁄₁₆ in.). Vienna, Graphische Sammlung Albertina 3099, D 78. Photo courtesy Fonds Albertina.

ALBRECHT DÜRER. *Saint Dominic*, 1506 (monogram). Brush and gray ink and white gouache heightening on blue paper (brush and gray ink). H: 41.6 cm (16³⁄₈ in.); W: 28.8 cm (11³⁄₈ in.). Vienna, Graphische Sammlung Albertina 3101, D 70. Photo courtesy Fonds Albertina.

mentioned but also in the relatively free calligraphic effect of the handwriting. And, as was first noticed by Winkler (1937, vol. 2, no. 288), this inscription must be autograph, since it and the inscription on the unquestionably authentic drawing *Smiling Windisch Peasant Woman*, also in the British Museum (inv. 1930-3-24-1; Strauss 1974, vol. 2, no. 1505/27), are inextricably related in their use of comparable flourishes. This similarity between the date on the *Stag Beetle* and that of the *Head of a Man* in the British Museum was pointed out by F. Anzelewsky, who considers it sufficiently definitive as a basis for attributing the *Stag Beetle* to Dürer.[3] Koreny's suggestion concerning the date, on the other hand, would inevitably lead to an attribution of the *Stag Beetle* to Baldung, an idea he has raised in conversation with the present writer since the publication of the 1985 Albertina catalogue. In addition to being based on a demonstrably mistaken analysis of handwriting, this hypothesis is entirely lacking in a historical, stylistic, or documentary basis.

In the same vein, removal of the later gold border has made it possible to study the monogram on the Museum's sheet. Examination reveals a clear relationship between it and other monograms on absolutely unquestioned drawings by Dürer. Two specific observations should suffice here. The form of the letters, their relative placement, the horizontal strokes at the base of the *A*, and the small hooks at its top, both left and right, can all be seen in the monogram drawn on the *Head of an Angel* in the Albertina (inv. 3099 D 78; Strauss 1974, vol. 2, no. 1506/19). Very similar features and a closely comparable form of calligraphy occur in the monogram on a sheet showing Saint Dominic, also in the Albertina (inv. 3101, D 70; Strauss 1974, vol. 2, no. 1506/12). Together with the evidence provided by the date, these similarities constitute unassailable objective proof of authorship.[4]

Stylistically, the *Stag Beetle* differs mainly from other Dürer animal studies in its more precise manner of modeling, especially along the back of the insect. This is to be expected since in reality the texture is less differentiated than that of a hare's fur or a roller's wing. The Museum's drawing also possesses a number of common features of technique such as the manner of capturing the shadow cast by the insect and the more varied textural effect overall than that found in copies by Hoffmann and Hoefnagel. Conceptually, the drawing combines the notion of representation with one of intellectual illusion, looking back to old anecdotes about Giotto and ancient painters composing deceptively real insects, and ahead to the scientific naturalism of the future. It is for this reason that the drawing had so great an influence in its century and has proven so affecting throughout its history.[5]

1. M. A. Fischer, "Die Natur als Vorbild und Abbild," lecture delivered at a symposium entitled "Albrecht Dürer und die Tier- und Pflanzenstudien der Renaissance," Vienna, June 7–10, 1985. Dr. Fischer kindly reiterated his views in a letter to the author, December 20, 1986.
2. Conversation with the author, 1986.
3. Letter to the author, September 21, 1985.
4. The authenticity of the monogram has been confirmed by H. Mielke (letter to the author, June 2, 1986).
5. Since the exhibition, F. Anzelewsky (letter of September 21, 1985), K. Oberhuber (letter of September 6, 1985), and C. White (letter of April 24, 1985) have informed the author that they continue to support the attribution of the *Stag Beetle* to Dürer.

130 Study of the Good Thief

Pen and brown ink; H: 26.8 cm (10%₆ in.); W: 12.6 cm (5 in.)

83.GA.360

MARKS AND INSCRIPTIONS: (Recto) in top right corner, inscribed *AD|*... in brown ink; in bottom right corner, inscribed *A1:Duro* in brown ink by a later hand; (verso) collection mark of William Mitchell (L. 2638).

PROVENANCE: William Mitchell, London (sale, Prestel, Frankfurt am Main, May 7, 1890, lot 22); H. von Mumm, Frankfurt am Main; private collection, Germany; art market, Munich.

EXHIBITIONS: None.

BIBLIOGRAPHY: C. Ephrussi, *Albert Dürer et ses dessins* (Paris, 1882), p. 228, n. 1; F. Winkler, *Die Zeichnungen Albrecht Dürers*, vol. 3 (Berlin, 1938), vol. 3, p. 50, under no. 593; F. Winzinger, "Eine unbekannte Aktstudie Albrecht Dürers," *Pantheon* 22 (1962), pp. 275–279; W. L. Strauss, *The Complete Drawings of Albrecht Dürer* (New York, 1974), vol. 2, no. 1505/7.

THIS DRAWING WAS FIRST PUBLISHED AS BY A DÜRER student by Ephrussi (1882), who noted its connection to a second study of the same subject, then also in the Mitchell collection. This sheet then disappeared from sight, and Winkler published the second Mitchell drawing (1938, no. 593), by then in the Koenigs Collection, Museum Boymans-van Beuningen, Rotterdam, as by Dürer. The second drawing disappeared in 1941 (Strauss 1974, vol. 2, no. 1505/8). The Museum's drawing was first published fully by Winzinger in his fundamental article of 1962.[1] There he argued that the relationship between it and the Koenigs drawing could not be that of original and copy due to the lack of corresponding strokes in both and the more frontal vantage point of the former. Rather, he believed them to be the work of two artists drawing from the same studio model. Pointing out the superiority of the Museum's drawing, he concluded that it, rather than the Koenigs drawing, was the work of Dürer.

A comparison between the two reveals that the Museum's *Good Thief* shows a complete comprehension of the structure of the body and the integration of its various parts. By contrast, the Koenigs study is stiffer, copying some elements from its model, but failing to relate individual forms to the whole. For example, the weight of the figure in the Museum's drawing brings the body fully forward, with straightened legs and taut arm muscles, the effect accentuated by the bowing of the cross. In the other study the cross remains upright, while the knees are bent and the arm flaccid, eliminating much of the physical coherence and expressive power of the image. While not a copy, the Koenigs drawing does appear to have presupposed a knowledge of the Museum's *Good Thief* and therefore was probably a variant of the latter made by an assistant in Dürer's workshop.

The *Good Thief* inspired still another representation of the subject, dated 1505 and in the Albertina, Vienna (inv. 3097; Strauss 1974, vol. 2, no. 1505/9), which derives from it the general placement of the figure in space as well as the expressive idea of having the good thief look toward Christ, turning away from his own pain and toward salvation. This and related studies (Strauss 1974, vol. 2, nos. 1505/10–12) are no longer considered to be by Dürer and may well be the work of Baldung. They are among several depictions of the Crucifixion in various media which were made by the Dürer workshop in the early years of the century. Two of those have special relevance for the drawing of the *Good Thief*. First is the woodcut of the subject (B.59[127] v.10,7), in which the bad thief is shown in a similar pose and with anatomy very like that of the good thief in the drawing. He is

sharply foreshortened, with just part of his far hand shown, his body hanging forward, belly protruding, legs straight, and feet resting on a wooden footrest. However, in place of the classicizing hair and calm expression of the good thief in the drawing, the bad thief in the woodcut is shown with wildly streaming hair, as is his counterpart on the other side of Christ, both of whom look away from him. In addition the *Good Thief* is more generally related to the representation of the same figure in the *Calvary* drawing in the Kunstmuseum Basel (Strauss 1974, vol. 2, no. 1505/22), usually given to Schäufelein, which was made in preparation for the central panel of the Ober-Sankt-Veit altarpiece. The basic pose and proportions are similar, though the figure in the Basel drawing is shown with the right knee slightly bent and in a less foreshortened pose. The Museum's *Good Thief* would appear to belong to the period in which these representations of the Crucifixion were made, that is, around 1503–1505, though it is not possible to connect it directly with any of them without further evidence.

The figure in the Museum's drawing undoubtedly was made from a studio model and first sketched rather quickly. The forms were better defined as Dürer went over the outline in most areas with a stronger stroke, which was also employed for the principal divisions of the chest and abdomen. The figure was then modeled, using a combination of thin, parallel lines, cross-hatching, and short, rapidly repeated strokes. The cross was drawn after the figure was completed. The modeling system and graphic means are quite similar to those found in a slightly earlier study of a nude woman seen from behind, now in the Sächsische Landesbibliothek, Dresden (inv. R-147, fol. 164r; Strauss 1974, vol. 2, no. 1500/14).

1. The attribution of the Museum's drawing to Dürer is supported by E. Schilling in a letter to Winzinger, October 16, 1962.

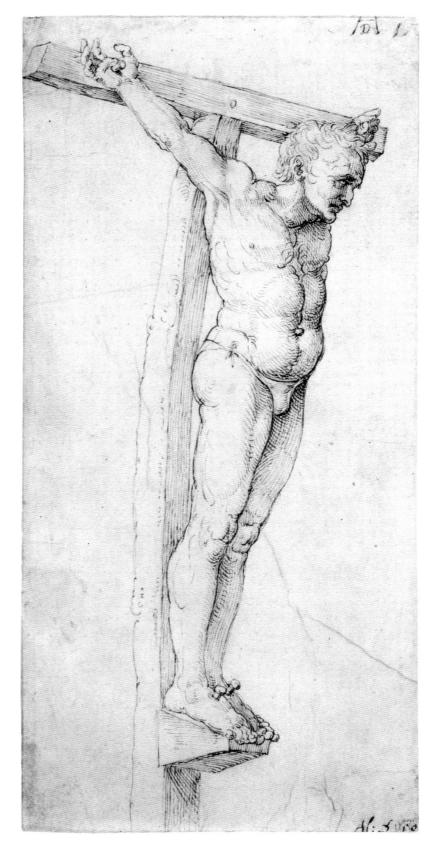

recto

WOLF HUBER

131 The Conversion of Saint Paul

Pen and black ink; H: 18.3 cm (7³/₁₆ in.); W: 12.9 cm (5¹/₁₆ in.)
85.GA.14

MARKS AND INSCRIPTIONS: At top left corner, dated *1531* in black ink; inscribed *AD* in brown ink by a later hand.

PROVENANCE: De Mestral de Saint-Saphorin; by descent (sale, Christie's, London, April 10, 1985, lot 144); art market, London.

EXHIBITIONS: None.

BIBLIOGRAPHY: None.

THE SUBJECT OF THIS DRAWING IS THE CONVERSION of Saint Paul, with idiosyncratic variations typical of the Danube school. The angel holding a scroll is unexpected in renderings of this theme, but angels do appear alongside God the Father in Baldung's woodcut of the same subject of around 1505–1507.[1] It is likely that this drawing was cut down and that God the Father and additional cherubim were shown above the dove of the Holy Spirit. Otherwise the iconography of the depiction is not heterodox. The horse's pose and the billowing drapery occur, respectively, in the *Conversion of Saint Paul* woodcuts by Baldung[2] and the engraving of the subject of circa 1495 attributed to Dürer.[3] The town view and water in the background are frequent features of renderings of the theme, and even the small armed horseman finds an analogy, in a south German drawing in the Kunstmuseum Basel (Kupferstichkabinett, inv. U.III.47).[4] Lastly, the conception of Saint Paul falling to the side reflects, in a general sense, the riders with Saint Paul in Baldung's woodcut of circa 1515/17.[5] Notwithstanding all of these precedents, the scene has been formulated with great ingenuity.

The poetic, idyllic atmosphere, the placement of the main participant on a foreground stage, the large tree with abundant foliage, and the delicate rendering of a mountainous background are hallmarks of Huber's drawings.[6] The florid, billowing motif of Saint Paul's drapery is also typical of his work. Compared to a student's effort,[7] Huber's unique ability to capture these complexly formed passages becomes evident. While the horse reflects the example of Baldung in the expressive conception of the head, its overall proportions and hindquarters with flowing tail are closest to the horse in profile in Huber's drawing of 1518, *Battle of Riders*,[8] as does the heavy outlining of the hind end and legs. The only motif from another artist is the angel, taken from Altdorfer's woodcut of the Annunciation to Joachim of circa 1513,[9] which had already influenced Huber in his depictions of the latter subject. Similarly, the bag hanging from Saint Paul's belt, which may have derived from Baldung's *Saint Paul* woodcut of 1505/07, had already made its way into Huber's *Battle of Riders*.

The graphic style of the Museum's drawing is subtle, exhibiting the finest gradations of line work and sensitively suggesting effects of light, texture, and space. The atmospheric character of the scene and the subtlety of its pen work separate it from the many drawings by followers of Huber and place it firmly within his work. Its technique is more precise than in most of his drawings, but this may well result from its purpose. The overall character and scale of the drawing are analogous to several of his woodcuts,[10] indicating that it may well have been made with a print in mind.

1. M. Mende, *Hans Baldung Grien: Das graphische Werk* (Unterscheidheim, 1978), no. 8.
2. Ibid., nos. 8, 42.
3. W. L. Strauss, *The Complete Engravings, Etchings and Drypoints of Albrecht Dürer* (New York, 1973), no. 3.
4. T. Falk, *Katalog der Zeichnungen des 15. and 16. Jahrhunderts im Kupferstichkabinett Basel*, Kunstmuseum Basel, Öffentliche Kunstsammlung: Kupferstichkabinett: Beschreibender Katalog der Zeichnungen, vol. 3 (Basel, 1979), no. 110.
5. Mende (note 1), no. 42.
6. C. Talbot et al., *Prints and Drawings of the Danube School*, exh. cat., Yale University Art Gallery, New Haven, and other institutions, 1969, pp. 78–79.
7. F. Winzinger, *Wolf Huber: Das Gesamtwerk* (Munich, 1979), no. 197.
8. Formerly in Rotterdam. Ibid., no. 59.
9. Talbot et al. (note 6), no. 28.
10. Winzinger (note 7), nos. 269, 271.

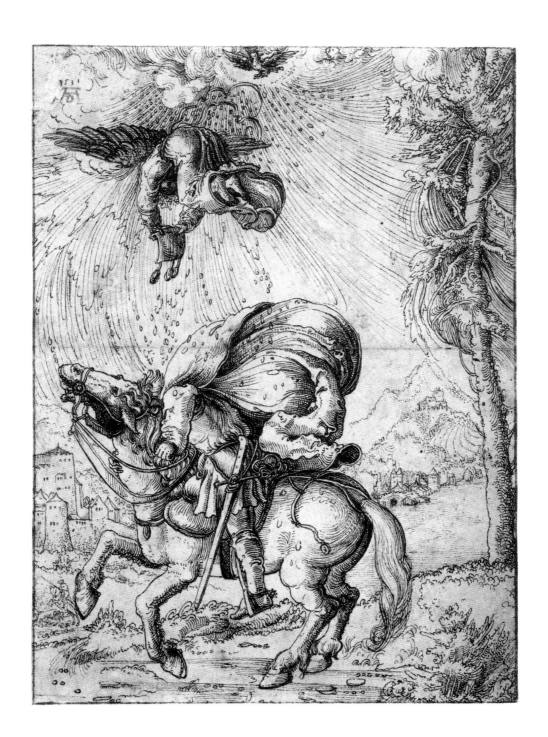

ADOLF VON MENZEL

132 *Figure Studies*

Carpenter's pencil; H: 37.9 cm (14¹⁵⁄₁₆ in.); W: 26.3 cm (10⁵⁄₁₆ in.)
84.GB.6

MARKS AND INSCRIPTIONS: At bottom right, signed *AD. Menzel.* in carpenter's pencil.

PROVENANCE: Private collection, Switzerland; art market, Munich.

EXHIBITIONS: None.

BIBLIOGRAPHY: None.

IN 1869 MENZEL WAS COMMISSIONED TO DESIGN A commemorative print on the occasion of the fiftieth anniversary of the Heckmann metal works. This commission led to an increasing interest on his part in industrial subject matter, and in 1872 he spent several weeks in the vast smelting works in Königshütte, Upper Silesia, making many drawings recording his impressions of the iron production process. Menzel employed these studies in the execution of his most important painting, *The Iron Rolling Mill*, a major example of nineteenth-century industrial depiction. He completed the painting early in 1875 and sold it immediately to the banker Adolph von Liebermann, who resold it in the same year to the Nationalgalerie in Berlin, where it remains.

This is one of many surviving studies for the *Iron Rolling Mill*, most of which are also in the Nationalgalerie.[1] This drawing is clearly related to the figures in the center of the composition who are moving a glowing piece of iron toward the rollers, while the rest of their co-workers are shown eating and washing, indicating a change of shift. Most likely, this sheet served as a study for the man with his back to the viewer at the center of the painting, though he is shown there in a somewhat more strained pose. This association is supported by the fact that Menzel made studies of this man on at least two other sheets together with studies for the man shown in profile with his hands above his head; these figures are shown in the same relative positions as in the painting (Berlin, Nationalgalerie, inv. 1065; Hamburger Kunsthalle, inv. 1953/57).[2] The careful modeling and detailing of the figure in the Museum's drawing suggest that it was made not as a study from life but as one of the more considered and finished drawings for the painting, achieved after some reflection.

1. K. Kaiser, *Adolph Menzels Eisenwalzwerk: Veröffentlichung der Deutschen Akademie der Künste* (Berlin, 1953), esp. figs. 18–55.
2. Ibid., no. 18; G. Hopp and E. Schaar, *Menzel—Der Beobachter*, exh. cat., Hamburger Kunsthalle, 1982, no. 105.

GEORG PENCZ

133 *Study for a Stained-Glass Window with the Coat of Arms of the Barons von Paar*^r *Study for a Scepter with the Initials MB*^v

Pen and brown ink and gray wash (recto); black chalk (verso); Diam: 24.7 cm (9¹¹⁄₁₆ in.)
83.GA.193

MARKS AND INSCRIPTIONS: (Recto) at bottom right corner of board hanging from tree, faintly signed *GP* in black chalk; on board, inscribed *STEMMATA . VI / RTUTI . ET . MUN / IFICENTIE . AD / AVCTA. HEROV[M] PROPRIA* in black ink; on circular border, inscribed *INSIGNIA. MARCI. BARONIS. GENTILIV[M] . Q[VE] . SUOR[UM] . A . PAR.*; (verso) unidentified collection mark of B. S. (L. Suppl. 414b).

PROVENANCE: B. S. collection; G. Schwarting, Delmenhorst; art market, London.

EXHIBITIONS: *Meister um Albrecht Dürer*, Germanisches Nationalmuseum, Nuremberg, July–September 1961, no. 265 (catalogue by P. Streider et al.). *Zeichnungen alter Meister aus deutschem Privatbesitz*, Kunsthalle Bremen, February–April 1966, no. 66 (catalogue by W. Stubbe).

BIBLIOGRAPHY: C. White et al., *Recent Acquisitions and Promised Gifts, Sculpture, Drawings, Prints*, exh. cat., National Gallery of Art, Washington, D.C., 1974, p. 42, under no. 7.

THE ARMS DEPICTED IN THIS DRAWING FOR A STAINED-glass window are identified by the surrounding inscription as those of Marcus Belidorus de Casnio (alive 1170), an ancestor of the von Paar family, who originated in Bergamo (Streider et al. 1961, p. 159). The base of the crossed scepter held by the crowned bull atop the escutcheon carries his initials, *MB*. The interior inscription, hanging from the tree, suggests the continuation of the glory of his descendents, stating: "The family trees of heroes grow greater through virtue and munificence." The sentiment expressed in this motto is a humanist one, as are the style of the lettering and the form of the plaque. The classicizing female figure holding the shield may reflect the influence of Giulio Romano, whose work Pencz might have seen on a trip to northern Italy around 1529, and also recalls the prints of Marcantonio Raimondi. The sheet also has been compared stylistically with a copy by Pencz after Michelangelo's *Flood* (Washington, D.C., National Gallery of Art, inv. B-26, 781; White et al. 1974, no. 7). The style of the Museum's drawing seems more developed and is more subtle in the use of wash than the copy after Michelangelo, and the figure looks ahead to Pencz's painting of a sleeping nude of 1544 (Pasadena, Norton Simon Museum). The integration of figure with landscape has been sensitively accomplished, and the latter has a distinctly Northern flavor in its openness and specificity. These factors would appear to argue tentatively for a date of around 1540 for the drawing.

INSIGNIA·MARCI·BARONIS·GENTILIV·Q·SVO·RA·PARIN

STEMMATA·VI
RTVTI·ET·MVN
IFICENTIE·AD·
AVCTA·HEROV·
PROPRIA·

recto

HANS SCHÄUFELEIN

134 Christ Taking Leave of His Mother

Pen and brown ink and black chalk; H: 27.6 cm (10¹³/₁₆ in.); W: 21.1 cm (8⁵/₁₆ in.)
85.GA.438

MARKS AND INSCRIPTIONS: At top, signed *HS* with shovel emblem and dated *1510* in brown ink (date slightly trimmed); at bottom left corner, inscribed *Hans Schiuele* in black ink by a later hand.

PROVENANCE: Comte Hubert Pourtalès, Paris(?); M. Cassirer, Berlin; Dr. Tobias Christ, Basel (sale, Sotheby's, London, April 9, 1981, lot 7); Robert Smith, Washington, D.C.; art market, New York.

EXHIBITIONS: *Meister um Albrecht Dürer*, Germanisches Nationalmuseum, Nuremberg, July–September 1961, no. 310 (catalogue by P. Streider et al.).

BIBLIOGRAPHY: K. T. Parker, "Hans Leonard Schäufelein," *Old Master Drawings* 10 (December 1935), p. 50; F. Winkler, *Die Zeichnungen Hans Süss von Kulmbach und Hans Leonard Schäufelein* (Berlin, 1942), pp. 128–129, no. 44; P. Murray, "Zwei Gemälde des *Abschieds Christi* aus dem Dürerkreise," *Wallraf-Richartz-Jahrbuch* 16 (1954), pp. 209–210.

THIS IS ONE OF A NUMBER OF REPRESENTATIONS OF Christ's leave-taking by Schäufelein in various media, including another drawing in the British Museum, London (inv. 1892-8-4-21; Winkler 1942, no. 11), a woodcut in Ulrich Pinder's *Speculum passionis* of 1507 (B.34-3[253] v.11,7), and two paintings (Staatliche Museen Preussischer Kulturbesitz, Berlin [formerly Halle]; art market [formerly London, private collection]). The subject appears in two fourteenth-century devotional texts, the *Marienleben* and the *Meditations on the Life of Christ*. In both, the Virgin, attended by Mary and Martha, bewails the imminent Passion of Christ and expresses her desire to accompany him. Among Schäufelein's other representations of the theme, the Museum's drawing is closest to the one in the British Museum and to the woodcut. As in the former, the Virgin is joined by two rather than three attendants, and Christ has been placed on the left side of the composition. The Getty Museum's drawing is more similar still to the woodcut, however, especially in the poses and details of the Virgin and Christ. The source for Schäufelein's conception of the scene is Dürer's woodcut *Christ Taking Leave of His Mother* from the Life of the Virgin (B.92[132] v.10, 7) (Parker 1935, p. 50). The wooden gate and fence as well as the view of Jerusalem in the background are already present in Dürer's print, while the round citadel in the center of the latter has been transformed into a Gothic chapel in Schäufelein's drawing.

Stylistically, the Getty Museum's drawing is much more developed and assured than the earlier depiction of the subject in the British Museum of circa 1507, which is unfinished. The figures here are more substantial and the lines more animated and varied. The sheet is analogous in these respects to three drawings of the life of Saint Peter in the Statens Museum for Kunst, Copenhagen (Winkler 1942, nos. 46–48).

135 *Mary Magdalene Transported by Four Angels*

Pen and black ink and white gouache heightening on reddish brown grounded paper; H: 17 cm (6¹¹⁄₁₆ in.); W: 16.1 cm (6⅜ in.)

83.GG.355

MARKS AND INSCRIPTIONS: At bottom right corner, unidentified blind collection mark.

PROVENANCE: (Sale of J. H. Cremer and Monsieur F . . . , London, Frederik Muller, Amsterdam, June 15, 1886); private collection, Switzerland; art market, Paris.

EXHIBITIONS: *Dessins des écoles du nord*, Galerie Claude Aubry, Paris, 1974, no. 34. *Le dessin et ses techniques du XVe au XXe siècle*, Musée de Pontoise, December 1981–February 1982, no. 30 (catalogue by G. Masurovsky et al.).

BIBLIOGRAPHY: None.

THIS DRAWING IS CONSIDERED TO BE A SOUTH German work by C. Andersson, F. Koreny, and J. Rowlands.[1] It has been compared by Andersson to a representation of the standing Madonna and Child in the Los Angeles County Museum of Art (inv. 62.4)[2] which is drawn in the same combination of pen and ink with white heightening on prepared paper. The use of both black and white strokes to model and to form outlines as well as the construction of parallel and cross-hatching are found in both studies. The latter feature is reminiscent of an engraver's technique, as has been pointed out by A.-M. Logan.[3] Equally, they share a common *retardataire* style, harking back in the case of the standing Madonna to the Master of Flémalle. It is probable that the *Mary Magdalene Transported by Four Angels* dates from the last ten to fifteen years of the fifteenth century, as both Andersson and Koreny have suggested.

1. Conversations with the author, Malibu, 1982–1985.
2. E. Feinblatt, *Old Master Drawings from American Collections*, exh. cat., Los Angeles County Museum of Art, 1976, no. 169.
3. Conversation with the author, 1985.

HERMANN WEYER

136 The Judgment of Midas

Pen and black ink, black, ocher, reddish, and gray wash, and white gouache heightening; H: 22.1 cm (8¹¹⁄₁₆ in.); W: 27 cm (10⅝ in.)
85.GG.293

MARKS AND INSCRIPTIONS: At bottom left corner, signed *H . . . V . . . Inventor / HEW fecit 1616* in black ink.

PROVENANCE: Sale, Sotheby's, Amsterdam, March 21, 1977, lot 11; private collection, England; art market, London.

EXHIBITIONS: *Old Master and 19th Century Drawings*, P. and D. Colnaghi and Co., London, November 1977, no. 4.

BIBLIOGRAPHY: H. Geissler, *Zeichnung in Deutschland, 1540–1640*, exh. cat., Staatsgalerie Stuttgart, 1979, vol. I, p. 230; T. DaC. Kaufmann, *Drawings from the Holy Roman Empire 1540–1680*, exh. cat., Art Museum, Princeton University, 1982, p. 80.

THIS COMPOSITION IS CLOSELY BASED UPON THE painting by Hendrick van Balen in the Staatsgalerie Stuttgart, as was first pointed out in the Colnaghi exhibition catalogue (1977, no. 4). The painting dates from 1606, that is, a decade before the drawing, and their relationship is significant evidence documenting Weyer's trip to the Netherlands. The drawing follows van Balen's painting in almost every respect, with a relatively minor variation in the foliage in the right foreground, which is more prominent in the drawn version. The technique used in the drawing is characteristic of Weyer's finished sheets, which were made as independent works. The richly varied and rather dark tonality, the colorism created by the ocher wash with white heightening, and the strong black ink lines are all features common to this type of drawing by him. As has been pointed out by Kaufmann (1982, p. 80), the technique recalls chiaroscuro prints, even though none of the drawings in this manner were employed as studies for prints. The nude at the left with her back to the viewer brings to mind bronzes by the Northern followers of Giambologna, in both surface effect and tonality. A drawing of comparable style and date showing the Adoration of the Magi is in the Crocker Art Museum, Sacramento (inv. 1871.19; Kaufmann 1982, no. 22).

HENRY FUSELI (Johann Heinrich Füssli)

137 *An Old Man Murdered by Three Younger Men*

Pen and black ink and gray wash; H: 42.2 cm (16⅝ in.);
W: 47.6 cm (18¾ in.)
84.GG.711

MARKS AND INSCRIPTIONS: None.

PROVENANCE: Art market, London.

EXHIBITIONS: *An Exhibition of Old Master Drawings*,
P. and D. Colnaghi and Co., London, June–July 1984,
no. 44.

BIBLIOGRAPHY: None.

THE SUBJECT OF THIS DRAWING HAS DEFIED IDENTI-
fication, resulting in part from Fuseli's original approach
to the depiction of literary themes. It has been dated by
G. Schiff to circa 1768–1772 (Colnaghi 1984, no. 44), but
the stylistic character of the scene argues for a somewhat
later date, certainly after the artist's arrival in Italy in 1770.
Its theatricality and its rather linear, abstract rendering of
monumental figures are reminiscent of Fuseli's Shake-
spearian drawings of the early 1770s.[1] The manner in
which the curtain is drawn over the upper right corner
occurs several times among the Shakespearian depictions
and heightens the stage-like effect. The rendering of the
figures is explicitly classicizing and may, as P. J. Holliday
has suggested,[2] reflect Fuseli's admiration for the *Niobid
Group* in the Uffizi, Florence. The two male figures with
daggers in the foreground seem based upon the statue of
one of the Niobids, whereas the woman holding a torch
is more generally related to the representation of Niobe
herself, especially in her facial expression.[3] Characteris-
tically for Fuseli, the figures have been transformed into
an idiom much more overtly dramatic and morpholog-
ically abstract than their sources and are shown in an ex-
plosively lit interior.

1. G. Schiff, *Johann Heinrich Füssli* (Zurich, 1973), nos. 446,
456, 458, 464.
2. Conversation with the author, 1986.
3. M. Bieber, *The Sculpture of the Hellenistic Age* (New York,
1955), figs. 253, 258.

138 *Portrait of a Scholar or Cleric*

Point of brush and black ink and black chalk on pink prepared paper; H: 21.9 cm (8⅝ in.); W: 18.5 cm (7¼ in.)
84.GG.93

MARKS AND INSCRIPTIONS: At top left corner, inscribed *HH* in black chalk with pricked *H* at right of initials.

PROVENANCE: William, second duke of Devonshire, Chatsworth; by descent to the current duke (sale, Christie's, London, July 3, 1984, lot 70).

EXHIBITIONS: *Old Master Drawings from Chatsworth*, Arts Council Gallery, London, 1949, no. 52 (catalogue by A. E. Popham). *Exhibitions of Works by Holbein and other Masters of the 16th and 17th Centuries*, Royal Academy of Arts, London, 1950–1951, no. 125 (catalogue of drawings by K. T. Parker et al.). *Old Master Drawings from Chatsworth*, National Gallery of Art, Washington, D.C., and other institutions, 1962–1963, no. 105 (catalogue by A. E. Popham). *Between Renaissance and Baroque: European Art, 1520–1600*, City Art Gallery, Manchester, March–April 1965, no. 322 (catalogue by F. Grossmann). *Old Master Drawings from Chatsworth*, Royal Academy of Arts, London, July–August 1969, no. 105 (catalogue by A. E. Popham). *Old Master Drawings from Chatsworth*, National Museum of Western Art, Tokyo, 1975, no. 91. *Old Master Drawings: A Loan from the Collection of the Duke of Devonshire*, Israel Museum, Jerusalem, April–July 1977, no. 45. *Treasures from Chatsworth: The Devonshire Inheritance*, Virginia Museum of Fine Arts, Richmond, and other institutions, 1979–1980, no. 90 (catalogue by A. Blunt et al.).

BIBLIOGRAPHY: J. D. Passavant, *Tour of a German Artist in England* (London, 1836), vol. 2, p. 146; G. F. Waagen, *Works of Art and Artists in England* (London, 1838), vol. 3, p. 236; A. Woltmann, *Holbein und seine Zeit* (Leipzig, 1874–1876), no. 140; S. Strong, *Reproductions of Drawings by Old Masters in the Collection of the Duke of Devonshire at Chatsworth* (London, 1902), p. 16; "A Drawing by Holbein in the Collection of the Duke of Devonshire," *Burlington Magazine* 1 (March–May 1903), pp. 223–224; S. A. Strong, *Critical Studies and Fragments* (London, 1905), p. 133; A. B. Chamberlain, *Hans Holbein the Younger* (London, 1913), vol. 1, pp. 336–337; J. Roberts, *Holbein and the Court of Henry VIII*, exh. cat., Queen's Gallery, London, 1978, p. 13; idem, *Holbein* (London, 1979), p. 93, no. 83.

THIS PORTRAIT OF A STILL UNIDENTIFIED MAN, TAKEN to be a scholar or cleric on account of his hat, has been recognized as a work of Holbein's second English period since Chamberlain (1913, pp. 336–337). More recently, Roberts (1978, p. 13) has suggested that the sheet once may have been part of the "Great Booke" of Holbein portrait drawings, first known in the collection of Lord Lumley and later belonging to the earl of Arundel, most of which are now in the Royal Library, Windsor. Given the many features of style, technique, and scale shared by this sheet and the other drawings from that group, Roberts' proposal has much to recommend it.

The drawing was first sketched quite freely in black chalk and then drawn over in ink with a pen as well as a brush. In the process of adding ink, Holbein made certain clear alterations in the design. The most notable of these are in the outline of the hat and in the part of the cloak just behind the subject's head, which has been lowered substantially and extended backward. The ink passages are both of the highest quality and fundamental to the evolution of the image, so that no question regarding their attribution to Holbein is possible.[1] The fine pen strokes used in the eyes, mouth, and chin are varied and subtle and include small dots to suggest the stubble of an incipient beard. The broader strokes of the brush apparent in the hat, hair, and drapery were achieved with painterly freshness. In the hair at the back of the neck Holbein made a further change, adding the locks that curl upwards toward the hat. The varied elements in ink find parallels in a number of other portraits of the artist's second English period.[2]

1. Only Grossmann (1965, no. 322) has suggested that the passages in ink as well as the chalk in the hat are later retouchings. He has cited with approval M. Jaffé's attribution of these details to Rubens. These hypotheses are entirely lacking in technical, stylistic, or historical plausibility and have not been taken up elsewhere.
2. K. T. Parker, *The Drawings of Holbein at Windsor Castle* (London, 1945), nos. 15, 22, 24, 32, 59.

139 Job on the Dung Heap

Pen and black ink and gray wash; H: 39.8 cm (15⅝ in.);
W: 31.5 cm (12⅜ in.)
85.GA.290

MARKS AND INSCRIPTIONS: At top, in cartouche, inscribed *Iob.1.XL11* in black ink; above the design, inscribed *Hoffnung is der tugentt Zier / Hoffnung spricht. hapt gutten Mut / Hoffnung mitt gedult ist noc[h] ein Zier. / Durch hoffnug werden bhallten wier / Verzagt nicht gar er wirdt noch gutt* in brown ink; at bottom, dated *1581* in black ink by Lindtmayer.

PROVENANCE: Private collection, France (sale, Hôtel Drouot, Paris, November 16, 1984, lot 145); art market, London.

EXHIBITIONS: None.

BIBLIOGRAPHY: None.

THIS IS ONE OF MANY SURVIVING STUDIES BY Lindtmayer for stained-glass windows, at least thirteen of which date from 1581. The subject is shown in the traditional manner, with several episodes in the saga of Job combined. At the right he is seated on a heap of dung wearing only a loincloth, his body covered with sores. To the left stand his wife and mocking friends. Behind Job stands an expressionistic figure of Satan who scourges him, while in the background his cattle are being stolen and his children flee a burning house. Patience and Hope are shown in the spandrels, personifying the words of the verse inscribed above. The choice of an Old Testament subject and the moralizing tone of the imagery are typical of Lindtmayer.

The architectural format of the design, with an almost circular central image within a rectangular design, occurs frequently in Lindtmayer's drawings after 1575. The rich plant and fruit ornamentation is also characteristic of his stained-glass designs. Other hallmarks of his style include the animated gestures and poses, lively pen work, and broad use of wash. Among his known drawings, perhaps the closest to this one in style and format was a sheet with the *Massacre of the Innocents* of 1582, destroyed during the Second World War.[1]

1. F. Thöne, *Daniel Lindtmayer, 1552–1606/7* (Zurich, 1975), no. 117.

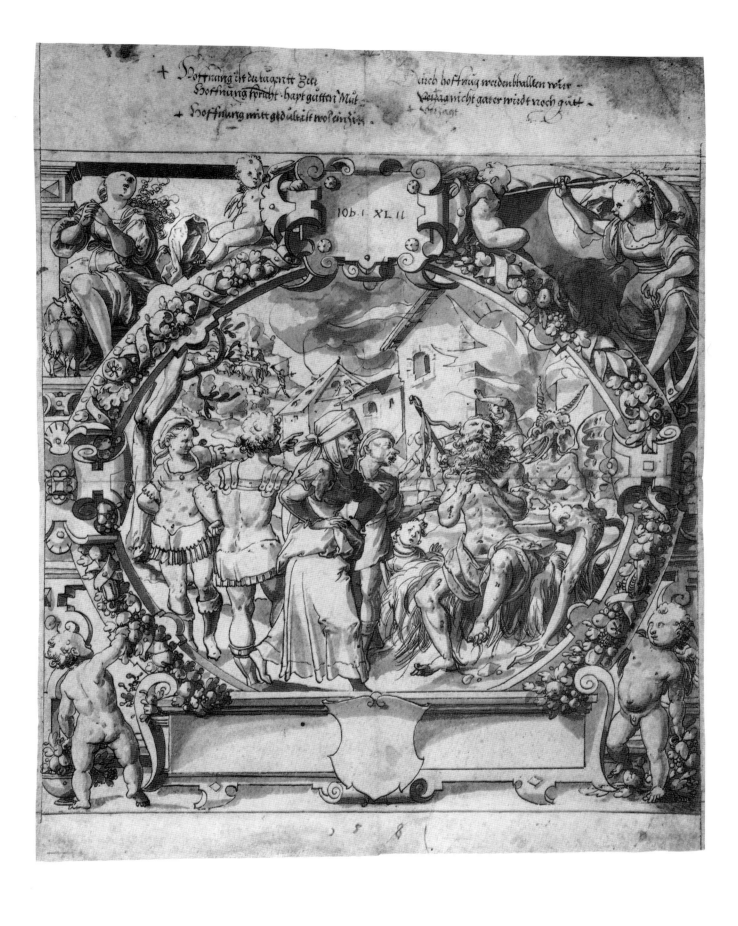

140 *The Mocking of Christ*

Pen and black ink, white gouache heightening, and gold on red-brown prepared paper; H: 31.2 cm (12⁵/₁₆ in.); W: 21.7 cm (8⁹/₁₆ in.)
84.GG.663 (SEE PLATE 15)

MARKS AND INSCRIPTIONS: (Recto) at bottom right, signed with monogram *.N.M.D* and dagger emblem in white gouache; (verso) inscribed with a paraph followed by *118* in brown ink; a slight sketch of a hand holding an escutcheon(?) in red chalk.

PROVENANCE: Professor Daniel Burckhardt, Basel; private collection, Langenbruck; private collection, Basel; art market, Munich.

EXHIBITIONS: *Niklaus Manuel Deutsch: Maler, Dichter, Staatsmann*, Kunstmuseum Bern, 1979, no. 168 (catalogue by H. C. von Tavel et al.).

BIBLIOGRAPHY: B. Haendcke, *Niklaus Manuel Deutsch als Künstler* (Frauenfeld, 1889), pp. 26, 114, no. 132; C. Escher, "Niklaus Manuel Deutsch," *Schweizerisches Künstler-Lexicon* (Frauenfeld, 1908), vol. 2, p. 315; L. Stumm, *Niklaus Manuel Deutsch von Bern als bildender Künstler* (Bern, 1925), pp. 31–33, 90, no. 43; W. Hugelshofer, *Schweizer Handzeichnungen des XV. und XVI. Jahrhunderts* (Freiburg im Breisgau, 1928), pl. 14; H. Koegler, *Beschreibendes Verzeichnis der basler Handzeichnungen des Niklaus Manuel Deutsch* (Basel, 1930), pp. 93–94, no. 105; C. von Mandach and H. Koegler, *Niklaus Manuel Deutsch* (Basel, 1940), p. 47, pl. 91; W. Hugelshofer, *Schweizer Zeichnungen von Niklaus Manuel bis Alberto Giacometti* (Bern, 1969), p. 80, no. 21; idem, "Nach der Niklaus Manuel-Ausstellung von 1979," *Zeitschrift für schweizerische Archäologie und Kunstgeschichte* 37 (1980), p. 304.

THIS IS ONE OF A NUMBER OF HIGHLY FINISHED DRAWings in pen and ink with white heightening on prepared paper by Niklaus Manuel Deutsch which appear to have been made as independent works rather than as studies for paintings or prints. It is largely contained within a frame drawn by the artist and includes unusual touches of gold around the head of Christ, adding to the probability that it was made as a presentation sheet.

The composition and the prominent detail of the centralized man with his right arm raised in a clenched fist above the head of Christ reflect the example of Grünewald's *Mocking of Christ* (Munich, Alte Pinakothek), while Christ's face suggests the influence of Dürer (von Tavel et al. 1979, no. 168). The dating of the drawing is quite uncertain, owing in part to its uniqueness within the artist's oeuvre as the only religious narrative other than stained-glass designs. Von Tavel has associated its figure style with Manuel's painting of the beheading of the Baptist (Kunstmuseum Bern) and also has noted the similarity between the monograms on the Museum's sheet and on the artist's drawing of a witch (Kunstmuseum Basel, inv. UX6; von Tavel et al. 1979, no. 159). Von Tavel has dated the *Mocking of Christ* to circa 1513/14.

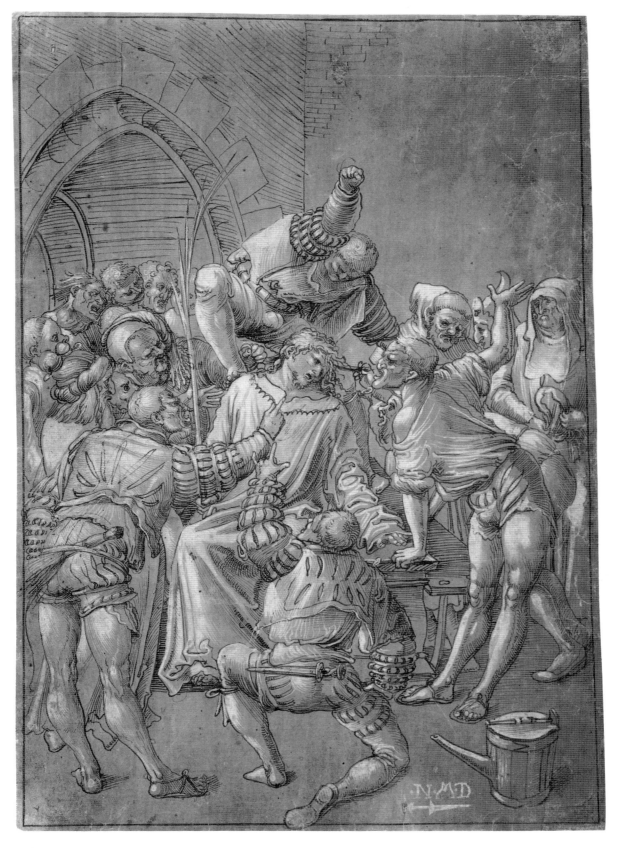

recto

141 *He Can No Longer at the Age of 98*

Brush and india ink; H: 23.4 cm (9³⁄₁₆ in.); W: 14.5 cm
(5¹¹⁄₁₆ in.)
84.GA.646

MARKS AND INSCRIPTIONS: At top center, inscribed *23*
in light brown ink by Goya; at top right corner, inscribed
21 in black ink by his son Javier; at bottom, inscribed *No
puede ya con los/98 años* in black ink by Goya.

PROVENANCE: Javier Goya, Madrid; Paul Lebas, Paris
(sale, Hôtel Drouot, Paris, April 3, 1877, lot 77); M. de
Beurnonville, Paris; private collection, Switzerland
(sale, Galerie Kornfeld, Bern, June 20, 1984, lot 378); art
market, Boston.

EXHIBITIONS: None.

BIBLIOGRAPHY: P. Gassier, "Un source inédite de des-
sins de Goya en France au XIXe siècle," *Gazette des beaux-
arts* 80, no. 6 (July–August 1972), p. 115, no. 77; idem,
Francisco Goya Drawings: The Complete Albums (New
York, 1973), p. 164.

THIS IS ONE OF SEVERAL STUDIES OF OLD PEOPLE BY
Goya which are part of his now dismembered "Album
D." No doubt drawn from life, the sheet depicts this very
aged figure hobbling along with two canes, almost over-
whelmed by the weight of his own body. Goya has en-
hanced the sense of isolation by placing the figure rather
low on the page and suggesting the void around him. Es-
pecially noteworthy is the rendering of his head, the bald
pate of which is masterfully evoked by the use of blank
paper. Closest to this drawing within "Album D" is one
showing an old woman—bearing the inscription *Habla
con su gato* and numbered *21* by the artist (Gassier 1973,
p. 163)—which is, however, more anecdotal and there-
fore a perhaps less universal image of old age. Like it and
other studies from this album, the Museum's drawing
has been dated by Gassier to 1801–1803 (1973, p. 140).

No puede ya con los
98 años

142 Contemptuous of the Insults

Brush and india ink; H: 29.5 cm (10¼ in.); W: 18.2 cm (7³⁄₁₆ in.)
82.GG.96

MARKS AND INSCRIPTIONS: At top center, inscribed *16* in light brown ink by Goya; at top right corner, inscribed *37* in dark brown ink; at bottom, inscribed *Despreciar los ynsultos* in graphite by Goya.

PROVENANCE: Javier Goya, Madrid; Paul Lebas, Paris (sale, Hôtel Drouot, Paris, April 3, 1877, lot 83); Paul Meurice, Paris (sale, Hôtel Drouot, Paris, May 25, 1906, lot 93); Maurius Paulme, Paris; Jean Groult, Paris; César de Hauke, Paris; Eric Ingerslev-Nielsen, London; art market, London.

EXHIBITIONS: *Exhibition of Old Master Drawings*, P. and D. Colnaghi and Co., London, 1974, no. 9. *Goya Zeichnungen und Druckgraphik*, Städelsches Kunstinstitut und Stadtische Galerie, Frankfurt, 1981, no. L45 (catalogue by M. Stuffman).

BIBLIOGRAPHY: P. Gassier and J. Wilson, *The Life and Complete Work of Goya* (New York, 1971), pp. 232, 234, 289, no. 1391; P. Gassier, "Un source inédite de dessins de Goya en France au XIXe siècle," *Gazette des beaux-arts* 80, no. 6 (July–August 1972), pp. 115, no. 83; 118; idem, *Francisco Goya Drawings: The Complete Albums* (New York, 1973), pp. 166, 213, no. 119-E.16; S. Holo, "Goya's *Despreciar los Ynsultos* Interpreted," *J. Paul Getty Museum Journal* 11 (1983), pp. 90–94.

THIS DRAWING IS PART OF THE NOW DISMANTLED "Black Border Album," which Goya drew around 1803–1812 according to Gassier (1973, p. 13). It is generally recognized that these drawings were made for Goya's own amusement and interest rather than for sale or other purposes. Gassier and Wilson (1971) have pointed out that these drawings are comparable to "little pictures," a quality emphasized by the autograph double black borders surrounding complete, self-contained compositions.

The Museum's drawing has been interpreted by most scholars as alluding directly to the French occupation of Spain and the War of Independence. The political meaning is presented in the form of the contrast between a Spanish gentleman and the caricatures of two Napoleonic generals as dwarfs. This analysis has been refined by Holo (1983), who has noted that the *chapeaux de bras* worn by the two soldiers were in general use in the early nineteenth century and that the interpretation of the scene should be broadened by the equation of these figures with all military oppressors in Spain. Equally, she has interpreted the gesture of the Spanish gentleman as a common sign of contempt and has suggested that the drawing is a highly personal reflection of Goya's defiant attitude toward military intruders, a view that is supported by the probability that the Spaniard is a self-portrait.

Desprecian los ynsultos

143 It's a Pity You Don't Have Something Else to Do!

Brush and sepia wash and pen and black ink; H: 20.2 cm (8 in.); W: 13.9 cm (5½ in.)
84.GA.35

MARKS AND INSCRIPTIONS: At top right corner, inscribed *78* in sepia ink by Goya; at bottom, inscribed *Lastima es q.ᵉ no te ocupes en otra / cosa* in sepia ink by Goya.

PROVENANCE: Mariano or Javier Goya, Madrid; Frans Koenigs, Haarlem (sale, Sotheby's, London, November 20, 1957, lot 72); Jean Davray, Paris; private collection, New Jersey.

EXHIBITIONS: None.

BIBLIOGRAPHY: P. Gassier and J. Wilson, *The Life and Complete Work of Goya* (New York, 1971), p. 285, no. 1314; P. Gassier, *Francisco Goya Drawings: The Complete Albums* (New York, 1973), pp. 224, 371; S. Holo, "An Unsuspected Poseur in a Goya Drawing," *J. Paul Getty Museum Journal* 13 (1985), pp. 105–108.

THIS CHARMING DEPICTION OF A YOUNG WOMAN holding water jugs in both hands comes from Goya's now dismembered "Album C" and is, according to Gassier (1973, p. 226), among those sheets which date from 1815–1824. The image has been associated with Goya's painting of a water carrier in the Szépmüvészeti Múzeum, Budapest (Gassier and Wilson 1971, p. 245), of circa 1808–1812. Gassier believes the Museum's drawing to be one of several depictions by Goya of humble working girls (1973, p. 371). By contrast, Holo (1985, p. 105) has pointed out that the young woman in the drawing is shown wearing a fine dress, jewelry, and a rather coy hairstyle. Equally, she has noted that the woman stands gracefully and is more delicately portrayed than the peasant figure in the Budapest picture. Therefore Holo has convincingly proposed that the scene with its spontaneous inscription by the artist was meant to admonish this upper-class woman who was playing at being a peasant, a not uncommon fashion of the period. Notwithstanding this complex interpretation, the drawing displays great spontaneity even in the inscription, providing a good example of how quickly Goya's eye and mind responded to formulate this striking image.

Lastima es q.^e no te ocupes en otra
cosa

144 *Pygmalion and Galatea*

Brush and sepia wash; H: 20.5 cm (8 1/16 in.); W: 14.1 cm
(5 9/16 in.)
85.GA.217

MARKS AND INSCRIPTIONS: At top right, numbered *90*
in sepia ink by Goya, *40* in black ink by his son Javier.

PROVENANCE: Javier Goya, Madrid; Paul Lebas, Paris
(sale, Hôtel Drouot, Paris, April 3, 1877, lot 54); M. de
Beurnonville, Paris (sale, Hôtel Drouot, Paris, February
16–19, 1885, lot 49); sale, Hôtel Drouot, Paris, March 21,
1985, lot 52; art market, Boston.

EXHIBITIONS: None.

BIBLIOGRAPHY: P. Gassier, "Un source inédite de des-
sins de Goya en France au XIXe siècle," *Gazette des beaux-
arts* 80, no. 6 (July–August 1972), p. 113, no. 54; idem,
Francisco Goya Drawings: The Complete Albums (New
York, 1973), p. 497, no. F.i; F. Duret-Robert, "Bilan
d'une saison," *Connaissance des arts* no. 404 (October
1985), p. 70.

THIS DRAWING ONCE FORMED PART OF GOYA'S
"Album F," dated by Gassier to circa 1815–1820 (1973,
p. 386). In the recent Paris sale catalogue (1985), it is pro-
posed by B. de Bayser that the subject is either a sculptor
at work or Pygmalion and Galatea. The latter hypothesis
has much to recommend it and has been endorsed by E.
Sayre, who also considers the figure of Pygmalion to be
a likely self-portrait and notes the suggestive placement
of the chisel.[1] This highly personal, clearly contempo-
rary, and perhaps mocking rendering of a well-known
ancient myth is redolent of Goya's complex, innovative
imagery. The athletic vehemence of Pygmalion and Gal-
atea's fearful response underscores Goya's novel ap-
proach to this theme, which may contain yet other
subtleties.

1. Conversation with the author, 1985.

EL GRECO (Domenico Theotocopuli)

145 Saint John the Evangelist and an Angel

Pen and pale brown ink and gray-brown wash on off-white paper; H: 33.7 cm (13¼ in.); W: 21 cm (8¼ in.)
82.GA.166

MARKS AND INSCRIPTIONS: None.

PROVENANCE: Mariano Fortuny, Rome; Tomás Harris, London; Marc Farquhar Oliver, Jedburgh; art market, New York.

EXHIBITIONS: *Drawings by Old Masters*, Saville Gallery, London, 1929, no. 25 (catalogue by T. Borenius). *Domenico Theotocopul, El Greco*, Gazette des Beaux-Arts, Paris, 1937, no. 40. *Exhibition of Greek Art*, Royal Academy of Arts, London, 1946, no. 353. *Domenico Theotocopul, dit Le Greco, 1541–1614*, Galerie des Beaux-Arts, Bordeaux, 1953, no. 82. *Timeless Master Drawings*, Wildenstein Gallery, New York, 1955, no. 28.

BIBLIOGRAPHY: A. M. Hind, "El Greco," *Old Master Drawings* 3, no. 10 (September 1928), pp. 29–30; F. Rutter, *El Greco 1541–1614* (London, 1930), pp. 110–111, no. 2D; F. J. Sánchez Cantón, *Dibujos españoles* (Madrid, 1930), vol. 2, no. 153; L. Goldscheider, *El Greco* (New York, 1938), p. 24, no. 89; E. Gradmann, *Spanische Meisterzeichnung* (Frankfurt am Main, 1939), p. 12, no. 3; E. du Gué Trapier, "Notes on Spanish Drawings," *Notes Hispanic* 1 (1941), p. 13; A. Bertram, *El Greco* (London, 1949), pl. 24; J. Camón Aznar, *Dominico Greco* (Madrid, 1950), vol. 2, pp. 1176, 1396; J. G. Sicre, *Spanish Drawings XV–XIX Centuries* (New York, London, and Paris, 1950), p. 29; F. J. Sánchez Cantón, in I. Moskowitz, ed., *Great Drawings of All Time* (New York, 1962), vol. 4, no. 930; H. Wethey, *El Greco and His School* (Princeton, 1962), vol. 2, pp. 151–152; F. J. Sánchez Cantón, *Spanish Drawings from the 10th to the 19th Century* (New York, 1964), pp. 20, 75; G. Manzini and T. Frati, *L'opera completa del Greco* (Milan, 1969), p. 106; G. M. Smith et al., *Spanish Baroque Drawings in North American Collections*, exh. cat., University of Kansas Museum of Art, Lawrence, 1974, pp. 14, 21, n. 15; D. Angulo and A. E. Pérez Sánchez, *A Corpus of Spanish Drawings, 1400–1600*, vol. 1 (London, 1975), p. 44, no. 160; T. Yoshikawa, *El Greco*, L'art du monde, no. 14 (Tokyo, 1976), p. 100; J. Brown, "Review of D. Angulo and A. E. Pérez Sánchez, *A Corpus of Spanish Drawings, 1400–1600*," *Master Drawings* 14, no. 2 (Summer 1976), p. 179; T. Crombie, "Review of D. Angulo and A. E. Pérez Sánchez, *A Corpus of Spanish Drawings, 1400–1600*," *Apollo* 103, no. 167 (January 1976), p. 74.

ALTHOUGH EL GRECO APPEARS TO HAVE BEEN AN active draughtsman whose estate included at least 150 drawings, only a small handful survives (Wethey 1962, vol. 2, p. 151). An early drawing, *Day* (Munich, Staatliche Graphische Sammlung), *Saint John the Evangelist* (Madrid, Biblioteca Nacional; Wethey 1962, figs. 349, 351), and this drawing are the only ones accepted without serious doubt as by El Greco. The Museum's drawing was first published by Hind (1928, pp. 29–30), who recognized it as a preparatory study for the *Crucifixion* in the Prado, Madrid (Wethey 1962, vol. 2, no. 75), of circa 1600. The pose and basic pattern of drapery folds is established in the drawing, as is the rich interplay of light and dark. The latter quality, as Hind already noted, is still more vivid in the drawing than the painting. The angel is very freely sketched and contains several *pentimenti*. Nevertheless certain details such as the billowing lower drapery reappear in the Prado picture. Given these clear connections, there is every reason to consider the drawing as a study for the Prado painting rather than a representation of Saint Matthew with an angel, as has occasionally been proposed (Sánchez Cantón 1930, vol. 2, no. 153). The technique employed here consists of long and rather free lines creating rich patterns of form whose resonance results from broadly applied wash.[1] The veils of form and light find their parallels in the artist's late paintings.

1. There are several horizontal creases in the lower portion of the sheet. These were present before the drawing was made, as was pointed out by Alexander Yow (Record of examination and treatment, November 23, 1982).

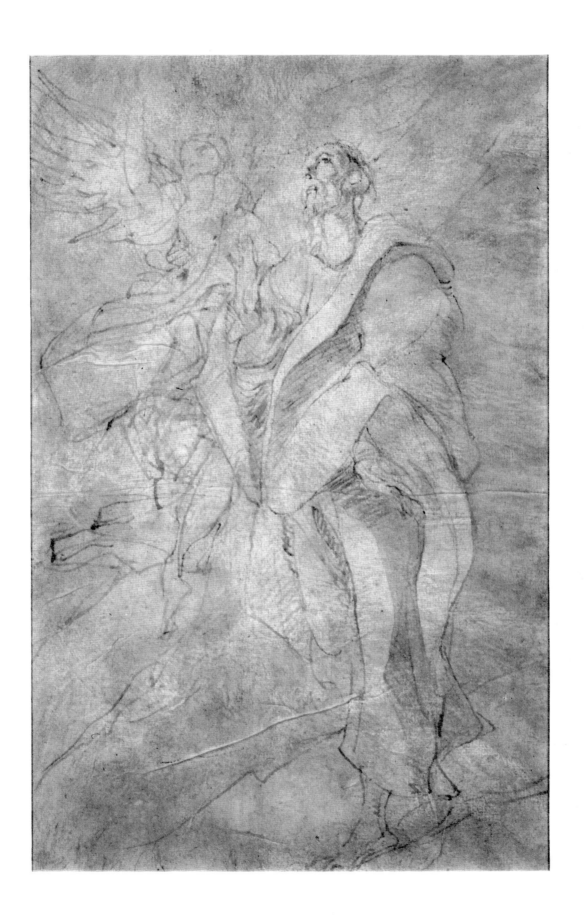

146 Satan Exulting over Eve

Graphite, pen and black ink, and watercolor over color print; H: 42.6 cm (16¾ in.); W: 53.5 cm (21 1/16 in.)
84.GC.49 (SEE PLATE 16)

MARKS AND INSCRIPTIONS: At bottom right corner, signed and dated *WBlake 1795* in brown ink.

PROVENANCE: Mrs. William Blake(?); Frederick Tatham(?); Joseph Hogarth(?); John Ruskin(?); Palser; William Bateson, California; Gregory Bateson, California; art market, London.

EXHIBITIONS: *Works by William Blake*, Carfax and Co., London, January, 1904. *Frescoes, Prints and Drawings by William Blake*, Carfax and Co., London, June–July 1906, no. 34. *Works by William Blake*, Art Museum, Nottingham Castle, 1914, no. 37. *Works by William Blake*, Whitworth Institute, Manchester, 1914, no. 57. *Blake Centenary Exhibition*, Burlington Fine Arts Club, London, 1927, no. 38 (catalogue by A. G. B. Russell). *William Blake Bicentennial Exhibition*, Achenbach Foundation for Graphic Arts, Fine Arts Museums of San Francisco, 1957. *William Blake*, Tate Gallery, London, March–May 1978, no. 86 (catalogue by M. Butlin). *William Blake and His Followers*, Achenbach Foundation for Graphic Arts, Fine Arts Museums of San Francisco, December 1982–February 1983.

BIBLIOGRAPHY: W. M. Rossetti, "Annotated Catalogue of Blake's Pictures and Drawings," in A. Gilchrist, *Life of William Blake* (London, 1863), vol. 2, p. 223, no. 109; 2nd edn. (London, 1880), vol. 2, p. 235, no. 132 (as "The Almighty Accusing Eve"); idem, *The Rossetti Papers 1862–1870* (New York, 1903), pp. 16–17; W. G. Robertson, "Supplementary List" (to Rossetti's "Annotated Catalogue"), in A. Gilchrist, *Life of William Blake*, 3rd edn. (London, 1907), pp. 411, 451, under no. 179; E. T. Cook and A. Wedderburn, eds., *The Works of John Ruskin* (London, 1909), vol. 36, pp. 32–33; L. Binyon, *The Drawings and Engravings of William Blake* (London, 1922), p. 9; D. Figgis, *The Paintings of William Blake* (London, 1925), p. 71; G. Keynes, *William Blake's Illustrations to the Bible* (London, 1957), p. 2, no. 9a; M. Butlin, "The Bicentenary of William Blake," *Burlington Magazine* 100, no. 658 (January 1958), p. 43; A. Blunt,

The Art of William Blake (New York, 1959), pp. 58–59, 62; J. Beer, *Blake's Humanism* (London, 1968), pp. 192, 256–257; A. T. Kostelanetz, "Blake's 1795 Color Prints: An Interpretation," in A. H. Rosenfeld, ed., *William Blake: Essays for S. Foster Damon* (Providence, 1969), p. 123; D. Bindman, *The Complete Graphic Works of William Blake* (London, 1978), p. 477, no. 325; M. Butlin, "Cataloguing William Blake," in R. N. Essick and P. Pearce, eds., *Blake in His Time* (Bloomington and London, 1978), p. 84; M. Butlin, *The Paintings and Drawings of William Blake* (New Haven, 1981), pp. 157, 160, no. 292; R. N. Essick, "Blake in the Marketplace, 1982–83," *Blake, An Illustrated Quarterly* 18, no. 2 (Fall 1984), pp. 68, 70, 75.

SATAN EXULTING OVER EVE IS ONE OF THE GROUP of twelve color prints of 1795 which are among the most impressive and complex of Blake's graphic oeuvre (Bindman 1978, nos. 324–336; Butlin 1981, nos. 289–329). The process he used appears to have consisted of drawing and brushing a design and broad color areas onto a piece of mill board, printing them on a piece of paper, and working them over considerably in watercolor and pen and ink. Each version of the various designs is therefore unique, and in no case are more than three variants of a design known to survive. Their titles range from *The Creation of Adam* to *Newton*, and their subjects are powerful reflections of Blake's philosophical outlook without necessarily having been conceived as a unified series.

Satan Exulting over Eve is known in two versions; the other is in the collection of John Craxton, London (Butlin 1981, no. 291). The latter is clearly the second pull of the print; Satan's far leg is missing and there is considerable overpainting. The subject recalls Milton's *Paradise Lost*, but cannot be directly connected with any passage in it (Butlin 1978, no. 86). As has been noted several times, this print appears to have been paired with another in the series, *Elohim Creating Adam* (London, Tate Gallery, inv. 5055), and it has been proposed that it "represents the second stage of the Fall, the division into two sexes" (Butlin 1981, no. 289).

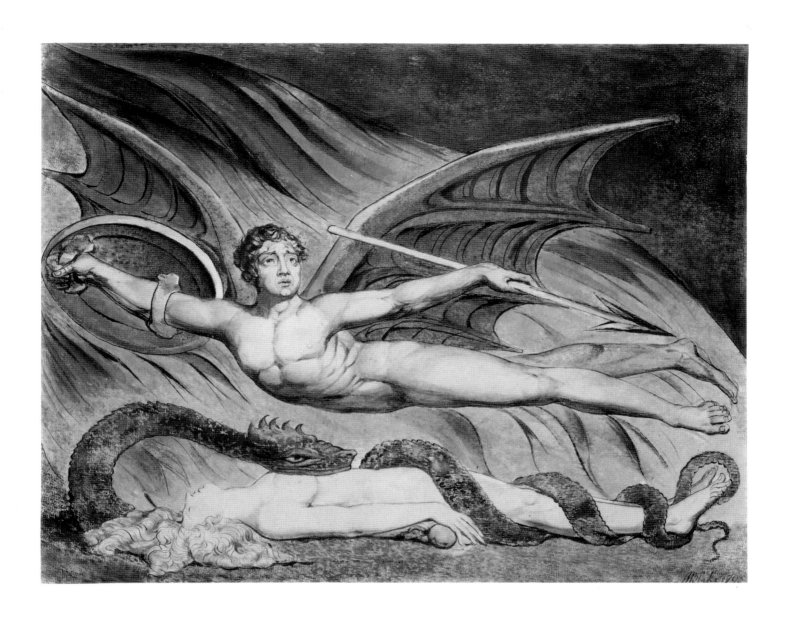

JONATHAN RICHARDSON, SR.

147 Self-Portrait Wearing a Cloth Hat

Black and white chalk on blue paper; H: 30.3 cm (11¹⁵⁄₁₆ in.); W: 23.2 cm (9⅛ in.)
85.GB.210

MARKS AND INSCRIPTIONS: None.

PROVENANCE: (Sale, Sotheby's, London, March 16, 1978, lot 23); art market, London.

EXHIBITIONS: None.

BIBLIOGRAPHY: None.

THIS IS ONE OF MANY SELF-PORTRAIT DRAWINGS BY Richardson, apparently made for their own sake. Clearly drawn late in life, it is comparable in pose and expressive character to a pen-and-pencil self-portrait in the National Portrait Gallery, London (inv. 3023), dated 1736. Another drawing showing the artist wearing a turban, in similar technique (with red chalk), was sold just after this one at Sotheby's from the same source (London, 1978, lot 24). The use in the Museum's sheet of black chalk on blue paper with luminous white chalk highlights reflects an interest in Venetian draughtsmanship, and the deep shadows recall contemporary drawings by Piazzetta.

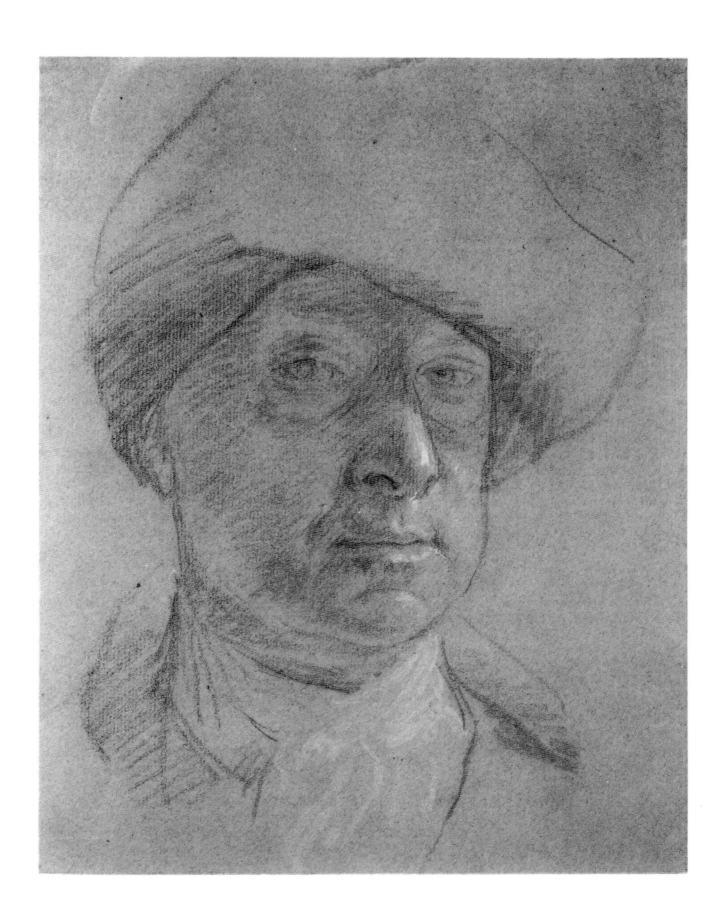

148 Box-Lobby Loungers

Pen and black and gray ink, gray and red wash, and graphite; H: 37.5 cm (14¾ in.); W: 56.1 cm (22⅛ in.) 84.GG.645

MARKS AND INSCRIPTIONS: At bottom center, collection mark of fourth earl of Warwick (L. 2600).

PROVENANCE: George Guy, fourth earl of Warwick, Warwick Castle (sale, Christie's, London, May 21, 1896, lot 336); Earl of Carnarvon, London; Captain Desmond Coke, London (sale, Christie's, London, November 22, 1929, lot 60); sale, Sotheby's, London, December 19, 1945, lot 70; Major Leonard Dent, Hillfields, Burghfield (sale, Christie's, London, July 10, 1984, lot 16); art market, Boston.

EXHIBITIONS: Royal Academy of Arts, London, 1785 (as *The Back of the Boxes at the Theatre, Covent Garden*). *A Loan Exhibition of Important Drawings by Thomas Rowlandson*, Ellis and Smith, London, 1948, no. 15. *Rowlandson—Drawings from Town and Country*, Reading Museum and Art Gallery, 1962, no. 65.

BIBLIOGRAPHY: J. Grego, *Rowlandson the Caricaturist* (London, 1880), vol. 1, pp. 180–182; B. Long, "Rowlandson Drawings in the Desmond Coke Collection," *Connoisseur* 79 (December 1927), pp. 208–209; D. F. T. Coke, *Confessions of an Incurable Collector* (London, 1928), pp. 126, 138–141; A. P. Oppé, "Rowlandson the Surprising," *Studio* 124, no. 596 (November 1942), pp. 149, 154; F. G. Roe, *Rowlandson: The Life and Art of a British Genius* (Leigh-on-Sea, 1947), pp. 25, 32; "Rowlandson's Record of London Life," *Illustrated London News* (May 15, 1948), p. 558; A. Bury, *Rowlandson Drawings* (New York, 1949), p. 8; B. Falk, *Rowlandson: His Life and Art* (New York, 1949), pp. 81, 135, 141, 191; P. Davis, "Rowly at Reading," *Illustrated London News* (April 21, 1962), p. 626; W. Gaunt, "Reading Shows the Best of Rowlandson," *Times* (London), April 13, 1962, p. 18; M. Hardie, *Water-colour Painting in Britain* (London, 1966), vol. 1, p. 219; J. Hayes, *Rowlandson Watercolors and Drawings* (London, 1972), pp. 44, no. 29; 93; J. C. Riely, *Rowlandson Drawings from the Paul Mellon Collection*, exh. cat., Yale Center for British Art, New Haven, and Royal Academy of Arts, London, 1978, pp. xi, 7, n. 4; F. Davies, "No Mere Buffoon," *Country Life* (September 27, 1984), p. 838.

THIS LARGE DRAWING WAS ETCHED BY ROWLANDSON and published by his friend John Raphael Smith on January 5, 1786. The inscription on the print, *Design by H. Wigstead / Etch'd by T. Rowlandson*, has prompted considerable speculation about the degree of the magistrate Wigstead's contribution to the design. Despite the inscription, however, there is every reason to attribute all but perhaps the choice of theme to Rowlandson. The scene shows various people in a theater lobby and caricatures their diverse personalities and the interplay between them. The principal figure of the tall gentleman near the center is identifiable as Colonel George Hanger, a friend of the Prince of Wales.[1] He is shown assessing two pretty young girls, while a trio of older and less savory characters at the left whisper to each other and the gentleman pays the corpulent woman for an unspecified reason. To the right, other young women are studied, while a short man mistakenly approaches an apparently annoyed middle-aged lady. The overtones suggested in the drawing are made more concrete by the playbill on the wall in the etching advertising "The Way of the World" and "Who's the Dupe?" The rich variety of characters, the humorous and biting rendering of human foible, and the entirely appropriate sharp linearity are all characteristic of Rowlandson at the height of his powers.

1. A. B. Waller and J. L. Connelly, "Thomas Rowlandson and the London Theatre," *Apollo* 86 (August 1967), p. 134.

149 The Fright of Astyanax (Hector Bidding Farewell to Andromache)

Pen and brown ink, brown wash, and blue and white gouache on brown prepared paper; H: 31.8 cm (12½ in.); W: 46 cm (18⅛ in.)
84.GG.722

MARKS AND INSCRIPTIONS: At top left corner, inscribed *From Benj.ⁿ West esq / to / Genˡ· Kosciusko / London June 10ᵗʰ. / 1797* in brown ink by West.

PROVENANCE: Benjamin West to General Thaddeus Kosciuszko, June 1797; General Thaddeus Kosciuszko to Thomas Jefferson, Monticello, until 1826; by descent to the Jefferson heirs;[1] private collection, United States; (sale, Christie's, New York, January 7, 1981, lot 55); art market, New York.

EXHIBITIONS: None.

BIBLIOGRAPHY: T. Jefferson, Inventory of art objects at Monticello, circa 1809, p. 6, no. 57 (University of Virginia, no. 2958); T. Jefferson, Monticello, to W. Thornton, December 14, 1814 (Thomas Jefferson Memorial Foundation, Monticello); Bernhard, duke of Saxe-Weimar-Eisenach, *Travels Through North America During the Years 1825 and 1826* (Philadelphia, 1828), vol. 1, pp. 198–199; M. G. Kimball, *The Furnishing of Monticello* (Charlottesville, 1927); 2nd edn. (Philadelphia, 1954), pp. 10, 12; idem, "Jefferson's Works of Art at Monticello," *Antiques* 59, no. 4 (April 1951), pp. 298, 308; W. G. Constable, *Art Collecting in the U.S.A.* (London, 1964), p. 12; H. E. Dickson, "Jefferson as Art Collector," in W. H. Adams, ed., *Jefferson and the Arts: An Extended View* (Washington, 1976), p. 121; S. Howard, "Thomas Jefferson's Art Gallery for Monticello," *Art Bulletin* 59, no. 4 (December 1977), pp. 599; R. C. Alberts, *Benjamin West: A Biography* (Boston, 1978), p. 222, n. 6; H. von Erffa and A. Staley, *The Paintings of Benjamin West* (New Haven and London, 1986), pp. 130, 133, no. 165.

THIS HIGHLY FINISHED COMPOSITION WAS PRESENTED by West to the Polish patriot Thaddeus Kosciuszko during the latter's brief visit to London in June 1797 after his release from a Russian prison.[2] They met on June 7th and Kosciuszko received the drawing three days later. By December of the same year he was living in Philadelphia, where he was introduced to then-vice president Thomas Jefferson in February 1798. It is very likely that the drawing was presented to Jefferson by Kosciuszko between their initial encounter and May 1798, the period in which they became close friends. It was later kept by Jefferson at Monticello.

In 1767 and 1771, West exhibited two paintings of this theme, both of which are lost, but there is no reason to associate this much later drawing with either of them. It has been suggested by von Erffa and Staley (1986, p. 130) that the choice of subject from the *Iliad* showing Hector departing from his family to face the hopeless combat with Achilles may allude to Kosciuszko's role in Poland's unsuccessful war of independence from Russia. This would indicate that the drawing dates from the period of the gift, which would agree with its style.

1. The drawing was placed in the Thomas Jefferson sale at the Athenaeum, Boston, on May 1, 1828 (lot 315), but apparently was withdrawn (Martha Jefferson Randolph to Thomas Jefferson Randolph, July 28, 1833, Thomas Jefferson Memorial Foundation, Monticello). This information was generously provided by S. R. Stein, Curator of Monticello.
2. This entry is largely based on a letter dated June 1, 1981, from A. Staley to a former owner of the drawing.

ARTISTS' BIOGRAPHIES

ANDREA DEL SARTO
Florence 1486–1530

Andrea del Sarto was among the leading painters of the High Renaissance in Florence. Although he was strongly influenced by his older contemporaries, especially Leonardo, Fra Bartolommeo, and Michelangelo, he rapidly developed a distinctive style characterized by rich effects of tone and color and subtly poetic expressive meaning. Sarto was responsible for numerous major paintings and frescoes in Florence, including the cycle of the life of the Baptist in the Chiostro degli Scalzi and the *Miracles of San Filippo Benizzi* and the *Birth of the Virgin* in SS. Annunziata. In 1518/19 he resided in France at the invitation of Francis I, but he soon returned to Florence, where his wife had remained. Sarto was highly influential on the next generation of Florentine painters, especially his pupils Pontormo and Rosso.

HANS BALDUNG GRIEN
Schwäbisch-Gmünd circa 1484/85–Strasbourg 1545

Born into a family of physicians, lawyers, and scholars, Hans Baldung, surnamed Grien, was among the earliest German artists to come to the profession from a learned rather than an artisanal background. He received his first training around 1499 in Strasbourg or possibly Swabia. About 1503 he entered Dürer's workshop in Nuremberg, quickly assimilating the master's graphic style. During this period Baldung produced paintings, prints, and drawings as well as designs for stained-glass windows. In 1507 he left for Halle, where he executed the *Martyrdom of Saint Sebastian* (Nuremberg, Germanisches Nationalmuseum), one of his first major commissions. In 1509 he settled in Strasbourg, where he stayed for the remainder of his life, save for the years 1512–1516, when he lived in Freiburg im Breisgau and painted the *Coronation of the Virgin* (Freiburg, Münster). As a result of the Reformation, Baldung turned increasingly to secular subjects. Especially powerful are his woodcuts portraying the demonic forces of nature, such as the *Bewitched Groom* of 1544. The most gifted of Dürer's pupils, Baldung is the major representative of the expressionist trend in German art of the early sixteenth century.

BACCIO BANDINELLI
Florence 1493–1560

Baccio Bandinelli began as an apprentice in the workshop of Giovan Francesco Rustici and distinguished himself early in his career both as a sculptor skilled in marble and bronze and as a draughtsman. Youthful works such as the *Saint Peter* (1515) for the Duomo in the city of Florence reveal his admiration for the Quattrocento masters and especially for the antique, which he studied diligently. Bandinelli was deeply influenced by Michelangelo, becoming both his imitator and his rival. His affiliation with Cardinal Giuliano de' Medici, later Pope Clement VII, was of major importance to his career both in Florence and in Rome. For his patron Bandinelli created the marble *Orpheus and Cerberus* (Florence, Palazzo Vecchio) and the well-known *Hercules and Cacus* (1534; Florence, Piazza della Signoria). One of his greatest works was the marble choir screen he began in 1547 for the Duomo; it was unfinished at the time of his death.

FEDERICO BAROCCI
Urbino 1535–1612

Barocci was born in Urbino and trained by his father, Ambrogio, and, later, by Battista Franco. In 1557 he painted the *Martyrdom of Saint Sebastian* for the cathedral of Urbino. In 1560 he was in Rome, where he worked with Federico Zuccaro on the Vatican Belvedere and the Casino of Pius IV. By 1565 Barocci was back in Urbino, where he remained for the rest of his life. He painted numerous important altarpieces, including *Il Perdono* (1574–1576; Urbino, San Francesco); the *Madonna del Popolo* (1579; Florence, Uffizi); the *Entombment* (1579–1582; Senigallia, Santa Croce); the *Madonna del Rosario* (1589–1593; Senigallia, Palazzo Vescovile); the *Visitation* (1583–1586; Rome, Chiesa Nuova); and the *Institution of the Eucharist* (1603–1607; Rome, Santa Maria sopra Minerva). Barocci was greatly influenced by Correggio and evolved a manner characterized by Baroque tendencies in both form and sentiment.

FRA BARTOLOMMEO (Baccio della Porta)
Florence 1472–1517

Fra Bartolommeo was one of the major protagonists of High Renaissance painting in Florence following the departures of Leonardo and Raphael. During his apprenticeship (1484–1490) in the studio of Cosimo Rosselli, he met Mariotto Albertinelli, with whom he often collaborated. In 1500 Fra Bartolommeo ceased painting for

four years and joined the monastery of San Marco in Florence. His mature works, including the *Noli mi Tangere* (1506; Paris, Musée du Louvre) and the *Vision of Saint Bernard* (1507; Florence, Uffizi) embrace the expansive, monumental High Renaissance style initiated by Leonardo and Raphael. During a 1508 visit to Venice, Fra Bartolommeo assimilated the Venetian light and luminous color of Giovanni Bellini, as can be seen in his *Madonna and Child with Saints* (1509; Florence, Museo di San Marco). In 1514 Fra Bartolommeo traveled to Rome, where the works of Michelangelo and Raphael made a profound impression upon him. Later altarpieces, including the *Annunciation* (1515; Paris, Louvre) and the *Isaiah* and *Job* (both 1516; Florence, Uffizi) recall the grandiose forms of Michelangelo.

GERRIT VAN BATTEM
Rotterdam circa 1636–1684

According to tradition, van Battem studied with Abraham Furnerius, a landscape draughtsman of the Rembrandt school. Van Battem might also have studied with his guardian, the painter Jan Daemen Cool. One of his earliest works, a landscape etching signed and dated 1658, shows the influence of Herman Saftleven. In 1667 van Battem married Margaretha Scheffer, sister of the Utrecht painter Anton Scheffer. Van Battem lived in Utrecht until 1669, when he returned to Rotterdam. In 1678 he received payment from the municipal government of Rotterdam for the restoration of a painting in the stock exchange. During the 1670s he painted the figures in a number of landscapes by Jacob van Ruisdael. Van Battem's rare oil paintings generally depict hilly, heavily wooded river valleys. He is best known for his thickly populated gouaches depicting winter scenes, canals, and imaginary views of Dutch towns.

DOMENICO BECCAFUMI
Siena 1486–1551

Domenico Beccafumi, one of the most original Mannerist painters of the sixteenth century, worked mainly in his native Siena. Between 1510 and 1512 he lived in Rome, where he studied antiquity and the work of Raphael and Michelangelo. However, the classicizing Florentine style of Fra Bartolommeo was ultimately more persuasive to him, as is demonstrated in *Saint Catherine Receiving the Stigmata* (1513–1515; Pinacoteca Nazionale di Siena). In 1518 Beccafumi began a series of designs for the narrative pavements of Siena's cathedral, a commission that occupied him intermittently throughout his career. Following a second Roman sojourn in 1519–1520, Beccafumi amplified the spiritual tenor of his painting

and concentrated on the dramatic effects of chiaroscuro. The contrast between plastic and atmospheric values and the exaggeration of proportions and color he favored were further emphasized in the *Nativity* (1522/23; Siena, San Martino) and the fresco decorations in the Sala del Concistoro (1529–1535; Siena, Palazzo Pubblico). Important later works such as the *Christ in Limbo* (1535/36; Siena, Pinacoteca) and the *Annunciation* (1545–1546; Sarteano, SS. Martino e Vittoria) developed these stylistic tendencies further.

GIAN LORENZO BERNINI
Naples 1598–Rome 1680

Bernini, one of the most important artists of seventeenth-century Italy, worked as a sculptor, architect, painter, and scenographic designer. His father, the sculptor Pietro Bernini, moved the family from Naples to Rome in 1605. Works of his early maturity, including the *Apollo and Daphne* (1621–1622) and the *David* (1623), both in the Galleria Borghese, reveal the young artist's fascination with the realistic rendering of forms and emotional expressions. For the Basilica of Saint Peter he undertook a series of projects which included the Baldachino (1624–1633) and the design for the Piazza, begun in 1656. In addition he realized numerous monumental commissions that transformed the appearance of Rome, including the *Fountain of the Four Rivers* (1648–1651) in the Piazza Navona and the church of Sant'Andrea al Quirinale (1658–1670). His greatest works are those in which he created an illusionistic, theatrical ensemble including painting, sculpture, and architecture, as can be seen in the Cappella Cornaro (1645–1652) in Santa Maria della Vittoria.

WILLIAM BLAKE
London 1757–1827

The son of a hosier, Blake entered Henry Par's drawing school in London in 1767. From 1772 to 1778 he was apprenticed to the engraver James Basire, through whom he gained his first exposure to medieval art by copying tombs for antiquarian publications. In 1779 Blake enrolled in the antique school of the Royal Academy, where he drew from casts. He devoted much of his energy to his poetry during this period, publishing his first book of verse, *Poetical Sketches*, in 1783. *Songs of Innocence* (1788) was the first in a series of illuminated books in which Blake used his unique technique of printing both text and design outline on one surface, with color and gold added later by hand. Around 1799 he established contact with his most important patron, Thomas Butts, for whom he made the first series of illustrations to the

Book of Job (circa 1805–1806; New York, Pierpont Morgan Library). During the 1790s and early 1800s Blake took up color printing, but he returned to watercolor in the books *Milton* and *Jerusalem*, which occupied him from around 1804 to 1820. In 1818 Blake met his second important patron, John Linnell, who in 1823–1824 commissioned illustrations to Dante's *Divina commedia*, which are among Blake's most powerful works. Blake's highly personal, visionary art had an important impact on the younger generation of British artists, especially Samuel Palmer.

ABRAHAM BLOEMAERT
Gorinchem 1564–Utrecht 1651

Bloemaert received his earliest training in Utrecht, first under his father, Cornelis, and later under Joos de Beer. Between 1580 and 1583 he lived in Paris, where he studied with Hieronymus Francken. In 1583 Bloemaert returned to Utrecht; he remained there until his death, save for a stay in Amsterdam in 1591–1593. At this time he came under the influence of the Haarlem Mannerists, in particular Hendrick Goltzius, and, through him, the work of Bartholomeus Spranger. Bloemaert's later works, such as the *Adoration of the Magi* (1624; Centraal Museum Utrecht), show the influence of the Caravaggist painters of Utrecht as well as Rubens. Bloemaert painted primarily religious and mythological scenes, often with landscape backgrounds. Bloemaert's influence as a draughtsman continued due to his *Artis Apelles Liber* . . . , a collection of engravings after his drawings published by his son Frederick that first appeared circa 1650.

FRANÇOIS BOUCHER
Paris 1703–1770

Boucher, one of the great decorative painters of the Rococo, trained with his father, Nicolas, and, later, with François Lemoine (circa 1720) and Jean-François Cars. Boucher was a skilled draughtsman and book illustrator and between 1722 and 1728 collaborated on Jean de Julienne's *Figures de différents caractères*, reproducing more than a hundred of Watteau's drawings in etchings. He won the Prix de Rome in 1723 and in 1727 traveled to Italy with Carle van Loo. Having returned to France by 1731, Boucher rapidly gained the favor of the court and of Parisian connoisseurs. Mme de Pompadour became his most notable patron. Boucher was admitted to the Académie in 1734 and elected president in 1765, the year in which he was also proclaimed *premier peintre du roi*. In addition to his decorations for private houses and the royal residences of Versailles, Fontainebleau, Marly, and Choisy, Boucher created tapestry designs for the royal factories and in 1755 was appointed *surinspecteur* at Gobelins. His voluptuous mythological fantasies, endearing depictions of domestic life, and light-hearted pastoral scenes are celebrated for their charming, graceful, and often titillating manner. His major works include the *Luncheon* (1739; Paris, Louvre), the *Rape of Europa* (1747; Louvre), and the *Shepherd and Shepherdess at Rest* (1761; London, Wallace Collection).

ETIENNE-LOUIS BOULLEE
Paris 1728–1799

Boullée first studied painting, but turned to architecture at his father's behest, working with Jacques-François Blondel and Jean-Laurent Legeay. During the 1760s and '70s, he designed a type of private residence having the appearance of a single story extended horizontally, as can be seen in the still-surviving Hôtel Alexandre, Paris (1763–1766), or the Hôtel de Brunoy in the same city (1774–1779; destroyed). In the 1780s Boullée concentrated his efforts as an educator, academician, and theoretician. His theory that architecture could elicit moral and emotional responses when the combination of forms suggested a union with divinity is illustrated in his drawings for projects such as the Metropole (1781–1782) and the cenotaph for Sir Isaac Newton in the Bibliothèque Nationale, Paris (1784; inv. HA.57, nos. 1–3, HA.57, nos. 5–10). These principles are preserved in his thesis *Architecture: Essai sur l'art*, which was published in 1793. Boullée's theories made an important contribution to the development of the Neoclassical style in architecture.

JACQUES CALLOT
Nancy circa 1592–1635

Callot, an important and influential printmaker, trained in Nancy with the goldsmith Demange Crocq and in 1608 traveled to Rome to apprentice with the engraver Philippe Thomassin. Moving to Florence in 1612, he studied with the scenographer/architect Giulio Parigi, began producing watercolors, and entered the service of the Medici court. He produced numerous drawings and etchings of fairs, festivals, courtiers, beggars, and hunchbacks, all described with a Mannerist's flair for elegance, wit, and picturesque detail, as can be seen in the *Balli di Sfessania* (1620–1635) or the *Fair at Impruneta* (1620). Returning to Nancy in 1621, Callot worked for the duke of Lorraine and nobles of the court depicting fanciful scenes of daily life, including the *Gardens of the Palace at Nancy* (1625). Callot also concentrated on more serious subjects in his masterpiece *The Miseries of War* (1633). Since most of his painted decorations have been destroyed, he is known today primarily as a graphic artist. His repertoire

of landscape, theater, genre, and religious themes offers a direct and immediate impression of the events of his time.

ANNIBALE CARRACCI
Bologna 1560–Rome 1609

Annibale Carracci learned painting from his cousin Ludovico and engraving from his elder brother Agostino. Between 1585 and 1595, Annibale produced a series of impressive altarpieces, including the *Madonna Enthroned with Saints* (1588; Dresden, Gemäldegalerie) and the *Virgin with Saints John and Catherine* (1593; Bologna, Pinacoteca Nazionale). They reveal his inheritance of the painterly north Italian traditions of Correggio and the colorism of the Venetian masters, the apparent result of trips to Parma in 1580 and Venice in 1581–1582. Most importantly, Annibale became one of the catalysts of the new style of painting in seventeenth-century Rome after he moved there in 1595, revitalizing traditions of the High Renaissance masters. The fresco cycles in the Palazzo Farnese that depict mythological love scenes (1595–1605) mark the high point of his career. These illusionistic frescoes stand among the first monuments of the new Baroque style.

GIOVANNI BENEDETTO CASTIGLIONE
Genoa circa 1610–Mantua 1663/65

Castiglione trained in Genoa with Giovanni Battista Paggi and Sinibaldo Scorza and may have studied there with Anthony van Dyck between 1621 and 1627. He specialized in biblical or pastoral themes populated with animals and still-life elements, as in *Noah Entering the Ark* (before 1632; Florence, Pitti). A prolific and imaginative draughtsman, Castiglione developed the techniques of brush drawing in oil and monotype. He admired the etchings of Rembrandt, whose influence is evident in Castiglione's own graphics such as the print *Pastoral Journey* (1638; B.28[25] v. 46,21). While living in Rome between 1630 and 1635 and again from 1647 to 1651, he frequented the circle of Nicolas Poussin. This contact resulted in the introduction of romantic, mythological subjects to his repertoire, as, for example, in the brush drawing *Saving of Pyrrhus* (Windsor Castle). Castiglione traveled to Naples, Venice, and, later, to Genoa; from 1651 on he resided in Mantua as court painter to the Gonzaga family. Castiglione's paintings were popular among eighteenth-century artists, who admired them for their picturesque quality.

PAUL CEZANNE
Aix-en-Provence 1839–1906

Cézanne, the son of a wealthy banker, studied law in Aix until his friend Emile Zola persuaded him to become an artist. In 1861 he moved to Paris, met Pissarro and the other Impressionists, and began painting in earnest. To avoid conscription during the Franco-Prussian War, Cézanne moved to L'Estaque in 1870 and between 1872 and 1874 worked alongside Pissarro at Pontoise and Auvers. There he adopted a brighter palette and swifter Impressionist execution, as can be seen in *Auvers, Panoramic View* (Art Institute of Chicago) or *Flowers in a Delft Vase* (Paris, Louvre). Cézanne exhibited twice with the Impressionists, in 1874 and 1877, but sharp criticism of the group caused him to withdraw permanently to Provence, where landscape, still-life, and imaginary figurative compositions became his themes. During the fruitful decades of the '80s and '90s, he produced masterpieces like *Bay of Marseille Seen from L'Estaque* (1883–1885; New York, Metropolitan Museum of Art) and *The Great Bathers* (1898–1905; Philadelphia Museum of Art). Cézanne was one of the major Post-Impressionist artists whose work had a profound impact on early twentieth-century art.

JEAN-SIMEON CHARDIN
Paris 1699–1779

Chardin, one of the most important painters of the eighteenth century, specialized in still-life and domestic genre scenes. He was born in the Saint-Germain-des-Près section of Paris, where he lived all his life. Chardin studied with Pierre-Jacques Cazes and Noël-Nicolas Coypel. Following the success of his first exhibition in 1728, he was admitted to the Académie des Beaux-Arts and thereafter exhibited regularly at the Salon until his death. Inspired by Flemish still lifes and Dutch genre scenes, Chardin developed a uniquely French approach to these cabinet pictures which became very popular with collectors. Examples include *The Buffet* (1728; Paris, Louvre), the *Lady Sealing a Letter* (1733; Berlin, Staatliche Museen Preussischer Kulturbesitz), and *Saying Grace* (1740; Paris, Louvre). Weakened by illness during his last years, he worked exclusively in pastel, producing such fine portraits as the *Self-Portrait with Eye Shades* (1775; Paris, Louvre).

CORNELIS CORNELISZ. VAN HAARLEM
Haarlem 1562–1638

"Cornelis the Painter," as he was called, was the leading figure painter in Haarlem at the end of the sixteenth cen-

tury. According to his biographer, Carel van Mander, Cornelis studied with Pieter Pietersz. at Haarlem. He is recorded in Rouen in 1579 and in Antwerp in 1580. After settling in Haarlem in 1580/81, he soon won fame with his *Banquet of the Civic Guard of Haarlem* (1583; Haarlem, Frans Halsmuseum). Around this time Cornelis is also reported to have founded the "Haarlem Academy" with Carel van Mander and Hendrick Goltzius, which probably provided the opportunity to draw from models and casts. In 1591 he produced the life-size *Massacre of the Innocents* (Haarlem, Frans Halsmuseum), one of the most important paintings of Dutch Mannerism. Between 1588 and 1602 Cornelis produced a number of designs for prints. In 1630 he helped reorganize the Haarlem guild of Saint Luke. Although few surviving drawings can be attributed to him with certainty, the 1639 inventory of his estate includes a large number of drawings of nudes, heads, and drapery.

CORREGGIO (Antonio Allegri)
Correggio 1489/94–1534

Antonio Allegri, known as Correggio after the provincial town of his birth, became one of the leading artists of sixteenth-century Italy. He may have worked in Mantua around 1510–1514; this would account for the influence of Mantegna's art on his own early development, as can be seen in the younger artist's *Nativity* (Milan, Pinacoteca di Brera) and *Madonna of Saint Francis* (1514–1515; Dresden, Gemäldegalerie). Around 1518 Correggio's style assumed a new monumentality and classical beauty, suggesting that he made a visit during the teens to Rome, where he saw the art of Raphael and Michelangelo. Characteristically, he emphasized the poetic features of the High Renaissance style. Correggio created his greatest fresco projects in Parma. His cupola decorations, the *Vision of Saint John on Patmos* (1520–1524) in San Giovanni Evangelista and the *Assumption* (1526–1530) for the Duomo, which are populated with animated figures in heavenly celebration, established an important precedent for the Baroque era. The artist returned to Correggio in 1530. Among his last works was a series depicting the loves of Jupiter which included the sensuous *Jupiter and Io* (1531; Vienna, Kunsthistorisches Museum).

LUCAS CRANACH THE ELDER
Kronach 1472–Weimar 1553

Cranach, who was born in Upper Franconia, is generally thought to have trained with his father, Hans. Around 1501 he traveled to Vienna, where he produced his earliest known works, such as *The Crucifixion* (Vienna, Kunst-

historisches Museum). In their expressiveness and emphasis on the power and dynamism of nature, these compositions mark the beginning of the stylistic movement known as the Danube school. In 1504 Cranach was called to Wittenberg by Frederick the Wise of Saxony, and stayed on to serve his two successors. In Wittenberg the artist specialized in paintings and murals of courtly subjects, including portraits, mythological themes, trophies, and hunts. His large workshop included his sons Hans (circa 1513–1537) and Lucas (1515–1586). From 1519 to 1545 Cranach served on the Wittenberg city council and was burgomaster on three occasions. He was also a close friend of Luther. Around 1550 Cranach went to Augsburg to join his then-patron, Elector John Frederick of Saxony, whom he accompanied in 1552 to Weimar, where he died the following year.

JACQUES-LOUIS DAVID
Paris 1748–Brussels 1825

David, who came from a family of artisans and shopkeepers, was sent to train in the atelier of Joseph-Marie Vien on the advice of François Boucher. In 1774, following four unsuccessful attempts, David won the Prix de Rome; he moved to that city the following year and remained until 1780. In Rome he developed a passion for classical antiquity from which he developed his own heroic style based on his perceptions of the moral and aesthetic values of that era. The *Oath of the Horatii* (Paris, Louvre), which was completed during David's second sojourn in Rome (1784–1787), established him as the leader of the Neoclassical school. It also signaled the beginning of his partisan participation in French politics. He became the artistic director of the Revolutionary regime and portrayed many of its important and tragic events, including the Tennis Court Oath (1791–1792; Musée National du Château de Versailles) and the death of Marat (1793; Brussels, Musées Royaux des Beaux-Arts de Belgique). David was a superb portrait painter who combined idealism with refinement, as can be seen in the *Portrait of Madame Sérizat* (1795; Paris, Louvre). He retained the favor of Napoleon, for whose regime he produced official commissions such as the *Coronation of Josephine* (1805–1807; Paris, Louvre). With the fall of the Empire, however, David sought asylum in Brussels, where he spent his last years.

CARLO DOLCI
Florence 1616–1686

Carlo Dolci was one of the leading painters of seventeenth-century Florence. A precocious youth, he is said to have entered the studio of Jacopo Vignali at age

nine. At sixteen, he painted a portrait of Fra Ainolfo de' Bardi (1632; Florence, Pitti), in which his characteristically sharp attention to detail and strong chiaroscuro are already evident. Although greatly esteemed as a portrait painter, Dolci's religious ardor inspired him to devote his talents to sacred imagery. His oeuvre consists largely of pious, sometimes sentimental half-figures of saints and the Virgin presented with great intimacy. These pictures, which are painted in a tight, highly finished style similar to miniature painting, include the *Madonna of the Lilies* (1642; Montpellier, Musée Fabre) and the *Saint Rose* and *Saint John* (both 1671; Florence, Pitti). Except for a brief visit to Innsbruck in 1672 to paint a portrait of Claudia Felicità, niece of Cosimo II de' Medici (Florence, Pitti), Dolci worked solely in Florence.

LAMBERT DOOMER
Amsterdam 1624–1700

The son of a frame-maker, Doomer worked initially in Amsterdam and may have trained with Rembrandt around 1644. In 1645/46 he visited his two brothers at Nantes, and returned via the Loire valley and Paris, accompanied by the artist Willem Schellinks. Doomer made many topographical drawings during his travels, particularly of Nantes and its environs. After his return to Amsterdam, he produced drawings reflecting trips to the province of Gelderland during the 1640s and 1650s, and a journey up the Rhine in 1663 through Cleves, Cologne, and Bingen, and the eastern Netherlands, including Utrecht, Rhenen, Arnhem, and Nijmegen. From 1669 to 1695 Doomer lived for long periods in Alkmaar. During the early 1670s he made and sold copies of his earlier drawings of France, the Netherlands, and the Rhineland. He spent his final years in Amsterdam. Among seventeenth-century Holland's finest and most prolific topographical draughtsmen, Doomer also painted religious scenes, portraits, and landscapes.

ALBRECHT DÜRER
Nuremberg 1471–1528

Dürer was trained in Nuremberg as a goldsmith by his father between 1485 and 1486 and as a painter by Michael Wolgemut from 1486 to 1489. Between 1490 and 1494 he traveled to Basel, Colmar, and Strasbourg as a journeyman. A trip to Venice in 1494–1495 inspired his lasting interest in Italian theories of proportion and perspective. During the years following his return to Nuremberg, Dürer published some of his greatest prints, including the *Apocalypse* woodcuts of 1498 and the engraving *Adam and Eve* of 1504. He took a second trip to Venice in 1505–1507 and while there painted the *Feast of the Rose*

Garlands (Prague, Národní Galeri) for the local community of German merchants. In 1511 he published the woodcuts of the Large and Small Passion and the Life of the Virgin. Beginning in 1512 Dürer undertook a number of projects for Emperor Maximilian I, who granted him a yearly pension in 1515. In 1520/21 he traveled to the Netherlands. The artist's later support of Luther is expressed in works such as the *Four Apostles* (1526; Munich, Alte Pinakothek). His *Vier Bücher von menschlicher Proportion* was published posthumously in 1528.

ANTHONY VAN DYCK
Antwerp 1599–London 1641

The son of a rich merchant, van Dyck was enrolled in the Antwerp guild of Saint Luke in 1609 as an apprentice to the figure painter Hendrick van Balen. Already active as an independent painter in 1615/16, van Dyck did not become a master in the guild until 1618. About this time he became Rubens' chief collaborator and also executed a number of important independent commissions such as *Christ Carrying the Cross* (Antwerp, Sint-Pauluskerk). Van Dyck traveled to London briefly in 1620. In 1621 he left for Italy, visiting Genoa, Rome, Florence, Venice, and Palermo and receiving numerous portrait commissions, particularly in Genoa. Returning to Antwerp in 1627, he continued to thrive as a painter of portraits and religious and mythological scenes. During the 1620s and '30s he also began to prepare drawings for his *Iconography*, a series of engraved and etched portraits of notable contemporaries, published in a complete edition in 1645. In 1632 van Dyck returned to London, where he was knighted by Charles I and appointed chief painter to the king. After visiting the Netherlands in 1634–1635, he settled permanently in London. Works such as *Charles I Hunting* (1635; Paris, Louvre) set the standard for aristocratic portraiture in England through the eighteenth century.

ALLART VAN EVERDINGEN
Alkmaar 1621–Amsterdam 1675

Everdingen was the son of a notary and the brother of the history painter Cesar van Everdingen. His biographer, Arnold Houbraken, reported that he studied with Roelandt Savery (presumably in Utrecht) and, afterwards, with Pieter Molijn in Haarlem. His earliest signed and dated painting, a seascape of 1640 (formerly Munich, Hoech collection), shows the influence of Jan Porcellis. Around 1643/44 Everdingen visited Norway and Sweden, where he produced annotated drawings of the sites he visited. His earliest signed and dated landscape, of 1644 (formerly London, Palmer collection), exhibits

Nordic scenery inspired by his travels. In February 1645, Everdingen was married in the city of Haarlem, and at some point afterward he joined the guild of Saint Luke there. In 1652 he moved to Amsterdam, where he remained until his death in 1675. From 1644 on, Scandinavian landscapes with rocks, waterfalls, and wooden huts dominated his artistic production. Everdingen introduced Nordic scenery to Dutch painting, and his work in this vein inspired Jacob van Ruisdael's interest in similar subjects.

JEAN-HONORE FRAGONARD
Grasse 1732–Paris 1806

Fragonard moved with his family from Provence to Paris in 1738. Following a brief apprenticeship with Chardin in 1747, he worked in Boucher's studio from 1748 to 1752. There he produced paintings in the master's style. Awarded the Prix de Rome in 1752, Fragonard entered the Ecole Royale des Elèves Protégés, directed by Carle van Loo, in preparation for his five-year stay in Rome (1756–1761). In Italy Fragonard studied at the French academy, admired the works of Giambattista Tiepolo and Francesco Solimena, and became friends with Hubert Robert and his first patron, the Abbé de Saint-Non. Fragonard created a variation of a compositional type known as the *fête galante*, or park scene with figures on a reduced scale, which was light-hearted and often erotic, as in *The Swing* (London, Wallace Collection), the *Fête at Saint-Cloud* (Paris, Banque de France), and his important series Progress of Love, commissioned by Mme Du Barry (1771–1773; New York, Frick Collection). His improvisatory brushwork and warm, vibrant colors admirably convey the delight and grace of these subjects. In 1773 Fragonard traveled again to Rome, returning to Paris the next year via Austria and Germany. In his later years, scenes of family life became the favored subjects of his paintings, as can be seen in *Education Does All* (Museo de Arte de Saõ Paolo).

HENRY FUSELI (Johann Heinrich Füssli)
Zurich 1741–London 1825

Fuseli's father, Johann Caspar, was a painter and writer in Zurich. As a youth Fuseli read widely, absorbing the works of Shakespeare, Milton, and Rousseau. He left Switzerland in 1763 with the physiognomist Lavater and later studied in Berlin with the mathematician and art theorist Sulzer. In 1764 Fuseli traveled to London, and in 1768 he met Sir Joshua Reynolds, who encouraged him to become a painter. Following this advice, Fuseli left for a period of study in Italy, remaining there from 1770 to 1778. He developed an expressive, daringly simplified style and explored an innovative range of themes from literature and classical and Northern mythology. Shortly after returning to England, Fuseli produced his first major success, *The Nightmare* of 1781 (Detroit Institute of Arts). During the following years he executed paintings for the Boydell *Shakespeare Gallery* and forty life-size compositions for his own *Milton Gallery*. In 1790 he was elected a full member of the Royal Academy; he became a professor in 1801. Many of his academy lectures were based on an 1802 visit to Paris, where he studied the art in the Musée Napoléon.

LATTANZIO GAMBARA
Brescia, circa 1530–1574

Lattanzio Gambara was the son of a tailor. His active career began in 1545, when Giulio Campi discovered him and brought the younger artist to Cremona as his student. In 1547 Gambara returned to Brescia to work under Girolamo Romanino, with whom he collaborated on numerous projects, including the fresco cycle depicting the four seasons (1550; Palazzo Averoldi-Valotti). Gambara became a versatile and skillful painter. His best works are in fresco and include facade paintings, and his most notable Brescian works are the altarpiece depicting the Nativity and frescoes showing scenes from Ovid's *Metamorphoses* in the Palazzo Avogadro. In 1567 Gambara moved to Parma, where he painted the fresco cycle in the Duomo depicting the Life of Christ (1567–1573). He also completed the *Ascension* on the west wall of the cathedral between 1571 and 1573. Gambara left for Brescia in 1573 to begin frescoes for the church of San Lorenzo; these were incomplete at his death.

BERNARDINO GATTI
Pavia circa 1495–Cremona 1575

Though born in Pavia, Gatti worked most of his life in Cremona, Piacenza, and Parma. The art of Correggio provided a source of inspiration for him throughout his career, beginning with his first painted altarpiece, the *Resurrection* (1529; Cremona, Duomo). In 1543 he was working in Piacenza at Santa Maria in Campagna, where he finished Pordenone's frescoes of the Life of the Virgin, located in the dome. During the late 1540s Gatti undertook several projects in Cremona, including the *Ascension of Christ* (1549) in the nave of San Sigismondo. In 1560 he moved to Parma, where he painted the *Assumption of the Virgin* (1560–1572) for the dome of Santa Maria della Steccata, a work reminiscent of Correggio's prototype in nearby San Giovanni Evangelista. Returning to Cremona in 1573, Gatti began an *Assumption* for the Duomo that was incomplete at the time of his death.

CLAUDE GILLOT
Langres 1673 – Paris 1722

Gillot, whose first teacher was his father, André-Jacques, a painter and embroiderer, moved to Paris around 1691 and studied there with Jean-Baptiste Corneille. In 1710 he became a provisional member of the Académie as a *peintre de sujets modernes*, and he was elected a full member in 1715. Gillot gained a reputation as a decorator and painter of arabesques; he was also a prolific engraver. A versatile artist, he designed vignettes for book illustrations, including the *Fables nouvelles* of A. H. de la Motte (1719); tapestry cartoons; and sets and costumes for the grand opera, including productions of *Amadis* and *Thesée* by Jean-Baptiste Lully. Gillot was inspired by the commedia dell'arte, banned in France from 1697 to 1716, whose lively characters and memorable stories he depicted in paintings and drawings throughout his career, as can be seen in *Scene of Two Coaches* and *Tomb of Maître André* (both Paris, Louvre). Most were etched by himself and Gabriel Huquier. Gillot is best remembered today as a teacher of Watteau.

ANNE-LOUIS GIRODET DE ROUCY TRIOSON
Montargis 1767 – Paris 1824

Girodet entered the studio of Jacques-Louis David in 1785 and won the Prix de Rome in 1789. In 1790 he moved to Rome. Following political riots related to the French Revolution, Girodet fled to Naples and then to Venice before returning to Paris in 1795. The *Sleep of Endymion* (1793; Paris, Louvre), an enormous success in Rome and Paris, illustrates the artist's departure from David's classicism toward a more romantic, poetic expression. A prolific and ambitious draughtsman, Girodet created illustrations for the Didot family of printers and publishers and also worked as a portrait painter. He received official and private commissions from Napoleon, including *Ossian* (1801) for the château at Malmaison. In 1815 Girodet was elected to the Académie des Beaux-Arts. The *Scene from the Deluge* (1806; Paris, Louvre) established him as a forerunner of Romanticism. Having inherited a large fortune from his adoptive father in 1812, he abandoned painting to devote his time to writing artistic theory and poetry on aesthetics.

GIULIO ROMANO (Giulio Pippi)
Rome circa 1499 – Mantua 1546

Giulio Romano trained as an assistant in Raphael's workshop and later collaborated with the master on several projects, including the Stanza dell'Incendio in the Vatican, which was finished in 1519, and the Loggia di Psiche (1518–1519) in the Villa Farnesina. In 1524 he moved to Mantua to work for the court of Federico II Gonzaga. There the artist created his most celebrated works, including the construction and decoration of the pleasure palace of the Mantuan court, the Palazzo del Tè (1524–1536). The bizarre narrative decorations, such as those in the Sala dei Giganti, are prime examples of Mannerist art in Italy. In 1536 Giulio began the reconstruction and decoration of portions of the Palazzo Ducale, including the Sala di Troia and the Sala dei Cavalli. The construction of his own palace (1544) was one of the last projects he completed before his death.

VINCENT VAN GOGH
Groot-Zundert 1853 – Auvers-sur-Oise 1890

Born the son of a pastor in rural Brabant, van Gogh left school in 1868. He was a clerk at an art firm until 1876. After teaching in England, he worked in a bookshop in Dordrecht in 1877, studied for the ministry in Amsterdam, and in 1878 became a missionary in a poor mining district in Belgium. In 1880 van Gogh decided to become an artist and worked with Anton van Rappard in Brussels. He later worked with Anton Mauve in The Hague. During a period in the isolated Dutch province of Drenthe and in the town of Nuenen outside Amsterdam, van Gogh concentrated on the production of landscapes, paintings of weavers, and powerful, grim scenes of peasant life, such as *The Potato Eaters* (1885; Amsterdam, Rijksmuseum Vincent van Gogh). After a brief enrollment in the Koninklijke Academie voor Schone Kunsten, Antwerp, he went to Paris in 1886 to join his brother, Theo, an art dealer; there he came under the influence of Impressionist and Neo-Impressionist painters such as Pissarro and Seurat. From February 1888 to May 1889 he spent a productive period in Arles in the south of France during which he was visited by Gauguin. He began to suffer a series of mental collapses, entering asylums in Arles and, later, Saint-Rémy-de-Provence, where he painted *Starry Night* (1889; New York, Museum of Modern Art). Thereafter, van Gogh moved to Auvers near Paris, dying in July 1890 after an apparent suicide attempt. The extraordinary body of letters he wrote to Theo provides an almost daily account of his life and artistic production.

HENDRICK GOLTZIUS
Mühlbracht 1558 – Haarlem 1617

Goltzius was trained by his father and in 1575 became an apprentice to the engraver Dirk Volkertsz. Coornhert in Xanten. In 1576/77 he moved to Haarlem, where he, Carel van Mander, and Cornelis van Haarlem founded

the so-called Haarlem Academy to foster figure drawing in Holland. During the mid-1580s Goltzius was greatly influenced by Bartholomeus Spranger, whose style he disseminated through engravings after Spranger's drawings, such as the *Marriage of Amor and Psyche* of 1587. During 1590/91 Goltzius traveled to Venice, Bologna, Florence, Naples, and Rome, studying antique sculpture and the works of Raphael, Titian, and other Renaissance masters. After his return to Haarlem he gave up Mannerism in favor of a more classical style. He was productive as a draughtsman and printmaker during the 1590s, but after 1600 he virtually gave up engraving for history painting. Goltzius' fame rests on his work as a printmaker and draughtsman. Of importance for the later development of Dutch art were his figure studies and his drawings of the dunes around Haarlem of circa 1600, which are among the earliest depictions of the landscape of Holland.

FRANCISCO JOSE DE GOYA Y LUCIENTES
Fuendetodor 1746–Bordeaux 1828

Goya was a pupil of José Luzas in Saragossa, and of Francisco Bayeu in Madrid from 1766. Between 1770 and 1771 he journeyed through Italy. Decorative works such as the frescoes for the basilica of El Pilar in Saragossa (1772) and the cartoons, now in the Prado, for the royal tapestry factory (1776–1791) exhibit the influence of Tiepolo. In portraiture Goya combined the ceremonial qualities of Anton Rafael Mengs, then court painter to King Charles III, with acute psychological observation, as can be seen in the *Duchess de Alba* (1797; New York, Hispanic Society of America). Goya was appointed painter to King Charles III in 1786 and court painter to Charles IV in 1789. A serious illness in 1792 left the artist completely deaf. Thereafter his art assumed an increasingly pessimistic, sardonic character. The nightmarish imagery of his etched series *Los Caprichos* (1793–1798) presents a bitter attack upon contemporary customs and manners. The cycle of political turmoil and violent repression that beset Spain during the Napoleonic Wars inspired a later series of etchings, The Disasters of War (produced 1810–1823, published 1863) as well as his painting *The Executions of the Third of May* (1814; Madrid, Prado). Disaffected by the corrupt brutality of King Ferdinand VII, Goya left Spain permanently in 1824, remaining in exile in France for the rest of his life save for a trip to Madrid in 1826.

JAN VAN GOYEN
Leiden 1596–The Hague 1656

From 1606 on, van Goyen studied in Leiden with Coenraet van Schilperoort, Isaack van Swanenburch, Jan de Man, and Hendrik Clock, and in Hoorn with Willem Gerritsz. He probably traveled in France in 1615/16. Around 1617 he studied in Haarlem with Esaias van de Velde, who shaped his early style, as can be seen in his first known signed and dated work, *Landscape with an Old Tree* (1620; New York, private collection). In 1618 he returned to Leiden and in 1632 moved permanently to the Hague, where he became a citizen in 1634 and the head of the guild of Saint Luke in 1638 and 1640. During the late 1620s, van Goyen shifted to simplified, diagonal compositions and a monochromatic palette, thereby helping to initiate the tonal phase of Dutch landscape painting. Later works such as *View of Leiden* (1643; Munich, Alte Pinakothek) show an increasingly bold technique and emphasis upon the rendering of light, atmosphere, and water. Van Goyen drew prolifically from nature, as in the black chalk drawings of his later career which reflect his travels in Holland, Belgium, and eastern Germany.

EL GRECO (Domenico Theotocopuli)
Candia 1541–Toledo 1614

El Greco received initial training in his native Crete. About 1567–1570 he lived in Venice, where he was influenced by Titian, Tintoretto, Veronese, and Jacopo Bassano. After moving to Rome in 1570 his style underwent further transformation through contact with the art of Michelangelo and his Roman followers such as Salviati and Vasari. The prospect of royal patronage lured him to Spain in 1576/77. He settled temporarily in Toledo in 1577 and made the city his permanent residence in 1583 following King Philip II's refusal to offer him patronage. El Greco subsequently gained many patrons among Toledo's noble intelligentsia and also executed ecclesiastical commissions throughout Spain, including *The Disrobing of Christ* (1577–1579; Toledo, Cathedral) and *The Burial of Count Orgaz* (1586–1588; Toledo, Santo Tomé). El Greco also emerged as the greatest Spanish portraitist of his time, as can be seen in such works as *Fray Hortensio Félix Paravicino* (Museum of Fine Arts, Boston).

JEAN-BAPTISTE GREUZE
Tournus 1725–Paris 1805

Greuze apprenticed in Lyons with the provincial portraitist Charles Grandon. Moving to Paris around 1750, he entered the royal academy as a pupil of Natoire; five years later he made a brief visit to Italy. A popular nar-

rative painter, Greuze combined the intimate views and realistic details of Chardin with the lighter overtones of Boucher. His favorite themes, love and the family, often had moral and sentimental content, as can be seen in *The Broken Eggs* (1756; New York, Metropolitan Museum of Art), *A Marriage Contract* (1761), or *The Son Punished* (1778; both Paris, Louvre). Diderot especially admired Greuze's selection of modern dramas rather than subjects from classical mythology as the subject of his paintings. Although he aspired to be recognized as a history painter, his election to the Académie des Beaux-Arts in 1769 was to the rank of genre painter. As a portraitist he combined naturalism and grace and, in his portrayals of children, a charming tenderness. Memorable paintings include *Madame de Porcin* (1769–1774; Musée d'Angers) and *Boy with a Dog* (London, Wallace Collection). The incisive characterization Greuze brought to the masculine portrait is fully evidenced in the *Portrait of Johann Georg Wille* (1763; Paris, Musée Jacquemart-André). Following the Revolution he suffered many personal setbacks, and he died in obscurity.

ANTOINE-JEAN GROS
Paris 1771–Meudon 1835

Gros, the son of miniature painters, became the pupil of David in 1785. In 1793 he traveled to northern Italy, where he studied the work of Venetian and Milanese artists as well as that of Rubens. Josephine Bonaparte, whom he met in Genoa, presented him to Napoleon, and thereafter Gros served as the official chronicler of the Empire. In *Bonaparte at the Arcole Bridge* (1796; Musée National du Château de Versailles), *Napoleon Visiting the Plague-Stricken at Jaffa* (1804), and *Napoleon at the Battlefield of Eylau* (1808; both Paris, Louvre), Gros gave greater weight to color than did his Neoclassical contemporaries. Following the Restoration and David's exile to Brussels, Gros worked for the French Crown, receiving the title of baron from Charles X, and assumed direction of David's large studio. Toward the end of his career, Gros returned to antique allegorical subjects.

GUERCINO (Giovanni Francesco Barbieri)
Cento 1591–Bologna 1666

Guercino was for the most part a self-taught artist. As a youth, he admired the work of Ludovico Carracci, whose paintings could be seen in Cento and nearby Bologna. In 1617 Guercino moved to Bologna, where he painted several important works for Cardinal Alessandro Ludovisi, later Pope Gregory XV; these included the *Raising of Tabitha* (1617; Florence, Pitti). Between 1617 and 1621 Guercino produced a series of powerful Ba-

roque altarpieces, including his early masterpiece *Saint William of Aquitaine Receiving the Habit* (1620; Bologna, Pinacoteca). From 1621 on, Guercino worked for Pope Gregory XV in Rome. There he began a number of projects, including the lyrical, illusionistic ceiling painting of Aurora in the Palazzo Ludovisi. He returned to Cento in 1623 to head an active studio and, following the death of Guido Reni in 1642, moved to Bologna to assume a preeminent artistic position in that city.

HANS HOLBEIN THE YOUNGER
Augsburg 1497–London 1543

Holbein, who trained in his father's studio in Augsburg, moved in 1515 to Basel, where he designed prints for book illustrations. In 1517 he was active in Lucerne, where he decorated the Hertenstein house with illusionistic frescoes. From Lucerne Holbein probably traveled to Italy. In 1519 he joined the painters' guild in Basel, executing large-scale altarpieces, such as the *Passion Altarpiece* (Kunstmuseum Basel), as well as portraits of the circle of patricians and humanists of which he was a part. Holbein traveled to France in 1524 and to Antwerp and England in 1526. On the recommendation of Erasmus of Rotterdam, he was introduced to Sir Thomas More, whom he portrayed in the well-known portrait of 1527 in the Frick Collection, New York. Holbein returned to Basel in 1528 and moved to England permanently in 1532. In 1536 he became court painter to King Henry VIII, a position he held until his death.

WOLF HUBER
Feldkirch circa 1480/85–Passau 1553

Huber probably apprenticed in Feldkirch in the Austrian province of Vorarlberg. Around 1505 he traveled to Innsbruck, Salzburg, and possibly Vienna and Augsburg. He was active in Passau and had a workshop by 1515, the date of the commission for his most important painting, the *Anna Altarpiece* (Bührle collection, on loan to the Vorarlberger Landesmuseum, Bregenz). In Passau he was court painter to Duke Ernest of Bavaria and Wolfgang von Salm, bishop of Passau. A number of Huber's drawings of specific places document trips up the Danube and to Germany in 1513/14 and down the Danube to Vienna in 1529/31. Around 1541 he became city architect of Passau. Huber was important as a painter of portraits and religious subjects, a designer of woodcuts, and a draughtsman. He is best known for his landscape drawings, which often show trees and mountain vistas and stress the vitality of nature and its dominance over man. Together with Albrecht Altdorfer, Huber was the most prominent artist of the Danube school.

JEAN-AUGUSTE-DOMINIQUE INGRES
Montauban 1780–Paris 1867

Ingres studied art first with his father and then, in 1791, at the Académie des Beaux-Arts, Toulouse. He entered David's Parisian studio in 1797 and won the Prix de Rome in 1801, though he did not leave for Italy until 1806. Ingres earned a living painting portraits such as *Mademoiselle Rivière* (1805; Paris, Louvre), in which his sensuous line and extraordinary ability to describe the sitter's individual features are fully evident. The narrative paintings he created in Italy to be sent to France, including *Oedipus and the Sphinx* (1808; Paris, Louvre), elicited severe criticism for their realism, and he remained in Italy for another sixteen years. He settled in Florence in 1820 and in the same year received a commission from the cathedral of Montauban for the *Vow of Saint Louis XIII* (1820–1824), his first great success at the Salon. Ingres returned to Paris in 1824 and was elected to the Académie in 1825, achieving recognition as a champion of Classicism against the Romantic movement. He was in Rome again from 1835 to 1841 as the director of the French academy. During his last years in Paris, he continued to produce works of great beauty, including *The Turkish Bath* (1859–1860; Paris, Louvre).

INNOCENZO DA IMOLA
Imola 1485–Bologna 1548

Sponsored by the commune of Imola, Innocenzo moved to Bologna in 1506 to train with the painter Francesco Francia. The young artist probably traveled around 1509 to Florence, where he worked for several years with Mariotto Albertinelli. In addition to Albertinelli, Innocenzo was particularly influenced by Fra Bartolommeo, Raphael, and Andrea del Sarto. His *Annunciation* (circa 1515–1520; Bologna, Santa Maria dei Servi) reveals his first-hand assimilation of the Florentine traditions of form, color, and composition. Returning to Bologna in 1517, Innocenzo opened his own studio and began an active career executing numerous local commissions that included the *Madonna in Glory with Saint Michael* (Pinacoteca Nazionale), the *Mystic Marriage of Saint Catherine* (1536; San Giacomo Maggiore), and the mythological fresco decorations for Cardinal Bonifacio Ferrari's Palazzino della Viola (1540–1543).

JACOB JORDAENS
Antwerp 1593–1678

Jordaens was recorded in the Antwerp guild of Saint Luke in 1607 as a pupil of Adam van Noort and became a master in the guild in 1615. The following year he married Catharina van Noort, the daughter of his teacher. In 1635 he participated in the decoration of Antwerp for the triumphal entry of the Cardinal Infant Ferdinand, and in 1636–1637 he helped execute paintings for the Torre de la Parada after designs by Rubens. During his later career Jordaens received commissions from Charles I, Queen Christina of Sweden, and Amalia van Solms, widow of the Dutch stadtholder, for whom he executed *The Triumph of Frederik Hendrik* (1652) to be hung in Huis ten Bosch outside The Hague. In addition to religious and historical scenes, Jordaens produced portraits and exuberant genre scenes, such as *The King Drinks* (Brussels, Musées Royaux des Beaux-Arts de Belgique), and became the leading painter in Antwerp after Rubens' death.

PIETER LASTMAN
Amsterdam 1583–1633

After studying with Gerrit Pietersz. in Amsterdam, around 1603–1604 Lastman traveled to Italy, where he was influenced by Venetian and Roman painting as well as the art of Adam Elsheimer. In 1607 he is again reported in Amsterdam, where he remained until his death. Lastman is counted among the city's most important painters in the Knight Rodenburgh's laudatory poem on Amsterdam of 1618. Exclusively a history painter, Lastman was attracted to dramatic incidents such as conversations, meetings, and miracles, often taken from the Bible, especially the Old Testament, as can be seen in *David and Uriah* (1619; Groningen, Groninger Museum, on loan from the Hague, Dienst voor's Rijksverspreide Kunstvoorwerpen). His work profoundly influenced Rembrandt, who was his pupil in 1623/24. Lastman's artistic production is well known today, with dated paintings existing at nearly regular two-year intervals from 1606 through 1631. He was the most important member of the Pre-Rembrandtists, whose work laid the foundation for the development of history painting in seventeenth-century Holland.

LEONARDO DA VINCI
Vinci 1452–Amboise 1519

Leonardo da Vinci's career embraced the arts of painting, sculpture, architecture, and music. His interests also included a variety of sciences, as is evidenced in his notebooks. He was apprenticed to Andrea del Verrocchio, one of the leading painter/sculptors of the fifteenth century. Leonardo's youthful Florentine paintings include the portrait of Ginevra de' Benci (circa 1474; Washington, D.C., National Gallery of Art) and the unfinished *Adoration of the Kings* (1481–1482; Florence, Uffizi). In 1481 or 1482 Leonardo moved to Milan to work at the

court of Duke Ludovico Sforza. There he painted the *Virgin of the Rocks* (circa 1482–1483; Paris, Louvre) and the fresco of the Last Supper in Santa Maria delle Grazie (circa 1495–1496). Leonardo left Milan in 1499 and visited Mantua and Venice. Returning to Florence in 1500, he painted the *Mona Lisa* (circa 1503) and began work on the *Virgin and Saint Anne* (circa 1508–1510), both in the Louvre. In 1506 he was invited to work for the French crown in Milan. There he stayed through 1513, save for a visit to Florence between the autumn of 1507 and that of 1508. Leonardo visited Rome in 1513 and in 1516 accepted the invitation of Francis I to live in France, where he spent the last years of his life.

DANIEL LINDTMAYER
Schaffhausen 1552–circa 1606/07
Born into a family of artists active in Schaffhausen, Lindtmayer probably trained there as a mural painter and designer of stained-glass windows. Around 1574–1575 he journeyed to Basel and on to Feldkirch in the Austrian province of Vorarlberg, where he married. He became an independent master in Schaffhausen in 1577 and was active there for the next eighteen years. Occasionally, he traveled to other towns to carry out commissions, working in Königsfelden in 1580/81 and Paradies in 1582/83. In 1595 Lindtmayer tried to murder the goldsmith Stulz in Constance, but escaped punishment on grounds of insanity. He is documented in the Swiss city of Schwyz in 1597 and in Lucerne around 1598–1601. About this time Lindtmayer probably converted to Protestantism. He was in Wolfenschiessen around 1602 and died at an unknown location around 1606/07. Lindtmayer's surviving oeuvre consists of approximately 350 drawings, including many designs for stained-glass windows, seven woodcuts, four etchings, and several paintings.

CLAUDE LORRAIN (Claude Gellée)
Champagne 1600–Rome 1682
Around 1613 Claude traveled to Italy, where he apprenticed with Agostino Tassi. Between 1618 and 1620 he probably lived in Naples as a pupil of the Fleming Goffredo Wals. Following a brief visit to Nancy in 1625–1626, Claude returned permanently to Italy. Influenced by Tassi, Adam Elsheimer, and Paul Bril, he is celebrated for the development of the ideal landscape, alive with atmospheric variations and the changing qualities of light. The idyllic beauty of the Roman countryside appealed to him as much as its ruins did. His work attracted many prominent patrons, including Pope Urban VIII. Claude's *Liber veritatis*, begun in 1636 (London, British Museum), was composed as a lifelong record of com-

pleted paintings in the form of drawings. In addition it was meant to protect him against the many forgeries of his work. Claude's masterpieces include *Ulysses Returns Chryseis to Her Father* (1644; Paris, Louvre) and *Landscape with Parnassus* (1652; Edinburgh, National Gallery of Scotland). In later years the significance of the figure increased in his work as he selected subjects from the Bible, mythology, and classical antiquity; this can be seen in *View of Carthage with Dido and Aeneas* (1675; Hamburg, Kunsthalle).

LORENZO LOTTO
Venice circa 1480–Loreto circa 1556
Lorenzo Lotto, one of the major Venetian artists of the Renaissance, worked primarily in the provincial cities of the Marches and Lombardy. The formation of his early style was influenced by the example of Giovanni Bellini and, later, by Raphael, Titian, and Dürer. From 1505 to 1507 he lived in Treviso, where he painted such moving altarpieces as the *Assumption of the Virgin* (1506) for the cathedral at Asolo. His work in Rome around 1509 was followed by a long, successful period (1513–1523) in Bergamo. Among his most well-known paintings from this time are the *Madonna Enthroned with Saints* (1521; Santo Spirito) and the matrimonial portrait *Marsilio Casotti and His Wife* (1523; Madrid, Museo del Prado). Returning to Venice in 1526, Lotto lived during the next twenty-six years in his hometown and in Jesi, Treviso, and Ancona. His last major altarpiece was the *Assumption of the Virgin* (1550) for San Francesco delle Scale in Ancona (Ancona, Pinacoteca). Shortly after he completed this work, in 1552, Lotto retired to the monastery of Santa Casa in Loreto.

AURELIO LUINI
Milan circa 1530–1593
Aurelio Luini was the son and pupil of Bernardo Luini and the brother of the painter Gian Pietro, with whom he occasionally collaborated. Aurelio's early style, as seen in the fresco cycle of the Life of Christ (begun 1555; Milan, San Maurizio) recalls that of his father and unites the Lombard attention to detail with the soft, chiaroscuro modeling of Leonardo. As a mature artist, Aurelio employed a style approximating that of the counter-*maniera*, adopting monumental figures that were eloquent in gesture and pious in demeanor. These characteristics are apparent in the *Baptism of Christ* in San Lorenzo, Milan, and the frescoes for Santa Maria di Campagna, Pallanza. Aurelio received the majority of his commissions from religious societies, and his works still decorate many churches in and around Milan, including the Duomo,

San Sempliciano, and the Sanctuario in Saronno. The culmination of his career was the fresco cycle (1592–1593) for the chapel of the Baptist in Milan's Ufficio del Tribunale di Provvisione, depicting the life of Saint Ambrose, the city's patron saint.

ANDREA MANTEGNA
Isola di Carturo 1431–Mantua 1506

Mantegna was an apprentice in the shop of the antiquarian Francesco Squarcione in Padua around 1441. He developed a precise, sculptural style and a vision of antiquity which was inspired in part by the intellectual culture of Padua and the presence of masterpieces by Donatello in that city. His earliest works in this vein include the *San Zeno Altarpiece* (1456–1459; Verona, San Zeno) and the undated *Agony in the Garden* (London, National Gallery). Mantegna moved to Mantua in 1460 to assume the position of court painter to the Gonzaga family. In that city he created some of the finest and most original works of the fifteenth century, including the fanciful, illusionistic decorations of the Camera degli Sposi in the Palazzo Ducale (1473–1474). In his later paintings, such as the *Parnassus* (1497) and the *Triumph of Virtue* (1504), both painted for Isabella d'Este and now in the Louvre, he departed from the geometric severity of his early style for a more natural classicism. Mantegna was also the most important Italian printmaker of the fifteenth century.

NIKLAUS MANUEL DEUTSCH
Bern 1484–1530

Deutsch was the son of Emanuel Alleman, an apothecary from a family that had emigrated from Chieri near Turin. About the time of his marriage in 1509, Manuel adopted his father's surname, translating it to "Deutsch." Nothing certain is known of his training. His earliest dated painting, *Saint Eligius in His Workshop* of 1515 from the *Anna Altarpiece* (Kunstmuseum Bern), executed for the Dominikanerkirche in Bern, shows the influence of the local painter Hans Fries, as well as that of the graphic work of Dürer, Burgkmair, and Urs Graf. In 1516 Manuel probably traveled to Italy as a soldier. Between 1516 and 1519 he painted the monumental *Dance of Death* (destroyed) on the encircling wall of the Dominican convent in Bern. His latest dated paintings are from 1520, and his latest dated drawings from 1529. It appears that after 1521 Manuel devoted increasing energy to the writing of poetry and to building support for the Reformation. He was important as a painter of religious scenes and portraits, and as a designer of stained-glass windows, a printmaker, and a draughtsman.

CARLO MARATTA
Camerano 1625–Rome 1713

Carlo Maratta was a leading exponent of late Baroque classicism in Italy at the end of the seventeenth century. Arriving in Rome about 1636, he trained with Andrea Sacchi, who encouraged his study of the heroic styles of Raphael and Annibale Carracci. His first major commission, the *Nativity* (1650) for San Giuseppe dei Falegnami, signaled the beginning of a long and successful career that was based almost exclusively in Rome. Maratta's major works include the *Portrait of Clement IX* (1669; Vatican, Pinacoteca) and the *Immaculate Conception with Saints* (1686; Santa Maria del Popolo). In addition he completed major fresco cycles in palazzos in Rome and Frascati and designed large-scale sculptural commissions such as the twelve marble apostles in San Giovanni in Laterano. Maratta served as president of the Accademia di San Luca in 1664–1665 and again from 1701 until his death.

ADOLF VON MENZEL
Breslau (Wroclaw) 1815–Berlin 1905

After an apprenticeship in his father's lithography shop, Menzel enrolled briefly in the Akademie der Künste, Berlin, in 1833. Initially, he worked chiefly as an illustrator. His wood engravings for Franz Kugler's *Geschichte Friedrichs der Grossen* (1842) and the *Werke Friedrichs der Grossen* (1846–1857) are among the masterpieces of the medium. In 1853 Menzel was elected to the academy. During the 1870s and 1880s he traveled through Holland, Austria, southern Germany, and Italy, and in 1885 he made the first of many trips to Paris, where he met Meissonier and his circle. From the 1860s on Menzel increasingly portrayed his own life and times. His monumental painting *The Iron Rolling Mill* (1875; Berlin, Nationalgalerie) is among the most important early depictions of the modern industrial worker. Ennobled in 1898, Menzel lived until the age of ninety and was prolific to the end. He drew tirelessly from life, in a style notable for its stark contrasts of dark and light and penetrating observation of reality.

JEAN-FRANÇOIS MILLET
Gruchy 1814–Barbizon 1875

Millet, the son of Norman peasants, trained in Cherbourg from 1833 to 1836 with Bon Ducoucel and Charles Langlois and then moved in 1837 to Paris, where he studied briefly with Paul Delaroche. At the Louvre he studied the works of Le Sueur, Poussin, and Rembrandt. During the 1840s Millet lived in Paris and Cherbourg and exhibited at the Salon. His youthful paintings recall the pas-

torals of the eighteenth century, while his technically assured portraits foreshadow his realist tendencies. Millet's first naturalistic pictures, such as *Return from the Fields* (Cleveland Museum of Art), which date from 1846, introduced a more somber palette and severe style. In 1849 Millet and his family moved to Barbizon. He produced paintings and drawings depicting scenes of farm labor and simple rustic life which convey a sense of grandeur and nobility of spirit. His major works, including *The Gleaners* (1857; Paris, Louvre) and *Harvesters Resting* (1853; Boston, Museum of Fine Arts), received reactions ranging from acclaim to hostility for what were perceived as his socialist leanings. In later years the landscape as motif became increasingly important to him as did the innovations of the nascent Impressionist school, as can be seen in *Spring* (1868–1873; Paris, Louvre).

PIETER MOLIJN
London 1595–Haarlem 1661

After emigrating to Holland at an unknown date, Molijn became a lifelong resident of Haarlem, joining the guild of Saint Luke there in 1616 and serving as dean in 1633, 1638, and 1646. His early style was strongly influenced by that of Esaias van de Velde and Jan van Goyen, whom he probably met around 1617 while the latter was the former's student. Molijn's work, together with that of van Goyen and Salomon van Ruysdael, represents the climax of pictorial realism in Dutch landscape painting. His most innovative period occurred during the 1620s, when he produced paintings and etchings of dunes and the flat countryside around Haarlem which are unified by prominent diagonals leading the eye into space, as in *Landscape* (1629; New York, Metropolitan Museum of Art). He made many drawings, particularly during his maturity, and they are almost always signed and dated.

JEAN-MICHEL MOREAU THE YOUNGER
Paris 1741–1814

Moreau, a draughtsman and engraver, came from a family of artists. Intent on becoming a painter, he studied with L.-J. Le Lorrain, following him in 1758 to Saint Petersburg to collaborate on theater designs and to teach drawing at the Académie des Beaux-Arts. Returning to Paris in 1759, Moreau joined the studio of the engraver Jacques-Philippe Lebas. His official positions included *dessinateur du cabinet du roi* in 1770 and *dessinateur des ménus plaisirs* in 1790. Assuming the role of unofficial historiographer of his time, Moreau engraved royal and civic ceremonies, including the coronation oath of Louis XVI (1775), and his prints provide a valuable record of the last

years of the ancien régime. In addition he produced engravings for book illustrations, including two series of the *Monument du costume* (1777, 1783), and *Les oeuvres de Rousseau* (1774). He exhibited regularly at the Académie from 1781 to 1810 and was elected a full member in 1789. Moreau visited Italy in 1785 and was elected professor at the Ecole Centrale in 1797.

NICOLO DELL'ABATE
Modena 1509/12–France 1571

As a youth, Nicolò trained with the decorator Antonio Begarelli in Modena before moving in 1548 to Bologna, where the art of Parmigianino exerted a strong influence on him. His major commissions, including the frescoes illustrating the *Orlando Furioso* (1548–1550) in the Palazzo Torfanini and the genre scenes in the Palazzo Poggi, reveal his talent as a decorator and illustrator of contemporary aristocratic life. Nicolò moved to France in 1552 to work with his compatriot Francesco Primaticcio at the court of Fontainebleau. His elegant Mannerist style, as seen in the decorations there, influenced French artists of the following generation. He continued to work for the French court until his death.

ADRIAEN VAN OSTADE
Haarlem 1610–1685

Van Ostade was the son of a weaver and the elder brother of the talented painter Isack van Ostade. A lifelong resident of Haarlem, he joined the guild of Saint Luke around 1634 and was made commissioner in 1647 and 1661, and dean in 1662. The remark of his biographer Houbraken that van Ostade and the Flemish low-life painter Adriaen Brouwer were fellow pupils in the studio of Frans Hals is supported by Brouwer's evident influence upon the early peasant scenes of van Ostade. He also developed a forceful chiaroscuro indicative of an acquaintance with the work of Rembrandt. In later pictures such as *Villagers Merrymaking at an Inn* (1652; Toledo Museum of Art), van Ostade abandoned his early imagery of coarse debauchery, preferring rustic interiors with carefully structured spaces, picturesque clutter, and figures that are calmer and more respectable than his earlier types. He also made etchings and was a prolific draughtsman.

ISACK VAN OSTADE
Haarlem 1621–1649

A native of Haarlem, Isack studied with his elder brother, Adriaen, and joined the Haarlem painters' guild in 1643. He died in 1649, having shown great talent and originality during a career that lasted only a decade. While his

early work consists primarily of rustic interiors based on the art of his brother, his later easel paintings and watercolors of outdoor scenes reflect his own creative ideas more clearly. Van Ostade's finest works include winter pieces and outdoor scenes that combine landscape and peasant genre elements, particularly conversations in front of a house or roadside inn, as can be seen in *Rest by a Cottage* (1648; Haarlem, Frans Halsmuseum).

GIOVANNI PAOLO PANINI
Piacenza 1691–Rome 1765

Giovanni Paolo Panini began his career in Piacenza painting architecture, ruins, and views under the tutelage of Ferdinando Bibiena, Giuseppe Natali, and Andrea Galluzi. In 1711 he moved to Rome, became a pupil of Benedetto Luti, and expanded his repertoire to include historical subjects. His picturesque frescoes of the Roman countryside (1721–1722) in the Palazzo Quirinale and the painted trompe l'oeil decorations (1725–1726) in the Palazzo del Senato brought him immediate fame. Panini specialized in *vedute*, real or imaginary topographical views of Rome's ancient and modern monuments. His major works in this genre include the *Interior of the Pantheon* (1740; Washington, D.C., National Gallery of Art) and *View of the Roman Forum* (1740; Paris, Louvre). He designed festival projects and produced paintings to commemorate special events in the city's history, such as *Charles III Visiting the Basilica of Saint Peter's* (1746; Naples, Museo e Gallerie Nazionali di Capodimonte). His works were much admired by artists such as Piranesi, Robert, and Fragonard.

PARMIGIANINO (Francesco Mazzola)
Parma 1503–Casalmaggiore 1540

Parmigianino worked as a painter, draughtsman, and etcher. His uncles Pier Ilario and Michele Mazzola provided his early training, but the example of Correggio was the major stimulus to his early development. Between 1522 and 1524, Parmigianino worked on the decorations for several chapels in San Giovanni Evangelista in Parma. In 1524 he traveled to Rome, carrying with him the unique, undated *Self-Portrait in a Convex Mirror* (Vienna, Kunsthistorisches Museum), which he presented to an appreciative Pope Clement VII, thereby securing work in the papal court. In Rome the influence of Raphael and of antique sculpture reinforced Parmigianino's attention to plastic values and refined elegance, as can be seen in the *Vision of Saint Jerome* (1527; London, National Gallery). In 1527 he moved to Bologna, where his major works included the undated *Madonna of Saint Zachary* (Florence, Uffizi) and the *Madonna of Saint Mar-*

garet (1528–1529; Bologna, Pinacoteca). Among the artist's last great works are the *Madonna of the Long Neck* (commissioned 1534; Florence, Uffizi) and the unfinished fresco decorations (1530–1539) for Santa Maria della Steccata in Parma.

GEORG PENCZ
Breslau(?) (Wroclaw[?]) circa 1500–Leipzig 1550

Pencz was active in Dürer's workshop as early as 1521, becoming a citizen of Nuremberg in 1523. In January 1525 he and the artists Barthel and Sebald Beham were briefly expelled from the city for atheism. Little is known of Pencz's artistic activities in the 1520s. It has been proposed that he was identical with the Master I. B., a Nuremberg printmaker active during this decade, but this is doubtful. Pencz is recorded in Nuremberg in 1530 and was made the official city painter in 1532. In 1534 he executed an illusionistic ceiling painting there, *The Fall of Phaeton* (Stadtmuseum Fembohaus), which indicates that he had studied Giulio Romano's frescoes in the Palazzo del Tè, Mantua, probably on a trip to northern Italy around 1529. Pencz's prints and drawings of the early 1530s reflect the influence of the Italian engraver Marcantonio Raimondi. About 1539/40 he returned to Italy, this time visiting Rome, where he made drawings after Michelangelo's frescoes *The Deluge* and *The Last Judgment* in the Sistine Chapel. Pencz returned to Nuremberg in 1540. His reputation as a portraitist led to his appointment as court painter to Albert, duke of Prussia, in 1550. However, he died in Leipzig the same year en route to his new post.

LUCA PENNI
Florence circa 1500/04–Paris 1556

Luca Penni came from a family of Florentine weavers. His early style had strong affinities with Raphael and his followers in Rome. In the late 1520s Penni worked with his brother-in-law, Perino del Vaga, in Genoa and Lucca. He traveled to France in 1530 and from 1537 to 1540 collaborated with Rosso Fiorentino and Francesco Primaticcio at the court of Fontainebleau, where his work included the gallery of François I. Penni also worked outside the court as a painter, draughtsman, and designer of tapestries. His works include a drawing of battling nudes (Paris, Louvre) and designs depicting stories of the goddess Diana. Penni settled in Paris in 1550, and from 1553 until his death worked principally as a designer of engravings by Jean Mignon, René Boyvin, and others. Their prints, based on Penni's designs, enjoyed wide circulation throughout Europe.

BALDASSARE PERUZZI
Siena 1481–Rome 1536

Peruzzi's career began in Siena. In 1502/03 he moved to Rome, where he rapidly attained success as an architect and decorator. Peruzzi was inspired by the traditions of classical antiquity and the art of his contemporary Raphael. From 1509 to 1516 he was engaged as the architect and designer of the Villa Farnesina. In 1516 he decorated the Cappella Ponzetti in Santa Maria della Pace and completed the fresco representing the Presentation of the Virgin for the same church. Peruzzi was appointed architect of Saint Peter's, and in 1520–1523 he painted the oval frescoes illustrating scenes from Ovid's *Metamorphoses* in the Villa Madama. He also traveled to Bologna, returning to Rome, where he designed Pope Adrian VI's tomb in Santa Maria della Anima. Peruzzi returned to work in Siena in 1527 as architect of the Sienese republic, but in 1535 he was again in Rome. In the same year he began construction of the Palazzo Massimo alle Colonne. His designs for architectural and scenographic projects had a great influence on Sebastiano Serlio, who used them as the basis for his treatise on architecture.

BERNARDINO POCCETTI (Bernardino Barbatelli)
San Mariano di Valdelsa 1548–Florence 1612

Poccetti received his artistic training from Michele di Ridolfo. In his youth he worked as a decorator, particularly as a painter of facades and grotesques. Following a brief visit to Rome in 1578 to study the work of Raphael and his school, Poccetti began his prolific activity as a narrative fresco painter. His vivid depictions of the lives of the saints—as seen in the lunettes of the Chiostro Grande (1582–1584) in Santa Maria Novella—and of the memorable exploits of noble Tuscan families—in the Palazzo Capponi (1585)—brought him much success in Florence. His works, including the *Stories of Saint Bruno* (1591–1592) for the Certosa di Val d'Ema and the decorations for the Cappella Neri in Santa Maria Maddalena dei Pazzi (1598–1600), combine the ornamental quality of the late *maniera* with elements of naturalism and classicism which recall the art of Raphael and Andrea del Sarto. Poccetti continued to paint narrative religious frescoes in the churches and cloisters of Florence until his death.

POLIDORO DA CARAVAGGIO
Caravaggio 1495/1500–Messina circa 1543

Polidoro moved from Caravaggio in Lombardy to Rome around 1515 and found work as a plasterer in the Vatican Loggie. Basing his style upon the art of Raphael and Giulio Romano, he quickly advanced to the position of fresco painter. In Rome Polidoro excelled as a facade painter specializing in monochrome friezes of ancient history, as can be seen on the Palazzo Ricci (1524–1525). Between 1525 and 1527 he decorated the Cappella Fetti in San Silvestro al Quirinale. Following the Sack of Rome in 1527, Polidoro traveled first to Naples and then, in 1528, to Messina. Far removed from the major artistic centers of Italy, his art became introspective, eccentric, and rather unclassical. During these last years he painted religious themes almost exclusively. His later works include the *Way to Calvary* (1534; Naples, Museo Nazionale di Capodimonte) and *Saint Albert the Carmelite* (Turin, Galleria Sabauda).

PONTORMO (Jacopo Carucci)
Pontormo (Empoli) 1494–Florence 1557

Around 1506, Pontormo, who was orphaned as a youth, moved to Florence, where he trained in the studios of Leonardo, Piero di Cosimo, Mariotto Albertinelli, and Andrea del Sarto. Youthful works, including the *Visitation* (1514–1516; Florence, SS. Annunziata), reflect the High Renaissance classicism of Sarto and Fra Bartolommeo. As early as 1518, in the *Madonna and Child with Saints* in San Michele Visdomini, Florence, Pontormo's art became increasingly complex and disturbing in form and feeling, signaling the beginning of the Mannerist style in Italy. His study of Michelangelo and the prints of Dürer further influenced his development of a highly personal, idiosyncratic style. The ambiguous composition and elongated, restless figures of the *Deposition* (1526–1528) in Santa Felicità, Florence, represent the culmination of this development. Pontormo received Medici patronage throughout his career, including a commission for the early fresco decorations (1520) of the family's country villa at Poggio a Caiano. Between 1546 and 1556, he painted the biblical scenes in the choir of the Medici parish church of San Lorenzo in Florence, which no longer exist.

NICOLAS POUSSIN
Les Andelys 1594–Rome 1665

Poussin was first encouraged to paint by the Mannerist Quentin Varin. He moved to Paris to become a professional painter in 1612 and made a visit to Italy around 1621. In 1624 he moved to Rome, where he discovered classical antiquity and studied the art of Raphael, Titian, and Domenichino, all of whom influenced his development. His patrons included Cardinal Francesco Barberini and the antiquarian Cassiano del Pozzo, for whom he painted the first series of the Seven Sacraments (1636–

1640; Washington, D.C., National Gallery of Art, and Leicestershire, Belvoir Castle, Duke of Rutland). Around 1629 or 1630 Poussin's repertoire of subjects changed, focusing now on classical and mythological themes. In 1640 he journeyed to France to work at the court of Louis XIII. He returned to Rome permanently in 1642 and began producing geometrically ordered landscapes, of which the two Phocion landscapes (1648; Shropshire, Oakley Park, Earl of Plymouth, and Liverpool, Walker Art Gallery) are prime examples. Poussin approached painting with a cerebral classicism that became an ideal for future generations of French artists.

FRANCESCO PRIMATICCIO
Bologna 1504 – Paris 1570

Francesco Primaticcio's early development remains unclear. It seems that his earliest formal training commenced in 1525/26 with his move to Mantua, where he became the pupil of Giulio Romano at the Palazzo del Tè. There he worked as a painter, decorator, sculptor, and architect. He was invited to France in 1532 by Francis I to participate in the decoration of the royal château of Fontainebleau, where he collaborated with Rosso Fiorentino in several of the major rooms, including the Chambre du Roi (1531–1535). Following Rosso's death in 1540, Primaticcio assumed the position of chief designer. He made several journeys to Italy on behalf of Francis I during the 1540s. With his compatriot Nicolò dell'Abate he continued to work on the decorations at Fontainebleau, which included the Galerie d'Ulysse and the Salle du Bal. Since little of his fresco and stucco work at Fontainebleau survives, our knowledge of Primaticcio's lively and sophisticated style derives mainly from his surviving drawings and paintings such as *Ulysses and Penelope* (Toledo Museum of Art).

GIULIO CESARE PROCACCINI
Bologna 1574 – Milan 1625

Procaccini, whose father and brothers were painters, moved with his family to Milan in the mid-1580s. Originally, he trained as a sculptor, but, following a trip to Parma around 1600–1602, he turned to painting. His earliest pictures, including the *Martyrdom of SS. Nazaro and Celso* (1606; Milan, Santa Maria presso San Celso) and the series of ten paintings for the Tribunale di Provisione commissioned in 1605 (Milan, Castello Sforzesco), reflect a knowledge of Parmigianino and Correggio and the influence of Procaccini's Lombard contemporaries Cerano and Morazzone. Between 1603 and 1613, Procaccini produced a large number of devotional paintings, including representations of the miracles of San Carlo Borromeo for the Duomo, the *Mystic Marriage of Saint Catherine* (Milan, Pinacoteca di Brera), and the *Madonna with Saints* (Saronno, Sanctuario dei Miracoli). He worked in Modena from 1613 to 1616 and in 1618 was living in Genoa. He returned to Milan in 1619.

RAPHAEL (Raffaello Sanzio)
Urbino 1483 – Rome 1520

Raphael was the son of the painter Giovanni Santi. He entered the Perugian workshop of Pietro Perugino around 1495, quickly assimilating and surpassing his master's style. While working in Florence between 1504 and 1508, Raphael enthusiastically embraced the examples of Leonardo and Michelangelo, as can be seen in the *Portrait of Maddalena Doni* (1506; Florence, Pitti) and the *Entombment* (1507; Rome, Galleria Borghese). In 1508 or 1509 he moved to Rome, where the artistic and intellectual climate offered new inspiration. Pope Julius II employed him to decorate the Vatican Stanze, including the Stanza della Segnatura (1509–1511). Raphael continued to work at the Vatican under Leo X in addition to accepting numerous private commissions. Notable masterpieces include the *Galatea* fresco (1514; Villa Farnesina) and the *Portrait of Baldassare Castiglione* (1515; Paris, Louvre). Raphael became increasingly occupied with architectural projects and in 1514 succeeded Bramante as architect of the new Saint Peter's. His last great altarpiece, the *Transfiguration* (Vatican, Pinacoteca), was made in direct competition with one by Sebastiano del Piombo.

REMBRANDT VAN RIJN
Leiden 1606 – Amsterdam 1669

The son of a miller, Harmen Gerritsz. van Rijn, Rembrandt attended Latin school and was enrolled at the Universiteit te Leiden in 1620. In 1621 he was apprenticed to the Leiden history painter Jacob Isaacsz. van Swanenburgh, and around 1623/24 he studied in Amsterdam with Pieter Lastman and Jacob Pynas. Around 1625 Rembrandt returned as an independent master to Leiden, where he worked closely with Jan Lievens and took his first pupil, Gerard Dou. By 1632 he had moved to Amsterdam and completed *The Anatomy Lesson of Doctor Tulp* (The Hague, Mauritshuis). During the 1630s he was a sought-after portrait painter and produced a series of Passion pictures for the stadtholder, Prince Frederick Henry. Rembrandt married Saskia van Uylenburgh in 1634. During the 1630s and '40s he had many students, including Govaert Flinck, Ferdinand Bol, Carel Fabritius, and Gerbrandt van den Eeckhout. The birth of his son Titus in 1641 was followed by Saskia's death in 1642,

which was also the year the artist completed *The Night-watch* (Amsterdam, Rijksmuseum). During the late 1640s, Hendrickje Stoffels came to live with him as a housekeeper. Financial difficulties set in, culminating in bankruptcy in 1656 and the auctioning of Rembrandt's possessions in 1657 and 1658. Some of his greatest portraits date to his later years, including the *Group Portrait of the Cloth Samplers (The Syndics)* (1662; Amsterdam, Rijksmuseum).

GUIDO RENI
Bologna 1575–1642

Guido Reni was first apprenticed to the Flemish artist Denys Calvaert; in 1594 he joined the Carracci academy. Between 1595 and 1599 he painted numerous altarpieces for local churches, including the *Madonna of the Rosary* (1596–1598; Basilica di San Luca). Around 1600 he moved to Rome, where the powerful naturalism and dramatic lighting of Caravaggio briefly attracted him, as can be seen in the *Crucifixion of Saint Peter* (1605–1606; Vatican, Pinacoteca). A more enduring influence was the ideal, monumental classicism of Raphael's art, as can be seen in Reni's *Aurora* fresco (1614; Casino Rospigliosi Pallavicini). Reni returned to Bologna in 1614 and soon became the city's leading artist. Among his most important works there are the *Pietà dei Mendicanti* (1613–1616) and the *Pala delle Peste* (1631), both in the Pinacoteca Nazionale. His late style is broader and looser, as in *Saint Jerome and the Angel* (1640–1642; Detroit Institute of Arts).

JONATHAN RICHARDSON, SR.
London 1665–1745

Richardson was an artist, a writer on art, and a distinguished collector of drawings. He studied with the portrait painter John Riley and went on to become a portraitist in his own right. Richardson is best known for his drawings of himself and his son, executed in black lead on vellum and in black and white chalk on blue paper. His theoretical writings, especially *Theory of Painting* (1715), were widely read and were of particular importance to Sir Joshua Reynolds, who studied with Thomas Hudson, a pupil of Richardson. Richardson is recognized as one of the greatest drawings connoisseurs in the history of collecting. He built a renowned personal collection and helped to shape other important collections of his time, such as those of the duke of Devonshire and the earl of Pembroke.

HUBERT ROBERT
Paris 1733–1808

Following a brief period of study with the sculptor Michel-Ange Slodtz, Robert accompanied the French ambassador, comte de Stainville, to Rome in 1754. There he became friends with Fragonard and his patron the Abbé de Saint-Non, traveling with them to Naples and Paestum. In addition the work of G. P. Panini had a decisive influence on Robert. A prolific draughtsman, he made studies of the picturesque scenery of Rome and its surroundings, creating real and imaginary views of antique ruins animated with small-scale figures in various activities, as can be seen in *The Winding Staircase at Villa Farnese, Caprarola* (1764; Paris, Louvre). He perfected this genre in France upon his return in 1765. Elected to the Académie in 1766, Robert enjoyed a successful career and expanded his repertoire to include views of contemporary Paris such as the *Demolition of Houses on the Pont Notre-Dame* (1786; Louvre). Robert's marriage of antiquity and modern life with the picturesque, executed with great technical facility, was admirably suited to the taste of his public.

SALVATOR ROSA
Arenella (Naples) 1615–Rome 1673

Rosa received his earliest training in Naples from his uncle Domenico Antonio Greco. Between 1632 and 1635 he worked in the studios of Jusepe Ribera and Aniello Falcone, followed by two extended trips to Rome in 1635–1636 and 1638–1640. Rosa specialized in rustic, picturesque landscapes and battle scenes, which became widely popular. Nevertheless, the recognition he sought was that of a learned painter of historical and philosophical subjects. Having moved to Florence in 1640, Rosa devoted himself to this end, encouraged by the erudite social circle he frequented. From these years date such masterpieces as the classicizing *Alexander and Diogenes* (Althorp House) and the *Grove of Philosophers* (Florence, Pitti). Returning to Rome in 1649, he maintained an intense level of artistic activity which included printmaking. Rosa developed a taste for mysterious and fantastic themes, as can be seen in *Democritus in Meditation* (1650; Copenhagen, Statens Museum for Kunst), the *Humanas Fragilitas* (Cambridge, Fitzwilliam Museum), and prints including *Jason and the Dragon* (1664; [B.18(275) v.45,20]). An unorthodox and eccentric personality, he is considered a precursor of the nineteenth-century Romantics.

ROSSO FIORENTINO (Giovanni Battista di Jacopo di Gasparre)
Florence 1494–Paris 1540

Rosso Fiorentino, with his contemporary Pontormo, introduced the Mannerist style into Florentine painting. His youthful *Assumption* (1517; Florence, SS. Annunziata) shows the influence of Andrea del Sarto and Fra Bartolommeo. Rosso's style, however, became increasingly idiosyncratic and dramatic. In the *Deposition* (1521; Volterra, Pinacoteca) and *Moses Defending the Daughters of Jethro* (1523; Florence, Uffizi), the dissonant colors, distressed figures, and compositional ambiguities run contrary to classical pictorial values. In 1523 Rosso moved to Rome, where the influence of Raphael and Michelangelo predominated. Following the Sack of Rome in 1527, Rosso continued his career in the provincial cities of Tuscany and Umbria. After visiting Venice in 1530, he accepted Francis I's invitation to work at his court in Fontainebleau. Rosso served as artistic director there from 1532 to 1537, adopting an appropriately sophisticated and courtly style. A number of his late drawings were made into prints.

THOMAS ROWLANDSON
London 1757–1827

The son of a textile merchant who went bankrupt, Rowlandson was raised by an uncle and aunt. He was admitted to the Royal Academy in 1772 and made a study trip to Paris around 1774. He first exhibited at the Royal Academy in 1775 with a painting entitled *Delilah Payeth Sampson a Visit in Prison at Gaza* (lost), his only known religious subject. During the early 1780s he probably visited Italy. His career reached a high point in 1784, when he exhibited his great watercolor *Vauxhall Gardens* (London, Victoria and Albert Museum) and also came to prominence as a political caricaturist. From 1786 through the early 1790s he traveled twice to the Continent and to Brighton with his friend the magistrate and amateur caricaturist Henry Wigstead. During the late 1790s Rowlandson began his association with the fine-art publisher Rudolph Ackermann, for whom he executed *The Microcosm of London* (1808–1811), *The Three Tours of Dr. Syntax* (1812–1821), and *The English Dance of Death* (1815–1816). The large corpus of drawings by Rowlandson provides a detailed pictorial account of everyday life in Georgian England.

PETER PAUL RUBENS
Siegen 1577–Antwerp 1640

The son of an Antwerp magistrate, Rubens spent the first ten years of his life in Siegen and Cologne. After his fa-

ther's death in 1587, he returned to Antwerp, where he studied with Tobias Verhaeght, Adam van Noort, and Otto van Veen, becoming a master in the Antwerp guild of Saint Luke in 1598. Rubens left for Italy in 1600 and entered an eight-year period of service with Vincenzo Gonzaga in Mantua, which was interrupted by a diplomatic mission to Spain. In 1608 the artist returned to Antwerp, where he was made court painter to Archduke Albert and Archduchess Isabella in 1609. He went on to execute numerous commissions in that city during the next decade, including the *Raising of the Cross* (1610; Antwerp, Notre Dame). Between 1622 and 1627 Rubens visited Paris several times in connection with a cycle of paintings glorifying the reigns of Marie de Médicis and her husband, King Henry IV (Paris, Louvre). In 1628 he went to Madrid to promote a peace plan between the Netherlands and Spain, and was appointed privy council secretary of the Netherlands by King Philip IV. In 1629–1630 Rubens was sent on a diplomatic mission to England, where he was knighted by King Charles I and received the commission to execute the ceiling paintings of the banqueting hall at Whitehall in London. In 1630 he returned to Antwerp and married Helena Fourment. He designed decorations for the triumphal entry into Antwerp of Cardinal Infant Ferdinand in 1634–1635. In 1635 Rubens purchased the château of Steen, the countryside around which inspired some of his finest landscapes. Rubens executed designs for a series of paintings to decorate the Torre de la Parada, Philip IV's hunting lodge near Madrid, in 1636–1638.

JACOB VAN RUISDAEL
Haarlem circa 1628/29–Amsterdam 1682

Jacob was the son and possibly the pupil of Isaack van Ruisdael, a frame-maker. Although it is likely that he studied with his uncle, the landscape painter Salomon van Ruysdael, Jacob's initial style shows stronger influence from the work of Cornelis Vroom. An artist of precocious talent, van Ruisdael had produced accomplished paintings, drawings, and etchings by 1646. During the early 1650s he toured the hilly eastern border region between the Netherlands and Germany with the artist Nicolaes Berchem, and also visited the ruins of the castle of Egmond near Alkmaar and the Portuguese Jewish cemetery at Oudekerk on the Amstel. Landscapes inspired by these travels, such as *The Castle of Bentheim* (1653; Blessington, Beit collection), show an increased heroic quality. By June 1657 van Ruisdael had moved to Amsterdam, where he remained for the rest of his life, except perhaps for a stay in Caen, where he may have received a medical degree in 1676. His later works include ro-

mantic Northern landscapes with waterfalls and boulders, and panoramic vistas such as *View of Haarlem with Bleaching Grounds* (circa 1670–1675; The Hague, Mauritshuis). Van Ruisdael was seventeenth-century Holland's greatest landscape painter.

CORNELIS SAFTLEVEN
Gorinchem 1607–Rotterdam 1681

Saftleven was the son and pupil of the painter Herman Saftleven, and the brother of the landscape painter Herman Saftleven the Younger. Soon after Cornelis' birth, the family moved to Rotterdam. His earliest dated paintings show fanciful animal allegories and scenes of hell. Around 1632/34 he traveled to Antwerp, where Anthony van Dyck made a portrait drawing of him. By 1634 Saftleven was in Utrecht, where his brother, Herman, was living, and the two began to paint stable interiors, a subject new to peasant genre painting. By 1637 Saftleven had returned to Rotterdam. Paintings of the following decades include landscapes with shepherds and cows and animal satires such as *Allegory of the Condemnation of Oldenbarnevelt* (1663; Amsterdam, Rijksmuseum). As a draughtsman, Saftleven is best known for his black chalk drawings of single figures, usually young men, and his studies of animals, which show the influence of Roelandt Savery. Saftleven remained in Rotterdam until his death.

HERMAN SAFTLEVEN THE YOUNGER
Rotterdam 1609–Utrecht 1685

Herman was probably taught in Rotterdam by his father and his elder brother, Cornelis Saftleven. Among his earliest works is a series of landscape etchings of 1627 in the style of Willem Buytewech. Around 1632 Saftleven moved to Utrecht, where he was deacon of the guild of Saint Luke in 1657, 1658, 1666, and 1667. During the 1630s and '40s he painted rustic stable interiors, but turned increasingly to landscapes, coming under the influence of Jan van Goyen, Roelandt Savery, and—later—Jan Both and Cornelis van Poelenburgh. Most of Saftleven's drawings date from after 1630. Under commission from the municipality, he made studies of buildings in Utrecht, particularly in 1648 and 1675. Between 1648 and 1652 he drew fantastic mountain landscapes influenced by Savery. During this period he also made precise drawings of sites he encountered during travels around Utrecht and along the Rhine. From the 1650s on Saftleven depicted imaginary panoramas reminiscent of the Rhineland, and in his last years made watercolors of flowers. During the 1660s the great Dutch poet Joost van den Vondel composed several poems in praise of Saftleven's work.

CARLO SARACENI
Venice circa 1579–1620

Saraceni's early artistic development owed much to the influence of the North Italian artists Jacopo Bassano, Girolamo Romanino, and Girolamo Savoldo. In 1598 he settled in Rome, where he familiarized himself with the contemporary trends represented by the Carracci and Caravaggio. However, the art of the German Adam Elsheimer made the greatest impression upon him. Saraceni began producing compositions similar to works by Elsheimer, small-scale biblical and mythological subjects set before vast landscapes, as can be seen in the series of six paintings in the Museo di Capodimonte, Naples, including *Ariadne Abandoned*. During the second decade of the seventeenth century, Saraceni developed a rather poetic interpretation of Caravaggio's art. His major works in this style include the *Virgin and Child with Saint Anne* (1611–1614; Rome, Galleria Nazionale d'Arte Antica e Moderna) and *Saint Berno Receiving the Keys of Meissen* (1616–1618; Rome, Santa Maria della Anima). He returned to Venice in 1619 to begin several private and official commissions, which were completed after his death by his friend and collaborator Jean le Clerc.

ROELANDT SAVERY
Kortrijk (Courtrai) 1576–Utrecht 1639

Roelandt Savery and his family left the south Netherlands during the early 1580s, arriving in Haarlem in 1585/86. By 1591 he is likely to have been in Amsterdam, where he studied with his elder brother Jacob and Hans Bol. Savery arrived in Prague in 1603/04 and probably entered the service of Emperor Rudolf II about this time. He traveled in Prague and Bohemia, and around 1606/07 went to the Tyrol, where he drew mountain scenery from life. After Rudolf's death in 1612, Savery remained in Prague for about a year, and between 1614 and 1619 he lived in Amsterdam intermittently. In 1619 he settled in Utrecht, where he spent the remaining twenty years of his life. Savery's most innovative work dates to his years in imperial service. His drawings and paintings are important for the development of several genres: the floral still life, paintings of cows and other animals, cityscapes, and landscapes. Most notably, his mountain scenes with precipitous rocks and waterfalls influenced later Dutch landscape painters such as Allart van Everdingen, Herman Saftleven, and Jacob van Ruisdael.

GIOVANNI GIROLAMO SAVOLDO
Brescia circa 1480–Venice or Brescia 1548

Savoldo was among the leading masters of the Veneto-Lombard school that included Moretto da Brescia and Girolamo Romanino. He matriculated into the Florentine painters' guild in 1508, although no works by him can be connected with this period in his career. Savoldo returned to Brescia by 1514, dividing his career between his native city and Venice, where he moved in 1521. He probably worked in Milan sometime between 1530 and 1532, when he enjoyed the patronage of Duke Francesco II Sforza. His work from these years reflects the descriptive realism characteristic of Lombard painting, especially in rendering landscape and light effects, as can be seen in the *Prophet Elijah* (Washington, D.C., National Gallery of Art). Single figure paintings like the *Shepherd with Flute* (Malibu, J. Paul Getty Museum) and the *Magdalen* (after 1540; London, National Gallery) recall the visual poetry of Giorgione and continue the Venetian tradition of vivid chromatic and textural effects. Savoldo's penetrating, naturalistic portrayals of figures attracted artists of later generations including Caravaggio.

HANS SCHÄUFELEIN
Nuremberg circa 1480/85–Nördlingen 1540

Most probably born in Nuremberg to a family originally from Nördlingen, Schäufelein entered Dürer's workshop about 1503. During Dürer's second trip to Venice in 1505–1507, Schäufelein painted the *Ober-Sankt-Veit Altarpiece* (Vienna, Dom- und Diözesanmuseum), which he based on Dürer's drawings, for the Schlosskirche at Wittenberg. He also executed most of the woodcuts for Ulrich Pindar's *Speculum passionis* of 1507, a collection of New Testament passages and texts by the Church fathers. Leaving Dürer's shop around 1506/07, Schäufelein may have passed through Augsburg; he traveled in 1509/10 to the Tyrol, where he painted the wings of an altarpiece in Niederlana near Merano. Between 1510 and 1515 he was in Augsburg, where he contributed to the *Theuerdank* and the *Weisskunig*, woodcut projects sponsored by Emperor Maximilian I. In 1515 Schäufelein settled permanently in Nördlingen, where he was appointed city painter. Works executed there include the mural painting of the battle of Betulia (1515) for the city hall, as well as many portraits and prints.

SEBASTIANO DEL PIOMBO
Venice circa 1485–Rome 1547

Sebastiano first studied with Giovanni Bellini and then with Giorgione. The experience of the latter's work was seminal for Sebastiano's Venetian period, and their paintings are similar in style and feeling. The tonal rendering and contemplative attitudes of the *Four Saints* painted on the organ shutters for San Bartolommeo a Rialto, Venice, are typical of this phase of his work. In 1511 Agostino Chigi invited Sebastiano to Rome to participate in the fresco decoration of his Villa Farnesina, where Peruzzi was already at work. The very different artistic environment Sebastiano encountered in Rome exerted a profound influence over his artistic development. He was attracted to the work of Raphael, but—more importantly—to that of Michelangelo, who became his close friend and supplied him with designs for paintings. In the *Pietà* (1517; Viterbo, Museo Civico) and the *Raising of Lazarus* (1517–1519; London, National Gallery), Sebastiano introduced bold, monumental forms and somewhat subordinated the role of color. Except for a brief visit to Venice in 1528–1529, he remained in Rome, where, following the death of Raphael in 1520, he became the city's leading painter.

HENDRICK VAN STEENWIJCK THE YOUNGER
Active by circa 1603–The Hague(?) 1649

The son and probably pupil of the painter of architecture Hendrick van Steenwijck the Elder, Hendrick the Younger's early style—as seen in *Interior of a Gothic Church Looking East* (1603; London, National Gallery)—was close to that of his father. In 1617 Steenwijck settled in London, where he probably remained until after 1637. By 1645 he was in Holland, as his portrait appears in the 1645 edition of van Dyck's *Iconography*; there he is described as a painter of architectural subjects in The Hague. He must have died in 1649, since there is mention of his widow having been in Leiden in that year. Steenwijck most frequently depicted Gothic church interiors, palace terraces, and prison interiors, the latter often showing the freeing of Saint Peter.

PIETER STEVENS
Mechelen (Malines) circa 1567–Prague after 1624

Stevens, who may have trained in Antwerp, became a master there in 1589. In 1590/91 he visited Italy, making drawings of sites in Rome, Tivoli, and Naples. Stevens' early graphic style shows the influence of Netherlandish artists in Rome such as Hendrick van Cleef and Paul Bril. Stevens was in Prague by 1594, when he was named court painter to Emperor Rudolf II. He is recorded among the court artists until 1600, and probably remained in imperial service until after Rudolf's death in 1612, inspiring several generations of painters in Prague. Paintings dating to his years in that city include render-

ings of peasant festivals, such as *Kermess Celebrating the Consecration of a Church* (1594; Paris, Institut Néerlandais), as well as mountain scenes, such as *Forest Landscape with a Natural Bridge* (circa 1604; Copenhagen, Statens Museum for Kunst). Many of his drawings done at the Rudolfine court were engraved by Aegidius Sadeler. From 1620 to 1624 Stevens was employed by Prince Karl of Liechtenstein, Stadtholder of Bohemia.

STRADANUS (Jan van der Straet)
Bruges 1523–Florence 1605
A student of Pieter Aertsen, Stradanus became a member of the Antwerp guild of Saint Luke in 1545. Shortly thereafter, he traveled to Venice, via Lyons, and finally took up residence in Florence, where he settled permanently, save for visits to Rome circa 1555, to the Netherlands in 1576–1578, and Naples circa 1578–1580. In Florence Stradanus collaborated with Vasari on the decoration of the palaces of the Medici, and around 1561 he began to produce designs for a series of hunting tapestries for Grand Duke Cosimo I, to be hung in the Villa Poggio a Caiano near Florence. The tapestries were woven at the grandducal *arazzeria* circa 1567–1577. Stradanus also supplied Antwerp publishers with designs for prints, the best known of which are several series depicting the art of hunting. Initially influenced by Antwerp Mannerism, Stradanus in his later works combined a figure style shaped by Vasari and Tintoretto with a characteristically Northern interest in naturalistic and topographical details.

PIETRO TESTA
Lucca 1612–Rome 1650
Pietro Testa worked as a painter and printmaker. By 1630 he was living in Rome, where he studied with Domenichino, followed by a brief period with Pietro da Cortona. Testa's surviving paintings are extremely rare and include the *Massacre of the Innocents* (Rome, Galleria Spada) and the *Miracle of Saint Theodore* (Lucca, San Paolino). He was, above all, a prolific and appealing draughtsman and found the graphic media most suitable to his expressive purposes. Early etchings such as the *Saint Jerome* (1630–1631; B.15[219] v.45,20) and the *Venus and Adonis* (B.25[222] v.45,20) reveal a neo-Venetian stage in Testa's art in the sensitive rendering of details, tonalities, and picturesque landscapes. During the 1630s and '40s he frequented the circle of the learned antiquarian Cassiano del Pozzo and became a friend of Nicolas Poussin. As a result his art assumed a more austere and classical tenor, as can be seen in *Plato's Symposium* (1648; B.18[220] v.45,20) and *The Death of Cato* (1648; B.20[220] v.45.20).

Testa's last years were occupied in writing a treatise on painting.

GIOVANNI BATTISTA TIEPOLO
Venice 1696–Madrid 1770
Tiepolo studied with Gregorio Lazzarini and was later influenced by Sebastiano Ricci, Piazzetta, and Veronese. He created elaborate fresco decorations and paintings for palaces and churches in northern Italy, Germany, and Spain with an inventive freedom of form and color expressive of the Rococo spirit. Tiepolo excelled in creating the illusion of infinite space articulated with luminous colors and atmospheric effects and animated with flickering brushwork, as can be seen in the *Glory of Saint Theresa* (1720–1725; Venice, Santa Maria degli Scalzi), the allegorical fresco decorations (1750–1753) for the prince-bishop's residence at Würzburg, and the *Anthony and Cleopatra* cycle (circa 1747–1750) in the Palazzo Labia, Venice. Tiepolo was also a graphic artist, and in his etchings for the *Scherzi di Fantasia* (1735–1740), published in 1743, he indulged his taste for the grotesque and fantastic in the tradition of Castiglione. He was summoned to Spain in 1762 at the invitation of Charles III to decorate several rooms of the royal palace and remained there until his death in 1770.

GIOVANNI DOMENICO TIEPOLO
Venice 1727–1804
Giovanni Domenico was the son and pupil of Giovanni Battista Tiepolo. He collaborated with his father on numerous projects and accompanied him to Würzburg in 1750–1753 and to Madrid in 1762–1770. Domenico received important commissions of his own beginning with the *Stations of the Cross* (1747) for the Oratorio del Crocifisso in the church of San Polo, Venice. Between 1754 and 1755 he painted the cupola of SS. Giovita e Faustina, Brescia, and in 1757 decorated the guest house of the Villa Valmarana, Vicenza, with delightful scenes of country life, rich in observed detail. During the 1770s Domenico produced a number of religious paintings characterized by animated, broken brushstrokes and an increased attention to realism and lighting effects, as can be seen in the *Institution of the Eucharist* (1778; Venice, Accademia). His personal style and expression favored the depiction of the daily preoccupations of the bourgeoisie and of clowns and mountebanks, often presented with sardonic wit and a tendency to caricature. These subjects are best represented in his vast production of prints and drawings, including the Punchinello series, and the frescoes in the family villa at Zianigo (1791–1793; Venice, Ca'Rezzonico).

TITIAN (Tiziano Vecellio)
Pieve di Cadore circa 1480/90 – Venice 1576
One of the greatest Venetian artists of the Cinquecento, Titian trained in Venice with Gentile and Giovanni Bellini and around 1508 entered into association with Giorgione, whose lyrical style he adopted. In the *Assumption* (1516–1518) for Santa Maria dei Frari, Venice, he introduced a monumental and richly coloristic manner. For the duke of Ferrara he created a series of exuberant mythological paintings, including the *Bacchanal* (1523–1525; Madrid, Prado). Titian's portraits, such as *Man with a Glove* (1523; Paris, Louvre) and *Pope Paul III* (1543; Naples, Museo Nazionale di Capodimonte) are admired for their brilliant combination of pictorial and psychological elements. He visited Rome between 1548 and 1551 and traveled twice during these years to the court of Charles V at Augsburg. Late masterpieces such as the *Rape of Europa* (1559–1562; Boston, Isabella Stewart Gardner Museum) and *The Crowning with Thorns* (Munich, Alte Pinakothek) are notable for their technical freedom and emphasis on surface values.

PAOLO VERONESE (Paolo Caliari)
Verona 1528 – Venice 1588
Veronese, best known for his grandiose civic and religious painting cycles, received his artistic training in Verona from Antonio Badile. The early fresco decorations (1551) for the Villa Soranza near Castelfranco suggest a knowledge of the art of Correggio, Parmigianino, and Giulio Romano. Moving to Venice in 1553, Veronese worked in the Sala del Consiglio dei Dieci, Palazzo Ducale, and began a series of projects for the church of San Sebastiano including the *Triumph of the Mordecai*. Veronese's youthful production culminated in the mythologies and allegories painted in Palladio's Villa Barbaro (now Volpe) at Maser in 1561. A noted portraitist, he imparted a serene, imposing air to his subjects, which are enriched with fine details of color and texture, as can be seen in the *Portrait of a Woman* (Paris, Louvre). His large "feast paintings" include the *Marriage at Cana* (1562–1563; Venice, Accademia) and *Feast in the House of Levi* (1573; Louvre). They are remarkable for their skillful and harmonious organization of large groups before stabilizing architectural backgrounds.

JEAN-ANTOINE WATTEAU
Valenciennes 1684 – Nogent-sur-Marne 1721
The son of a master tiler, Watteau trained with J.-A. Gérin in Valenciennes in 1699. He went to Paris before 1702 and shortly thereafter met Claude Gillot. Watteau worked with Gillot from 1703 to 1707 and was influenced by his passion for the commedia dell'arte and theater, as can be seen in *Mezzetin* (1718–1719; New York, Metropolitan Museum of Art). From 1708 to 1709 Watteau worked with the decorator Claude Audran III, who also served as curator of the Rubens paintings in the Palais du Luxembourg. Watteau's close study of this Flemish master profoundly affected his own art. His patron, Pierre Crozat, encouraged Watteau to study the drawings and Venetian paintings in his collection. In this way the artist began to combine Flemish and Venetian elements, developing a unique style characterized by rich, decorative coloring, graceful figures, and a tender, poetic mood. In 1717 he was elected to the Académie in a special category created for him, *peintre de fêtes galantes*. His major works include *Pilgrimage to the Island of Cythera* (1717; Paris, Louvre), which he presented to the Académie as his reception piece, and *Gersaint's Shop Sign* (1720; Berlin, Kunstamt Charlottenburg).

BENJAMIN WEST
Springfield 1738 – London 1820
Born into an American Quaker family, West was encouraged early in his career by William Smith, provost of the College of Philadelphia, whom he met in 1756. West's ambitious early portraits of the 1750s display the influence of the painter John Wollaston. In 1760 West traveled to Italy, where he encountered the work of the German Neoclassical painter Anton Raphael Mengs, who was then active in Rome. Moving to England in 1763, West showed a picture in the first Royal Academy exhibition of 1769. In 1771 he exhibited his most important work, *The Death of General Wolfe* (1771; Ottawa, National Gallery of Canada), which captivated the public through its elevated and heroic presentation of a contemporary historical event. West succeeded Sir Joshua Reynolds as president of the Royal Academy in 1792, and between 1772 and 1811 held the post of historical painter to King George III. During this time West executed numerous works for Windsor Castle, including scenes from early British history such as *Queen Philippa Interceding for the Burghers of Calais* (1788; Detroit Institute of Arts). Late in life he completed a series of very large canvases, including *Christ Rejected by the Jews* (1814; Philadelphia, Pennsylvania Academy of the Fine Arts).

HERMANN WEYER
Coburg 1596 – after 1621
Little is known of Weyer's life save that his father, Hans Weyer, was a painter active in Coburg and his brother, Hans the Younger, worked there as a portrait painter. Hermann Weyer appears to have worked exclusively as

a draughtsman, possibly earning a living selling his drawings, which are dated from between 1607 and 1621 and are often highly finished. Neither his training nor his place of activity are documented, and his style until about 1615 seems to have been entirely his own. It has been postulated that he made a trip to the Netherlands around 1616. Moreover, reflections of other Netherlandish artists such as Abraham Bloemaert and Paulus Moreelse appear in his later oeuvre. Highly stylized, dramatic in its use of chiaroscuro, and generally focused on figural groups in landscapes, his work represents an original and seemingly independent form of late Mannerism in Central Europe.

JOACHIM ANTHONISZ. WTEWAEL
Utrecht 1566–1638

The son of a glass-painter, Wtewael was a pupil of Joos de Beer in Utrecht. Between 1586 and 1590 he spent two years in Padua and two years in France. In 1592 he became a member of the Utrecht saddler's guild; in 1596 he executed designs for two of the windows of the Sint-Janskerk in Gouda. Among the most important of the Dutch Mannerists, Wtewael continued to work in this style later than most other Dutch artists. His Calvinism and fervent support of the Netherlands' struggle for independence informs a number of his works, including his stained-glass windows at Gouda, his *Thronus justitiae* engravings of 1605 and 1606, and his series of allegorical drawings of the Eighty Years War.

FEDERICO ZUCCARO
Sant'Angelo in Vado 1540/41–Ancona 1609

Federico Zuccaro was one of the most prominent painters of the late Cinquecento and an exponent of the late Mannerist tradition. He trained in his brother Taddeo's Roman workshop, assisting him on such important commissions as the decorations for the Casino of Pius IV (1561–1563). Between 1563 and 1565 Federico worked in Venice and Florence, returning to Rome in 1566. Taddeo died in the same year, and Federico completed his outstanding commissions, including the fresco cycles in the Palazzo Farnese, Caprarola, and the Sala Regia, Vatican, and embarked on several new projects in Rome, including the *Flagellation* (1573) in the Oratorio del Gonfalone. In 1574 Federico traveled to the Netherlands and England. By 1575 he was working in Florence on the cupola frescoes in the Duomo. The grand narrative schemes of *The Submission of the Emperor Frederick Barbarossa to Pope Alexander III* (Venice, Palazzo Ducale, Sala del Gran Consiglio) occupied him from 1582 on. From 1585 to 1588/89, Federico worked as court painter to Philip II of Spain. Returning to Rome in 1590, he was instrumental in founding the Accademia di San Luca in 1593, and his treatise on painting was published in Turin in 1607. His later work reflects a keen interest in naturalism.

JACOPO ZUCCHI
Florence 1541/42–Rome circa 1590

Jacopo Zucchi trained with Giorgio Vasari and later worked with him on several projects, including the Sala dei Cinquecento (1563–1565) in the Palazzo Vecchio, Florence. Zucchi was employed as Vasari's assistant in Rome in 1567, later returning with him to Florence to participate in the decorations of the Studiolo of Francesco I dei Medici. For the Studiolo, Zucchi painted the *Mining of Gold*, a synthesis of Tuscan Mannerism and Flemish attention to lively detail derived from Stradanus. Zucchi moved to Rome in 1572, entering the employ of Cardinal Ferdinando de' Medici, for whom he decorated the Palazzo Firenze (1574–1575). In his frescoes and altarpieces for Roman churches, including the *Pentecost* (1576; Santo Spirito in Sassia) and the undated *Birth of the Baptist* (San Giovanni Decollato), he adopted a simple, more pious manner following the dictates of the Counter-Reformation. However, his preference for exquisite, precious detail and fantastic compositions is best represented in three small paintings of around 1580 in the Uffizi, Florence: the *Age of Gold*, the *Age of Silver*, and the *Age of Iron*.

LIST OF ARTISTS

Numerals in boldface indicate entry numbers; those in regular type indicate the pages on which artists' biographies appear.